THE ARTIST PROJECT

THE ARTIST PROJECT

WHAT ARTISTS SEE WHEN THEY LOOK AT ART

THE METROPOLITAN MUSEUM OF ART

FOREWORD—THOMAS P. CAMPBELL 11

HOW ARTISTS SEE ART—CHRISTOPHER NOEY 12

THE ARTIST PROJECT 15

ARTIST BIOGRAPHIES 258

CAPTIONS AND CREDITS 263

ACKNOWLEDGMENTS 272

VITO **ACCONCI**	GERRIT RIETVELD'S *ZIG ZAG STOEL*	16
ANN **AGEE**	VILLEROY *HARLEQUIN FAMILY*	18
NJIDEKA **AKUNYILI CROSBY**	GEORGE SEURAT'S *EMBROIDERY; THE ARTIST'S MOTHER*	20
GHADA **AMER**	*GARDEN GATHERING*	22
KAMROOZ **ARAM**	ANCIENT ARTS OF IRAN	24
CORY **ARCANGEL**	HARPSICHORD	26
JOHN **BALDESSARI**	PHILIP GUSTON'S *STATIONARY FIGURE*	28
BARRY X **BALL**	EGYPTIAN FRAGMENT OF A QUEEN'S FACE	30
ALI **BANISADR**	HIERONYMOUS BOSCH'S *THE ADORATION OF THE MAGI*	32
DIA **BATAL**	SYRIAN TILE PANEL WITH CALLIGRAPHIC INSCRIPTION	34
ZOE **BELOFF**	ÉDUOARD MANET'S *CIVIL WAR (GUERRE CIVILE)*	36
DAWOUD **BEY**	ROY DECARAVA'S PHOTOGRAPHS	38
NAYLAND **BLAKE**	POWER OBJECT (BOLI)	40
BARBARA **BLOOM**	VILHELM HAMMERSHØI'S *MOONLIGHT, STRANDGADE 30*	42
ANDREA **BOWERS**	HOWARDENA PINDELL'S WORKS ON PAPER	44
MARK **BRADFORD**	CLYFFORD STILL'S PAINTINGS	46
CECILY **BROWN**	MEDIEVAL SCULPTURES OF THE MADONNA AND CHILD	48
LUIS **CAMNITZER**	GIOVANNI BATTISTA PIRANESI'S ETCHINGS	50
NICK **CAVE**	KUBA CLOTHS	52
ALEJANDRO **CESARCO**	ALBERTO GIACOMETTI AND BALTHUS IN GALLERY 907	54
ENRIQUE **CHAGOYA**	GOYA'S *LOS CAPRICHOS*	56
ROZ **CHAST**	ITALIAN RENAISSANCE PAINTING	58
WILLIE **COLE**	CI WARA SCULPTURE	60
GEORGE **CONDO**	CLAUDE MONET'S *THE PATH THROUGH THE IRISES*	62
PETAH **COYNE**	JAPANESE OUTER ROBE WITH MOUNT HŌRAI	64
JOHN **CURRIN**	LUDOVICO CARRACCI'S *THE LAMENTATION*	66
MOYRA **DAVEY**	ROSARY TERMINAL BEAD WITH LOVERS AND DEATH'S HEAD	68
EDMUND **DE WAAL**	EWER IN THE SHAPE OF TIBETAN MONK'S CAP	70
THOMAS **DEMAND**	STUDIOLO FROM THE DUCAL PALACE IN GUBBIO	72
TERESITA **FERNÁNDEZ**	PRE-COLUMBIAN GOLD	74
SPENCER **FINCH**	WILLIAM MICHAEL HARNETT'S *THE ARTIST'S LETTER RACK*	76

ERIC **FISCHL** MAX BECKMANN'S *BEGINNING* 78

ROLAND **FLEXNER** JACQUES DE GHEYN II'S *VANITAS STILL LIFE* 80

WALTON **FORD** JAN VAN EYCK'S *THE LAST JUDGMENT* 82

NATALIE **FRANK** KÄTHE KOLLWITZ 'S PRINTS 84

LATOYA RUBY **FRAZIER** GORDON PARKS'S *RED JACKSON* 86

SUZAN **FRECON** DUCCIO DI BUONINSEGNA'S *MADONNA AND CHILD* 88

ADAM **FUSS** MARBLE GRAVE STELE OF A LITTLE GIRL 90

MAUREEN **GALLACE** PAUL CÉZANNE'S STILL LIFE PAINTINGS 92

JEFFREY **GIBSON** VANUATU SLIT GONGS 94

NAN **GOLDIN** JULIA MARGARET CAMERON'S PHOTOGRAPHS 96

WENDA **GU** ROBERT MOTHERWELL'S *LYRIC SUITE* 98

DIANA **AL-HADID** CUBICULUM, VILLA OF P. FANNIUS SYNISTOR AT BOSCOREALE 100

ANN **HAMILTON** BAMANA MARIONETTE 102

JANE **HAMMOND** SNAPSHOTS AND VERNACULAR PHOTOGRAPHY 104

JACOB **EL HANANI** MASTER OF THE BARBO MISSAL'S *MISHNEH TORAH* 106

ZARINA **HASHMI** ARABIC CALLIGRAPHY 108

SHEILA **HICKS** *PRAYER BOOK: ARGANONÄ MARYAM* 110

RASHID **JOHNSON** ROBERT FRANK'S PHOTOGRAPHS 112

Y. Z. **KAMI** EGYPTIAN MUMMY PORTRAITS 114

DEBORAH **KASS** GREEK VASES 116

NINA **KATCHADOURIAN** EARLY NETHERLANDISH PORTRAITURE 118

ALEX **KATZ** FRANZ KLINE'S *BLACK, WHITE, AND GRAY* 120

JEFF **KOONS** ROMAN SCULPTURE 122

AN-MY **LÊ** EUGÈNE ATGET'S *CUISINE* 124

IL **LEE** REMBRANDT'S PORTRAITS 126

LEE MINGWEI CHINESE CEREMONIAL ROBES 128

LEE UFAN MOON JAR 130

GLENN **LIGON** *THE GREAT BIERI* 132

LIN TIANMIAO ALEX KATZ'S *BLACK AND BROWN BLOUSE* 134

KALUP **LINZY** ÉDOUARD MANET'S PAINTINGS 136

ROBERT **LONGO** — JACKSON POLLOCK'S *AUTUMN RHYTHM (NUMBER 30)* — 138

NICOLA **LÓPEZ** — WORKS ON PAPER — 140

NALINI **MALANI** — *HANUMAN BEARING THE MOUNTAINTOP WITH MEDICINAL HERBS* — 142

KERRY JAMES **MARSHALL** — JEAN AUGUSTE DOMINIQUE INGRES'S *ODALISQUE IN GRISAILLE* — 144

JOSIAH **MCELHENY** — HORACE PIPPIN'S PAINTINGS — 146

LAURA **MCPHEE** — PIETER BRUEGEL THE ELDER'S *THE HARVESTERS* — 148

JOSEPHINE **MECKSEPER** — GEORGE TOOKER'S *GOVERNMENT BUREAU* — 150

JULIE **MEHRETU** — VELÁZQUEZ'S *JUAN DE PAREJA* — 152

ALEXANDER **MELAMID** — ERNEST MEISSONIER'S *1807, FRIEDLAND* — 154

MARIKO **MORI** — BOTTICELLI'S *THE ANNUNCIATION* — 156

VIK **MUNIZ** — THE HENRY R. LUCE CENTER FOR THE STUDY OF AMERICAN ART — 158

WANGECHI **MUTU** — EGON SCHIELE'S DRAWINGS — 160

JAMES **NARES** — CHINESE CALLIGRAPHY — 162

CATHERINE **OPIE** — LOUIS XIV'S BEDROOM — 164

CORNELIA **PARKER** — ROBERT CAPA'S *THE FALLING SOLDIER* — 166

IZHAR **PATKIN** — *SHIVA AS LORD OF DANCE* — 168

SHEILA **PEPE** — EUROPEAN ARMOR — 170

RAYMOND **PETTIBON** — JOSEPH MALLORD WILLIAM TURNER'S PAINTINGS — 172

SOPHEAP **PICH** — VINCENT VAN GOGH'S DRAWINGS — 174

ROBERT **POLIDORI** — JULES BASTIEN-LEPAGE'S *JOAN OF ARC* — 176

RONA **PONDICK** — EGYPTIAN SCULPTURAL FRAGMENTS — 178

LILIANA **PORTER** — JACOMETTO'S *PORTRAIT OF A YOUNG MAN* — 180

WILFREDO **PRIETO** — AUGUSTE RODIN'S SCULPTURES — 182

RASHID **RANA** — UMBERTO BOCCIONI'S *UNIQUE FORMS OF CONTINUITY IN SPACE* — 184

KRISHNA **REDDY** — HENRY MOORE'S SCULPTURES — 186

MATTHEW **RITCHIE** — *THE TRIUMPH OF FAME OVER DEATH* — 188

DOROTHEA **ROCKBURNE** — ANCIENT NEAR EASTERN HEAD OF A RULER — 190

ALEXIS **ROCKMAN** — MARTIN JOHNSON HEADE'S *HUMMINGBIRD AND PASSIONFLOWERS* — 192

ANNABETH **ROSEN** — CERAMIC DEER FIGURINES — 194

MARTHA **ROSLER** — THE MET CLOISTERS — 196

TOM **SACHS**	SHAKER RETIRING ROOM	198
DAVID **SALLE**	MARSDEN HARTLEY'S PAINTINGS	200
CAROLEE **SCHNEEMANN**	CYCLADIC FEMALE FIGURES	202
DANA **SCHUTZ**	BALTHUS'S *THE MOUNTAIN*	204
ARLENE **SHECHET**	BRONZE STATUETTE OF A VEILED AND MASKED DANCER	206
JAMES **SIENA**	*BUDDHA OF MEDICINE BHAISHAJYAGURU*	208
KATRÍN **SIGURDARDÓTTIR**	HÔTEL DE CABRIS, GRASSE, FRANCE	210
SHAHZIA **SIKANDER**	PERSIAN MINIATURE PAINTING	212
JOAN **SNYDER**	FLORINE STETTHEIMER'S *CATHEDRALS* PAINTINGS	214
PAT **STEIR**	KONGO POWER FIGURE	216
THOMAS **STRUTH**	CHINESE BUDDHIST SCULPTURE	218
HIROSHI **SUGIMOTO**	*BAMBOO IN THE FOUR SEASONS*	220
EVE **SUSSMAN**	WILLIAM EGGLESTON'S PHOTOGRAPHS	222
SWOON	HONORÉ DAUMIER'S *THE THIRD-CLASS CARRIAGE*	224
SARAH **SZE**	TOMB OF PERNEB	226
PAUL **TAZEWELL**	ANTHONY VAN DYCK'S PORTRAITS	228
WAYNE **THIEBAUD**	ROSA BONHEUR'S *THE HORSE FAIR*	230
HANK WILLIS **THOMAS**	DAGUERREOTYPE BUTTON	232
MICKALENE **THOMAS**	SEYDOU KEÏTA'S PHOTOGRAPHS	234
FRED **TOMASELLI**	*GURU DRAGPO*	236
JACQUES **VILLEGLÉ**	GEORGES BRAQUE'S AND PABLO PICASSO'S PAINTINGS	238
MARY **WEATHERFORD**	GOYA'S *MANUEL OSORIO MANRIQUE DE ZUÑIGA*	240
WILLIAM **WEGMAN**	WALKER EVANS'S POSTCARD COLLECTION	242
KEHINDE **WILEY**	JOHN SINGER SARGENT'S PAINTINGS	244
BETTY **WOODMAN**	MINOAN TERRACOTTA LARNAX	246
XU BING	JEAN-FRANÇOIS MILLET'S *HAYSTACKS: AUTUMN*	248
DUSTIN **YELLIN**	ANCIENT NEAR EASTERN CYLINDER SEALS	250
LISA **YUSKAVAGE**	ÉDOUARD VUILLARD'S *THE GREEN INTERIOR*	252
ZHANG XIAOGANG	EL GRECO'S *THE VISION OF SAINT JOHN*	254

FOREWORD

The Metropolitan Museum of Art has always been a museum for artists, so it comes as no surprise when I hear from even the most cutting-edge of today's practitioners that this is where they go for inspiration. Wander through our Roman galleries and you might find Jeff Koons admiring a colossal Hercules or Adam Fuss moved by the ancient grave marker of a young girl. Deborah Kass could be a few galleries away looking at the Greek vases that she sees as "comics of another age." Kehinde Wiley navigates our European paintings galleries like he owns them—and he does (we all do; at The Met, ownership is the reward of long and careful looking, available to anyone). Kehinde might run into Nina Katchadourian while exploring our early Netherlandish portraits or Roz Chast among the Italian Renaissance works: all consumed by and consuming the work of their predecessors. And there are, of course, plenty of artists here every day whom we don't yet know, looking and learning, stretching to understand what has come before so they can embrace or reject it.

In 2015–16, while I was serving as Director of The Met, 120 artists collaborated with us to create an online feature called *The Artist Project*. Each artist chose a work of art or gallery that sparks their imagination and has significant meaning to them. Their ideas and responses were recorded and made into three-minute episodes released over the course of fifteen months. The artists were both local and international, working in a variety of media, and at different stages in their careers. That award-winning online series is the basis for this publication, which provides additional context for the artists' unique and passionate interpretations of The Met's collection. I hope it will encourage readers to look at art in a new way.

The Artist Project online feature, which was conceived and developed by a team led by Christopher Noey, Series Director, and Teresa Lai, Series Producer, would not have been possible without the support of Bloomberg Philanthropies, and I am grateful to them for having the foresight to support the online series as part of their Bloomberg Connects program. Phaidon, with its long history of creatively publishing books about art and contemporary artists, was the perfect publisher to deliver this volume, developed and overseen by Gwen Roginsky, Associate Publisher at The Met, and by Deborah Aaronson, Vice President, Group Publisher at Phaidon.

Finally, I want to thank the 120 artists who took precious time away from their studios to participate in this series and share their personal thoughts and insights. You can hear their voices and see more images online at artistproject.metmuseum.org. Their words give visibility to something we have known about The Met and its collection for a long time: it is a thrilling place for anyone to discover and be inspired.

Thomas P. Campbell

HOW ARTISTS SEE ART—CHRISTOPHER NOEY

From the fall of 2014 to the spring of 2016, I sat down with nearly all of the 120 contemporary artists included in this volume to engage in conversations about a work of art or a group of works in the collections of the Metropolitan Museum. Finding out what these artists see when they look at art became the basis for *The Artist Project*, which was initially produced as an online series and has now engendered this publication. These artists represent a broad array of voices, and they approach works of art from diverse points of view, but they have all faced the challenge of making something that can move a viewer. They have spent their careers exploring the creative process, and it is not surprising that each of them had wonderful insights into what it means to encounter a work of art.

What criteria did we follow in selecting artists for *The Artist Project*? For one thing, we wanted artists who enjoyed talking about art, the kind of people you'd like to spend time with in a museum. This group includes artists who have works in The Met's collection and others who do not, artists both established and emerging—in short, an array of voices as diverse as the works of art they discuss. The artists bring a contemporary perspective to looking at art, but their curiosity is boundless—they encourage readers to travel across five thousand years of art history from regions and cultures that span the globe.

In creating *The Artist Project*, we were often reminded of the memorable series of articles that *New York Times* art critic Michael Kimmelman wrote about exploring museums with contemporary artists. The difference is that while Kimmelman and his collaborators extended their conversations across multiple galleries, our interviews focused on a single work or space and gave the artists an opportunity to take a longer, more in-depth look. Concentrating on individual works allowed us to both represent the breadth of art history and encourage our audiences to have what John Dewey called "an experience" with the object—intense, focused viewing that would open up, rather than shut down, the imagination. The format in which readers encounter these works of art in this book—juxtaposed with brief curatorial interpretations and the artists' interviews—is one that invites comparison, not just between the works of art chosen by the artists and their own works but also between the artists as well. It reminds us what great conversations can be sparked by a work of art.

Each interview lasted about thirty minutes, and I was fortunate enough to conduct nearly all of them myself. The actual conversation could be very far-reaching, but I essentially asked only three questions: Why does this work of art rock your world? What are some decisions the artist made that impress you? How is this work contemporary?

Listening to these artists, I experienced a joy of discovery in seeing the works through their eyes. They know how to unpack a work not only analytically but also emotionally. They have a way of making it personal. Some of them speak about an epiphany, the moment when a work set them on the path to an art career. For instance, when Maureen Gallace, who paints serene, unpeopled landscapes inspired by her native New England, first saw Cézanne's apples as an art student, she thought, "'Oh, I can paint like this.' I did not find them intimidating. Cézanne gave permission. I saw that there was a way in for me. And despite getting older and having been a painter for twenty-five years, they still deliver."

One of the pleasures of exploring this book is the opportunity to compare the works discussed by the artists with examples of their own work. Reproduced alongside each other, the images create compelling connections. Although we didn't explicitly ask the artists to relate their work to the objects they selected, it was inevitable that as they talked about other artists' works, we would learn about their own strategies as well. Kehinde Wiley admits to being seduced by John Singer Sargent's virtuosity, even as he gleefully acknowledges that Sargent is manipulating him: "I'm a young black man trying to deal with the ways in which colonialism and empire are present in these pictures—but they're fabulous! It's a guilty pleasure," he says. It didn't surprise me that Eric Fischl chose to explore a Max Beckmann painting of a boy coming of age, a theme that has resonated so profoundly in his own career, or that street artist Swoon looks at Daumier's *The Third-Class Carriage* and finds "something deeply antiauthoritarian about just looking, observing, and telling the truth as you saw it." It *did* surprise me when Nan Goldin told me she had only recently discovered in Julia Margaret Cameron's work some of her own struggles—against male photographers who have questioned her technical ability and her subject matter—as well as the strength born of a shared trust between photographer and subject. Speaking with her gave me a new perspective on both Cameron's work and Goldin's.

Some artists gravitated to well-known masterworks—such as Julie Mehretu on Velázquez's dazzling portrait of Juan de Pareja, Arlene Shechet on the haunting Hellenistic Greek veiled dancer, or Suzan Frecon on Duccio's *Madonna and Child*—while still pointing out something unexpected in them. But among the joys of this series are the less familiar works that the artists invite us to discover: eighteenth-century porcelain figurines that initially "horrified" Ann Agee, or a Bennington earthenware deer that prompted Annabeth Rosen to look beyond the masterpieces:

The goddamn Metropolitan Museum! Every exquisite example of a treasure—the epitome of greatness in terms of culture and art—exists here. This doe—she's small and insignificant until you really catch her eye. Then there's this kind of connection.

The book encourages readers to study and reconsider the works of art while reading the artists' words. As diverse as these artists and their perspectives are, they consistently prompt us to look closely and then look again—and not necessarily at favorite works. As Dana Schutz points

out, "Sometimes you can actually get more from the paintings that bother you."

In my conversations with the artists included in this book, I often found myself transported into the studio at the moment of creation, as if I were standing behind them, watching them at work. Here, for example, is Kerry James Marshall dissecting Ingres's *Odalisque in Grisaille*:

> Ingres's image has been stylized to produce an effect.... The way the upper part of the torso is turned, and that breast under her arm is in a mighty awkward place—it's almost right on the side of her body, as opposed to where it's supposed to be. If you follow the curve of the woman's back to her thigh and then down across her knee and to the foot that's at the bottom, there's a very nice rhythmic curve that goes all the way from the left side of the picture to the right.... He needed to keep the flatness of that plane so that the figure remains decorative.

Because we wanted the breadth of art history to be represented, we decided early on that there should be no duplication of works. This led to one slightly delicate case, involving the Power Object (Boli) created by the Bamana people of Mali. It was selected by Nayland Blake, but after we had already interviewed him about it, four other artists requested the same object. In a museum with no shortage of canonical masterpieces, I never suspected how many artists would share my fascination with this amorphous ritual object that defies conventional notions of style, authorship, and completion. Made of blood, mud, and other matter that has been added to it over the years, the *boli* is iterative, or, as Blake so poetically describes it, "made in the same way a snowdrift is. It finds its final shape as a result of many forces acting independently." The boli is performative, a sensibility that Kalup Linzy conjures up when he imagines Manet's studio as a place for dress up, with "the models coming in and putting [the costumes] on and posing as the characters." The boli engages the community, and many artists were drawn to the idea that a work of art would be made not just *for* a community but *by* it. These themes resonate again and again throughout the conversations in this book.

Ultimately, my greatest pleasure in conducting these interviews was the surprises they gave me, the unexpected turns of phrase that unlocked these works of art for me and invited me to connect with them, both intellectually and emotionally. Pat Steir expresses a touching familiarity with the Kongo Power Figure, which was created to protect a village. "He's doing his best here in the museum," she says, admitting that the sculpture brings tears to her eyes every time she sees him in The Met; "he's like a retired football player." Wangechi Mutu says of Egon Schiele's drawing: "There's nothing proper about it. It's raw—the way sex is raw, the way relationships are raw." And David Salle calls a lobsterman's red shirt painted by

Marsden Hartley "heartbreaking," adding, "It's the paradox of the tragedian's art: that he can depict tragic events or express a tragic sense of life in a way that is piercingly beautiful."

In so many of these works of art, there are things I hadn't seen, but after listening to these artists, now I do. They know that a work of art can tell us about the past, connect us to distant lands and peoples, explore the unfamiliar, and, of course, spark the imagination and open a path to the future. That's why it's important to know what artists see when they look at art. They remind us how much is at stake every time an artist creates.

THE ARTIST PROJECT

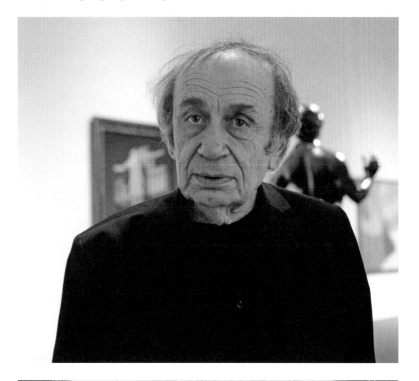

"It's almost like a chair pretending to be a person."

I never really studied art. At the very end of the sixties, I started doing work that involved my own person, and by the end of the seventies, I was starting to do something that resembled design or architecture. I realized I wanted to do this because I really hated the position that "the viewer is here and the work is there." That's what bothered me about the word *performance*—it requires words like *viewer*, *audience*. I wanted to do work that people could be part of, almost like utensils; I want people to use the work I'm making.

The *Zig Zag Stoel* is probably the easiest chair to make. Gerrit Rietveld—he's one of the most precise thinkers I've ever come across. He has a kind of intellectual way of making.

On the one hand, it's such a basic chair, but on the other hand, it's incredibly rigorous—almost a mathematical problem. There are four planes of wood, two of which are the same size—one to sit on and one for the base on the ground. The front of the base is directly beneath the front of the seat and it has no arms. He didn't need the back of a chair, but I think Rietveld wanted to make something that said "chairness."

He must have thought, how do I put these together so it supports itself? Suddenly, a light bulb must have gone off: it has to be a diagonal. Twenty years later, in the early sixties, there were new materials. Verner Panton didn't need a diagonal because he could use all curves. Then Frank Gehry did a similar thing with cheaper materials. But the Rietveld chair is the beginning. It's almost like a chair pretending to be a person. If I crouch on the ground, I've animated the chair.

It's something that a monk or a priest might gravitate to. There's a bit of sacrifice here; it gives you the feeling of being not so comfortable.

I think Rietveld wanted to make geometry as much as he wanted to make a chair. It's one of the few things I can look at and say, "This is incredibly beautiful" because beauty isn't about decoration; it's not about a lot of different parts coming together. This chair seems so basically simple that—I hate to say this because I come from a Catholic background—it's almost holy. This is an idea in the artist's mind that, I think, became very real. It seems perfect.

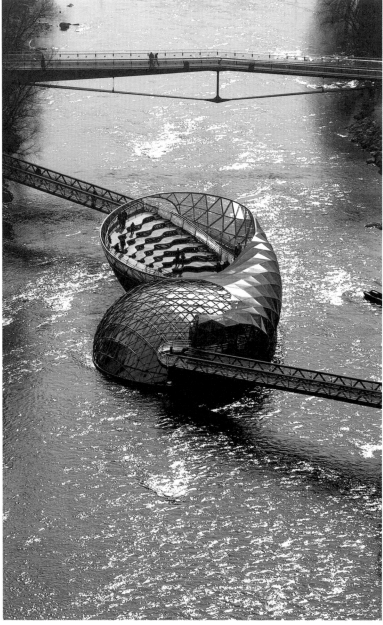

ACCONCI STUDIO, *MUR ISLAND*, GRAZ, AUSTRIA, 2004 ←

GERRIT RIETVELD, *ZIG ZAG STOEL*, CA. 1937–40 →

Composed of four flat wood boards articulated end to end to form a Z-shape, Rietveld's chair rejects conventional chair features: two arms, four legs, and a padded seat. Each board joins the next at mathematically precise angles with a bare minimum of supports and nuts and bolts. The piece asserts its inherently linear design and appears to be as much a sculpture as a utilitarian object. Rietveld's interest in abstract design was rooted in his earlier participation in the avant-garde movement De Stijl, which espoused abstraction as the representation of pure spirit.

"They're who you want to be but maybe can't be because you're too stuffy."

I studied painting. In school everybody was showing their paintings, but it became a bit boring after a while that the status of the object was already art—whether it was good or bad, it was already serious. I was smitten with ceramic objects after realizing that if you put your painting onto a functional object, then it dropped in status. I liked that challenge.

I actually didn't like these Villeroy figurines when I first saw them—I was kind of horrified by them. But then I learned that they would not have been displayed sitting like this. They were originally made for the dessert table and would have been taken away with the dishes. When I heard that, I thought, they're not sculpture—they're functional objects. And that made them very interesting to me.

The Met is an interesting place because everything's all mixed together. You see paintings and sculpture with functional objects—I love that.

Displaying a figurine in a room is rather surreal. The scale shift is a little bit like *Alice in Wonderland*. The man's smiling, laughing face draws you over to him, and then you're wrapped up in the piece. The man is so odd. He's got a couple of moles on him and this wonderful nose. The woman's face is a little bit more of a stock character popped out of the mold. She's delicate and beautiful, but he's really hilarious. These are street-theater characters. They're sort of like hippies, I think. They're bohemian, they're jokey, and they're lighthearted and sweet.

I see them as slightly subversive in the room. I don't think they are the inhabitants of this room, so the piece being here is slightly twisted, and a great relief. They're who you want to be but maybe can't be because you're too stuffy. They represent total fun and a lively embrace of life, and a kind of resilience.

There is such a desire in our time to assign an author to an artwork, but this is authorless. The Met is full of wonderful examples of lost forms. The *Harlequin Family* is of its period, but as an artist I'm still inspired by it. It is like a Bernini sculpture to me.

The man and woman are joined at the hips, and then all the other parts are moving around. There's this incredible flow—as if they're flying—and so much movement and openness. It's just this spinning top over there in the room—it's really alive.

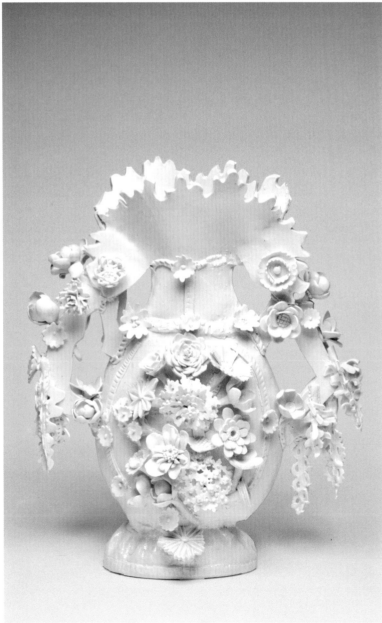

ANN AGEE, *VASE*, 2009 ←

HARLEQUIN FAMILY, CA. 1740–45 →

Harlequin Family is a dramatically enlarged version of a small Italian comedy group modeled by Johann Joachim Kändler at Meissen in 1738 and represents the only known example of this composition from the Villeroy factory. Kändler's original design would have been enhanced by vivid coloring, but absence of decoration here conveys a mood of greater gentleness. Unusual for both its large scale and reliance on a Meissen source, this is likely an experimental model, as evidenced by the extensive firecracks and discoloration.

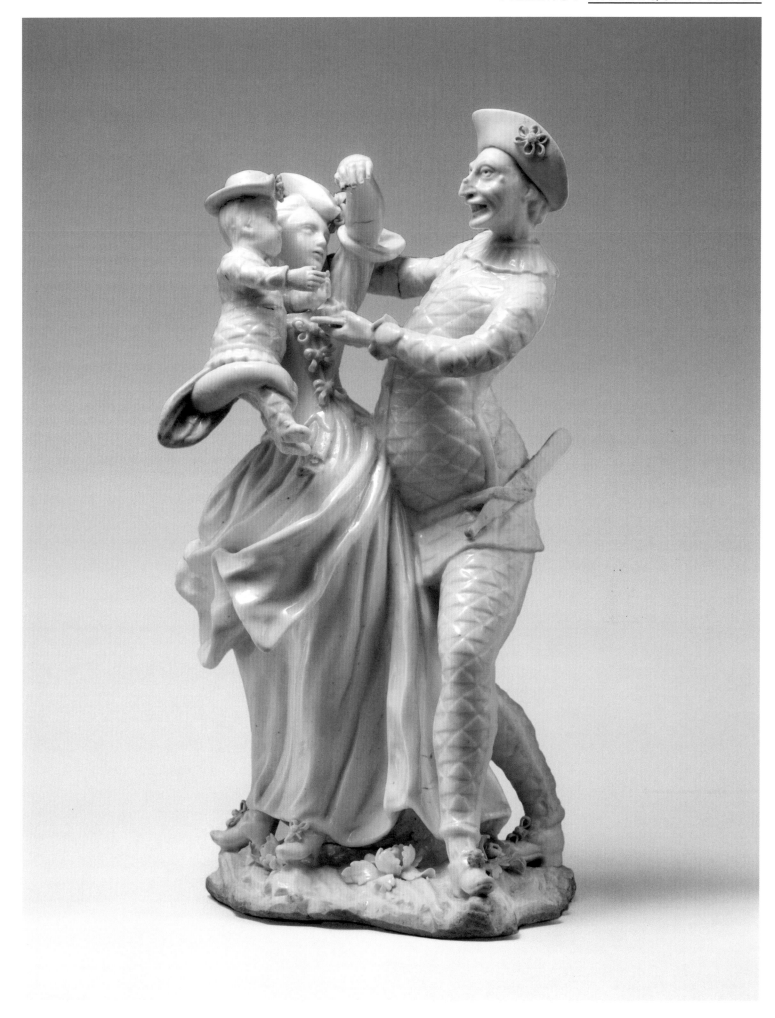

NJIDEKA AKUNYILI CROSBY

"It's quiet, but at the same time it vibrates."

My work deals a lot with my life and domestic spaces. I let viewers take a glimpse into my everyday life—which is exactly what Georges Seurat's *Embroidery; The Artist's Mother* does. It's a representation of the artist's mother embroidering, which seems like an activity she probably did a lot, but it's a lot more than what it represents. So much of the beauty of this piece comes from the tactility of it—the way the Conté crayon sits on the paper. The light in it is incredibly luminous, and the way the dark builds, you can almost see Seurat making these loops—this mark over a mark over a mark. That quality echoes the action of embroidering, which speaks to the life his mother had during that time period: quiet, sitting in the corner, and doing needlework. There's an obsessive quality to the image, especially in the darkest parts, which surround most of her. We feel the love and connection he had for his mother. It's quiet, but at the same time it vibrates.

Something I do in my work, and which drew me to this image, is create a space within a piece that is very dark but that has so much information when a person comes up close to it. When you look at this work up close, the subtle shifts and passages begin to make themselves known and clear, and it becomes a very different experience. That's what creates the intimacy, because you do become part of Seurat's world and his space and his life.

Sometimes it's hard to make paintings or drawings that are sentimental or romantic without getting too saccharine, but Seurat achieves that here. I think it's the abstraction of the work that holds it back from becoming overly sentimental. Seurat is walking this line between abstraction and figuration—using a limited vocabulary to tell a very complex story.

What makes this piece contemporary is Seurat's ability to work from a tradition but also find a way to make it different, to invent from that tradition. It's cheesy to say that it is so beautiful, but you can't deny this—it truly is a beautiful drawing. I guess we are taught now to always ask why; it's not enough to just say it's beautiful.

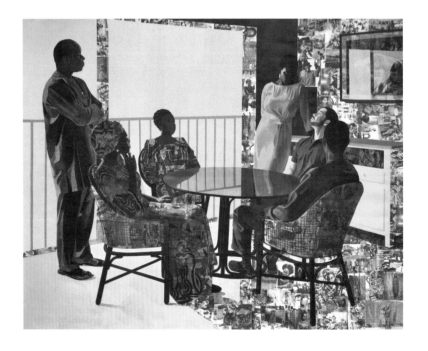

NJIDEKA AKUNYILI CROSBY, *I STILL FACE YOU*, 2015 ←

GEORGES SEURAT, *EMBROIDERY; THE ARTIST'S MOTHER*, 1882–83 →

This tranquil portrait of the artist's mother, Ernestine Faivre, is a tour de force of modeling in Conté crayon, Seurat's favorite graphic medium. The work is drawn entirely without line in tonal passages of velvety black. Scarce atmospheric light subtly evoked by lessening pressure on the crayon illuminates the interior, where a woman sews, creating a scene of quiet domesticity. The abstract beauty achieved in such works earned the praise of fellow artist Paul Signac, who called them "the most beautiful painter's drawings that ever existed."

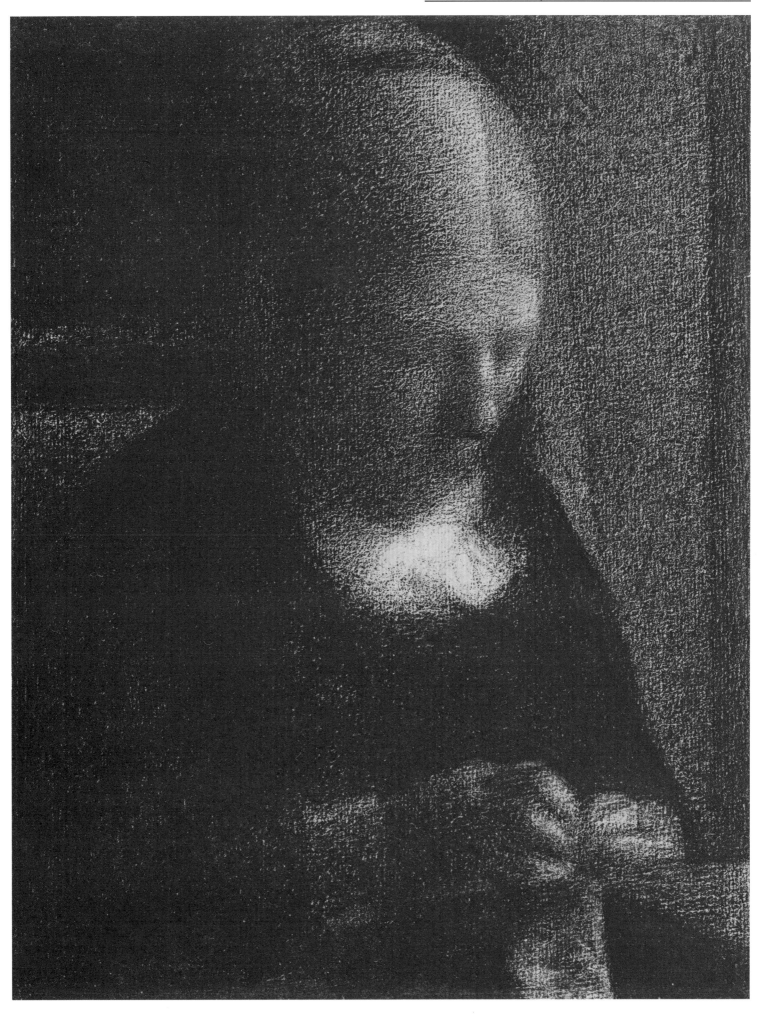

GHADA AMER

"This is a very Matissean painting, before Matisse."

I was born in Egypt, grew up in France, and am now an American. But people still—in America at least—always like to refer to me as Muslim or Egyptian. It has bothered me so much because it's a rejection, in a way. This is exactly why I chose an example of Islamic art because people already want to put me in this box, so I have to be aware of it. It's like an identity quest.

This Iranian tile panel was very striking to me. I like this woman in the center. The man is kneeling toward her, paying respect. She is powerful. There's a certain kind of lust in her; I like that. She is smiling, and she is giving him something and he is giving her something. It's about love. It's about man and woman encountering each other without any veils. The other ladies—the ones bringing more wine—are happy. Outside in the garden, everywhere there are flowers. I also like how they are drawn with the outlines, like patterns. It's a little bit naïve—like a children's drawing with all of the naïveté but also all of the happiness. This is a very Matissean painting, before Matisse. So it feels, in this sense, contemporary.

I like the fact that it's made of tiles: low art versus high art, which is related to the West versus the East. This would never pass as a painting in the Western world. This is ceramic, so it would be considered a lesser art.

The medium of painting was invented by men: this is what they want us to believe. That's why medium is a very important question in my work. Medium differentiates you: Do you make low art? Do you make high art? It has always interested me to see how people view material or medium. Why is one medium more valued than another?

I don't like art that is too intellectualized. I like art that speaks to my heart. To go out, live in peace, and talk to strangers... It's an exchange. Really, this is what I identify in the tiles. She is out and she's free. She is the queen.

GHADA AMER, *HEATHER'S DÉGRADÉ*, 2006 ←

GARDEN GATHERING, 1640–50 →

In this tile panel from Iran, a woman at the center of the scene leans on a bolster pillow and languidly holds out a filled cup. Making somewhat immodest eye contact with the viewer, she displays burn marks, associated with mystics and lovers, on her lower arms. A male figure, in European dress and hat, perhaps a merchant, kneels before her. The other figures offer refreshments and conversation.

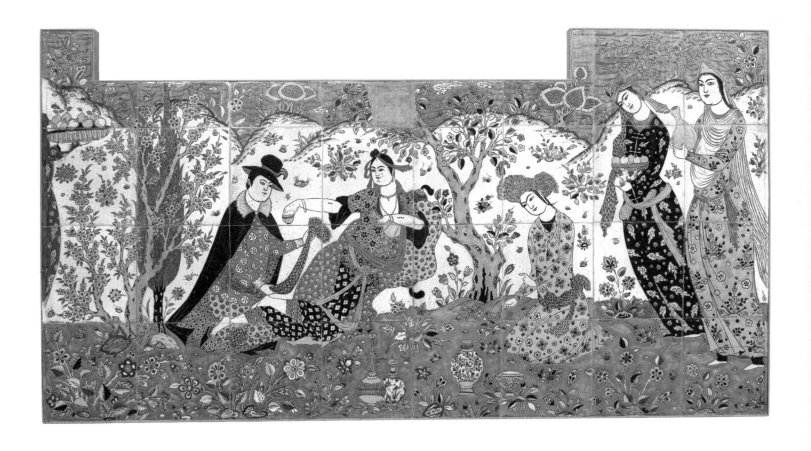

"We go into these galleries with ancient art, and we dream of the past."

One of the things that fascinates me about the galleries displaying art from the ancient Near East is that they are sites for what I refer to as "cultural nostalgia"—specifically, the idea that Iranians, particularly those living in the West, will go to museums like The Met and experience their glorious past.

The question of representation is important to me. We're essentially looking at a contemporary display of objects with a past. And I don't think there's such a thing as neutral context for these objects. The museum context is as important as the object itself in informing what the object says to us today. So I also pay attention to the way the objects are displayed and how they're lit.

These bricks were once a part of architecture and most likely part of a pattern that went around an entire room, whereas now they're displayed as a fragment: one floral unit. You can see repetition already starting to happen, and that alone changes our understanding of it.

Time is another element that affects all of these ancient objects. When we look at them, we see that passage of time. Years of weathering have given the bricks a painterly quality, almost like a painter who applies paint to the canvas and scrapes it away, leaving evidence of previous marks. This quality, which really moves us, was not present in the object when it was first made. The colors may have been bright and gaudy in a way that we would find unattractive today.

I often wonder if there were certain conventions in the past that we are not aware of. There is a myth that in the ancient Near East they were not sophisticated enough to create lifelike depictions of natural forms, but if somebody was capable of carving those stylized eyes or a floral pattern so precisely, certainly that same person would have been capable of making an object that looks like a real bull's head. Perhaps the artist was more concerned with interpreting the essence of the animal rather than replicating its physical likeness.

It is fascinating to observe the mythologies that get projected onto these objects. We go into these galleries with ancient art, and we dream of the past. When we look at objects for meaning, we essentially assign meaning to them. I'm not suggesting that one should forget the original context, because that would be somewhat irresponsible, but at the same time, there's something compelling about seeing them as contemporary objects. That's essentially what they are—objects with a past that are displayed in a museum in New York City today—and that's okay. We don't have to come to terms with their histories every time that we look at them.

KAMROOZ ARAM, *A MONUMENT FOR LIVING IN DEFEAT*, 2016　←

BRICKS WITH A PALMETTE MOTIF, CA. 6TH–4TH CENTURY BC　↗

BULL'S HEAD FROM COLUMN CAPITAL, CA. 5TH CENTURY BC　→

These two fragments of architectural decoration date to the Achaemenid period (550–330 BC). The glazed brick tiles were once a part of the extensive polychrome wall decoration in the palace complex at Susa, an ancient Persian city that was revived during the Achaemenid period. At Persepolis, the empire's large, ceremonial capital city originally built by Darius I (r. 521–486 BC), the ceilings of porticoes and halls of major buildings were supported by slender fluted columns, which were topped by a variety of monumental stone capitals. This example of a capital, found near Persepolis, takes the shape of a bull's head.

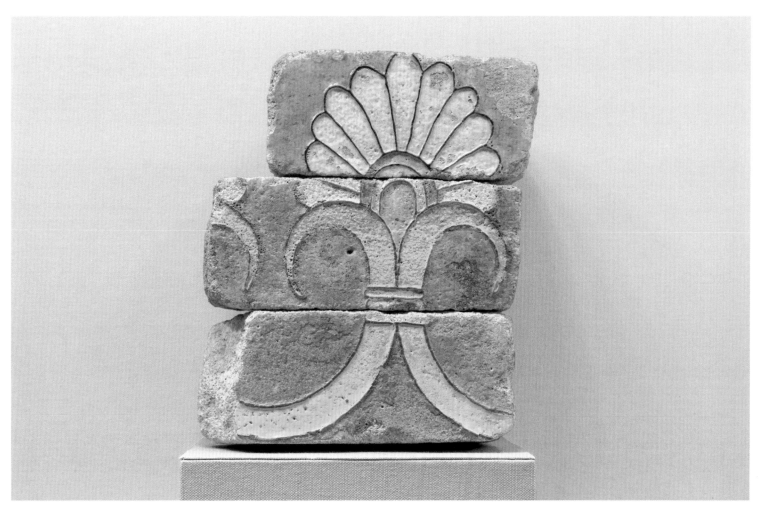

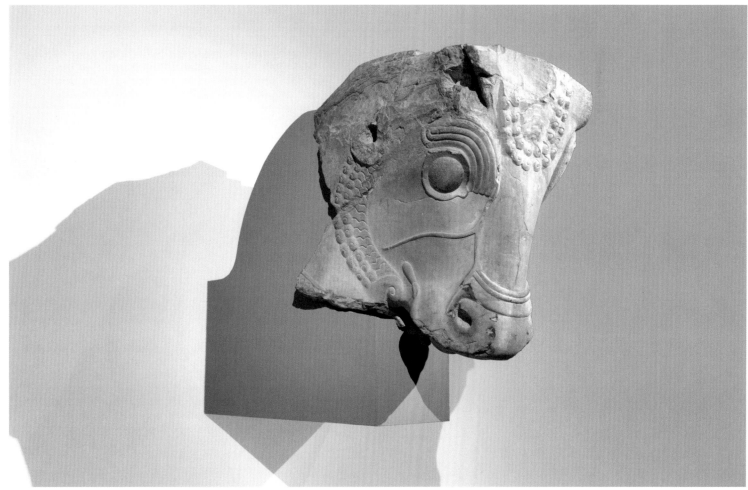

CORY **ARCANGEL**

> ## "I have this fixation with the harpsichord because I like to work with stuff when people are looking the other way."

My work deals with preservation of obsolete technology. I have written computer programs that produce some, hopefully, interesting results. Music is similar—it is a set of instructions to be run on a particular technology, such as a piano, a flugelhorn, or a clarinet.

The harpsichord is my favorite kind of obsolete musical technology. A harpsichord is a plucked string instrument, so it doesn't matter how hard the keys are pressed—every note comes out at the exact same volume. The innovation later introduced by the piano was a mallet that hits the strings, and the mallet can be hit with different velocities, which means the instrument can play loudly and softly.

When I think of the harpsichord, I think about the historical moment right after the harpsichord. I would love to have been around when people's minds were blown. When I sat down at a computer for the first time, it's probably similar to what people were thinking when they were first introduced to the pianoforte.

When I see a harpsichord, I think first about the harpsichord and then about the piano. And then I think about technology, and then about all these things that are lost. It just spirals on. People aren't accustomed to thinking about music in terms of these issues.

Music always seems so alive in our lives, it's so experiential. I don't need to hear the music to think about those things, but what is great about the harpsichord is that it is meant to be played, and it has a great, great sound. What could be better than that? The higher notes sound quite beautiful, but the lower notes have a pretty raw sound that is bizarrely contemporary, like a weird bass sound that somebody might stick in a hip-hop song. I just love that rigid, raw, mechanical sound.

I have this fixation with the harpsichord because I like to work with stuff when people are looking the other way. You're no longer susceptible to cultural pressure because once something becomes dated, it basically ceases to exist in culture. For my purposes as an artist, it's finding what hasn't been preserved yet and then declaring it artwork, then convincing people that it's artwork, and then sneaking it into museums. Then I have won the game. That's what I do. The weird thing is seeing my own work become dated. That's been a trip!

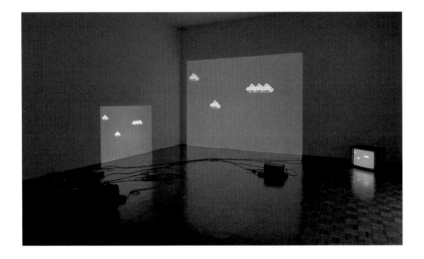

CORY ARCANGEL, *SUPER MARIO CLOUDS*, 2002 ←

HARPSICHORD, LATE 17TH CENTURY →

This Italian harpsichord has three sets of unison strings. One set is plucked at a point very close to the apparatus that holds the strings (called a nut) and produces a brighter sound than the others. The painting inside the lid is a landscape with a hunter and his dog. On the lid above the keywell, a scene depicts Tobias and the angel Raphael. The conventionalized foliage and the aerial perspective are associated with the work of Gaspard Dughet, brother-in-law of Nicolas Poussin.

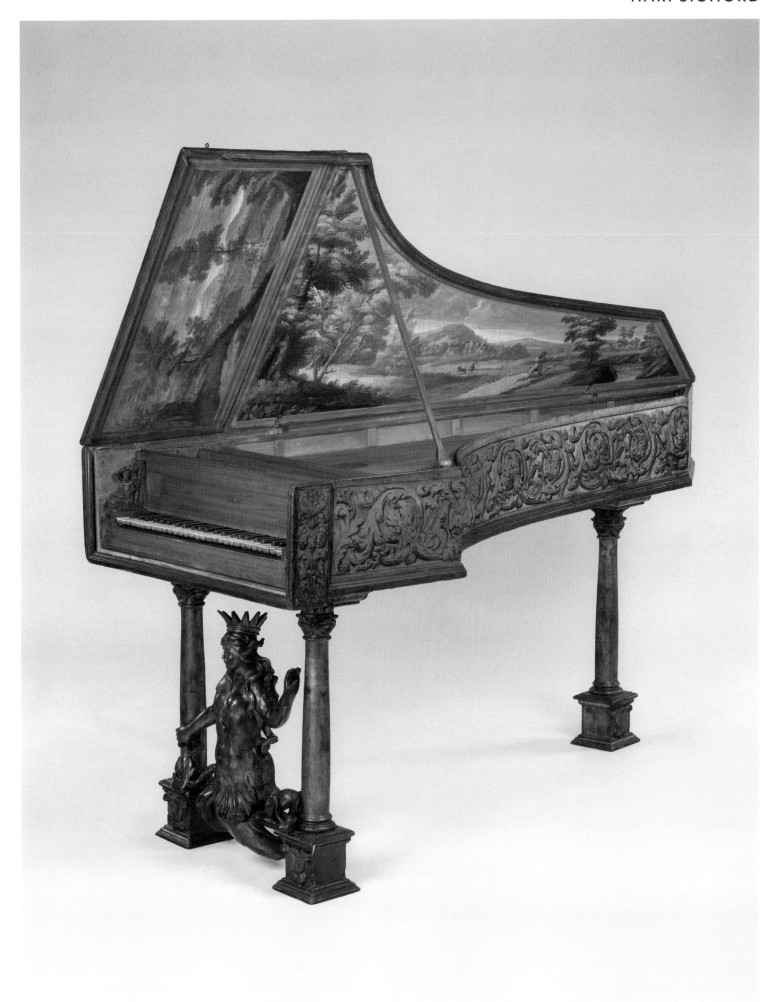

JOHN BALDESSARI

"I think it's brilliant: making art look like it's not about skill."

I get labeled a conceptual artist, which I think is a misnomer, but everybody gets a label in life. I get labeled a California artist too, and I think that's a misnomer also. I would rather just be called an artist.

I first became interested in Philip Guston when I was in high school. My parents subscribed to *Life* magazine, and his early works were in it. I would tear out those pages and save them. It was very sophisticated work. When he started doing this later work, he was severely criticized: it wasn't art, and blah, blah, blah. And I thought, well, he's on the right track if people are saying that about him.

What I like about Guston is that he is trying to deskill himself and take all the sophistication away—that he's just like a really dumb artist. And I'm using *dumb* in a good way. So it's this seemingly clumsy but very sophisticated brushwork. His works don't have slick surfaces; you can see the brushwork.

I also like his simplicity of choice in subject matter. Like Van Gogh's painting of a pair of old boots: you don't need to paint a cathedral, you just have to be an interesting painter. It's utter simplicity, those bug eyes. And where's the nose? Have we ever seen a mouth? It's almost like the eyebrow and the ear could be interchanged. And his figures are always smoking a cigarette. There's always that dumb cloud of smoke, which if it weren't for the cigarette, could be a rock, could be anything! Don't you laugh when you see that?

It's macabre humor. It's a laugh that's also shadowed by the thought of the brevity of life. A poetic mind would think that death is absurd and funny. There are elements of time: the light and the clock and the short duration of the cigarette. There's more light inside the room where he is than there is outside. It's like a prison cell. He's almost in bondage with the bedclothes—you might even call it a straitjacket. It's nightmarish, in some ways—being constrained and trapped by time.

The painting's tough to like. I think the average viewer is going to say, "Yeah, my kid can do that." And that would be dismissive. I think it's brilliant: making art look like it's not about skill. He knew he was going to ruffle feathers and irritate people. I absolutely identify with his courage in doing that. It's one of the things I've always emphasized: don't be a virtuoso, and don't be a show-off.

JOHN BALDESSARI, *SOUL (RARE VIEW)*, 1987 ←

PHILIP GUSTON, *STATIONARY FIGURE*, 1973 →

At Guston's October 1970 exhibition at Marlborough Gallery, many who admired his elegant abstractions were shocked to discover a return to the representational imagery he had abandoned two decades before. As Guston put it, "I got sick and tired of all that Purity! I wanted to tell stories." The solitary figure here—an anxious smoker, often interpreted as a self-portrait—lies awake in a desolate room while the clock ticks away the small hours of the night.

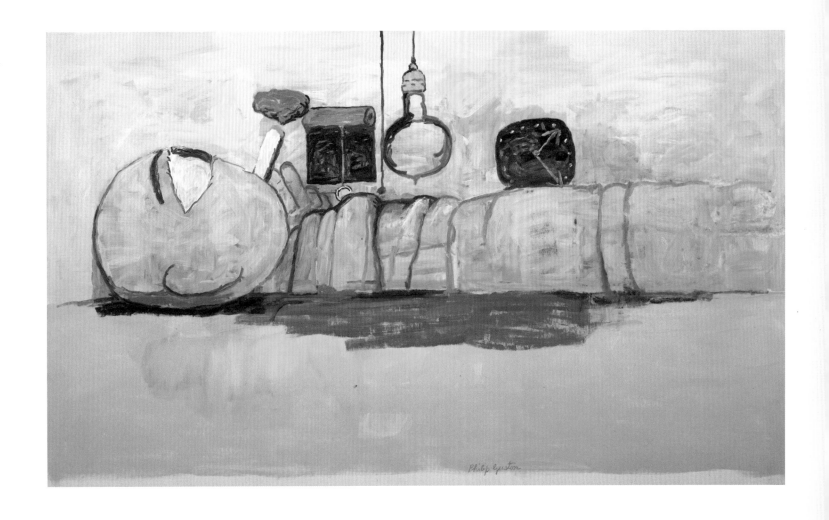

"[It's] a balance between incredible idealization and humanity."

This Amarna-period Egyptian fragment of a queen's face is a balance between incredible idealization and humanity. The loss, the parts that are not there—you feel guilty saying this—give it even more power, even though it shows a mouth, not the eyes. One would think the eyes would be the more powerful fragment.

There's a beautiful ridge line around the lips that makes the mouth seem kind of otherworldly and not human. It also works to make the lips look fleshy. She was obviously a gorgeous woman, but there are little puckers coming through the stylization—a couple of wrinkles in the neck, for example, which are just beautifully incised.

There's a strong sense of integrity I get thinking about the making of this—there is no unimportant part. Even though we only have a fragment, there's a feeling that the whole piece must have been like a jewel. It's yellow jasper, which is harder than steel. The artist was obviously using another stone to carve it—that's all that would have been available. Even with every advantage that the twenty-first century offers me, I would have a hard time equaling this in terms of pure technical achievement.

This woman was a royal personage; this wasn't just anybody. Egypt had a brief period when they flipped from polytheism to monotheism, and then they flipped back again. Amarna people and their followers destroyed each other's works. When politics and religion, etc., change, why does change always have to be ushered in with the destruction of what we artists do? I pour my life into the making of my pieces. This thought is hard for me to take emotionally.

The minute I'm hit with an object like this one, I feel like I understand what they were going for in Egypt; it doesn't seem all that distant to me. There's something to admire. It's human, like us.

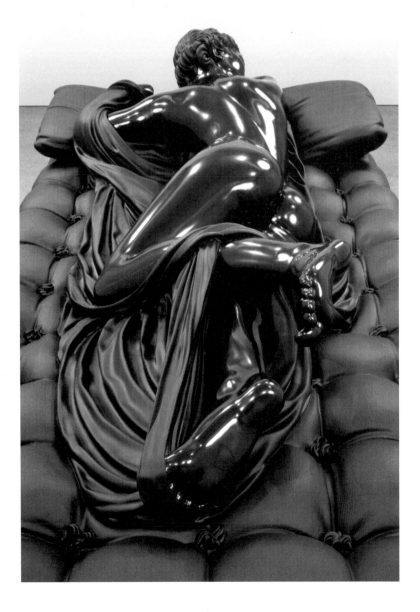

BARRY X BALL, *SLEEPING HERMAPHRODITE*, 2008–10 ←

FRAGMENT OF A QUEEN'S FACE, CA. 1353–1336 BC →

This fragment is from a statue of a royal woman whose identity is not known with certainty. The statue was composed of different materials, including yellow jasper for the face and limbs and possibly Egyptian alabaster to represent a white linen garment. Queen Tiye—the mother of Akhenaten—might be shown here, as a beauty of strikingly sensuous character, but Queens Nefertiti and Kiya are also possible subjects.

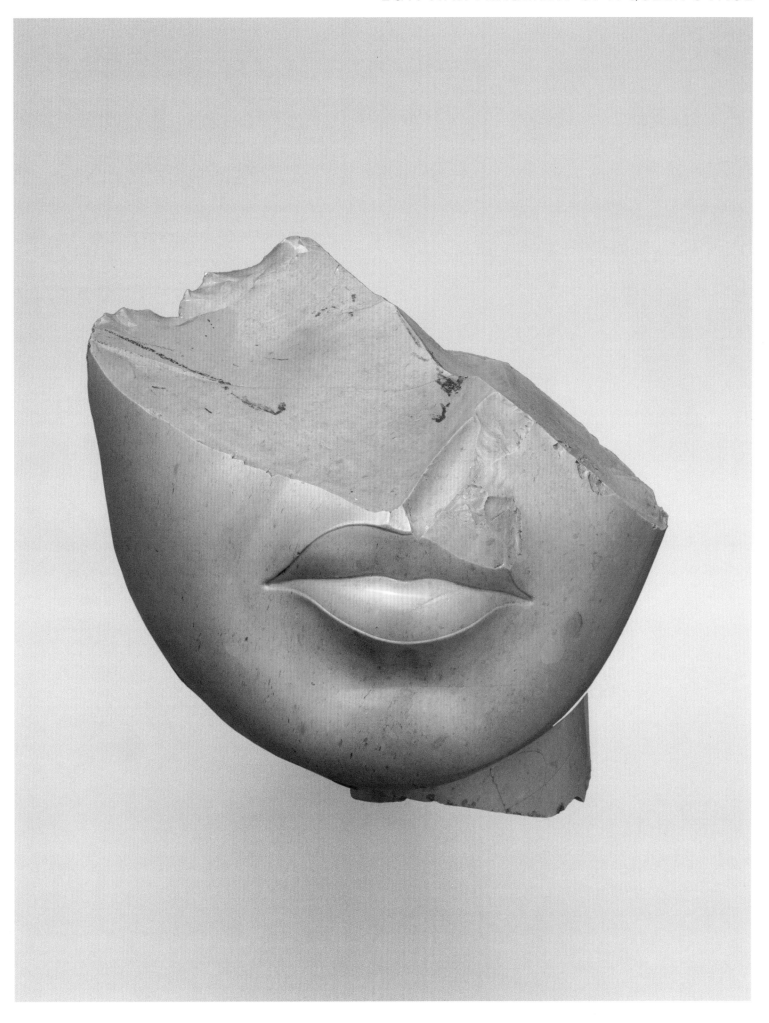

ALI BANISADR

"The world Bosch paints is more like hallucinations or dreams."

I have synesthesia: within my own work, I hear sounds. That's what helps me compose the work. When I go and see art, the pieces that really appeal to me are the ones that also have this sound—and in Hieronymus Bosch's *The Adoration of the Magi*, I can hear the sound traveling through those walls. Bosch creates worlds, all from the imagination, channeling unknown places of the psyche, which is what interests me.

The Adoration of the Magi is one of his most "normal" paintings, but when I look at it, I sense something has already happened, some kind of explosion. You can see the ruins, and looking more closely at the details, other little elements stick out. Bosch's paintings always have this sense of mystery.

Bosch had a bird's-eye view of the situation. Even though there are central figures, the composition brings you into the painting and lets you move in and out of the windows, or into the background and then back again to the foreground. Your eyes move around freely. It's like God's point of view—since you're not in it, you can judge what you're witnessing. You keep finding little hints and mysteries and little things that might give you some clue as to what Bosch was trying to say.

The way Bosch arranged groups of figures is always interesting, and I really like their faces. They're all contained within themselves. They're not in dialogue with each other; they're in their own minds. To me, he was a social critic, and that's why the subject matter could be seen as contemporary. The figures would have different outfits or different roles, but they're human—the same things happen over and over; they're not going to go away. The world Bosch paints is more like hallucinations or dreams. You think, what am I looking at here? What is this? I think that's what painting does, really. Let it unveil itself to you as what it is rather than categorizing it, and then it starts to communicate with you.

Over the years, I've learned to make my own painting in this way. I have to open myself up to it, and it directs me where it wants to go. That has also helped me to look at other paintings. That's what tells me there's something within those walls that will unleash some kind of a madness. There are other sounds within the work, but that's the sound that's very strong for me when I look at this painting.

ALI BANISADR, *INTERROGATION*, 2010 ←

HIERONYMUS BOSCH, *THE ADORATION OF THE MAGI*, CA. 1475 →

Technical examination of numerous works by Bosch has allowed for the reconsideration of his oeuvre. Long thought to be a later pastiche, this panel can now be placed among Bosch's earliest works. Elements that closely relate it to other early paintings by the master include the salient features of its underdrawing, the tunnel-like perspective, and the rather wooden figure types with sensitively rendered faces. The stage-like setting of the scene with a curtain held aloft by angels might indicate that the composition was influenced by religious plays, which were performed in Bosch's hometown of 's-Hertogenbosch.

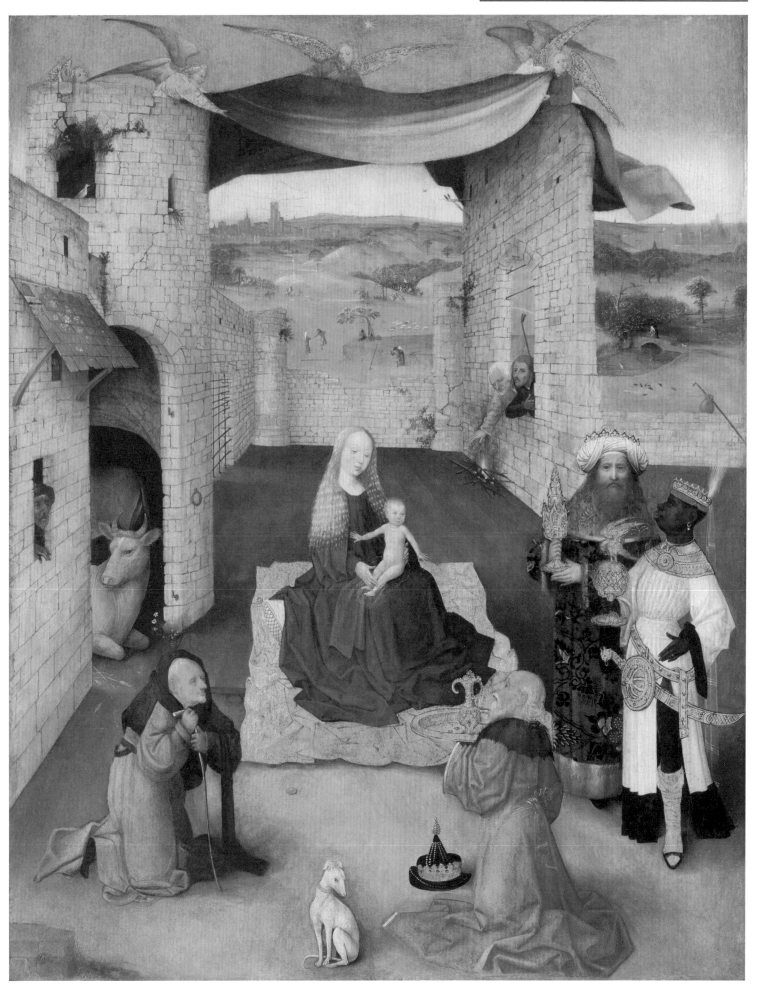

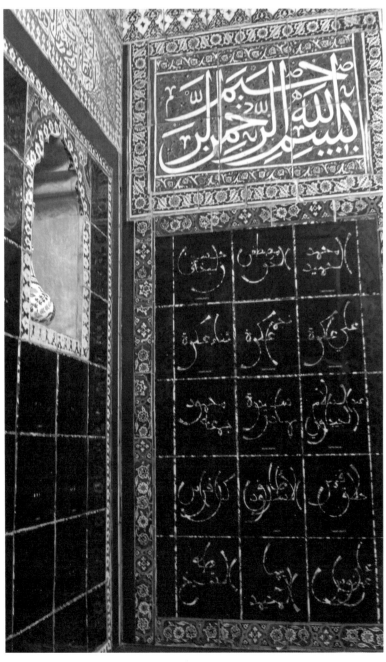

"When you look at details in such ancient art and zoom in, there's a human connection."

The work I do is context-specific using Arabic language and text. I used to go to galleries and museums to visit Islamic art and would think, this has all been stolen from our part of the world. But in light of the recent conflicts and destruction in the region, I'm actually pleased that certain pieces have been preserved. The mosque that this panel came from may not be there now, but we have the privilege of standing in front of the sign to that building.

Even if you can't read Arabic, it's a beautiful, stunning work of art that has meaning and cultural implications, but it now sits within another context. It conveys this very simple message: "The weak servant Kayun ibn 'Abdallah, the sinful, the one in need of God's mercy, founded this blessed mosque." For those who do read Arabic, it's difficult to read the inscription. You really have to take time because the composition of the words is not in one line the way they should be read; it's intertwined.

There's so much focus on form, and on negative and positive. The background is dark blue—everything pulls your focus to the actual calligraphy itself. Some of the spaces within the letters are colored in turquoise. I find that interesting because it's either that the artist ran out of that particular blue, or started and then thought, oh, this doesn't look good. So that made me smile. It's also interesting that the artist was trying to convey this very simple message, but the work is very well studied, very well worked, and really opulent. It's a celebration of God and who He is.

It's interesting that the artist probably worked within a certain architectural area; the size and dimension of the panel and inscription are confined by that. Its environment would probably have been an elaborate dome, with beautiful light coming in and elaborate walls with floral patterns. You'd feel a sense of awe, definitely. I'm an atheist, but I'd still feel awe just because I would be a small being inside a much larger space.

When you look at details in such ancient art and zoom in, there's a human connection where you kind of wonder, what was he thinking? What was he doing? Sometimes the line shivers a little bit. It reminds me that the maker was an actual person. We sometimes forget this when we're in a museum in front of an artwork.

DIA BATAL, *MOURNING HALL*, 2012 ←

TILE PANEL WITH CALLIGRAPHIC INSCRIPTION, →
DATED AH 1000 / AD 1591–92 (WITH DETAIL)

Traditional ceramic production in Syria continued after the region came under Ottoman control in the early sixteenth century. Syrian tiles and ceramics of this period are related to Iznik wares, but do not include red in their palette. This large inscription panel was created in Syria for an unidentified mosque. Its calligraphy reads: "The weak servant Kayun ibn 'Abdallah, the sinful, the one in need of God's mercy, founded this blessed mosque. It was built in the year 1000 [AH / AD 1591–92]."

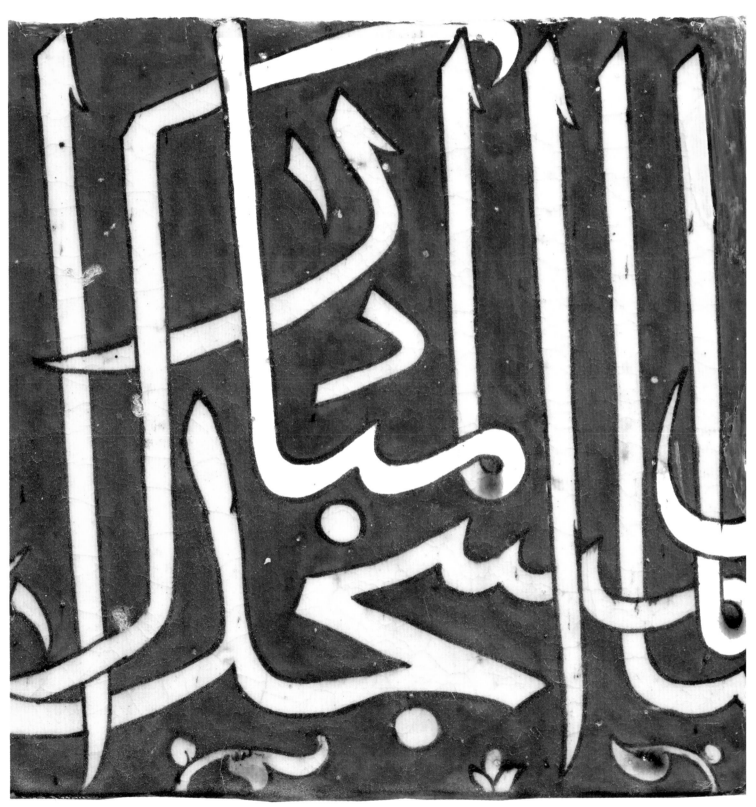

ZOE **BELOFF**

"Beautiful or not beautiful, that's not really the point. Does it clearly convey an idea?"

I'm interested in looking to the past to help us think about the future. For me, Édouard Manet helps me think about what's going on in our world right now. He was an artist that was very engaged with ideas, what it means to be a modern citizen under modern capitalism. He was painting the world around him. In his work you see one of the dead working-class people at the barricade, out of roughly twenty thousand who were massacred by the French army. Manet was engaging in history painting from the perspective of the ordinary working people, people whose names we will never know. He is telling us that the people who matter in history are not so much the politicians and leaders, but the people on the street. These are people that we must memorialize.

The Paris Commune was the first great occupation during which the working people took over their own city and formed a community that was based on social justice. After three months the government marched into Paris and slaughtered them. When people are shot down in the street, it's random and brutal—this is what the picture shows us. To have painted a funeral would have sanitized it.

Those ungainly legs also suggest a kind of haphazardness. It's very direct. All the lines are really tough: they're hard; they have something to say. It's not an abstract thing—I admire that. Beautiful or not beautiful, that's not really the point. Does it clearly convey an idea? That's its beauty. It's also interesting because it's a detail. It is a very photographic composition. Manet can't show us everything, but through this detail he suggests that there are many more bodies outside the frame.

I see our world in the work, because it's also happening right now in the United States—African Americans are shot in the street, not by the army but by the police—and we are still fighting their fight. That's what touches me: it's not over. And that's why I'm interested in history—it gives me hope because I feel like I have someone to share my anguish with. Manet is saying, "We need to spend time with these people, because these people are heroes and they need to be memorialized."

ZOE BELOFF, *THE DAYS OF THE COMMUNE*, 2012 ←

ÉDOUARD MANET, *CIVIL WAR (GUERRE CIVILE)*, 1871–73 →

Manet signed and dated this lithograph 1871, but it is believed that the date reflects the historical year of the scene depicted rather than the year in which Manet made the work. The image records and commemorates the slaughter of soldiers and civilians who fell together in the fighting that brought the Paris Commune to a close. Realized with velvety black lines and the abstract patterns formed by short sideways jabs of the crayon, the anonymous victims are treated with a tough sobriety.

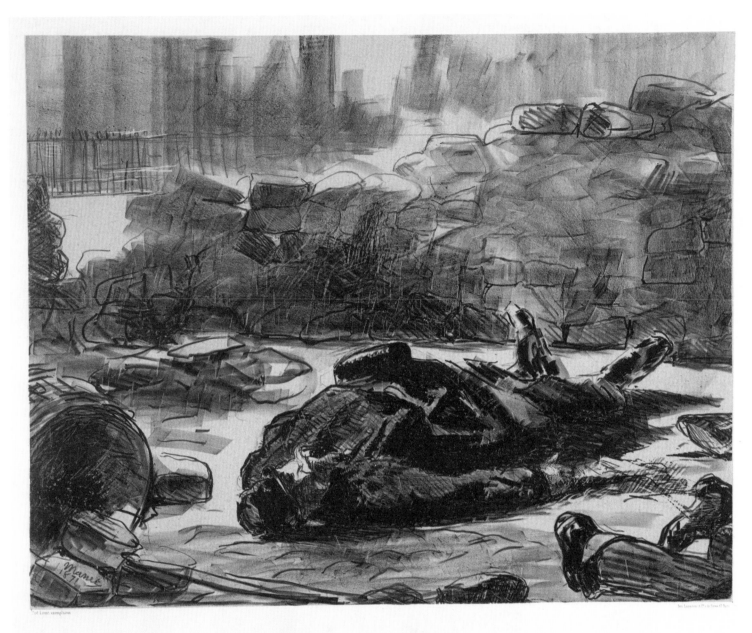

GUERRE CIVILE

"His deeper contribution was as an African American artist who took that piece of himself out into the world and brought it into his work."

Roy DeCarava was the first African American artist working within the medium of photography who I could look to as an inspiration. All of his photographs are made in the course of the ongoing movement and flow of everyday life: the people and places he encountered in the course of living.

In DeCarava's photograph *Man Coming Up Subway Stairs* (1952), the man's sleeves are not buttoned, his shirt is rumpled, his hat is kind of crushed. He looks like he's willing himself up the subway stairs into that patch of glorious light. DeCarava was there waiting—hoping—for something exactly like that to happen.

As a printmaker, DeCarava enhanced all of those narrative elements. When you look at his print *Billie Holiday* (1952), it's printed very soft, and the way that she's engaging with him, it's a very soft and tender moment. They clearly know each other.

There's a deep formal underpinning to DeCarava's work. His image of the Mott Avenue subway station is a very minimal photograph. It's devoid of the human subject, although the advertisement in the image suggests one. Certainly, in the photograph *Man with Portfolio* (1959), there's a lot of tension in that man's firm grip, which is then partly offset by the woman's leg that appears to be coming into the frame. But ultimately, it's what DeCarava chose to wrap that formal structure around that is the deeper meaning of the photographs.

His photographs were not only of African American subjects, but his deeper contribution was as an African American artist who took that piece of himself out into the world and brought it into his work. He understood that his own particular racial subjectivity was a deeply embedded part of the meaning of the work—that his identity was very much a part of what he was seeing, why he was seeing it, how he was seeing it, and how, ultimately, he came to make photographs out of those experiences.

DAWOUD BEY, *THE BLUES SINGER*, 1976 ←

ROY DECARAVA, *MOTT AVENUE*, 1951 →

DeCarava emerged during the fifties as one of the most important visual artists in New York City. Trained as a painter, DeCarava took up photography in the late forties. He is perhaps best known for his photographs of Harlem and his portraits of jazz musicians, which have been justly celebrated as intimate, lyrical, unsentimental expressions of the black American experience. DeCarava is also known for his exquisite gelatin silver prints and a poetic palette he characterized as "an infinite tonality of grays." In his approach to the medium, rather than a plaintive blues, he presented a sophisticated, extended improvisatory jazz solo.

NAYLAND **BLAKE**

> ## "So much of its meaning as a sculpture is bound up not in what you can see on the outside but what it contains within."

There are so many things that are visually louder or pull me in more readily, but the *boli* is the object that I feel like I've learned the most from. So much of its meaning as a sculpture is bound up not in what you can see on the outside but what it contains within. That was an immensely exciting idea to me: that sculptures could have secret places.

The boli is used by the Bamana people of Mali and only seen at certain times by people who have gained the right to access it. It has a structure inside that's much like a digestive tract. Water is poured through, and you can drink it from the other end. A great way to think about it is less as a sculpture and more as an instrument—these objects can be used to perform. When in use, people pour blood and other materials over it; its final shape is determined by the encrusting of all of this material.

In a number of ways, the boli is a real challenge to the sort of conventions around art that have built up in the West. We're very used to the idea that you have a flash of inspiration and then you're done. That's not necessarily the way it happens. This sculpture is made in the same way a snowdrift is. It finds its final shape as a result of many forces acting independently.

In the West we're feeling a sense of alienation from contemporary art because it's so disconnected from a particular place and time. This object is a thing that a community makes. It carries with it this resonance that comes from everything people gave up in order to make that form. That, as an idea, has its own power.

As you look at this, ask yourself the questions: What do I think is powerful that I hide? What do I overlook? It's what's on the inside that counts. And that's a rare experience. It's about more of a sustained relationship.

NAYLAND BLAKE, *WORK STATION #5*, 1989 ←

POWER OBJECT (BOLI), 19ᵀᴴ–FIRST HALF OF 20ᵀᴴ CENTURY →

A boli (pl.: *boliw*), or power object, is composed of a wooden armature core wrapped in white cotton cloth, which is encrusted with clay and various sacrificial materials. Many take on the loose zoomorphic form suggested in this example from Mali, while others may be anthropomorphic. Their primary function is to accumulate and control the naturally occurring life force, called *nyama*, for the spiritual benefit of the community. Traditionally, boliw are owned by male associations and are safely handled only by members equipped with rarified expertise and knowledge.

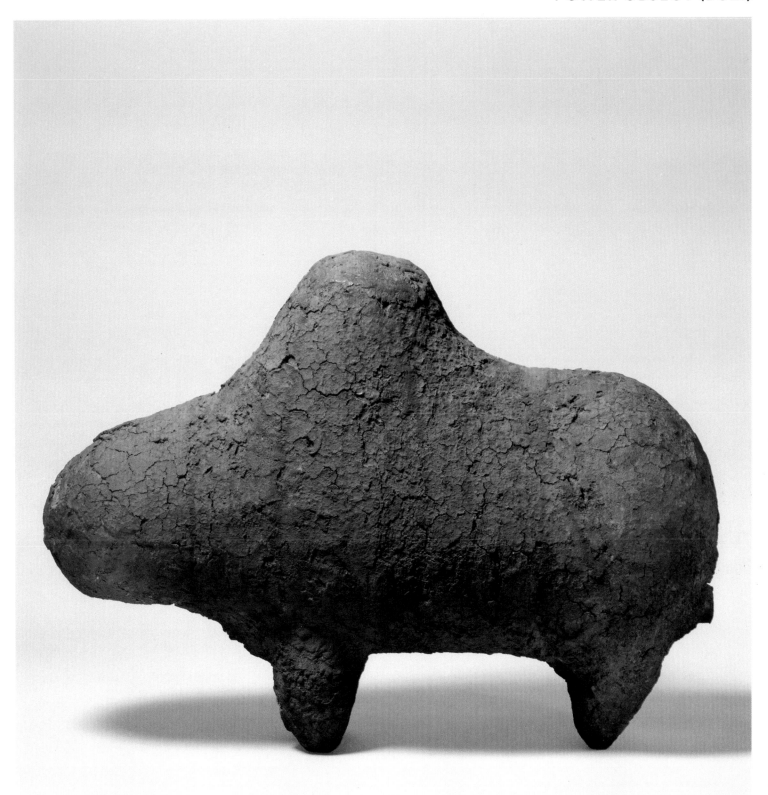

BARBARA **BLOOM**

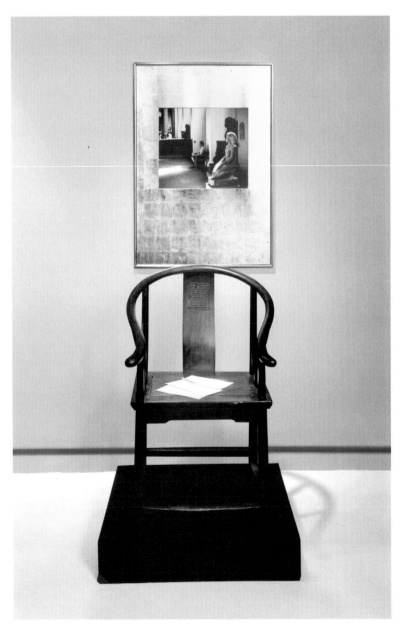

"As an artist your job is to show people something they haven't seen before."

I have a particular interest in depictions of absence. How can you depict something that is not there? I'm not a painter, but I'm drawn to Vilhelm Hammershøi's paintings because they're so enigmatic. They're rigorously composed scenes of the apartment where he and his wife, Ida, lived in Copenhagen. He painted that apartment over and over and over again. Your first inclination when you see the painting is not to think about what was happening in that room, but to observe the room in the same way that you might observe something that is three-dimensional.

Hammershøi's paintings make Vermeer's interiors look cluttered. This one feels sparse, but it doesn't feel spartan. You don't let the glow of light fall over a door if you want a scene to be spartan. The painting is so loving and beautifully, tenderly rendered. It doesn't feel deprived; it feels sensuous. It resists adjectives. It feels empty but not lacking; it's lonely but not melancholy—it's this but not that. It's like a philosophical argument.

As an artist, you think about what Hammershøi was setting out to do and whether the painting is a depiction of a state of mind. There's something egalitarian about it. He's allowing us to care equally about everything we're seeing. It's almost as though the light grants importance to everything it falls on. It falls on the floor and on the walls; it passes by the door and hits the doorknob.

Many, many cultures have depictions of death—the death mask or the devil or angels or a halo—and they stand in for something that we don't know. But this is actually a depiction of something we don't know but that's right there all the time. He's inducing a state of not knowing what you're looking at. How rare that is!

All of the musing and the questions that come up by looking at this painting are exciting. They contribute to the melancholic, mysterious depiction of something that's not there. I don't like the word *ghostly*—because there's nothing ominous about this scene. It's very ordinary. If as an artist your job is to show people something they haven't seen before, the great gift of this painting is that when you walk out of here, you don't need the painting anymore because you start seeing the world as a Hammershøi.

BARBARA BLOOM, *GREED*, 1988 ←

VILHELM HAMMERSHØI, *MOONLIGHT,* →
STRANDGADE 30, 1900–1906

Hammershøi's apartment in Copenhagen inspired many of his finest paintings. He depicted this room, with its view onto a windowed loggia, in early morning, at noon, and at night. It became his most iconic image. The unadorned interior seen here, glowing deep mauve in the moonlight, encapsulates the artist's reputation as the painter of "silence and light." Muted and mysterious, this composition amplifies a sensibility developed in the work of fellow northern Symbolists, including the Belgian Xavier Mellery and the Norwegian Edvard Munch.

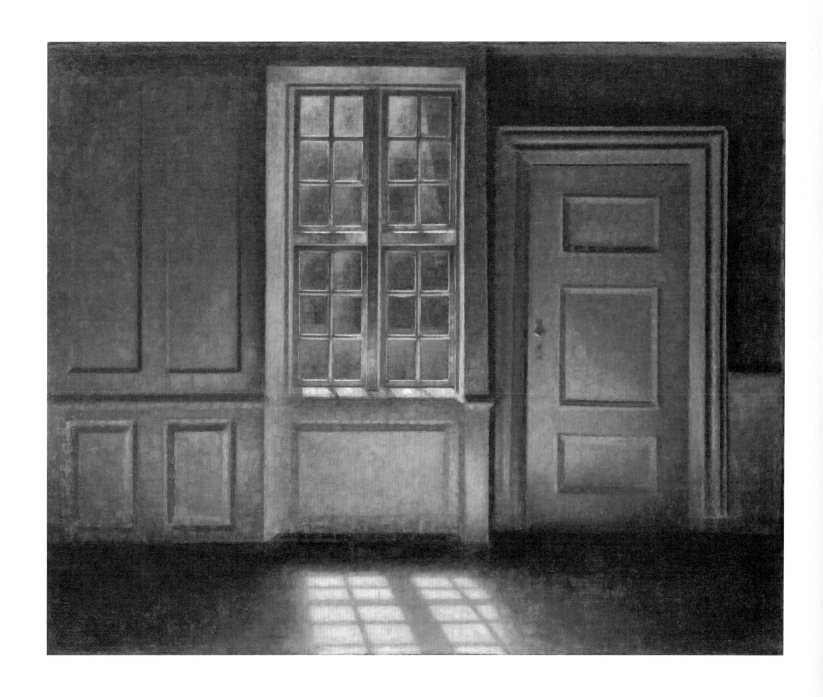

ANDREA BOWERS

I'm a political artist, so I'm interested in thinking politically about form. We think about form as neutral, but aesthetic decisions come from somewhere—they have a history. The most important thing about an artwork is being able to hear what an artist is saying. What do they care about? What is their voice?

Howardena Pindell studied painting at Yale in the sixties. She talked about how art teachers would say, "You won't be taken seriously if you use pastel or glitter or flowers." So she decided she was going to use those things. She took painted paper and punched holes out and glued them all over. There's string, which becomes very three-dimensional; there's glitter. She's expanded aesthetics to prioritize other colors, forms, or textures that have been seen as nominal or insignificant or too feminine.

I love this postcard piece, *Oval Memory Series II: Castle Dragon*, because, first of all, it's this crazy, organic oval and not the square grid of patriarchy. Pindell started writing on these postcards because she had been in a really bad car accident and was trying to retrieve her memories. But it's about two forms of loss of memory because this is also about the African diaspora—people forced into slavery and moved to all of these different countries. She connects the personal to the historical.

I've read a lot of the reviews of Pindell's work, and every review talks about her rage. It's a horrible stereotype that black women are angry, and I don't see rage in those works at all. Just because she has a political voice and she's standing up for what she believes in does not mean rage.

As viewers we have to be conscious of what we're assuming and what we're projecting onto an artwork. If you're not a white person, you're used to looking at artwork and knowing that none of it was made for you, that you're excluded from it. Pindell was way ahead of her time because her work is so diverse. She did representational works, abstract works, printmaking. In the early seventies, she had to deal with being both a woman and a person of color in the art world. She eventually became a curator, but our museums are still mainly filled with the works of white men because it comes down to who has the money to buy the artwork that eventually ends up in a museum. We have to start looking at the histories of other peoples and not looking at the history of the oppressors.

I love the concept of "radical patience"—change doesn't happen in one lifetime. Change starts before you and will happen after you, and you just work on it while you're alive. And there's so much work to do. I spend my life trying to learn from artists like Pindell. She teaches me.

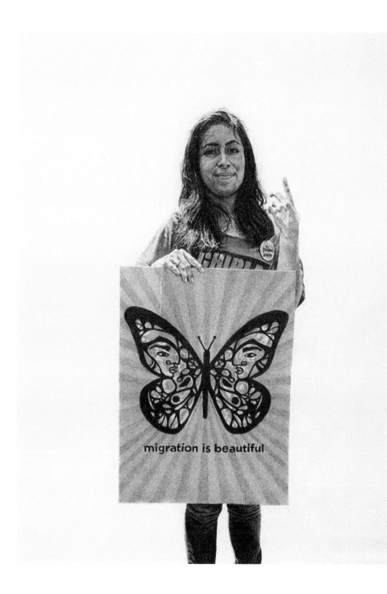

ANDREA BOWERS, *MIGRATION IS BEAUTIFUL II* ←
(MAY DAY, LOS ANGELES 2013), 2015

HOWARDENA PINDELL, *OVAL MEMORY SERIES II:* →
CASTLE DRAGON, 1980–81 (WITH DETAIL)

Signed by the artist at the lower right and also upside down at the upper left, this collage is meant to be viewed in either orientation, as reproduced here or inverted. Dissected postcards with added fluorescent paint and colorful punched papers create a kaleidoscopic landscape. In an artist's questionnaire completed soon after The Met acquired this work, Pindell wrote that she had originally intended to depict a castle, but that the image of a dragon or lizard "appeared by accident."

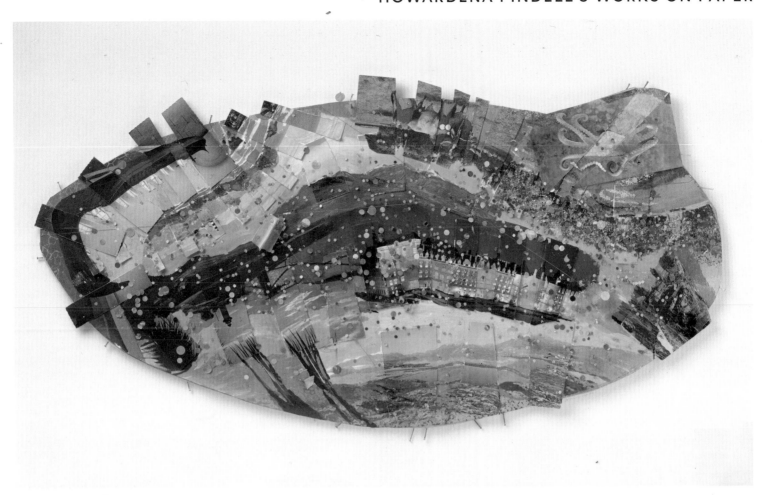

> ## "To use the whole social fabric of our society as a point of departure for abstraction reanimates it, dusts it off."

Being an abstract painter, I am fascinated by that 1950s moment in New York when Abstract Expressionism began. Clyfford Still pushes back against intimacy. It's big. It's not easel painting that was containable and something you snuggle up around and get cozy with. When I see a mark that's being repeated almost obsessively I always ask myself, what is he trying to get to? There's a conversation that he's having with that surface and with himself, and probably with art history and his peers. He's leaving little markers, guideposts, for us. As an abstract painter, I do the same thing: I leave bits of the conversation.

The canvas itself almost becomes a color, a pigment. It doesn't feel as if it's just a background. There's an agitation at the edges, and it feels as if the whole surface was torn away.

You can tell Still used a palette knife and that he labored. I'm amazed at how he's able to control the temperature emotionally. It doesn't look like madness. Still ground all of his own pigments, determining the vibrancy, hue, and texture. He was able to take a color that's loaded and hot, like a red, and reduce it down. What I find fascinating is specifically his use of blacks. Black was his favorite color. In the fifties! I mean, he is like, "I'm a 1950s white male and black is not terrifying, it's not threatening, and I'm going to use it constantly, in large areas of work. And I'm gonna talk about the color." You don't know if he was being political. But at the same time modernism was going on, the civil rights movement was going on. My God, it was around the same time as Emmett Till! I mean, how can you separate that from the baggage?

Is it inherently abstract? Maybe not. It goes back to the artist's intent, and Still imposed a lot of rules on where and how his work was to be displayed. It couldn't travel, and it couldn't be loaned. He is like the ultimate stage mother—he is controlling it even from the grave. I suppose I'm the opposite of that. I would be the mother that, once the child leaves the house, is like, "Good luck and God be with you." You gotta let a kid go. It's just part of life.

The artist taking responsibility and control over his own destiny is something that I really respect, but you know that there's always going to be slippage. As a twenty-first-century African American artist, when I look back at Abstract Expressionism, I get the politics, I get the problems, I get the theories, I can read his manifestos; but I think there are other ways of looking through abstraction. To use the whole social fabric of our society as a point of departure for abstraction reanimates it, dusts it off. It becomes really interesting to me, and supercharged. I just find that chilling and amazing.

MARK BRADFORD, *CRACK BETWEEN THE FLOORBOARDS*, 2014 ←

CLYFFORD STILL, *UNTITLED*, 1950 →

Still's compositions are typically divided into vertical units—as is this painting from 1950—and his canvases are usually large in size. Interlocking areas of color are juxtaposed rather than overlapped and paint is rigorously applied with a palette knife wielded with what the artist described as "tense slashes and a few thrusts." Eliminating all representational imagery and any sense of illusionistic space, Still concentrated on the physical, surface aspects of paint. Underlying rhythms permeate his compositions, creating what he called a "living spirit."

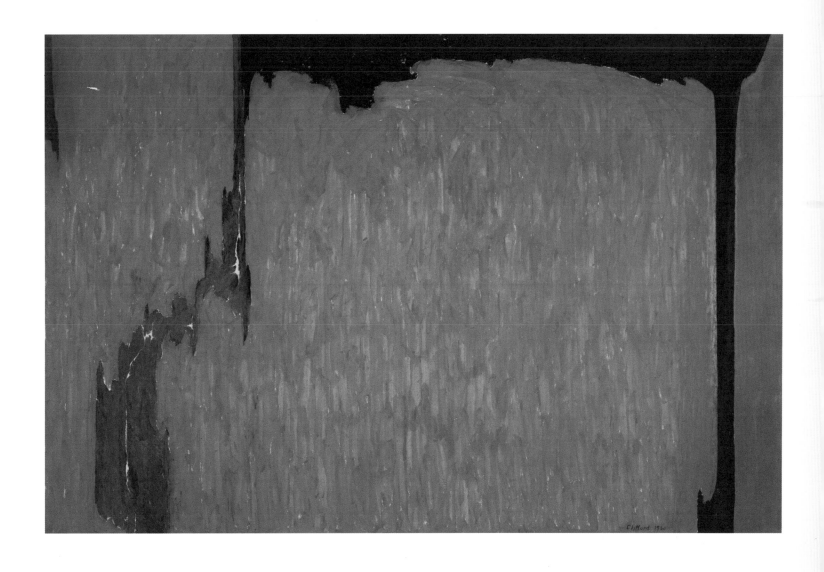

CECILY **BROWN**

"Even though they're all of the same subject, there is such a range within that."

Art has always been my religion, in a way. It fulfills a role in my life that other people might fill through religion. I often think that looking at art is the ultimate escapism. You're in this total and complete world. I love the room of medieval sculpture at The Met as a total environment. The atmosphere feels completely outside of time. Not that it feels old-fashioned, but it's a world unto itself.

I've always liked the fact that when I make a painting, I know what my limitations are. There's something very reassuring, but also exciting, about knowing that you've got your rectangle and it's flat and has edges, and within that is where you can be inventive. I get the feeling that each of the Madonna and Child sculptures in this gallery was commissioned for a specific place. Even though they're all of the same subject, there is such a range within that. There's a playfulness and an inventiveness and imagination to them, whether Christ is playing with a little bird, or stroking the Madonna's cheek, or chucking her chin. And the artists needed to depict the Christ child's feet: in some sculptures they're covered by the drapery, and in another there are little toes peeping out.

There's no definitive Madonna and Child. It's always the Madonna, but you can't quite pin her down to just one reading. There's a dreamy feeling in this gallery, and a part of that comes from the feeling that each Madonna has the others inside of it. They carry a whole range of emotions. They've really got personality. Some of them seem surprisingly coquettish, almost sassy. You feel they represent a strong, interesting, complex woman offering this provocative gaze. I'm very conscious of the body beneath the drapery being very sensual, almost in a taboo way. The child is the only thing keeping her chaste. The artists must have been trying to tread a fine line between showing her feminine beauty without making her overly sexual.

The sculptures have this playfulness, but at the same time a great sense of gravity and seriousness. Age has probably enhanced that. I almost always prefer the ones that are a little more beaten up. The traces of paint add poignancy. It's a contemporary sensibility to prefer the broken and the fragmented. They have in-built sweetness and sadness, and a sense of loss. These sculptures embody flux, a sense of time having passed, and that makes you realize how fast and slow it all is.

CECILY BROWN, *FAIR OF FACE, FULL OF WOE*, 2008 ←
(WITH DETAIL)

VIRGIN AND CHILD, 1345 →

In 1345 the Beguines—a religious order of laywomen—of Saint Catherine at Diest, near the Meuse valley in eastern Belgium, paid two pounds for this sculpture. It originally stood on the high altar of the church, and a copy remains there today. It was probably carved by a sculptor working in the middle Meuse valley around Liege, who followed the type of the Magny Virgin but worked in his local idiom. The statue belongs to a group from this region that all have the same exaggerated drapery pocket and facial features—large, wide-set eyes, prominent noses, and thin lips.

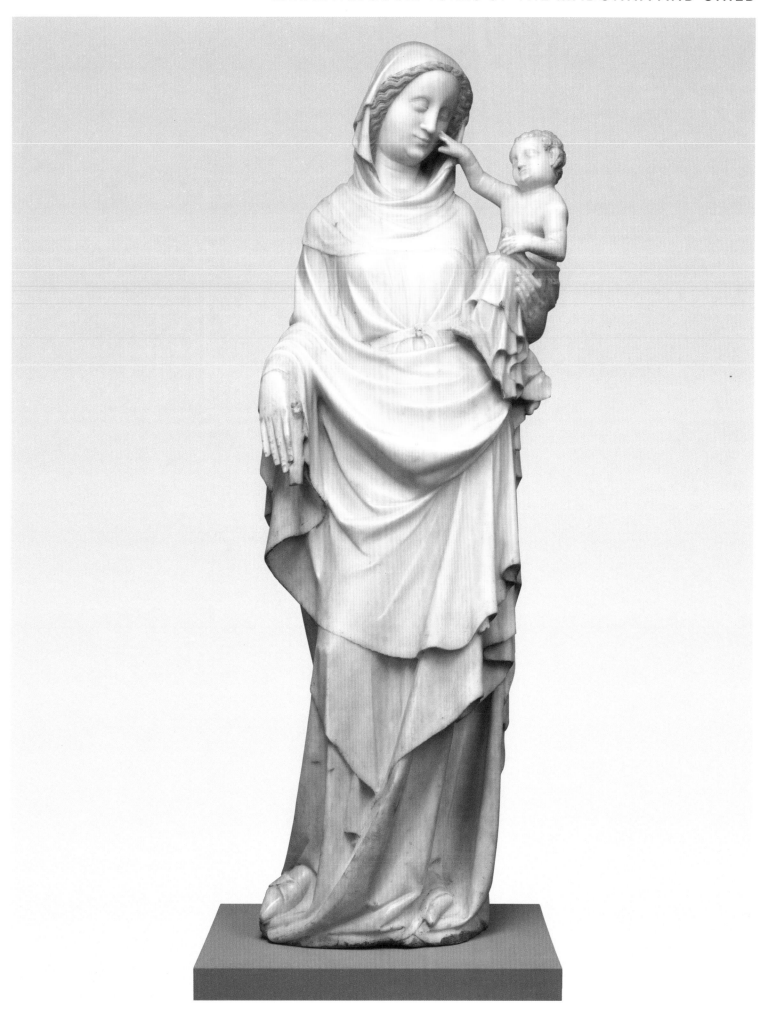

LUIS CAMNITZER

"Piranesi predicted Pop art in terms of creating icons of irrelevant stuff."

I don't like to be categorized under a skill. Art really is about expanding knowledge, and it doesn't matter what skill you use. I decided I'm not a printmaker who is trying to do art but an artist who sometimes uses printmaking. I'm not an art historian, but I don't like conservative printmaking that was developed to reproduce paintings and not to come up with new knowledge on its own terms. Giovanni Battista Piranesi is one of the printmakers who managed to generate knowledge. Piranesi was a failed architect, but he used this background to deconstruct architecture into the smallest units and then organize them in his prints. He makes a taxonomic order of things. His work was really not about the technique but about organizing the universe.

That makes me say that his work is contemporary. Until the early twentieth century, rendering was the ultimate achievement in art. Re-presentation—you present again what's there. That worked for a while, it developed skills, and then in the sixties, the concept became more important than skill. I feel Piranesi predicted Pop art in terms of creating icons of irrelevant stuff.

I think art history in general is a projective activity: we project our present onto an object and don't know if we understand it in the terms of the creator. We're in that sense very selfish. We understand it in terms of what's useful to us. There's nothing wrong with this; we just should take responsibility for what we're doing.

My politics are basically antiauthoritarian. I feel dogma should be examined and not accepted, that heresy is healthy. Ultimately, art is really about dealing with orders: challenge the given orders to make sure they are operative and connect orders to find out new things. Because it's the only area in which you have unbound imagination.

Piranesi tells you that you can organize anything as long as you have the criteria to do so, and you are free to establish your criteria. That gives you permission to start your own order, and that's very important.

LUIS CAMNITZER, *LANDSCAPE AS AN ATTITUDE*, 1979 ←

GIOVANNI BATTISTA PIRANESI, *DELLA MAGNIFICENZA E D'ARCHITETTURA DE' ROMANI*, 1761 →

Piranesi's *Della Magnificenza e d'Architettura de' Romani* was a contribution to the continuing debate over whether Greek art and architecture was superior to that of Rome. In the 1750s, intellectual circles were increasingly in favor of Greece. When French architect Julien-David Le Roy published *Les ruines des plus beaux monuments de la Grèce* in 1758, Piranesi responded with *Della Magnificenza*, arguing in favor of Roman architectural ornament.

NICK CAVE

"Somehow within the chaos there's order; that's really where the magic sets in."

When I saw these textiles at the age of eighteen, it brought me some clarity to find something that shares the same mindset I'm operating from. I respond to pattern within its own sense of order and rhythm. Although these textiles are flat, there's movement and motion in the way the pattern lies on the surface. There's structure, but there's a sense of randomness, too.

These Kuba cloths are in a position where they can be both viewed as artifacts and presented as a plank or painting. It's interesting to look at them that way, but in reality they originally served a purpose. They were ceremonial skirts.

I like that option, that play, of taking something out of context and it being able to stand on its own. So that has led me to look at my works in the same way: they can be sculptural, static, and yet actually function—as a skirt.

Building these cloths is community based: that sense of camaraderie, of family. The hand has been part of the building of the surface. Somehow within the chaos there's order; that's really where the magic sets in.

The Kuba cloths are connected to people, but they also provide a space to imagine, and it's authentic in the purest way. For me, this is everything I can imagine creating: How do I get myself to a place or a mindset in which I'm designing cloth that has a rhythm, communicates, and speaks about a purpose, or where I'm able to think in a broad sense about design?

You don't have to do a lot in order for something to be extraordinary. I think sometimes simplicity is the most powerful form.

NICK CAVE, *SOUNDSUIT*, 2008 ←

WOMAN'S CEREMONIAL UNDERSKIRT, EARLY TO →
MID-20TH CENTURY (WITH DETAIL)

The various stages of textile production and adornment engage the collaborative efforts of all members of Kuba society in the Democratic Republic of the Congo. The cultivation and subsequent weaving of raffia palm are the responsibility of Kuba men, while techniques applied by female embroiderers over the centuries have yielded a dazzling spectrum of formal design solutions.

ALEJANDRO CESARCO

"Maybe a story is not fully articulated, but it's presenting a point of view."

I'm interested in questioning the stories we tell and the way we tell them. When I visit a museum, I can't help but ask, what type of story is the room articulating? I don't think art should present a conclusion, but what are the questions that the room is asking? It allows for these creative misinterpretations, for play.

Once you start making art, you become like a professional viewer. It's very hard to go back to looking at things in a more amateurish way. But there is something productive about allowing yourself to be surprised, or suspending cynicism. For example, is it possible to look at one sculpture by Alberto Giacometti without knowing his entire body of work, its history?

There's something ultimately very sad and hollow about this statue, *Woman of Venice II*. It's not a fun object. It stares back at you. We're not aware of what she is waiting for or why exactly she's standing so still, so aligned. But the surface of the body makes it feel not quite rigid. It is as if she's broken and agitated, trembling from within. The scratches or wounds cover the body; are they meant as self-inflicted, or do they come from the outside? Why is her body so elongated, so thin, so anemic? Does it refer to the historical context, to the images that were circulating of bodies in concentration camps? In any case, the passage of time creates a different context today, so the framing is part of the meaning of the work.

In the case of Gallery 907, we could look at this Giacometti sculpture and ask, what is the woman looking at? What is she contemplating? Why is she so still? Is she overseeing these young girls in the Balthus paintings nearby? Is there judgment involved in that? Are those memories from her past? I don't know—I can go on and on. It's obvious that all that I said is wrong. It has nothing to do with the work. This is just my projection onto the work.

That is what always happens in art. There's always this mistranslation. The museum can be a rather abstract voice. Maybe a story is not fully articulated, but it's presenting a point of view. Someone is making these decisions. It provokes us to consider: What does looking mean?

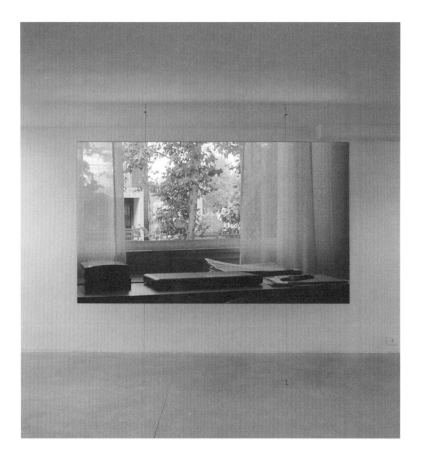

ALEJANDRO CESARCO, *MUSINGS*, 2013 ←

ALBERTO GIACOMETTI, *WOMAN OF VENICE II*, 1956 ↗

Giacometti's characteristic figures are extremely thin and attenuated.
This work is part of a series of fifteen female nudes modeled from the same clay, on the same armature, nine of which were cast in bronze.

GALLERY 907 INSTALLATION VIEW →

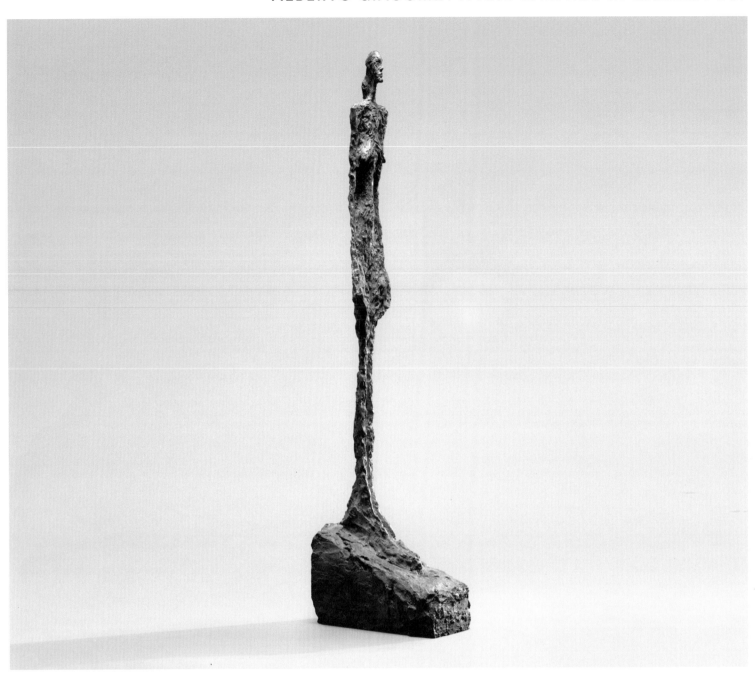

ENRIQUE **CHAGOYA**

"He's not specific about a particular time and place. The human experience transcends history."

I make works that appropriate imagery, creating my own language. I have a background in political economy that inspires me to add social content in every work I do.

I was only a teenager when I discovered *Los Caprichos*. As a student, I wanted to buy one, but I couldn't afford it, so I did my own versions. It's really important to see the original work because even though it's small in scale, you still can see a three-dimensional element of the etched line. It's not flat, like a reproduction.

Los Caprichos are a window into the world of the late 1700s, but once you study the imagery, you start realizing that certain things haven't changed much since then. And that's, for me, the genius of Goya. He's not specific about a particular time and place. The human experience transcends history, but it also runs into spirals during which you seem to circle back to the same place you were before.

Although the prints were made during the last years of the Holy Inquisition, Goya was still nervous about it, so there's a lot of ambiguity in *Los Caprichos*. This happens with censorship, because the artist has to be smarter than the censors. It's not clear whether he is in favor or against, but for me, clearly he's against!

Print 43 is a self-portrait of Goya having a nightmare, but today's monsters are worse. Like global warming and war—how could we stop them? The bats, the cat, the owls are no longer threatening—in fact, they are mostly endangered species—but the message is still relevant: we need to wake up.

Even though Goya's monsters are metaphorical figures, they represent very real social situations: anything from greed, apocalyptic fears, and corruption to how people disguise themselves to look better than what they are. We are seeing ourselves reflected in them because that's us, that's a human experience.

Without humor, these prints would be unbearable. Goya was very keen on bringing light to the darkness of the human spirit. It's not only about being good; it's also about improving our experience. Whatever is good for humanity and the world is good because we are part of the world. Art might not change that, but art helps us to think about it. And I'm amazed that art like Goya's still makes us think.

ENRIQUE CHAGOYA, *THE HEADACHE,* ←
A PRINT AFTER GEORGE CRUIKSHANK, 2010

GOYA (FRANCISCO DE GOYA Y LUCIENTES), *THE SLEEP OF* →
REASON PRODUCES MONSTERS (EL SUEÑO DE LA RAZON
PRODUCE MONSTRUOS), PLATE 43 FROM *LOS CAPRICHOS*, 1799

This is the best-known image from *Los Caprichos*, Goya's series of eighty aquatint etchings published in 1799, generally understood as the artist's criticism of the society in which he lived. Goya worked on the series between 1796 and 1798, and many drawings for the prints survive today. Although the inscription on the preparatory drawing for this print indicates that it was originally intended as the title page to the series, it became plate 43 in the published edition. Nevertheless, it has come to symbolize the series as a whole: what happens when reason is absent.

"Sometimes a funny narrative will occur to me."

I love this era because it was before everything got so perfect and all of the rules of perspective were in place. The works are more fanciful. I like the flatness; I like the made-up backgrounds, the attempts at architecture and anatomy that don't always work out. I love it!

Sometimes a funny narrative will occur to me, especially in this painting, *The Birth of the Virgin* by Fra Carnevale. The figures in the center are washing the newborn baby, and in the foreground there are groups of women, some of whom seem to be pregnant, and they're like, "Yeah, I'm about, you know, seven months." In the background, there's a woman having some sort of beauty treatment, I think. It's like a mud bath—I don't even know. And then there's this huge architectural structure happening that is not related to the subject matter at all.

A lot of the Italian Renaissance paintings I pay attention to have elements that are not religious. In the foreground is the religious stuff, but in the background there are just everyday activities, like somebody bringing wheat to market.

I often think about how rare it would have been for people in these paintings to look at images, since they lived in a world where they weren't constantly bombarded. I don't even know if they had mirrors at this time, and regular people didn't have portraits.

In many of these paintings, there's a lot more detail than there needs to be. That's what draws you in, what makes it feel real. Walt Disney said that to make a cartoon look realistic, you have to put more in the scene than somebody can see. It's not just a schematic. When I'm making a cartoon, there's the joke and the people, but I also want to make the reader feel that the scene is realistic—that if they opened up a drawer in the drawing they know what they would find in that drawer.

Knowing how hard it is to draw, I can see, in some of these paintings, the artist trying to work it out. Looking at them becomes like a conversation; maybe it's because I can hear the voice of the painter. The painter seems more human and less mechanical to me. There's a tension between what the painter knows and what he doesn't know, as if he is saying, it's too complicated for me to paint, so I'm going to make up a way of painting it that will work. That's what I like.

ROZ CHAST, *PIGEON LITTLE*, 2009 ←

FRA CARNEVALE (BARTOLOMEO DI GIOVANNI CORRADINI), →
THE BIRTH OF THE VIRGIN, 1467

Breaking with convention, the artist shows the Madonna's birth in contemporary terms. In the background the newborn baby is bathed by midwives, while in the foreground women greet each other. The imposing palace, patterned on the ducal palace of Urbino, is decorated with reliefs derived from Roman sculpture. The picture is from an altarpiece commissioned in 1467 for the church of Santa Maria della Bella in Urbino.

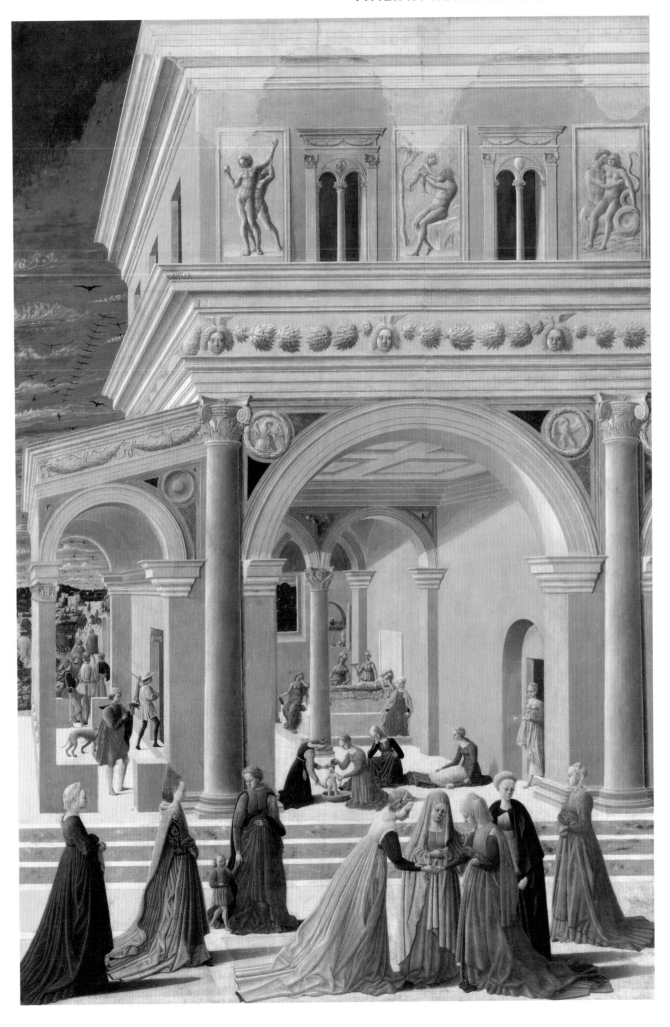

"I can sense the power in objects that are designated as ceremonial."

I like to think of myself as a perceptual engineer. Perception is an outgrowth of awareness or education. I was in high school from 1968 to '72, just after the riots in the sixties, the Kennedy assassination, Martin Luther King, which all led to the Black Consciousness Movement. That influenced our art department, and we began to discuss African art in the classroom. We were not searching for Africa, but they put Africa on us. One assignment we had was to choose a piece to re-create, and I chose the *ci wara* headdress.

I could extrapolate and say that because a ci wara headdress was used ceremonially as part of an agricultural ritual, its connection to the land appealed to me. But I'm only aware of that function through gaining knowledge about it. At first glance, it was just the graphic quality, the symmetry of it, that appealed to me. You can pretend it has a front view, but the front view doesn't reveal its form. Rather, the left and the right side are necessary to understand it. I'm of that age; I read *MAD* magazine, *Spy vs. Spy*—that's the same face.

There's just expression, and life. This ci wara has a small figure on the back, which I see as a mother-and-child image. I read everything as living. I can sense the power in objects that are designated as ceremonial.

Of course, years later I began to make ci wara out of bicycle parts. Someone told me that the words *ci wara* mean "work animal," and in the United States the bicycle is a work animal, at least to me. My ritual objects come with life and history because I create them from things that people use and handle. I assume that the carver may have considered the life in the tree, since these sculptures are carved from wood. The life in this first existed in nature, and the artist is aware of that. After it's carved into sculpture, it's going to have to go through some ceremony to become empowered.

Without education you wouldn't be able to recognize the object as something from the past. The quality of the wood and the patina could suggest that to you, but if you just look at the form itself, it could be from the future. Education makes us see things differently. It inspires everything I see. So suddenly, Africa is in my world, and my reference points for shapes and designs are going to come from that, too. It made me start to explore the term *African American*, and I decided at that point that I would make African things out of American things. The ci wara headdress opened the door.

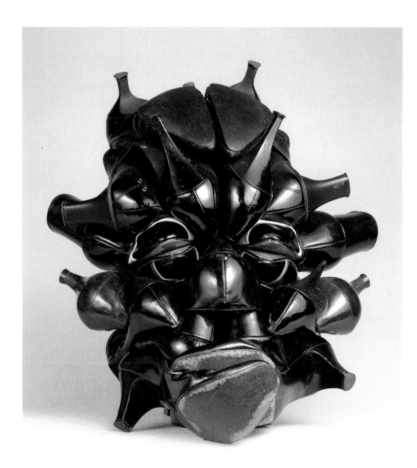

WILLIE COLE, *SHINE*, 2007 ←

HEADDRESS (CI WARA): FEMALE ANTELOPE, →
19ᵀᴴ–EARLY 20ᵀᴴ CENTURY

Among the Bamana peoples of Mali, oral traditions credit Ci Wara, a mythical, divine being who is half mortal and half animal, with the introduction of agriculture to their society. Under Ci Wara's guidance, humans first learned to cultivate the land and became prosperous and able farmers. Today Bamana society remains a primarily agricultural one, and the majority of Bamana peoples are subsistence farmers. These headdresses, also called ci wara, are carved to honor that original mythical being. The ci wara tradition continues as one of the most widely recognized forms in all of African art.

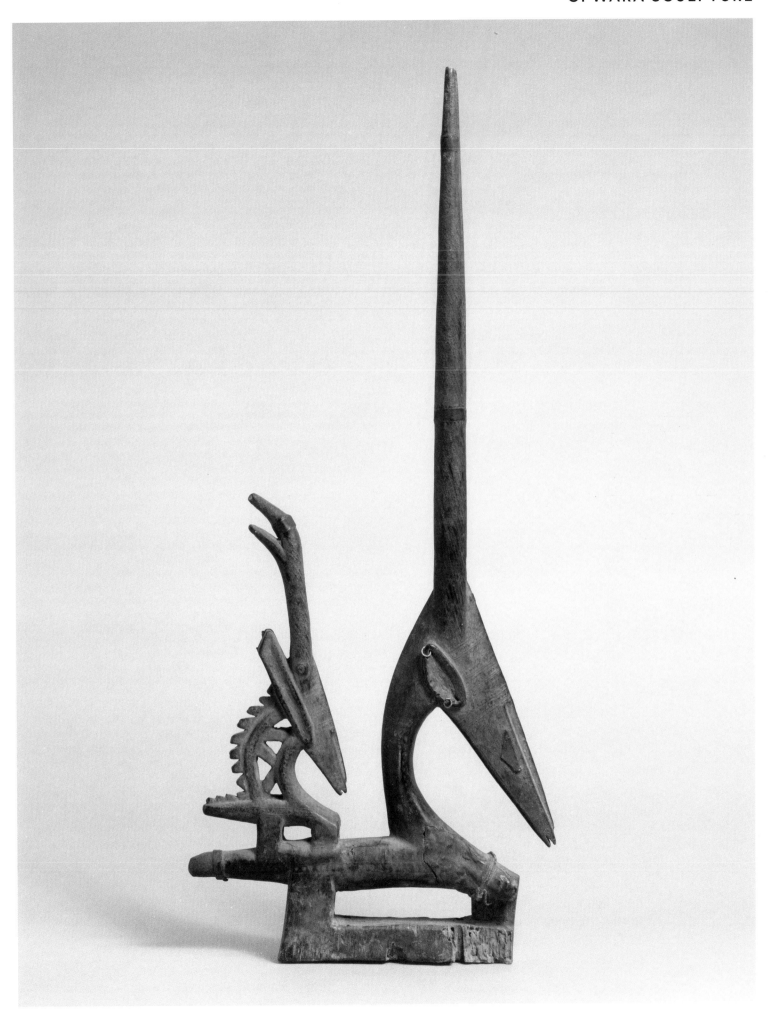

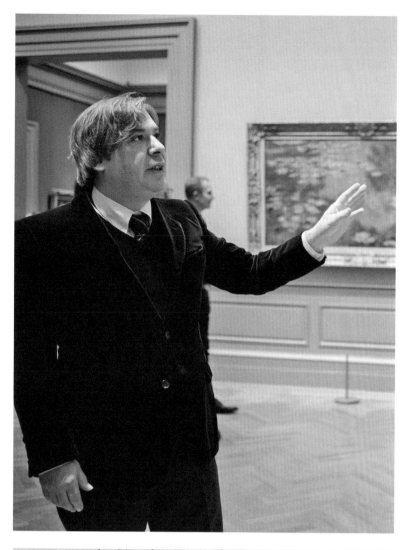

"There was the most stunning transformation. Something that is sort of horrible turned into this exquisite daydream."

I've been looking at Claude Monet's work quite a lot recently. I came to The Met and saw this painting and thought, this is a really wild piece. It has some of the ugliest combinations of colors I've ever seen in my life: polar-opposite tones, like purple and yellow, with oranges and green mixed in.

The surface is extremely active. I don't know if Monet painted this on top of an earlier work, because strokes are moving left and right and don't correspond with the strokes that actually make up the content of the painting. There's a dry surface to his canvases. Things diffuse, they sort of disintegrate. There are spots and stains and random little bits and pieces of paint that seem to have just fallen off his brush—and he left them there.

There's no optical experience as radical as the one that takes place in a Monet. Up close it looks like one thing, then you step back and it looks like another. What's surprising with this piece is that at ten feet away, it still looks the same; and also at about fifteen feet, the palette is still very rugged, disjointed. So what I did next was to go to the end of the hall and look at *The Card Players* by Paul Cézanne, and when I turned around and looked back at the Monet, there was the most stunning transformation. Something that is sort of horrible turned into this exquisite daydream.

You see an aerial view, with the top of the leaves and the shadows reflecting onto the walkway. If you look at the scale of the actual flowers, you can imagine that the path itself must be only about six or seven feet. And the canvas is about six feet. It's actually a beautiful transcription of one particular moment in space and time.

I paint from memory, for the most part. I don't like to work from life and I never work from photography. I enhance my memory by just imagining. This painting feels like a vivid recollection, but Monet's practice was to paint from life. His eyesight was failing then; he might have felt like time was running out and unless he captured these scenes in nature as he had orchestrated them there in the garden he would never again be able to paint them.

I often don't step back from my paintings until I'm done with them. I like to be right up in the painting, imagining how it will look when you step back from it. I think of Monet when I'm painting that way.

The most genius thing about this painting is Monet's ability to work with those nuances of random strokes up close that crystallize into a precise image. It's an absolute masterpiece. It's like you can't see that the earth is round unless you're on a spaceship. This is what I get out of this Monet. The further away you get, the closer you are.

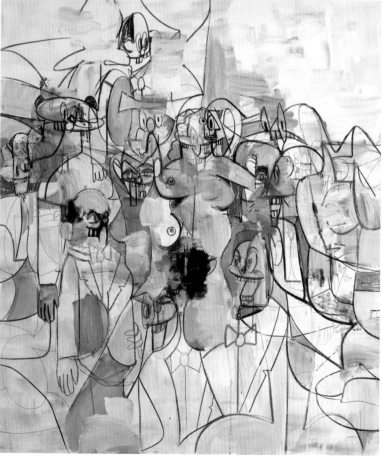

GEORGE CONDO, *RUSH HOUR*, 2010 ←

CLAUDE MONET, *THE PATH THROUGH THE IRISES*, 1914–17 →

Irises, among Monet's favorite flowers, lined the pathways leading up to the house and Japanese bridge on the artist's property at Giverny, France. This bird's-eye view of a garden path belongs to a series of monumental works Monet painted during the First World War that capture the vital essence of these flowers with intensity and breadth of vision.

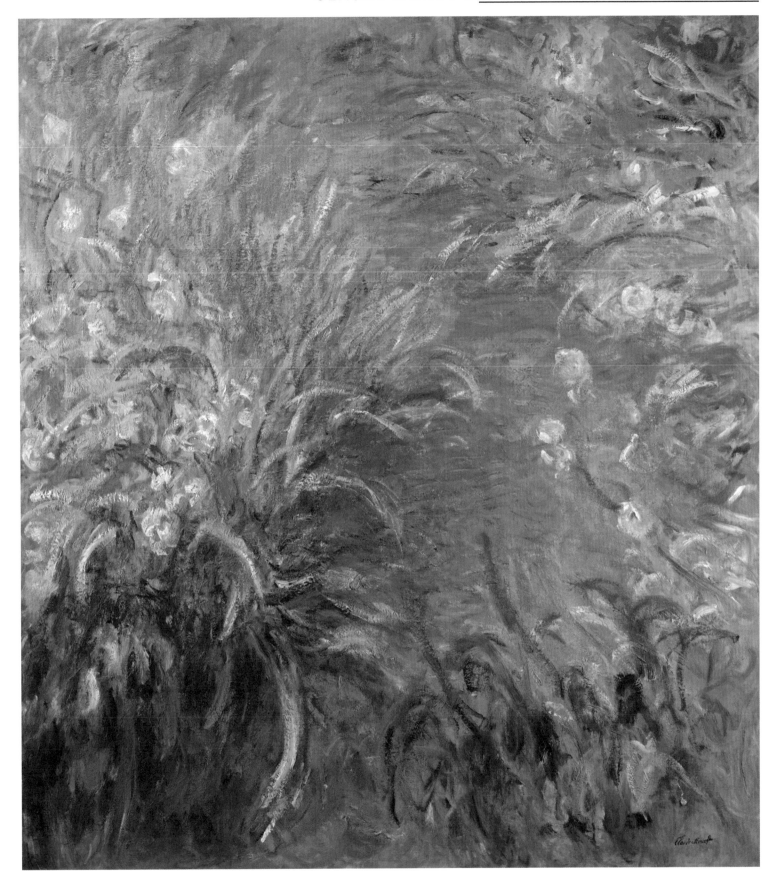

"It's almost a painting, except the whole image is made by thread."

I'm the biggest haunter of the museum, and afterwards, when I'm in my studio working, all of the pieces that I've seen there filter in and become part of the patina on everything I make. This wedding kimono is absolutely beauty personified. It's almost a painting, except the whole image is made by thread. And the thread is not flat but it's actually three-dimensional. Each element—the birds, the plum trees, the bamboo—is sewn differently. You can't imagine the quality unless you really inspect it closely, and that is what is so exquisite about it.

It depicts a fantasy island. You can't get there as a human, but Daoist masters can fly there on the backs of these birds. The bride is everything that the island represents. She brings to her new family everything shown: like the pine, which represents strength; bamboo, which represents flexibility; and the plums blooming under the snow, which suggest amazing fortitude and fertility. And the island represents longevity.

Some brides could have a plum tree or a bamboo tree, or some might have the pine trees, but the bride who wore this kimono had all of them—she was the most privileged bride. She put this on and moved around, probably at night under candlelight, so the gold thread—which is real gold—would shimmer as she moved. Wearing this robe was like performance art, and the act of wearing it meant everything. The bride was leaving her family; when she came back, she would be coming as a guest. There's a horror and a sadness in it, a great sadness. It must have been a terribly emotional day, to leave everything you've known and enter into something completely unknown. That's pretty scary.

Leaving one family and joining another was definitely a ritual—it was an incredible ritual, and a very different one at that time than what is practiced now. Our culture is kind of turned upside down right now, but rituals still glue us together.

PETAH COYNE, *UNTITLED #875 (BLACK ATLANTA)*, 1997 ←

OUTER ROBE (*UCHIKAKE*) WITH MOUNT HŌRAI, SECOND →
HALF OF THE 18TH CENTURY–FIRST HALF OF THE 19TH CENTURY

The ancient Chinese legend of Penglai (Japanese: *Hōrai*), a mythical mountain of eternal life located in the eastern seas, lives on in this late-Edo-period robe. In Japan, the fantasy island Mount Hōrai became stylized as a gathering of cranes and tortoises in a bright landscape, like this one, dominated by pine, plum, and bamboo. The use of Mount Hōrai as a motif on bridal garments was a common practice.

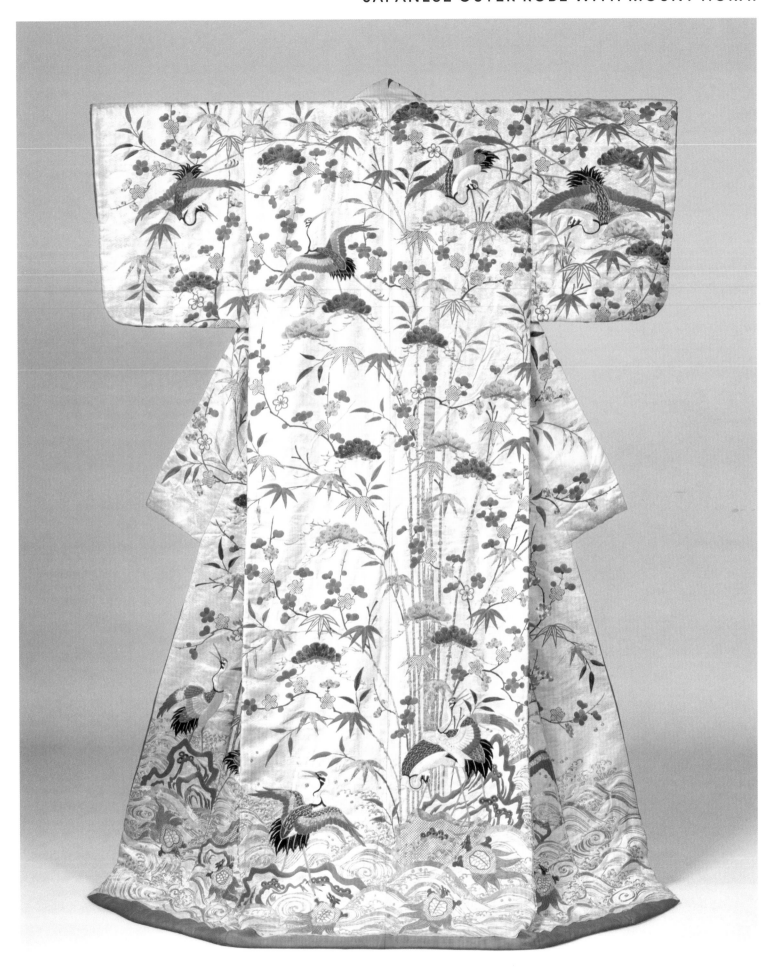

JOHN **CURRIN**

"It sets up rules and then contradicts them, and exists in a paradoxical state of the real and unreal."

I wasn't raised going to church, so I look at religious paintings like I would any other painting. They sometimes lead me into religious contemplation, but great things lead you all over the place and then back into your own life. They're works of art, not works of religious philosophy. I think this is true of Ludovico Carracci's work. Great paintings are very elastic that way.

There is a kind of backwardness to this painting of the Lamentation. Rules that are set up in one part of the painting are completely forgotten in another part. The living figures are very mannered and stylized. If you actually tried to make a human into a mannerist figure, you'd have to break their bones and twist them and kill them. And then the figure of Christ is absolutely real, but he's been stylized by violence. This dead guy is the one that we relate to bodily and can feel in our gut. It's as if what's happening pictorially to Mary and everybody else actually did happen to Christ in reality!

There's a lot in the painting that makes no sense, like that weird forehead with no face. It's part of a magic world back there, but it's necessary. It gives you relief from having to embody Christ. There are so many conflicts that would have been easily resolved by moving one element over, but you start to realize that's the point: Carracci likes those things. Sometimes when you're painting, you get into a slightly magical realm where the painting is kind of happening by itself—instead of pushing it, you're riding it.

The rules that Carracci follows in doing her face, I've always been interested in myself: lighting faces from slightly below, and the whiteness of the light areas—whether that represents the whiteness of skin or the brightness of light. Also, the parallelogramming of the Virgin Mary's face, which is sort of tipped back and over rather than being an upright head in space—which he would have been perfectly capable of painting. What he's doing is reminding you of the flatness of the painting and then obliterating it. That, to me, is the magical thing about any painting: it sets up rules and then contradicts them, and exists in a paradoxical state of the real and unreal, of depth and flatness—all those things that became explicit and kind of tiresome with modernism but have always been latent as part of the spectacle of painting.

I've never liked the idea of art that radically changes the language of its medium, although it's always spectacular when someone does it. As a figurative painter, I've had to accept that I will never make a stylistically consistent work of art, so it's pleasurable to see something similar occurring at the very height of the Baroque. He's made something that has a mysterious physical presence: it's neither flat nor real and, in a way, is dead and also alive the way Christ is.

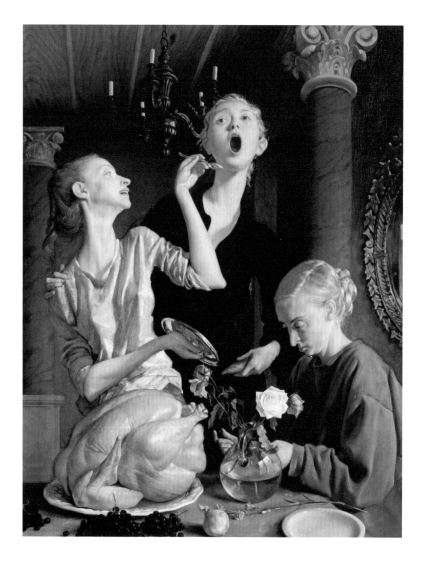

JOHN CURRIN, *THANKSGIVING*, 2003 ←

LUDOVICO CARRACCI, *THE LAMENTATION*, CA. 1582 →

This astonishing painting by Carracci is a landmark of his reform of painting. The figure of Christ, based on a posed model, is painted with a directness and lack of idealization that sixteenth-century critics found shocking. The figures of the Virgin, the three Maries, and Saint John are notably stylized in comparison to Christ. This type of experimentation with the means of representation rather than an abstract sense of harmony and beauty is characteristic of Carracci's early work.

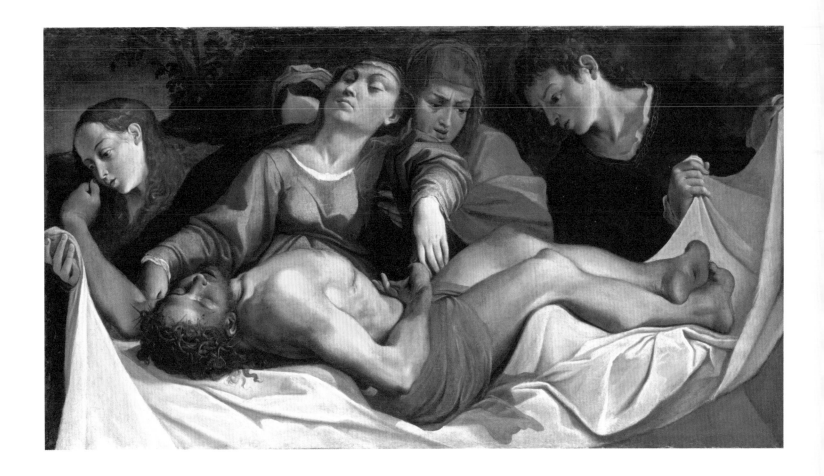

"It reminds you of death, but at the same time you can be in denial because the exquisite nature of the object or place takes over."

I believe that most humans are obsessed with death, because it's the one thing that we just can't know anything about. I find myself coming back to these themes over and over again. I was really struck by this little ivory carving. It's a rosary bead about two-and-a-half inches tall. What you see initially is a young couple in love. It's funny because to my eye they don't look young. They actually look kind of tired. Their eyes are droopy, but they have tiny smiles on their faces. As you circle around the object, a skeleton appears. It has drapery over its shoulder, but if you look closely, you'll see that a salamander is crawling into the skull and coming out the mouth. This is death rotting in the ground—a reminder that this is the destiny of all humans.

The artist connected the three figures by mirroring the drapery and the gesture of the hands. The man is holding his hand above the woman's, and the death figure in the back has his bony skeletal hands in pretty much the same positions, but does so completely alone. It's another way of reinforcing this idea of mortality.

Another thing I noticed is the plant motif at the base. It's stylized and abstracted but it still suggests something unfolding. The emerald might also represent fertility and nature. We have life and we have decay.

The idea of holding the bead miniaturizes death. I can almost see a sense of humor. It's literalizing what happens to the body. There's something almost comic book about it—each of those little worms and caterpillars on the skull.

The bead doesn't freak me out. There's something kind of beautiful about it, in the same way that cemeteries are beautiful. They're gardens, and we can go to these places and enjoy them. It reminds you of death, but at the same time you can be in denial because the exquisite nature of the object or place takes over, and you can lose yourself in that.

MOYRA DAVEY, *COPPERHEAD GRID*, 1990 ←

ROSARY TERMINAL BEAD WITH LOVERS →
AND DEATH'S HEAD, CA. 1500–1525

A string of beads is used as a memory aid in the recitation of the rosary, a multipart devotion to the Virgin. Here, the striking terminal bead announces the constant proximity of death by joining a skeleton to a pair of vivacious lovers. Such an image is known as a memento mori (reminder of death), as it encourages one to reflect on the transience of life.

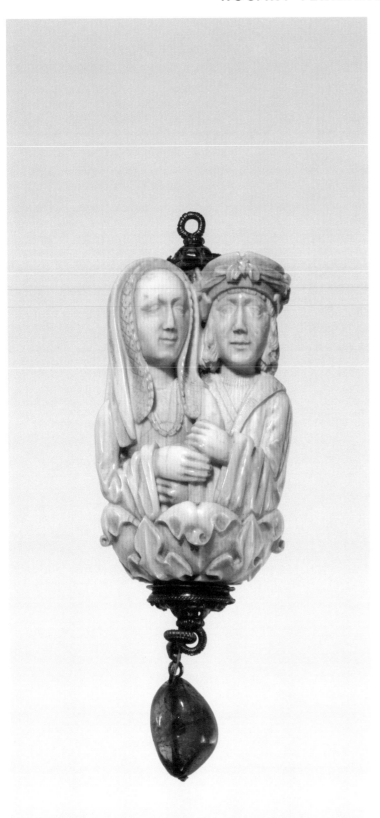

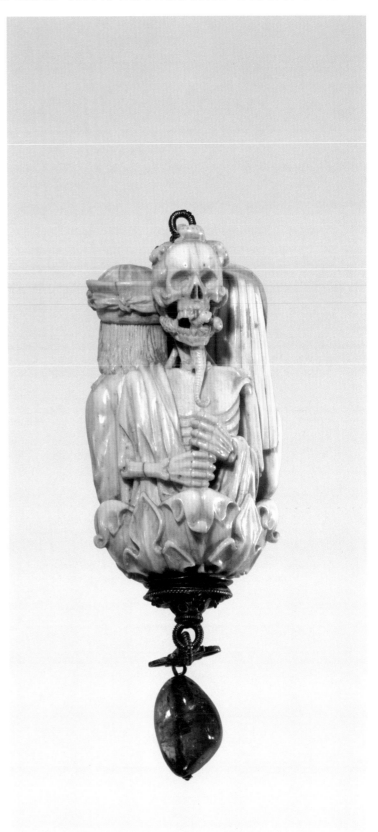

EDMUND DE WAAL

"I'm trying to work out what making pure objects in this impure world means."

I spend my life thinking about white—I mean, I make porcelain, for goodness' sake. I'm trying to work out why people—throughout millennia—do not decorate things. It's a very profound choice. There is nothing whiter than this ewer. It was so white when it was made that there was a special term given to this particular style of porcelain: "sweet white ware."

This pot was made at the same time that sugar was discovered, but when you look at it, it looks so extraordinarily contemporary. It looks like something from the 1920s. It could have been made by a Russian radical or in the Bauhaus, or it could be a bit of postwar American functionalism, but actually it's five- or six-hundred-year-old Chinese porcelain.

Trying to join two bits of porcelain together is very, very difficult. It's the kind of thing that goes wrong all the time in porcelain. On this ewer, there's a ludicrous, wide, lyrical handle and a huge, bulbous belly of the pot, and then these angular series of shapes going right up to the rim.

It's called a Tibetan monk's cap ewer. Why would you make a ewer that looked like a Tibetan monk's cap? Well, it's a great story. These particular objects were made for the Yongle emperor. He came through a sea of blood to gain the throne, and when he obtained it, he had a strange relationship with Buddhism—in a penitential way. He tried to purify himself by bringing sacred art into the Chinese court.

White symbolizes mourning—which it absolutely does in Chinese culture—and at the same time it's utterly about erasure—the white page, the sense of empty space on a scroll. More empty space than you would ever find in any bit of Western art. The power of white, of leaving something be, speaks to us of revolution, modernity, of taking everything away, erasing everything and starting again. Nothing out of all those shapes should be coherent. Exactly the kind of formal puzzle that is modernism: How can you bring strange things into connection and make them work?

The things that really matter to me have always had some kind of kinship with the contemporary. They feel necessary. They feel like something that I come back to. They provoke. This is a quite provocative object, and it's profoundly contemporary for me because I'm trying to work out what making pure objects in this impure world means. That's the big question for me: What does it mean?

EDMUND DE WAAL, DETAIL FROM *LICHTZWANG*, 2014　　←

EWER IN THE SHAPE OF A TIBETAN MONK'S CAP,　　→
EARLY 15TH CENTURY

Vessels with globular bodies and dramatic stepped tops are known as monk's cap ewers because their rims resemble a headdress worn by Tibetan Buddhist monks. Used for pouring liquids for purification and cleansing during rituals, these ewers first appeared during the Yuan dynasty, when the Mongol court practiced a form of Tibetan Buddhism. The white porcelain with *anhua* (hidden motif) designs, which are delicately incised into the surface and almost disappear when covered with a glaze, suggests that this vessel was made during the reign of the Yongle emperor (r. 1403–24).

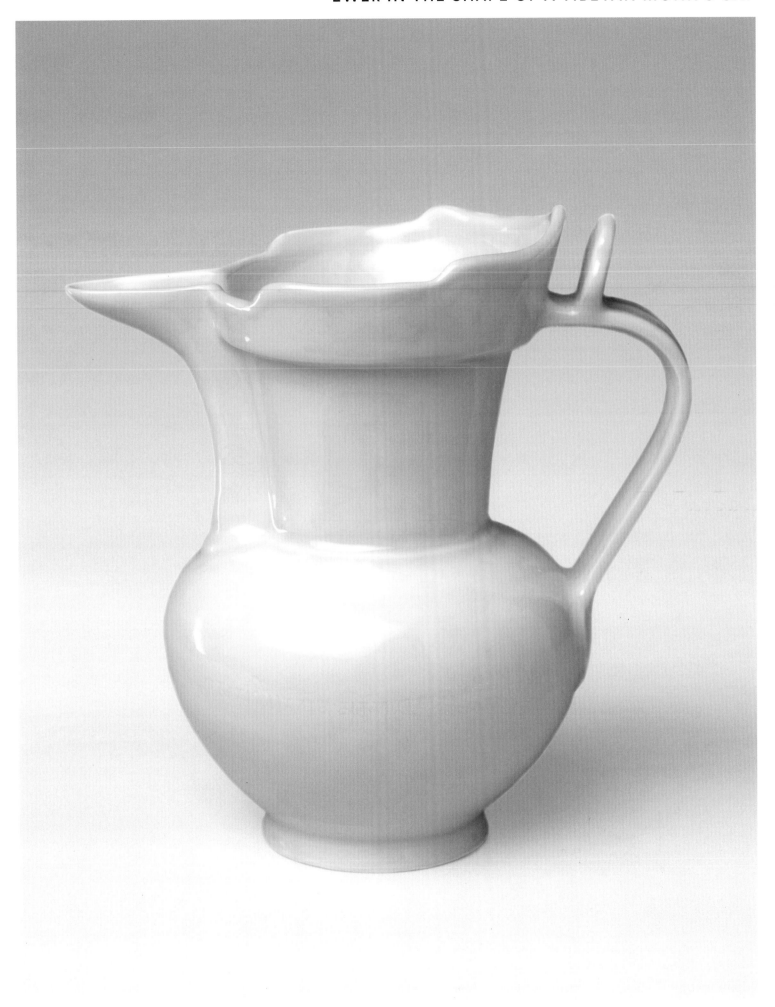

"It's the promise that with the genius of the human brain, one can somehow cage the horrors of daily life."

I make life-sized sculptures of spaces and rooms made entirely out of cardboard, which I photograph. What I'm very often after in my photographs is to show a space and its potential, or a space and its character. It's about human presence represented by something else, like the coincidental array of things or a half-opened door, where you have a glimpse of a moment. That's what I see in the *studiolo*, just like—bam!—what a moment, completely frozen in veneer. Everything you see is actually flat wood. It's a translation of the real world into geometrical shapes, which I find quite amazing.

The Duke of Urbino had this studiolo built in Gubbio, and it's a highly allegorical space. Every object means something, and it conveys a high sense of culture. Earlier kings would have a big crown or lots of gold, and that would be the representation of their power. Here, the representation of a book can do that. One of the books depicted on the wall has a little paper divider, and you can even see the shadow of it on the side of the book. So the book is there not to say, "I like books" or "I want you to know that I have books," but to say, "I read the book, and I just left it in the corner there."

The room is full of wonders and full of mastery. One of my favorite parts is a *mazzocchio* on the bench. It's the little ring with all the angles. It's enormously difficult to do right, and it is a sign of total mastery of the media.

There are also little vignettes that seem to be completely abstract, so the artist was aware of the illusionistic character of the whole piece. It goes beyond the point of tricking your eye. It represents a state of mind and a way of thinking about humanistic ideals.

In the early Renaissance, central perspective was a new tool. The trick here is that the whole perspective is accurate when you step into the room—and only then. When you go to the window, you see how distorted the bench on the side is. You have one viewpoint, and it's actually very unhuman. Not inhuman, but unhuman because our head is moving all the time. So our reception of the world is actually one of a moving eye. The central perspective totally works, but it's too clean. You have this translation of the real world, which is not clean, into geometry, into mathematics. It's the promise that with the genius of the human brain, one can somehow cage the horrors of daily life. It was a real utopian proposition at the time, the idea of a virtual space. You can still feel the modernity in it.

Art, if it's good, can bridge centuries. When I see it—I see it today, not five hundred years ago—my brain works on it now. It lets me have my own observations; it lets me have my own ideas about it. That's what I love about art. And if it's displayed in a 360-degree, panoramic way like this, it makes me just plain happy.

THOMAS DEMAND, *VAULT*, 2012 ←

STUDIOLO FROM THE DUCAL PALACE IN GUBBIO, CA. 1478–82 →

These details are from a *studiolo*, a room intended for meditation and study. Its walls were made with a wood-inlay technique known as intarsia. The latticework doors of the cabinets, shown open or partly closed, indicate the early Renaissance interest in linear perspective. The cabinets display objects reflecting the Duke Federico da Montefeltro's wide-ranging artistic and scientific interests, and the depictions of books recall his extensive library.

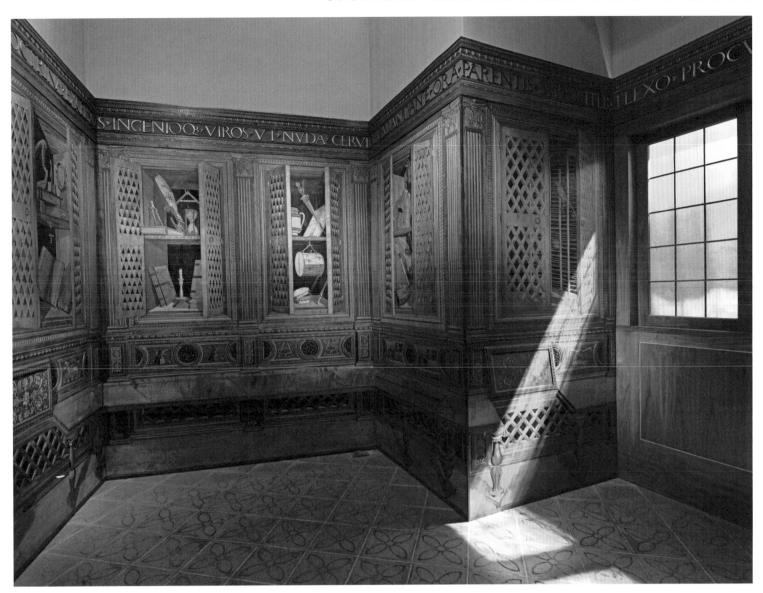

TERESITA **FERNÁNDEZ**

"We know that these gold works represent greatness, and yet now we only have a handful of examples left that point to it."

I make large-scale sculptural works that deal with the connection between the subterranean and the cosmos. I'm fascinated by the human narrative that attaches earthly metals to heavenly counterparts: what's below corresponding to what's above. Gold is the ultimate example of that—it has always been associated universally with the sun, and gold objects are literally parts of nature, extracted from riverbeds and earth.

The pre-Columbian gold at The Met is like a well-kept secret hiding in plain sight. It's radiant. I know that the sun bouncing off of them and creating all kinds of shimmering light would have been an important part of the experience. That element of movement, of natural light animating these objects, is something that we can't witness when we view them in a case.

The abstract quality of some of these works is so sophisticated. You'll see the naturalistic representation of something dissolving before your eyes and becoming a completely graphic, geometric, minimal shape. There are images within images. I think that's what abstraction is about, how one thing can suggest something else.

In the United States we often forget that "America" is actually "the Americas." These objects are part of an often overlooked or entirely invisible history. There's no way to trace gold's provenance. When you melt it down, it's just itself.

Most pre-Columbian gold was systematically loaded onto Spanish galleons, already melted into ingots. When I see gold in European collections, I can't help but know that it was once in the shape of masks or pectorals or twin crocodiles or flattened feline whiskers.

It's as though every gold object has a ghost image of what it was before. These objects retain the memory of every form they've ever been. They're not defined by their present physicality.

Throughout history there have been attempts to erase other people's histories. In this particular case, it's poignant because there was so much of it. We know that these gold works represent greatness, and yet now we only have a handful of examples left that point to it. For me, this group of gold objects at The Met is like looking at the tip of an iceberg, where one sees a tiny glimpse of what can only be imagined.

TERESITA FERNÁNDEZ, *FIRE*, 2005 ←

FUNERARY MASK, 5ᵀᴴ–1ˢᵀ CENTURY BC →

Hammered masks are some of the largest objects produced in gold in the ancient Americas. This mask comes from the Calima region in southwestern Colombia, where people took advantage of abundant alluvial gold deposits to develop a distinctive gold-working tradition that lasted for at least two thousand years. Hammered from a single sheet of metal of high gold content, Calima masks of the Ilama era are often flat, with generic details of the human face. On this example, the metalsmith created individualized features through repoussé with raised areas and cut out the sheet to indicate the pupils and the mouth. Six perforations along the edges of the cheeks allow for the attachment of the mask.

"I'm really interested in unconventional representations of conventional ideas in art."

I'm really interested in unconventional representations of conventional ideas in art. Trompe l'oeil seems so gimmicky—but then there's William Michael Harnett. You look at this artist's letter rack, a nineteenth-century painting, and it's an abstraction. If you squint, you can't really see the details. It becomes quite a beautiful abstraction—look at the choice of color, the position of those orange envelopes and the blue, and then there's this weird little piece of string.

The whole idea of trompe l'oeil painting addresses the very basis of what painting is: this idea of representing objects, re-creating reality, and how closely you're trying to reproduce something when you're making something else.

It's not only just an abstraction; it's also like a portrait, almost like a diary. To think about a portrait created out of a collection of papers—it's unconventional, but it's also a way of organizing information and images in a very analog way. That's what is happening here. If you look at the tape that runs over one envelope, that envelope's placed on top of another envelope, which is over a ticket that is then under another piece of tape. Also, this weird spirographic flower—it's like graffiti. It's a little bit of a joke, a drawing within a painting. The faded wood where a document was pulled off makes you think about what the sunlight is like in the room.

In some ways *The Artist's Letter Rack* is frighteningly similar to contemporary imagery. The background is similar to the wallpaper of a computer screen. It doesn't have the richness that other works of art have. There's a quality of transparency to the image because it is photorealistic; there's not that tension between what it is and what it says. It seems that there's not a lot of reflection, that he's just a copyist and not adding a lot, but I think there's more going on than that.

As an artist, one looks at work with certain goals in mind: things you can both learn and use in your own practice. This painting made me think about it in those terms. I like that it's so minor. There's something poor about it; these sorts of objects wouldn't normally be the subject of art. It's so modest: an artwork that accepts its own limitations. At the same time, there's this obligation to make art, in spite of all these incredible odds against it.

Harnett was really thinking about the ontology of the painting as well as the ontology of the object. What does it mean to make a work of art? There are kernels of that philosophical exploration in this painting.

SPENCER FINCH, *BRIGHT STAR (SIRIUS)*, 2010　　←

WILLIAM MICHAEL HARNETT,　　→
THE ARTIST'S LETTER RACK, 1879

This is the earlier of Harnett's two known "rack" pictures, a subject he and his contemporary John F. Peto had inherited from seventeenth-century Dutch painters. The wood boards of the background, the pink tape of the rack, the cards and envelopes that are tucked into it, and the surrounding paper scraps are all carefully delineated. Curling edges, subtle shadows, and distinctive textures tease the viewer into imagining that all the painted elements are real.

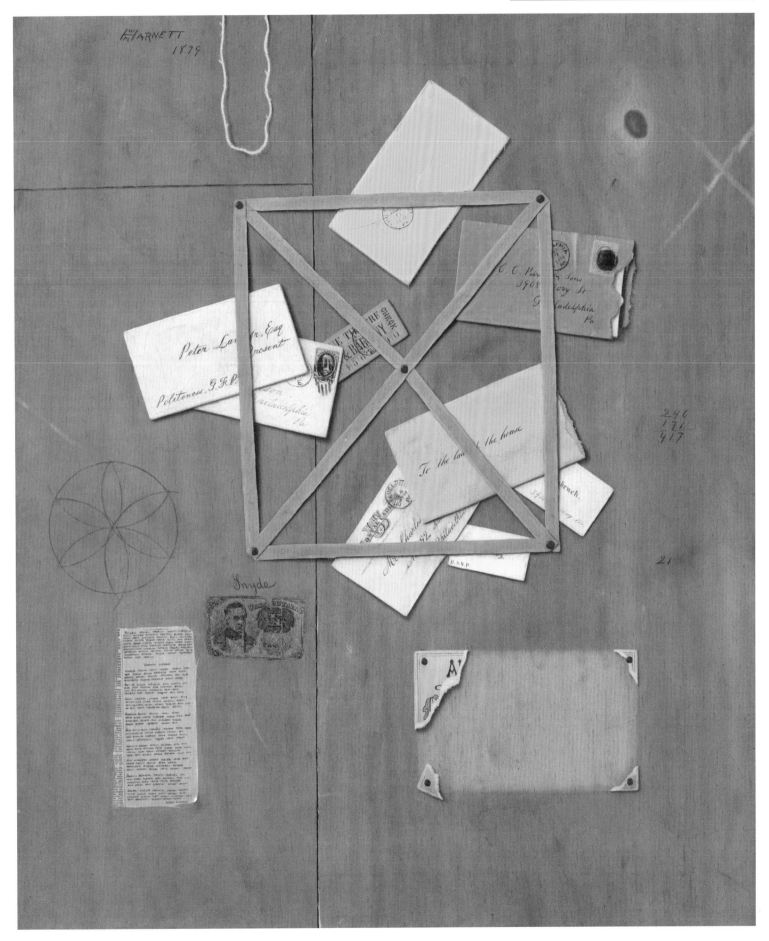

ERIC FISCHL

"He's painting about the struggle of being human."

People distrust that they can actually read a painting. It seems like you have to know a lot about what's outside of the painting in order to understand why you're even looking at it. The great thing about Max Beckmann's paintings is that no single reading of them is actually right. They contain narratives that are based on deeply personal associations, coupled with mythologies you may not actually need to know to enjoy the work—but they just add layers and layers once you do.

I feel very close to the general narrative of *Beginning*: a boy coming of age. In the central panel, Beckmann presents a boy dressed like a prince on his hobbyhorse, which is very animated. During puberty, boys destroy their toys: Puss in Boots hanging helplessly immediately sets that in motion.

The painting on the right is of an elementary school. It's all male, and some of them are behaving badly. In showing you the picture, Beckmann implicates you as a disciplinarian or as a participant, making you remember when you did this. There's an old man, who seems to be the teacher, and behind him is what appears to be a mature male figure but is only a bust. Then there is a globe that also is like a ball, and it looks like it's going to land and pop. He makes it very precarious.

In the panel on the left, the boy is looking out at what he is going to enter or possess. He jumps over everything between youth and death. It's almost a dreamlike transformation. Beckmann's sense of hierarchy comes from emotional necessity. You can see him really weighing how to describe something.

A part of a ritual in society is that you collectively recognize the momentousness of it, and you share it. You go through puberty, and it begins to call up the nature of desire, objectification, the currency of exchange. It makes me feel like I'm not the only one.

Nobody can compete with the complexity of Beckmann's works. He's both constructing and watching something fall apart simultaneously, and yet he stays very close to the human drama. He's painting about the struggle of being human.

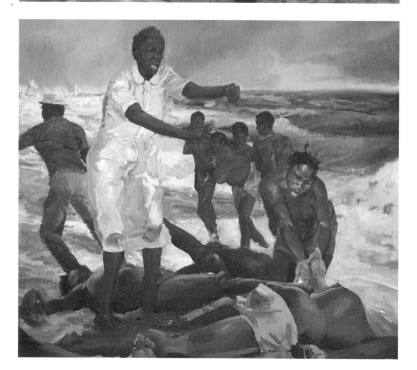

ERIC FISCHL, *A VISIT TO / A VISIT FROM / THE ISLAND*, 1983 ←
(WITH DETAIL)

MAX BECKMANN, *BEGINNING*, 1949 (WITH DETAIL) →

Completed in 1949 when the artist was sixty-five years old, the panels of *Beginning* are autobiographical. Beckmann's memories of his schooldays in Leipzig, Germany, seen on the right panel, are balanced by a dream fantasy on the left. In the central panel, childhood memories and dream worlds intermingle. Deeply impacted by the two World Wars and his exile from Germany, Beckmann typically integrates tragic themes with expressionistic brushwork and bright colors.

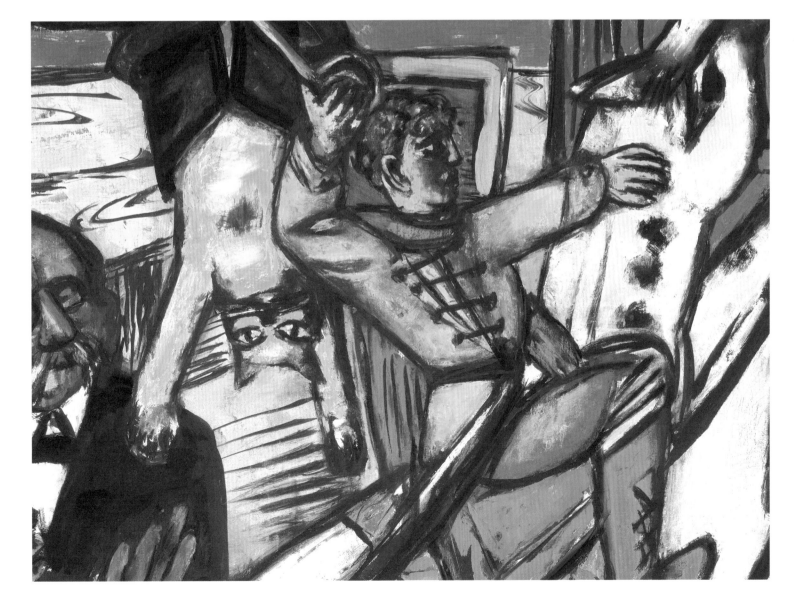

ROLAND FLEXNER

"I think of it as a film noir."

I made a drawing inspired by this painting when I was working on a series on vanitas. Vanitas is a genre of still life painting that was very popular and flourished in the Netherlands in the seventeenth century. It was painted on the back of portraits as a reminder of death. This is the first-known freestanding vanitas, but the artist, Jacques de Gheyn, is not well known.

Vanitas is a neutral approach. The painters never tried to develop a personal style—it's conventional and very stiff. This painting shows all the classic symbols of the vanitas. The symbolism of the objects is all preestablished; everyone who went to church in the seventeenth century would have known the meaning of those objects because they had biblical references.

The soap bubble is a different story because it's a total innovation. When I first saw this painting, I thought the vertical arrangement was very powerful. The theme of the skull and the bubble is *homo bulla*, "man is a bubble." It addresses people's mortality. Actually, I made a collage with the skull inside the bubble—it fits perfectly!

The painting is not realistic. The bubble is levitating right in the middle of the niche, and there is a scary symmetry in the picture. Even the front teeth are symmetrically removed from that skull. The painting is conceptual: you have the two philosophers at the top pointing at the bubble, which in this case represents a terrestrial globe.

The way you approach this painting as a contemporary viewer, you aren't looking for moral and theological meaning behind the objects. If I make contemporary vanitas, they're certainly not about the symbolic. They're more about making the ephemeral happen in the material itself. The paradox of the vanitas is that you represent absence with an illusion of presence. I think of it as a film noir: the tulip will wither, the smoke will disappear, the money will vanish, the bubble will burst—nothing escapes death.

One aspect that I like a lot about this painting is that inside the bubble, the paint is very thin so a lot of it has disappeared. If the fragility happens in the material of painting, then painting is really the supreme vanity. The passage of time is at work.

ROLAND FLEXNER, *UNTITLED*, 2007 ←

JACQUES DE GHEYN II, *VANITAS STILL LIFE*, 1603 →

De Gheyn was a wealthy amateur artist best known as a brilliant draftsman, but he also painted and engraved. This panel is generally considered to be the earliest known independent still life painting of a vanitas subject. The skull, large bubble, cut flowers, and smoking urn refer to the brevity of life. Images floating in the bubble, such as a wheel of torture and a leper's rattle, and the coins and medal at the base of the composition refer to human folly.

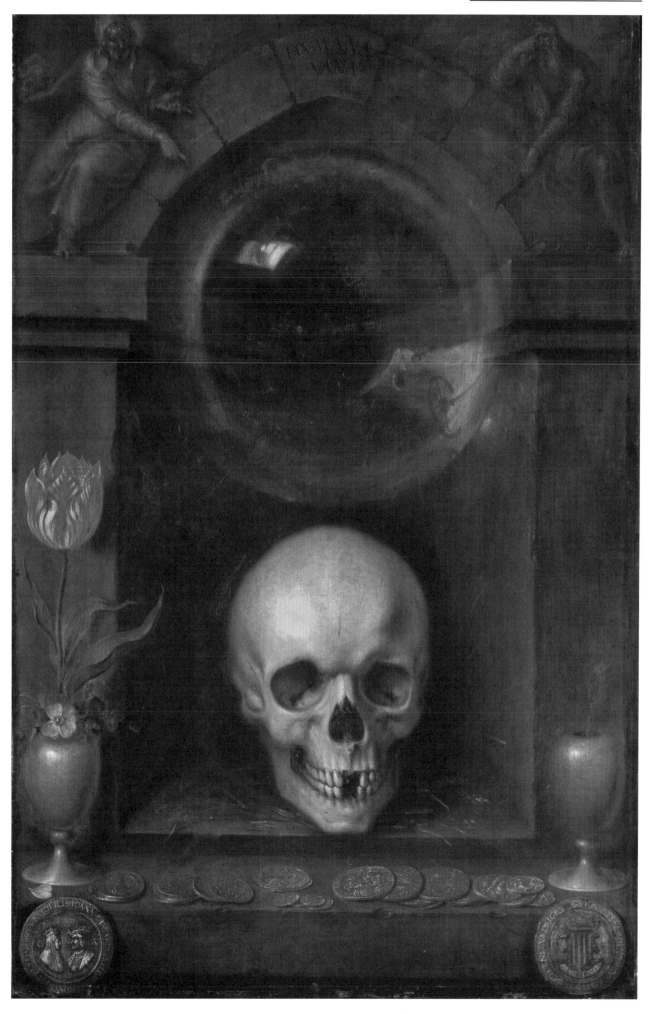

WALTON **FORD**

"You get the feeling that because it's hell, Van Eyck was able to break all kinds of rules."

I've been painting my whole life, and I'm in awe of this painting, *The Last Judgment*. It is one of the great monster paintings in all of art history. Heaven looks like a board meeting where they're all up there watching the Last Judgment. The audience is sitting there while what's interesting takes place onstage. The stage, in this case, is the end of the world.

To create these demons, Jan van Eyck had to go out and look at things. That horror is there in nature. This creature—it's got a sort of monkey's head, frog's legs, wings from a beetle, and spots on his back like a toad. All Van Eyck would have had to do was beachcomb, perhaps walk along the beach and pick up bits of lobster and crustacean and little horny bits of spider crabs. Then he could go to the fish market and look at really nasty, weird fish. He's making monsters. This work is about as wide as a sheet of loose-leaf paper, but it's just packed.

You get the feeling that because it's hell, Van Eyck was able to break all kinds of rules. It's the time for invention, transgressive nudity, and gore. The souls are vacuumed into the earth, sucked under the waves, and shat out by a skeletal-bat figure that divides the underworld from the rest of us. They are crapped into this horror, totally tortured, and eaten and bored into by these hideous beasts until so much blood pours out that they drown in the blood below. Then, I guess, the process starts all over again, for eternity—it's like a slasher film. It's so vivid. Van Eyck may have actually seen someone be ripped in half because it's pretty frickin' convincing the way that he portrays it.

In our culture we're separate from the horror of everyday death, so we need to understand it. For instance, when people slow down on the highway to look at a car accident, they're not being shallow, they're actually trying to gather needed information. You can tell that Van Eyck comes from that world, and it teaches you something about the spirit, the flesh, and the transient nature of life.

WALTON FORD, *VISITATION*, 2004 ←

JAN VAN EYCK AND WORKSHOP ASSISTANT, →
THE LAST JUDGMENT, CA. 1440–41 (WITH DETAILS)

Despite its restricted format, *The Last Judgment* is filled with an extraordinary amount of detail. Deep space is presented vertically—compressed into the foreground of the painting—and is divided into three layers corresponding to the realms of heaven, earth, and hell. In a formulation novel for its time, the saved and the damned are organized in groups at the top and bottom of the composition, respectively, rather than appearing to the right and left of Christ. Between the realms of the damned and the saved, the earth and sea are shown splitting apart, surrendering their dead, as told in Revelation 20:13.

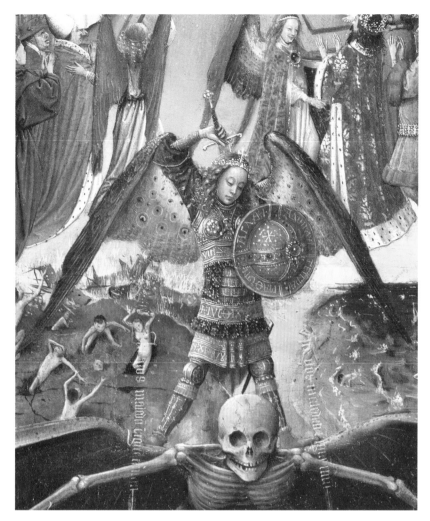

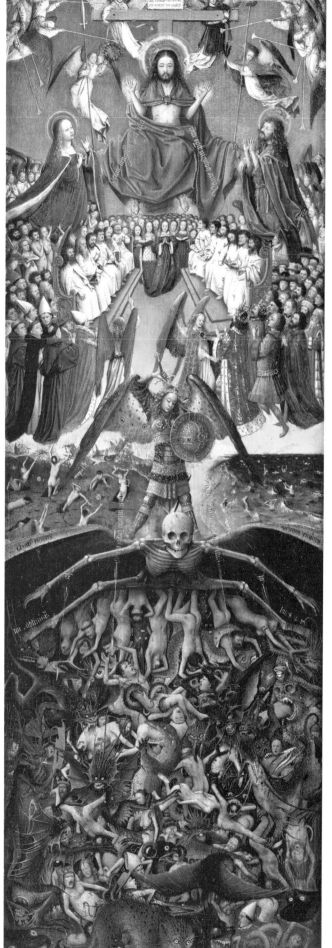

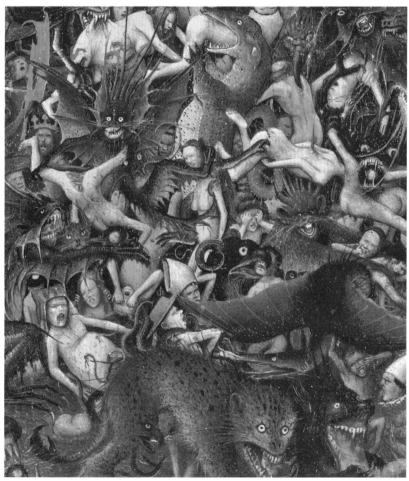

NATALIE **FRANK**

"Her work was the first time I saw the world through a grown woman's eyes."

Käthe Kollwitz was the first woman artist whose work I was introduced to. I read a lot as a child, and all of the literature seemed to be from the vantage point of men. Her work was the first time I saw the world through a grown woman's eyes.

For instance, the image of *Raped* is definitely by a woman. How she's lying, you can feel the weight of her body, the weight of her leg—her thick, muscular thighs—the weight of her head. Her arms are bound behind her. Her legs are splayed open. There's a little girl in the back looking down on the scene. It's purely a domain of women. A man has obviously been there, but this was, for me, one of the first representations of sexual violence toward a woman, from the vantage point of a woman.

That's what I get from Kollwitz. It's empathy. The images of young women and their husbands, or even a woman by herself—you feel the weight of what it feels like to be a woman.

Her physical presence and her autobiography are everywhere in her work, and it is so pure and intense and unguarded. As a young person trying to figure out what she wants to make her work about, what her story is, the bravery to do that is compelling.

I coveted a lot of her skills that I didn't feel I had. She was an incredible draftsman, and I was always drawn to paint and color. She put together figures like she was grappling, trying to show something interior, and at the same time there was mastery. It came out as a complete idea, perfectly laid out. Printmaking is incredibly difficult because there's no erasing, and once you've taken something away, you can't put it back. It's also printed in the reverse. To have that kind of foresight and control was incredible to me.

It hasn't been that long since Kollwitz made these images. A lot has changed, but a lot hasn't. Women are still unheard. And so for that reason Kollwitz resonates. She's a feminist. She was making avant-garde images at a time when women were still kept out of schools. She took so much from her life and her surroundings and made it into something that gave her access. And she was recognized during her life and celebrated.

In everything she did, you felt her politics and her sincerity and her belief in herself and the power of her own narrative. She's someone I'm constantly thinking about, who's ever present in how I see the world because of how daring her work is.

NATALIE FRANK, *ALL FUR III (GRIMM'S FAIRY TALES)*, 2011–14 ←

KÄTHE KOLLWITZ, *RAPED (VERGEWALTIGT)*, 1907 ↗

KÄTHE KOLLWITZ, *YOUNG COUPLE (JUNGES PAAR)*, 1904 →

Raped is from Kollwitz's *Peasants' War*, a series of seven prints based on the brutality imposed by sixteenth-century German nobility and the resultant revolts. Depicted is the scene of a violent crime: amid the lush vegetation and flowering forms is the semi-hidden body of an assaulted woman, her vulnerability emphasized by her exposed flesh and disheveled clothes. Behind her is a young girl, perhaps her child, who bows her head, echoing the surrounding sunflowers. In *Young Couple*, a cramped and claustrophobic space represents the tension and emotional distance that divides the two figures. The man turns his back and recedes into shadow, while the woman, her body separated from him by overstuffed pillows, faces forward, her face nearly devoid of emotion.

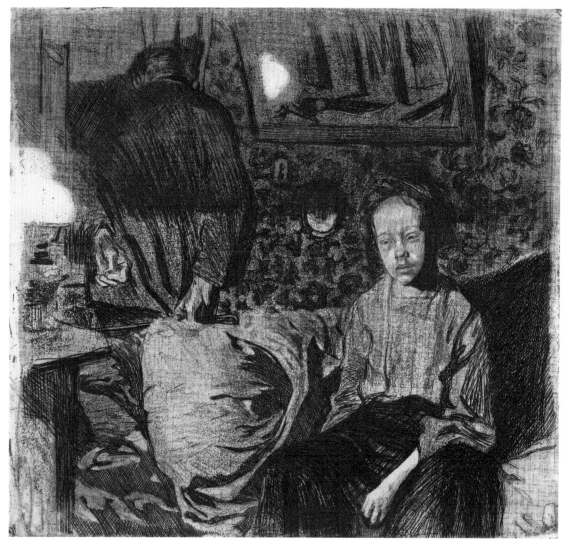

LATOYA RUBY **FRAZIER**

"There's tremendous beauty in people's pain and suffering."

Since I was a teenager, I've been obsessed with early twentieth-century social-documentary photography. In the photo history books that I trained with, one of the only significant African Americans was Gordon Parks. He allows the poor, ostracized, and alienated to have power and authority through their images; he's photographing them with so much dignity and human awareness and care.

The photograph *Red Jackson* is important because it's from Parks's first assignment with *Life* magazine, known as *The Harlem Gang Leader*, in which he photographs Leonard Jackson, who goes by the nickname Red. In 1948 there wasn't much opportunity for young teenagers: the education system was failing, they were living in squalor, and economically they were disempowered.

On its own, it's a nonjudgmental portrait, but the way it was handled in the magazine was not. The subtitle includes the words *violence* and *frustration*, and *Life* set it up so the whole layout shows Leonard as a threat or a menace. People would rather only see a binary between good and bad.

What is impressive about Parks is that he was able to balance this cruel and tender world in a poetic way. Aesthetically and formally, I see Vermeer; I see the light and the shadow of a Rembrandt; I see Goya. I see beautiful understanding of texture, framing, proximity, juxtaposition...

There's tremendous beauty in people's pain and suffering. This is why we make art. The truth is we need social documentary, especially today. When I look at this image, I think about all the black men being killed by police right now, and the fact that there is no justice for them.

This photograph is also symbolic of Parks himself. In this portrait of Red, I can see the poetry of Parks. I see him as a film-maker and a composer—it's a silent image, but I can hear it. There's a sound that comes from it.

That's the genius of Parks—that's what excites me about him and what encouraged me to keep using my camera. He could completely smash any stereotype by showing multifaceted dimensions of any one person's psychology. It's so humane and universal, and it's undeniable.

LATOYA RUBY FRAZIER, *GRANDMA RUBY AND ME*, 2005 ←

GORDON PARKS, *RED JACKSON*, 1948 →

The most prominent African American photographer and journalist of the 1950s and 1960s, Gordon Parks documented the experiences of underrepresented people and communities while also producing celebrity, fashion, and news photography. This image of Harlem gang leader Red Jackson is one of a series Parks made for *Life* magazine in 1948. The photo-essay was the first to look closely and soberly at the reality of life in Harlem at midcentury and anticipates the more strident civil rights exposés by Parks and other photojournalists in the 1960s.

"I get lost in it, and I think that's the wonderful experience of art: that you are no longer here."

I've seen this painting many times, and every time I see it, I'm taken by its power. It's small, but it's compelling to see it from a distance. It's almost a miracle that this painting has survived seven centuries. It ages beautifully because it's such a good painting. I find that if a bad artist paints the Madonna and Child, you don't really stay with it; it doesn't warrant looking at it over and over again. But Duccio di Buoninsegna knew how to compose.

I consider Duccio a great colorist. For me, as a painter, the more colors I put into a painting, the more complex and difficult it becomes. I admire how he made all these colors and lights and darks work in the painting. I think color is light and life: the Madonna's blue robe, the delicate pink of the veil, the earth green under the flesh tones that gives the figures an enigmatic quality and keeps them beyond your reach.

The painting's depiction of mother and child is something that we can relate to. She knows that her son will be crucified, and the artist succeeds in portraying her timeless sorrow in her features.

I believe this was done for a private patron as a devotional painting. The patron could use it in prayer and be moved by it. The gold was symbolic of what you were supposed to feel—you were illuminated by this painting. The gold is also incised—it's not a plane of gold—which was meant to create a kind of explosion of light. It's almost magical or mystical.

The painting is always in a state of suspension that was orchestrated by Duccio to give to the viewer. Duccio gave the mystery of art to us. The viewer is brought into the reality of the painting; it has infinite dimensions that it's broadcasting and connecting with the viewer's sight and mind.

It takes me out of myself. I get lost in it, and I think that's the wonderful experience of art: that you are no longer here. You're in a place that you haven't been before, and it can happen over and over and over with a good work of art.

SUZAN FRECON, *SOFOROUGE*, 2009 ←

DUCCIO DI BUONINSEGNA, *MADONNA AND CHILD*, →
CA. 1290–1300

This lyrical work by Duccio—the founder of Sienese painting—inaugurates the grand tradition in Italian art of envisioning the sacred figures of the Madonna and Child in terms appropriated from real life. The Christ Child gently pushes away the veil of his mother, whose sorrowful expression reflects her foreknowledge of his crucifixion. The beautifully modeled drapery enhances their three-dimensional, physical presence, and the parapet connects the fictive, sacred world of the painting with the temporal one of the viewer.

"She's saying goodbye to the world, and isn't it masterful of an artist to capture that reluctance?"

I was fascinated by Greek and Roman art when I worked as a waiter at The Met. We could make extra money by working parties at night, and I found myself frequently walking through the classical galleries alone and in the dark. The environment the sculptures were in seemed to suit their nature as sacred objects.

This marble grave stele of a little girl is a doorway into a lot of ideas. It's a grave marker, and that makes a lot of sense to me because my own work speaks to the passage between material and something else. This sculpture has this dual character of intense beauty and intense sadness. It's a story of a life. We're poised in an almost cinematic moment of a child losing her life. I understand the bird to be symbolic of her life, representing the passage between the body and beyond. The intimacy between the symbol of the bird and her mouth speaks to the idea of her final breath. It's the life force recognizing the sadness in the passage out of the world.

I find this work extraordinarily beautiful: the quality of the carving, her hair. It reminds me so much of water. Such an interesting form, too—it's a sculpture, but it's as much a drawing in stone. The motion of the fabric is also symbolic of the life force: it's falling off, it's broken, and so her life is falling away.

She's full of the optimism of a child, kissing her pet doves goodbye. She's saying goodbye to the world, and isn't it masterful of an artist to capture that reluctance? So much of this work is an attempt to address that part of our experience when the curtain's closing, and trying to peek behind the curtain because we're sure as hell going into that drama.

There's all of that unlived potential, an inherent tragedy—and yet so much beauty as well. It's a loving embrace.

ADAM FUSS, *ARK*, 2004 ←

MARBLE GRAVE STELE OF A LITTLE GIRL, CA. 450–440 BC →

The gentle gravity of this child is beautifully expressed through her sweet farewell to her pet doves. Her peplos is unbelted and falls open at the side, while the folds of drapery clearly reveal her stance. Many of the most skillful stone carvers came from the Cycladic islands, where marble was plentiful. The sculptor of this stele could have been among the artists who congregated in Athens during the third quarter of the fifth century BC to decorate the Parthenon.

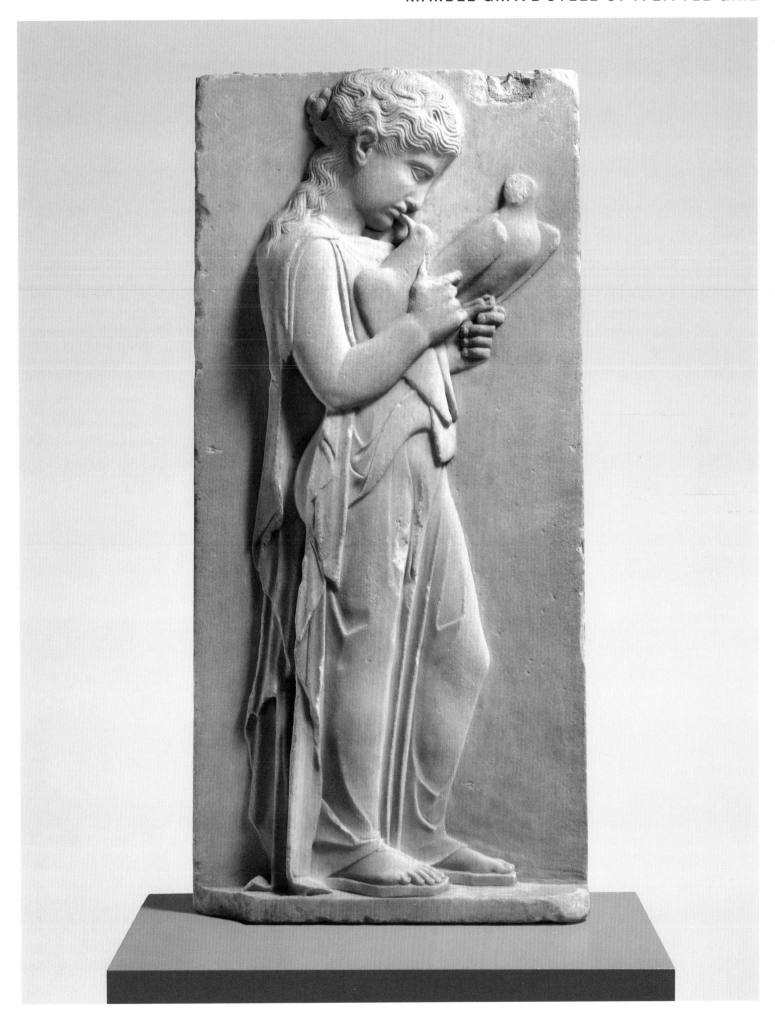

MAUREEN GALLACE

"It's a type of experience that some painters have: a need to...get at the essence of what painting is, even if it's just by using an apple."

Paul Cézanne really gets credit for opening the door for abstraction. His still life paintings are so relevant, particularly now when abstraction and representation are both equally represented in contemporary art. When I first saw these paintings, I was young. I remember thinking, "Oh, I can paint like this." I did not find them intimidating. Cézanne gave permission. I saw that there was a way in for me. And despite getting older and having been a painter for twenty-five years, they still deliver.

His subject was this simple, naïve, everyday object that we're all familiar with, but the paintings don't ever feel like they're just about copying the apples. They're about painting. You can see the canvas. Everything points to what it took to make it. Every mark is laid bare—he wanted everybody to know the experience of the painter.

Cézanne took forever to make the paintings—sometimes he didn't use apples, sometimes he used peaches or pears—but I'm fairly sure that one of the reasons he used apples was that they don't spoil quickly. I understand that process—I'm someone who often takes an hour to make a brush mark. Painting is a lot of thinking and a lot of staring.

The emotion comes from the way the paint is handled. The forms seem kind of crude because they're built up from the marks. They're so solid, the apples—they become sculptural. You can almost feel them in your hand. And there's a black outline, but it doesn't quite touch the shape, so the apples appear to vibrate.

There is an uneasiness to these paintings, and I think that comes from the shifting perspective. There's no horizon line. The tablecloth hides the edge of the table, and the tilting feels a little claustrophobic and destabilizing.

There's perfectionism there. It's so tightly controlled, but it wasn't about one painting being the masterpiece. That was the point: to keep going, keep going, keep going, and get better and better and better. It was okay to fail. There's less pressure on the painting because he could just get it right the next time.

I think Cézanne was trying to put everything that he knew about painting into each object. It's a type of experience that some painters have: a need to distill things down, to get at the essence of what painting is, even if it's just by using an apple.

MAUREEN GALLACE, *RAINBOW ROAD, MARTHA'S VINEYARD*, 2015 ←

PAUL CÉZANNE, *STILL LIFE WITH APPLES AND A POT OF PRIMROSES*, CA. 1890 ↗

PAUL CÉZANNE, *STILL LIFE WITH A GINGER JAR AND EGGPLANTS*, 1893–94 →

Still life was one of Cézanne's favorite genres. He was intrigued not only by the juxtaposition of shapes, patterns, and colors, but also by the challenge of depicting the arrangement of objects in space. The artist rarely painted flowering plants like the one in *Still Life with Apples and a Pot of Primroses* as they were susceptible to wilt before he finished working. More often he preferred hardier fare, such as apples or the purple eggplants in *Still Life with a Ginger Jar and Eggplants*.

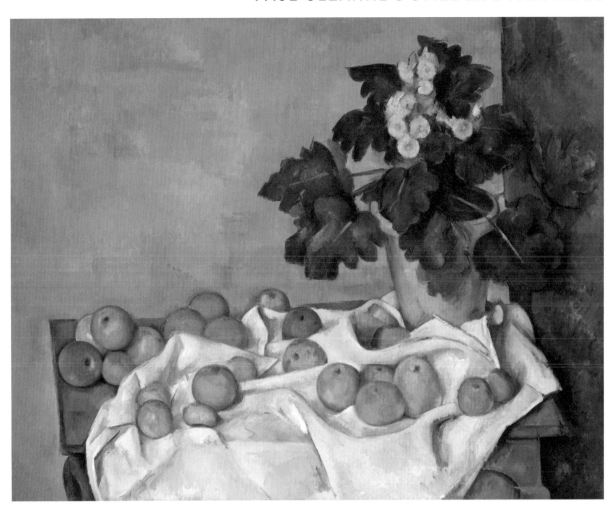

"Initially, I had no idea that these were gongs, and without that knowledge I was able to look at them as sculptures."

I started working in ethnographic collections in Chicago, when I was a research intern. It wasn't until my thirties that I started being able to revisit those collections and understand how much of an impact they had on the way that I think about definition, about form, and about abstraction.

I go to the Oceanic galleries every single time I visit The Met, and I have never researched the history of these objects. As a Native American, that is kind of shocking to me because we were taught that this was one of the worst things you could do; you were basically a colonizer if you approached something without knowing the full story. First of all, knowing the full story is an impossibility. Maybe, subconsciously, I'm resisting because there's a joy in this kind of childlike curiosity—that I can come here and get lost in my imagination.

I find the gongs playful and quirky. There's something figurative about them. I've always known that these were not made as art— they were made for a purpose and to be used in a very specific context. By removing them from their original context and putting them into another one, gaps in knowledge begin to occur, and those gaps can sometimes lead toward abstraction. Initially, I had no idea that these were gongs, and without that knowledge I was able to look at them as sculptures—all sides being equally important—and look for how the maker made decisions about form.

The eyes have these red pupils and there's something radiating from the center of them—something not human. We're only anthropomorphizing them because we easily recognize head, arms, and eyes. I always assumed that the part underneath what I read as the nose is the mouth, but actually the slit down the front of the gong is considered the mouth. I think that is amazing because it's the one part that doesn't resemble a mouth. Instead, it takes on the function of a mouth: when you play the gong, the ancestral voice comes out.

These objects aren't made quickly. The tree has to grow; the tree has to be hollowed out. There's the history of the deity and a ceremony the makers take part in. I'm drawn to objects that result from a commitment to a belief because they make me question what we are devoted to in our contemporary lives.

I wasn't raised with a religion, nor do I have a specific spiritual practice, but I'm always amazed when people make objects from a sense of faith. As a contemporary artist, I have struggled before with trying to figure out where we are going to go—what's going to provide a new trajectory to push it even further?

JEFFREY GIBSON, *PEOPLE LIKE US*, 2014 ←

TIN MWELEUN, SLIT GONG (ATINGTING KON), → MID- TO LATE 1960s

The towering slit gongs of northern Vanuatu are among the largest musical instruments in the world. In each village, a number of gongs, comprising a sort of informal orchestra, stand on the village dancing ground and accompany all major social and religious events, such as initiations, funerals, and dances. Each musician stands in front of his gong and strikes the lip of the slit with a clublike wooden beater. Rhythms of immense variety and complexity can be produced by the carefully coordinated actions of multiple drummers.

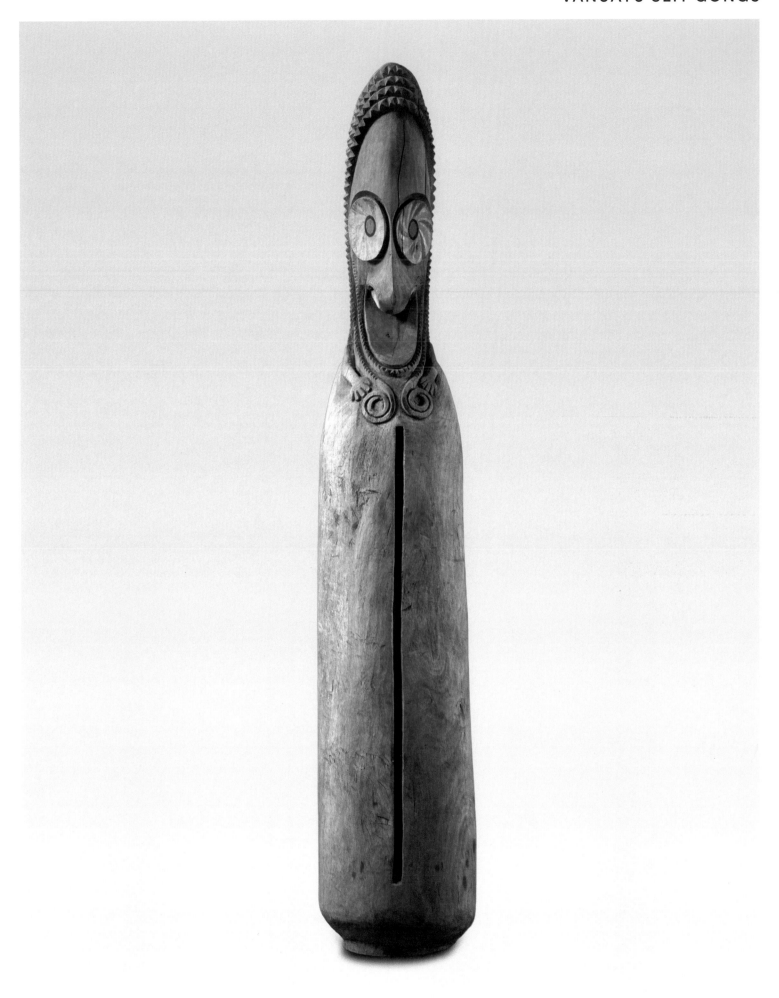

"It's a celebration of love, which for me is the highest thing art can do."

For years male photographers gave me a hard time, both because of my lack of technical ability and for my subject matter. I had issues with a lot of the philosophy of photography. I don't believe that there's such a thing as the Henri Cartier-Bresson "decisive moment." Every moment is decisive. It's the in-between moments when art can be the most interesting.

I never liked Julia Margaret Cameron because I thought of her as technically heavy, until I came to The Met and discovered her to be a kindred spirit. Her work was unprecedented in her time because the images are out of focus. She was using a big camera, and people had to sit still for extended periods of time, and as a result the very earliest pictures were out of focus. It was a mistake, but she decided she loved it and that she didn't want things to be sharp. That's been the history of my work, too: the best stuff is from mistakes.

Cameron shows the souls of people, especially in the photographs where their eyes are kind of floating. She photographed the same people over and over again, and you can see that these pictures couldn't have happened unless there was trust. She released the women from the frames at a time when women weren't allowed to show emotion—it was all very polite.

People made me aware that they considered my work political for gender politics, which hadn't occurred to me. I think the same of Cameron; her work can be seen as political because she was tracing a big change in Victorian women. She was celebrating the beauty but also, increasingly, the autonomy of women, which was new in that era.

She was very interested in mythology, and in some of these photographs, the women are playing roles of saints or famous characters like Sappho and the goddess of summer. *Pomona* is a picture of Alice Liddell, the same Alice that inspired *Alice in Wonderland*. The way she placed her hand on her waist, she's not just modeling as a beauty—she's tough. She's showing how autonomous she is and how strong she feels.

Cameron's favorite model was Julia Jackson, who was her niece and the mother of Virginia Woolf. Cameron made her into a Madonna. She's otherworldly, but she's also a woman who's very much present, looking right into the camera.

I don't know how many women have done such strong work depicting other women. I don't think a man could have taken these pictures. Cameron photographed the relationships between women. It's a celebration of love, which for me is the highest thing art can do.

There's no distinction between my work and my life, and I think that must have been true for her.

NAN GOLDIN, *AYLA AT MY APARTMENT*, BERLIN, 2015 ←

JULIA MARGARET CAMERON, *POMONA*, 1872 ↗

JULIA MARGARET CAMERON, *JULIA JACKSON*, 1867 →

One of the greatest portraitists in the history of photography, Cameron blended unorthodox technique, a deeply spiritual sensibility, and a Pre-Raphaelite-inflected aesthetic to create vivid portraits and to mirror the Victorian soul. When she received her first camera in 1863, Cameron was forty-eight, a mother of six, and a deeply religious, well-read, somewhat-eccentric friend of many notable Victorian artists, poets, and thinkers. Condemned by some contemporaries for sloppy craftsmanship, she purposely avoided the perfect resolution and minute detail that glass negatives permitted. Instead, she opted for carefully directed light, soft focus, and long exposures that allowed the sitter's slight movements to register in her pictures, instilling them with an uncommon sense of breath and life.

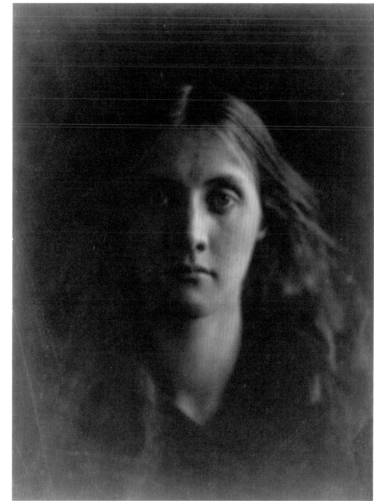

"It continues to evolve—another shape, another experiment. So there's a kind of life."

As an artist I merge the scholarly traditions of classical Chinese landscape and calligraphy with Western contemporary art. I was a student when Robert Motherwell's work came to China. It widened the perspective of what ink and rice paper can do. It's a kind of spontaneous expression.

I'm not sure how much Asian culture influenced Motherwell. When he created *Lyric Suite*, he must have had some imagination that was different than when he created the big canvases. It's kind of bleeding. This work is all about control: you have to control the color, tone, and water volume. Otherwise, it would be a total mess.

These works are not totally abstract like his oil paintings. There are some realistic gestures in them—the sky, the landscape. His simplicity is beautiful. He's not sophisticated in the traditional scholarly painting techniques. He used his own creativity and applied it to something raw and new. It's more playful. It continues to evolve—another shape, another experiment. So there's a kind of life.

A good scholarly painting is all about ink and speed and your inner motion control. In China, Buddhism has two chapters: one school is "by accident," the other school is accumulation, meaning you need to practice daily.

I think it's a contradiction, and the effect is that it is Asian material but with the Western idea. No culture can be precisely translated into another culture. It's not possible. Misunderstanding is creation. Two things can merge and become something else.

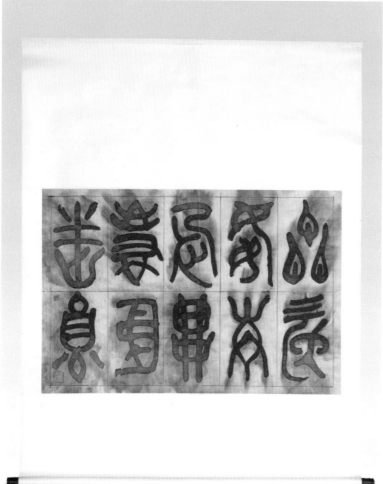

WENDA GU, *THE MYTHOS OF LOST DYNASTIES— FORM C: PSEUDO-SEAL SCRIPTURE IN CALLIGRAPHIC COPYBOOK FORMAT*, 1983–87 ←

ROBERT MOTHERWELL, *LYRIC SUITE*, 1965 →

Motherwell found inspiration in the ideas and methods of Zen painting, which he described as "unadulterated automatism." In the *Lyric Suite* series, Motherwell gave his unconscious free rein. He placed sheets of rice paper on the floor and used a combination of darting and slow, flowing motions to apply the ink. Chance effects appeared as the ink spread quickly through the loose fibers of the paper and swelled greatly. Motherwell's spontaneous gestures convey the exhilaration and sense of freedom he got from drawing, which was for him "perhaps the only medium as fast as the mind itself."

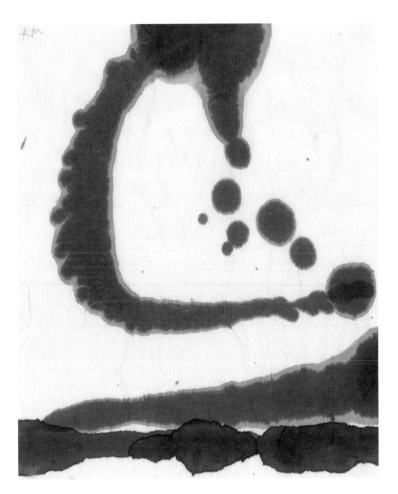

DIANA AL-HADID

"I'm interested in that line between something that's illusionistic and something that's literal."

I started making sculptures that were large enough that they stopped being objects and started becoming environments. I see these spaces as installations. They're actual rooms that were lived in. Villas like this one were on the outskirts of Naples and were kind of like the Hamptons—ancient Hamptons, I guess. You really see the opulence; the owner was a show-offy guy. This area was a bedroom and was meant for a single visitor. It's indulgent. And this was the first century BC—it's astounding.

Even though it's a flat wall, the perspective in the frescoes is exaggerated. You can sink deep into the space and go infinitely past these impressive, proud buildings into gardens. It's got narrative muscle; it's telling you exactly where you are and where you might go in this land beyond.

But then you can also pull yourself up to the surface and examine the trompe l'oeil details. Sometimes it looks like it's metal, and sometimes it looks like it's marble. The shadows cast from one particular angle related to an actual window in the room—it's very smart.

At first glance it feels wide and expansive, but then you snap back to the symmetry: the west and the east walls are mirrors of each other. There's a real sense of depth, but it also feels a little fictitious to me—those stacked buildings, for instance, don't look possible.

The viewer is confronted with the fact that this is still on a wall. I'm interested in that line between something that's illusionistic and something that's literal. There's reliance on and denial of the wall.

I can't look at these and divorce myself from the event that brought them to us: the eruption of Mount Vesuvius in 79 AD. Who doesn't love the story of Pompeii? It's one of the most unfortunate—but for history's sake, fortunate—events. It's kind of horrible to say, but it's a strange paradox: this complete destruction annihilated an entire region but at the same time preserved it.

You're reminded of this at every moment because there are long cracks, fissures on the surface, so the event is laminated into the image. You realize that this was made thousands of years ago. History feels impossibly long and hard to conceptualize, but as Pompeii shows us, history is actually a sudden, instant thing. This room connects that fuzzy boundary between something real and something imagined. It's a rare, clear glimpse into a historically charged moment.

DIANA AL-HADID, *GRADIVA'S FOURTH WALL*, 2011 ←

CUBICULUM (BEDROOM) FROM THE VILLA OF P. FANNIUS →
SYNISTOR AT BOSCOREALE, CA. 50–40 BC (WITH DETAIL)

In 79 AD, the eruption of Mount Vesuvius in southern Italy brought death and destruction to the Roman towns of Pompeii and Herculaneum, as well as to other sites around the Bay of Naples. One of those sites was a rural villa that contained this cubiculum, whose wall paintings were preserved by volcanic ash. They are richly painted with scenes of townscapes, sanctuaries, and idyllic landscapes of grottos and fountains, evoking a world of luxury, sophistication, and leisure.

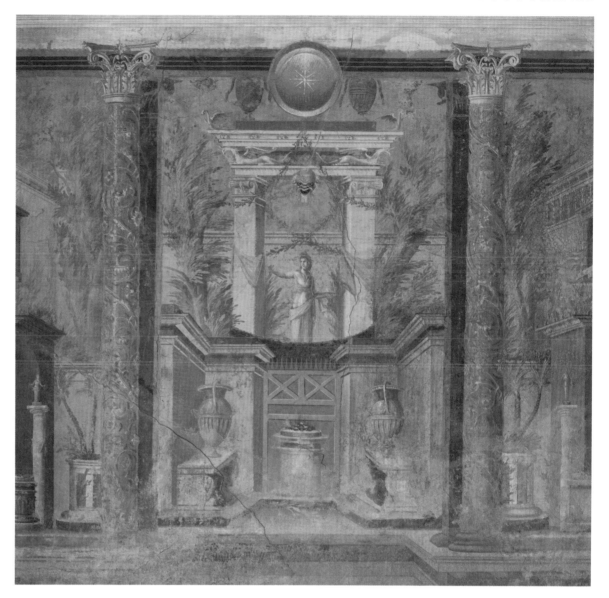

ANN HAMILTON

"For me, the act of making is also an act of finding something."

For me, the act of making is also an act of finding something, and you hope that you can set up the conditions to find what you need. The museum sets up the conditions for associative, meandering thinking. Different objects draw me in, and this is one that I've returned to again and again. This is a puppet, or marionette. It has all these traces of having been used: the fabric is stained, it's worn in places. It had a life in the world, but now it's completely removed from that life.

There's this whole "body empathy"—there's an address from the object to me as a viewer. We recognize the figure with the most minimal of information. The red hands—they're wooden and they don't have a lot of gesture in them, but they hold the possibility of becoming any gesture. And then there's the magic of the hands that actually manipulated it.

You have to imagine the marionette actually moving. Imagine the very rigid stoicism of the face or the head, which seems helmeted and regal. Then imagine this cloth and how it moves, and how this puppet could become something that just glides across or commands a presence in a story.

The modesty of it gives it more potential. It is made of the most ordinary materials: string, cloth that's falling apart, pigment, a little bit of wood and metal. Out of those common materials is this animate presence.

I would love to be able to make this, but I can't in my culture. This marionette connects me to a place and culture where the artist has a role of telling stories. It originally had a function in a world outside the museum, but many, many contemporary artworks assume the space of the museum, whether or not they ever get inside one. This is obviously an object that was made to be animated but is now mute, and it's now possible for me to animate it in another way.

How do you take the things that you love, that you are drawn to, and approach what they do? You have to go in through a side door. What is it that makes this alive? You could think about this as an object that's emblematic of the role of the artist. Maybe our task is to animate, much like a puppeteer. You can address things through a puppet that perhaps you can't approach face-to-face: contemporary politics and social issues, for example. Then you can bring that lens back to your own process.

ANN HAMILTON, *ABC*, 1994/1999 ←

MARIONETTE: MALE FIGURE (MEREKUN), → 19TH–20TH CENTURY

Along the Niger and Bani Rivers in the region of Ségou, the former capital of the Bamana kingdom, in Mali, the village youth association stages performances with brightly painted and costumed puppets. A small mobile stage is covered with cloths or grasses concealing the men inside, who move the stage across the dance area. Fitted in front with a wooden animal head with articulated jaws, the stage is itself a large puppet. Through the movements of the puppets and the songs that accompany them, the youth association comments on the social and political life of the community.

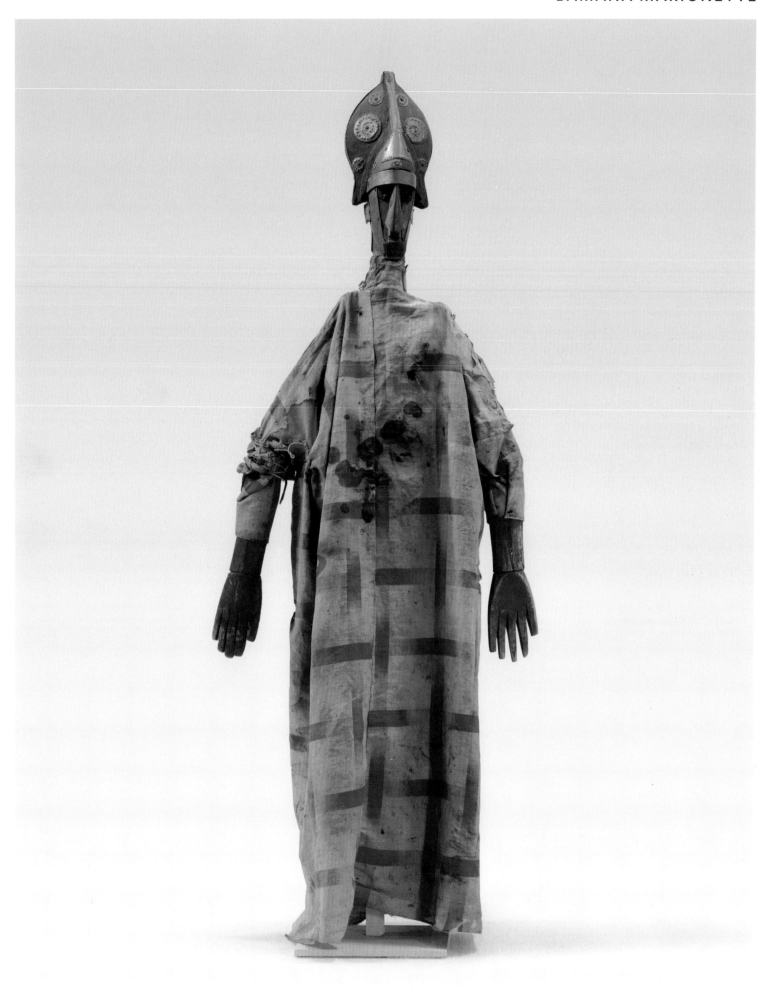

JANE HAMMOND

"I have a theory that photography is the poor man's taxidermy."

I have a very diverse practice of collecting found information and transforming it, so I've become a collector of snapshots. There's extreme particularity to each picture in Peter Cohen's collection of snapshots and vernacular photographs. We don't know the photographers, when they lived, or the reasons they took the pictures. One of the reasons why people pull out their cameras is to capture something ephemeral: a flight of locusts, a heavy snow. It's like, "I built this snowman. He'll never look better than he looks right now—let me get the camera."

I have a theory that photography is the poor man's taxidermy. In other words, a person might take a picture to show you the deer they shot. The photo becomes a kind of trophy. Or it might be that people are hyperaware that the photo is a record similar to reality TV. It's unscripted behavior, but it's behavior that wouldn't be happening if a camera weren't there.

The art of these photographs is somewhat in the eye of the beholder. The people who created these images are so unprofessional, there's something kind of moving about it. There are some really wonderful mistakes. Where the accident ends and the self-reflexivity we associate with modern art begins in this genre, one never knows.

We all are familiar with the Duchampian idea that you can take something that wasn't intended to be art, and you, the artist, with your big deal artistic intentions, can recontextualize it and call it art. We accept that. But what happens if no one calls it art, ever? What if they die and go to their grave, and they've never said, "This is art"?

This collection of photographs is stimulating creatively. I mine the images for specific things I want: I want this guy's boots, or I want this head in the sand. So there's a forensic quality to these snapshots. They're filled with information, with what I call the thinginess of things: curtains, cardboard, cornfields, agave plants. Here's the man wearing a hula skirt. I know exactly what it feels like to have that skirt on: it's our skirt. It's cultural shared information.

People are coming to have greater and greater regard for vernacular snapshots. I think it's this combination of the ubiquity of amateur photography—everyone's taking pictures—oddly coupled with the decline of analog photography and the fact that it is vanishing. The people that made these photographs weren't artists, and nobody inside the pictures—the subjects—thought they were part of a work of art either. We have no reason to think they imagined their images would end up at the Metropolitan Museum, but you can learn more about photography after you've looked at these pictures.

JANE HAMMOND, *UNTITLED (41,231,85,56,200,35)*, 1991 ←

243 AMATEUR SNAPSHOTS, 1900s–1970s →

Vernacular photographs in The Met's collection reveal the unexpected visions of anonymous amateurs. Cut loose from their original context but charged with the aesthetic spirit of their time, these fresh, accidental artworks were created as the camera emerged as a nearly ubiquitous, easy-to-use accessory of modern life. Although never intended for public display—most of the photographs in the collection were discovered at flea markets, in shoeboxes, or in family albums— these found images often bring to mind the work of such master photographers as Walker Evans, Man Ray, Henri Cartier-Bresson, and Diane Arbus.

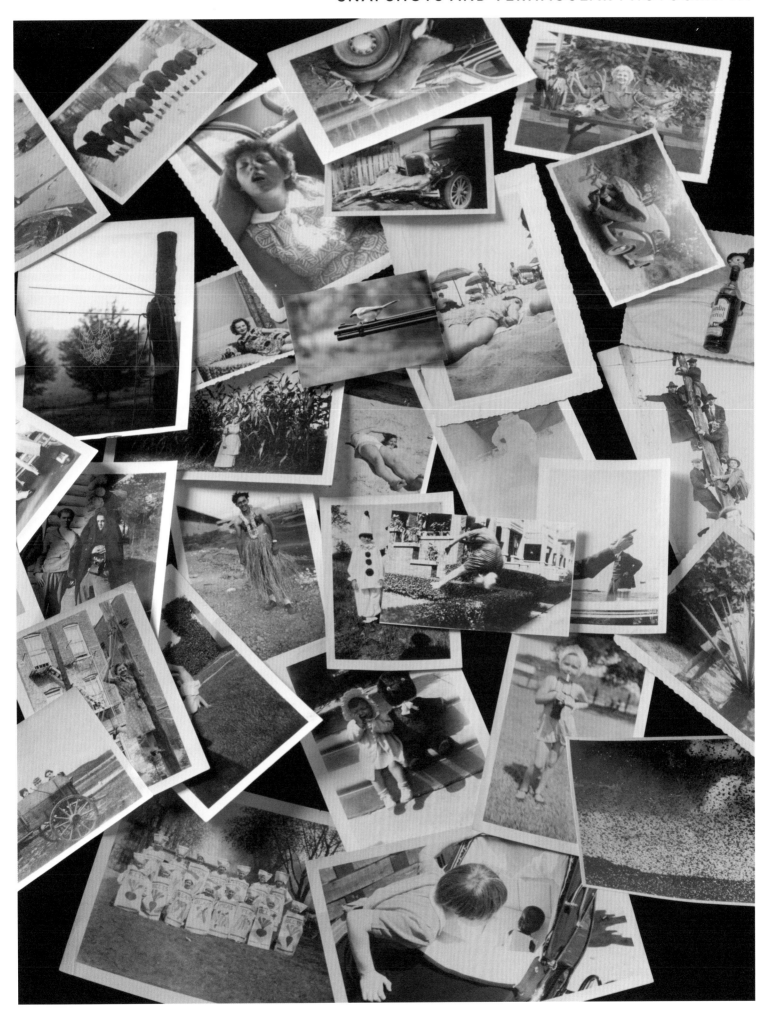

JACOB EL HANANI

"Books were made to last forever."

I was born in Morocco and moved to Israel when I was six-and-a-half years old. When I came to New York in the seventies, I took drawing to an extreme because I was curious to see how small it could get, and I worked twelve hours a day, sitting and making lines. I practically drew time. When I first saw this *Mishneh Torah*, I was amazed that the entire book was done by hand. I related to it because I could understand the time that was needed to write it, to make the images and to paint them. It was also familiar, since I grew up with this text.

The *Mishneh Torah* contains essays on every subject of Jewish life, from health to sex to God to food. Rabbis still consult it today. My family was not religious, but we went to synagogue and we read Hebrew. That was the power of the Haggadah, the Torah, and prayer: it was part of our activities. Turning pages two hundred times a day become part of the way we grew up. Repeating the prayers aloud, even when we knew them by heart, we were still supposed to look at the book so we could concentrate. You had to literally see the letters.

I was stunned by how everything in New York was fast: fast food and fast art; everything seemed instant and immediate. I didn't come from that background. Paper was expensive in Israel, a country that had few trees, and the American practice of colors and paint was not available for me. So, for me, making small drawings had to do with lack of means. But there was plenty of time. And some of my work took a tremendous amount of time.

Today they say the average person spends three seconds in front of a painting. The person who made this *Mishneh Torah* had to have spent a few years completing it. I relate to that. The painter who illustrated the book probably never traveled more than fifty miles from where he was born. There was no printing press at the time, so it makes sense that people devoted an entire lifetime to a book; books were made to last forever. It's a miracle that the paint and the colors and the gold are as clear as if the book had been done today.

JACOB EL HANANI, *TEHILIM*, 1978–81 ←

MASTER OF THE BARBO MISSAL, *MISHNEH TORAH*, CA. 1457 →

The *Mishneh Torah* is the magnum opus of renowned medieval philosopher Moses Maimonides. His remarkable text consolidates Jewish law into a systematic, comprehensive, and accessible anthology that is still consulted by rabbis and scholars today. This manuscript copy of the *Mishneh Torah* from northern Italy is one of the most sumptuous ever made. Large illuminations, attributed to Master of the Barbo Missal, illustrate aspects of the law and preface the different sections of the book. With no iconographic precedent to guide him, the painter looked to the world around him. Thus, the manuscript also provides an opulent guide to contemporary costume, buildings, and customs.

ZARINA HASHMI

"When you are separated from language, it's a great loss."

When I go to museums, I just walk around. I didn't know anything about this work, but it caught my eye because I'm into calligraphy. My work is very much connected to writing, to calligraphy, because I don't use color.

I didn't realize that somebody could carve like this. I researched it a little bit, to find out what it says. It comes from Bengal. It's not easy to carve this marble, but this is very finely carved. I think the top is totally decorative. The vertical lines, they're *alif*, the first letter of the Arabic alphabet, as well as the Farsi and Urdu alphabets. The significance of alif is that it's how you write *Allah*.

Muslim children, when they are four years and four days old, are taught to write Arabic, accompanied by a little ceremony. The first letter they learn to write is alif. There's a philosophy around the straight path that is part of a prayer that repeats the line, "God, show me the straight path." The prayer is the center of the Qur'an, and most people know it by heart.

At the bottom of the piece is an inscription from the Prophet Muhammad. But it's not Qur'anic. It says that Allah will give anybody who constructs a mosque a house in the heaven. It sounds very beautiful, and it's very beautifully written.

The text overlaps so it's hard to read. I can read *Muhammad* and I can read letters, but I can't read the whole sentence because I don't know Arabic, although I know the Arabic alphabet. The person who taught me the Qur'an didn't teach me the translation. I would memorize the prayers and I could pray, but I didn't know what I was saying.

I do read and write Urdu, which uses the same alphabet. I've lived outside India almost fifty years, but I have kept up with my language because of the cultural connection. When you are separated from language, it's a great loss. You don't have access to your own scriptures, your poetry, your literature.

That's why, emotionally, I'm attached to this. I didn't even have to know what it says. Instinctively, it touched something in me.

ZARINA HASHMI, *HOME IS A FOREIGN PLACE*, 1999 ←

DEDICATORY INSCRIPTION FROM A MOSQUE, →
PANEL, DATED AH 905 / AD 1500 (WITH DETAIL)

This dedicatory inscription in tughra script, dated AH 905 / AD 1500, is from a mosque in western Bengal built for Prince Daniyal, a son of Sultan Husayn Shah. The inscription is an outstanding example of Indo-Muslim epigraphy. The regular pattern in which the vertical letters are arranged and the skillfully inserted, bowlike words that structure the pattern are typical of Muslim calligraphy in medieval Bengal and later in the Deccan.

"It's...the kind of art you take home with you, metaphorically. You take it into your life; it becomes yours."

I've always been an artist, ever since I was able to walk, look, think, see, and touch. I don't consider it a profession; I consider it a way of living. I weave on a small frame that's about the size of my hands. I hand pick line by line with thread, and the work becomes almost like a text or calligraphy, or even like a prayer.

I was attracted to this book, which is about the size of my little loom, because I had never seen anything like it before. It's an Ethiopian prayer book. It's art as an extension of the body because you can hold it in your hands and possess it. At the same time, it enables the imagination to embark on a trip that's monumental because graphically it's so powerful. The pages could almost be architectural drawings for doors, windows, or temples.

Each little line is handwritten. It has a sense of solidity. It's not this thick-and-thin, sinuous calligraphy. The letters are all in bold. It almost seems carved, and turning a page is like going around a corner. Each page is different: a total surprise.

The pages are not in the realm of either figurative or abstract art—they encompass both. The priest with the upraised hands leads me to look at his abstract breastplate and halo. There is a humorous aspect to him—very friendly, approachable. It's not a horrific religious depiction—it's enticing. There is a folio in the book with an endearing little bird walking across the page. It makes me think that perhaps all the little symbols in the borders are just footprints of birds.

You can't walk past this little book and not stop. It has staying power. You don't just glance and glaze over it. You want to penetrate and go into it. It's so intimate, the kind of art you take home with you, metaphorically. You take it into your life; it becomes yours.

The book contains so many ideas. For me, it's just an immediate, strong way of thinking about line, of thinking about blocks, of thinking about texture, of thinking about composition. I don't have to go through the whole understanding of how it fits into art history.

I'm used to this because I've lived and worked in many places and cultures. I don't see myself as a tourist, I see myself as an infiltrator into other places, other times, other cultures. So I'm an infiltration artist. The art may be ethnographically very far from your world. So what? Just be brave and jump in, and relate to it, without worrying about which century it is. It becomes universal.

SHEILA HICKS, *ÉCAILLES*, 1976 ←

ATTRIBUTED TO BASELYOS, *PRAYER BOOK: ARGANONÄ* →
MARYAM (THE ORGAN OF MARY), LATE 17TH CENTURY

This prayer book is a Marian text arranged according to the days of the week. In such works, passages of visual elaboration serve to amplify the power of spoken prayers. The subject matter of the four illuminations that enhance this 148-page manuscript from Ethiopia range from the introductory image of the author Abba Giyorgis in an attitude of prayer to purely graphic interludes of geometric ornament.

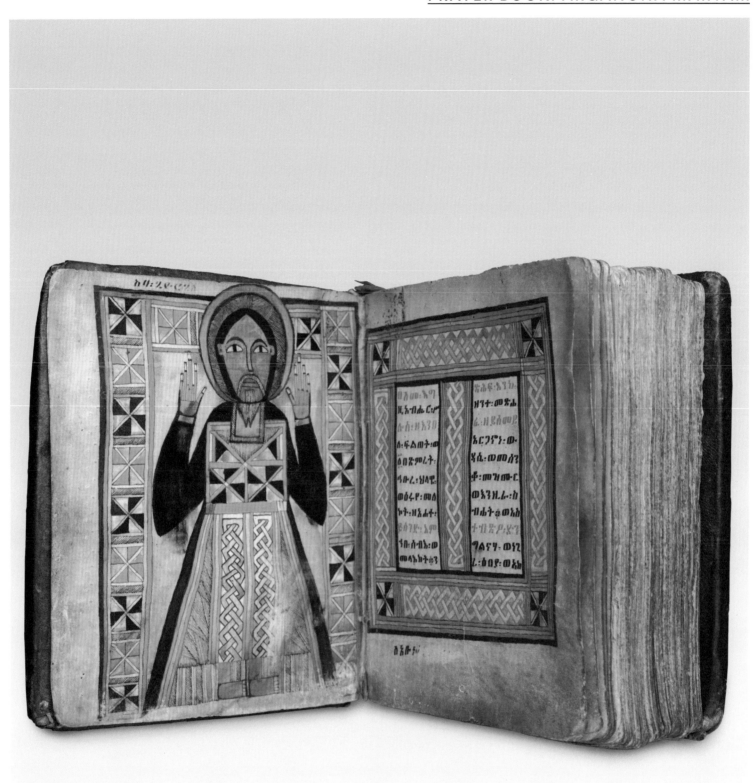

RASHID **JOHNSON**

> ## "Frank allows us to see just a few things, and the narratives that we're able to build as a result are what make his work so important."

I was introduced to the work of artist and photographer Robert Frank at a very early stage in my career. At that time I didn't understand much about candid photography. I remember looking at the photographs he made for a book called *The Americans* and thinking about the narrative they started to build for me. It's interesting: he was a German Jew, born in Switzerland, and basically a nomad; yet he still noticed what was happening in the United States in 1955 and used it as a point of emphasis for his photography in this book, which is essentially an attempt to tell an American story.

Frank's photograph *Trolley–New Orleans*, shows a segregated trolley that goes from white to this dark space. Rarely do you see a photograph with this ability to frame itself in and out so many times. The single photograph becomes five or six photographs, which requires a true vision on the part of the artist to see in a strategic sense. If you're questioning whether the eye of the photographer is in any way substantial, a photograph like this tells that story clearly.

In another photograph, *Parade, Hoboken, New Jersey* (1955–56), he puts focus on the flag, an object of national pride. It must have been strange the way that the image of the flag functioned in people's everyday lives. In this photograph they're kind of being drowned by the flag. The American people are taking a backseat to the monolithic idea of America. We are all subject to this national identity.

There's an economy of moves, where Frank allows us to see just a few things, and the narratives that we're able to build as a result are what make his work so important. When you think about the approach that we have in photography today, it's incredibly different. There was a rawness in knowing that your only opportunity was in that thirtieth of a second. That is something that's, in some ways, missing today.

Images tell a certain truth, and if we don't continue to make ourselves aware of what we've had to negotiate in the past, we're bound to repeat it. Bodies of work like this help us understand the past and the decisions that we make going forward.

RASHID JOHNSON, *THE NEW NEGRO ESCAPIST SOCIAL AND ATHLETIC CLUB (MARCUS)*, 2010 ←

ROBERT FRANK, *TROLLEY–NEW ORLEANS*, 1955 →

During 1955 and 1956, Frank traveled the United States, from New York to California, taking the photographs that would eventually constitute his landmark book, *The Americans* (1958). The journey dramatically altered the photographer's impression of the United States. Rather than the freedom and tolerance imagined by postwar Europeans, Frank found alienation and racial prejudice simmering beneath the seemingly happy surface of the Eisenhower era. Frank's disillusionment is poignantly embodied in this elegiac view of somber passengers riding a streetcar in New Orleans.

Y. Z. KAMI

"In front of a human face you always have an emotional reaction."

I paint mostly portraits. My mother was a portrait painter in Iran, where I come from, and I grew up painting portraits. I remember very well my first encounter with Fayum portraits. They were not like anything that I had seen. What struck me as a young painter was the eyes that were so exaggerated, so large, but at the same time so real and convincing. They're soulful, as if they're giving us information about another dimension.

Altogether, there must be around seven to eight hundred Fayum portraits in different parts of the world, and we know nothing about their painters. The only thing we know is that this technique and style were used in a region in Egypt called Fayum, which is an oasis on the west side of the Nile.

When you encounter the portraits for the first time, you think they are post-Renaissance, but they were painted two thousand years ago, in the first century. The aesthetic comes from Greek and Roman tradition—classical art—but the function is Egyptian: they were painted to be put on top of the mummies of the deceased. An artist was commissioned to paint the portrait, which was then hung in the home of the subject. When the person died, the portrait was cut to accommodate the mummy. As a result, they all have this narrow, odd shape.

They are painted with encaustic, which is a mixture of wax and pigment that you have to heat in order to use. These were made for eternity: that's why they're painted with encaustic. Everything is still preserved after two thousand years.

Each tells the story of one human being. They're not generic. The transparent white that they use is the same and the backgrounds are all painted in a light grey—but the palette of the faces doesn't have a formula. Each is individualized. For example, one portrait is of a boy with an injured eye (his little mustache shows that he's an adolescent), and another is of a woman with her blue mantle—they are both so real.

In front of a human face you always have an emotional reaction. Fayums are as immediate to us as an actual photograph. People relate to these paintings. Maybe this is a cliché to say, but a true work of art that comes from depth does not have a cultural boundary. It's timeless.

Y. Z. KAMI, *MAN WITH VIOLET EYES*, 2013–14 ←

PANEL PAINTING OF A WOMAN IN A BLUE MANTLE, AD 54–68 →

This work belongs to the first generation of painted panel portraits. The young woman is depicted frankly in direct white light, her tiny, elaborate curls and light-blue mantle striking a somewhat discordant note with her somber eyes and large, strong face. The texture of the encaustic medium, worked with brushes and tools, reveals the artist's careful shaping of the curves and dimensionality of the face. The sitter's hairstyle and other features of the painting date the panel to the mid-first century AD.

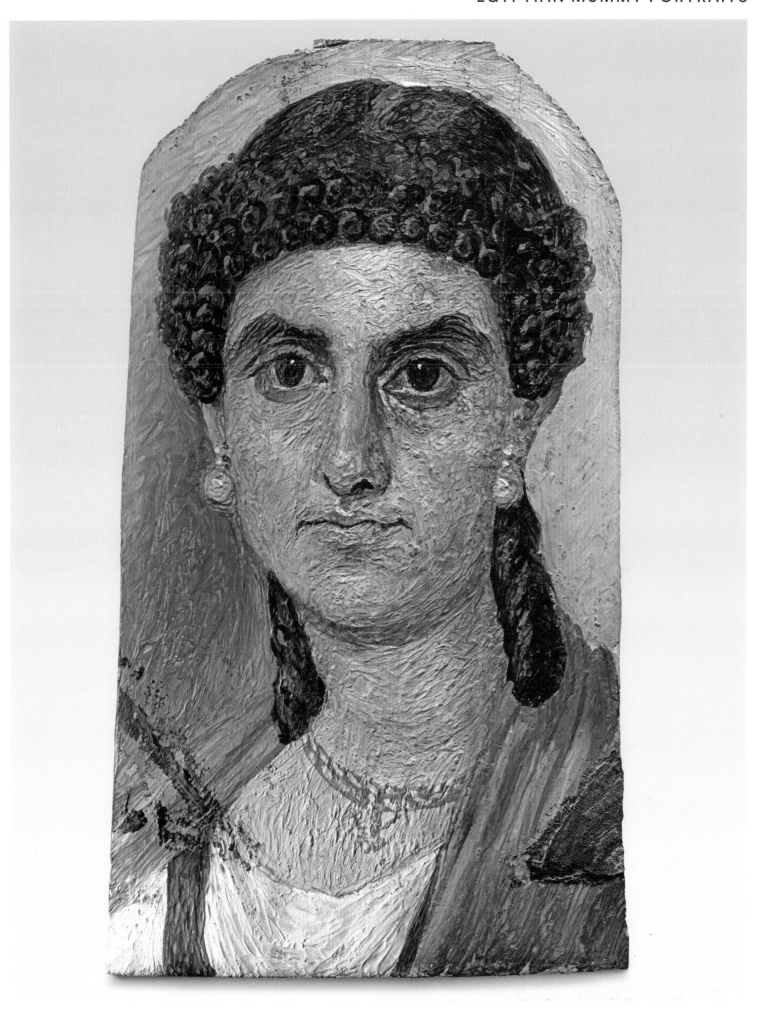

DEBORAH **KASS**

"I'm looking at comics of another age that I can't decipher anymore."

I think everybody who's an artist was probably one of those kids who drew all the time, so it's not a surprise that I love these pre-Christian pots. I love the style of this drawing. I can't get myself out of the vase room. The drawing on them is so stylish. I am completely entranced by Greek pots.

I think the way to navigate a Greek-vase gallery is to think about cartoons and comics. That's how I think about them: I'm looking at comics of another age that I can't decipher anymore. In a thousand years, for example, I'm sure no one will be able to decipher *Peanuts*. So I feel like I'm looking at a *Peanuts* cartoon from 500 BCE. If you were living in Greece during this time, you knew exactly the stories you were reading. You knew what these people and gods were doing and who they were.

I'm not completely uninformed about these images. This guy's a satyr. They are the party monsters—they're bringing the wine, they're bringing the music, they're bringing the girls or the boys.

Imagine lying around in togas, drinking wine out of this, during an orgy, before Christianity, before all that morality kicked in.

Obviously, there was a different aesthetic then, if small penises were in style. And why aren't small penises in style anymore? This was considered beautiful then.

I always thought I was a pagan because I believed the idea of one god was kind of silly, when you could have so many more, and so many of them could be female.

You know what? My attraction could be from a past life. I think I was around at the time these vases were made. But chances are I was a potter, not one of the people drinking the wine!

This was another time: one of pleasure and intellectual excitement.

If you're a visual person, you can go through life diving in and looking voraciously around at the world. That's what you do—wander about and enjoy the feast. This vase is about sensuality, and that's the power of it.

DEBORAH KASS, *DOUBLE RED YENTL, SPLIT (MY ELVIS)*, 1993 ←

SIGNED BY HIERON AS POTTER, ATTRIBUTED TO MAKRON, →
TERRACOTTA KYLIX (DRINKING CUP), CA. 480 BC

The symposium (drinking party) was a major social institution in ancient Athens, and this cup is one of the finest, most informative early representations. Only citizens—men—could participate. The women here are for their pleasure, and the boy under one handle is a servant. The paraphernalia include a wreathed column-krater containing wine mixed with water and a lamp stand with a ladle and strainer. The satyr and maenad on the interior are followers of the wine god, Dionysos, and are mythological counterparts to the Athenian symposiasts.

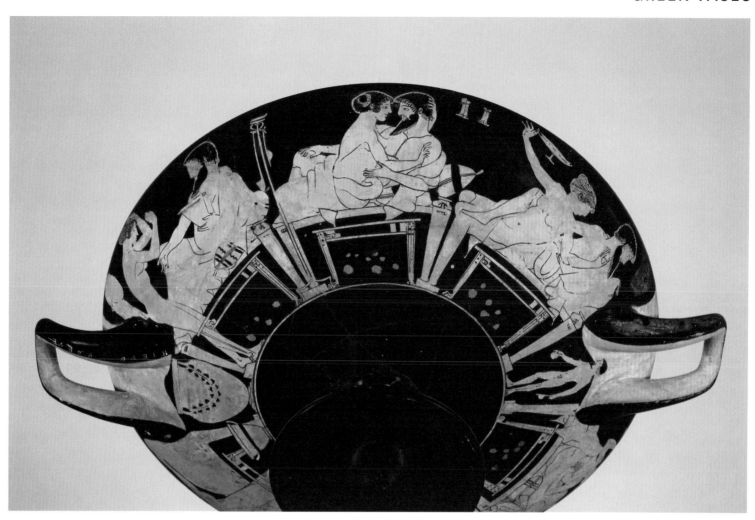

NINA **KATCHADOURIAN**

"They have become like friends I want to visit."

I'm a very twenty-first-century kind of artist/maker. I have never in my life made a painting, but whenever I visit The Met, I always head for these paintings. They have become like friends I want to visit.

In this portrait pair by the painter Hans Memling, the woman seems to be the one in control of the situation, which historically is probably quite false because her husband is older—quite a lot older—than her. He appears to be in his forties; she is fourteen? That's interesting already—and a little alarming for our contemporary sensibilities. But the arch of her eyebrows, the slight skepticism—she looks like someone who knows what she thinks.

I imagine their dialogue, what their interaction would be. How happy were they to be together? I'm aware that my readings of these may also be inflected by my contemporary headspace. I'm really responding, in some ways, recklessly and irresponsibly, which I actually think is okay.

A lot of my subject matter is based on the mundane, everyday stuff that surrounds us. I look to the most unspectacular things as starting points for my work.

I love the austerity of these paintings. They are so high contrast and bold. There's a lot packed in. But there's a kind of low, humming tension around it. You're watching someone alone—the body positioning, the facial expression, the solemnity, the calm. Maybe this connects to my own questions about how little you can harness in order to have the biggest impact.

This may be a strange way to try to connect my practice to that of someone like Memling, but I do try to be an acute observer of all that surrounds me. I see that as the job: pay attention to things in the world, and then try to show people, who are looking at your work, what you have been paying attention to and what you want to show them.

NINA KATCHADOURIAN, *LAVATORY SELF-PORTRAIT IN THE FLEMISH STYLE #4*, 2011. FROM THE PROJECT *SEAT ASSIGNMENT*, 2010–ONGOING ←

HANS MEMLING, *TOMMASO DI FOLCO PORTINARI (1428–1501); MARIA PORTINARI (MARIA MADDALENA BARONCELLI, BORN 1456)*, CA. 1470 →

The clever balance of verisimilitude and idealization in the features of this pair demonstrates the obvious skill that made Memling the most sought-after portraitist of his day. The Florentine Tommaso Portinari was the branch manager of the Medici bank in Bruges and probably commissioned these portraits upon the couple's marriage in 1470. They originally formed a triptych with a central devotional image of the Virgin and Child. Beyond demonstrating the couple's piety, Maria's elaborate necklace and gown display their wealth and social status.

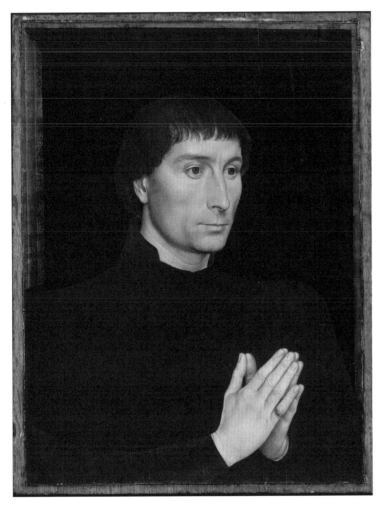
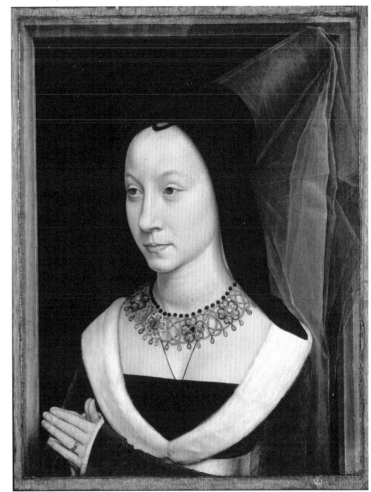

"He didn't have an art-making policy. It's very romantic, following something intuitive."

There are a lot of rules in painting that tell you what you can and can't do. I'm a colorist and a figurative painter. When I first showed a painting in 1954, an older painter came over to me and said, "Figuration is obsolete, and color is French." People expected a narrative out of figurative art. The work had to be about human- ism or the concept of the "lonely American." All that stuff just seemed very corny to me. I knew what I wanted to do, and it wasn't that. Narrative takes place in time, and I'm trying to get into the immediate present. That's why I always liked abstract painting a lot. My grammar is abstract—it's not illusionistic—and it comes from looking at abstract paintings.

I always liked Franz Kline. Of all of the Abstract Expressionist guys, he's the one that I like the best. I just relate to him. He took more risks emotionally than the other ones, and he had quick light. His paintings come off the wall really fast—I wanted that kind of speed.

I don't know if *Black, White, and Gray* is the best work he ever did, but I always liked this painting a lot because of the risk of its becoming an atmospheric painting. Particularly at that time, you weren't supposed to do atmospheric painting—you were supposed to paint Concrete. Modern art, communism, fascism, and the Ten Commandments—they all make dogmas. They're all the same. Everything's fixed.

When Kline first started out, his paintings were graphic, and by the midfifties, when he got into big, expansive painting— painting with his whole arm—he went to another place. He had a fairly good image to start with on paper. And when you blow things up, if they're literal they're usually a little stiff, but he opened them up and let them breathe.

Franz Kline is more like Frank O'Hara than Clyfford Still. The painting is very gestural and calligraphic. There are only so many strokes, and there is real substance to the work. If you look at it up close, it's really physical. But you also get it from a distance: it's a real powerhouse painting, very muscular but very refined. The edges are like Édouard Manet's—elegant, fancy brushwork, almost foppish. He's essentially a bohemian painter. He didn't have an art-making policy. It's very romantic, following something intuitive.

The fixed-value system doesn't seem to work well now. We live in an age with more variables. Kline's work was not absolute. In one sense it was, with the black and white, but when he moved toward this atmospheric direction, he extended himself from the flat plane. It seems like an emotional gesture. He was out of the absolutes into another place.

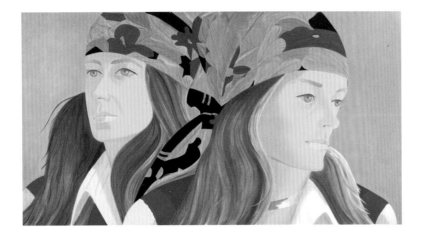

ALEX KATZ, *FACE OF A POET*, 1972 ←

FRANZ KLINE, *BLACK, WHITE, AND GRAY*, 1959 →

Kline, whose short and brilliant career was almost entirely contained within the decade of the 1950s, was noted for his powerful use of black and white, continuing and developing a theme already begun by Willem de Kooning, Jackson Pollock, and Robert Motherwell in the late forties. Kline's dynamic and seemingly recklessly balanced black-and-white canvases also owed something to sources in earlier landscape paintings, such as Marsden Hartley's Maine logjams and cataracts, and—despite the artist's denials—Japanese Zen calligraphy.

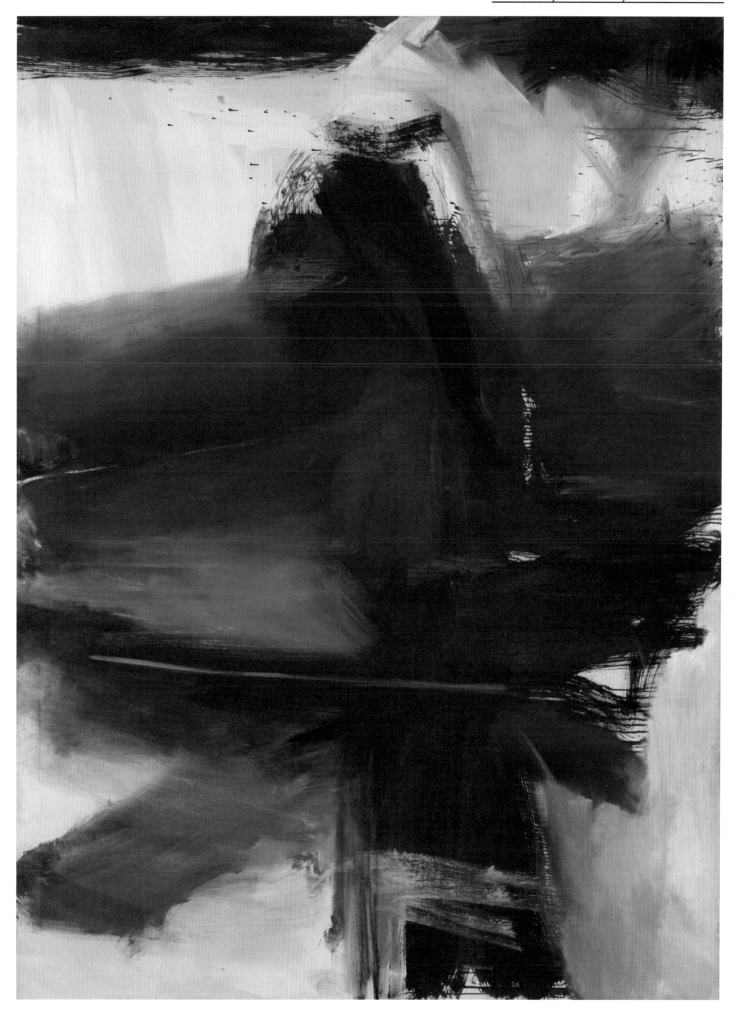

"Desire and beauty are very important within art to make the body sensual."

I love the ancient Roman time period when people were creating things that competed with nature and that were above Man himself. In the Roman Sculpture Court at The Met, a sense of the eternal is conveyed both through the biological and through ideas. A lot of the sculptures are Roman copies of Greek originals, and you can feel the dedication that the Romans had to preserving all of the power within the original Greek pieces from third century BC. At the same time, there was always the desire to create a new form, a new material realization.

Through the senses you develop ideas, and so you go from the richness of physical biology to the abstraction of pure ideas. Every intention was realized with just the movement of the flesh, a detail of the eye, the length of a toe, the shaping of a breast, or the way the hair moves. All of these different characteristics, from one statue to another, inform you of who they were—whether it's Hercules or Aphrodite. All of this information was placed within the work of art.

The little details in Roman sculpture can be so awakening. The bodies are vehicles for a dialogue about life, about fertility, about procreation. Desire and beauty are very important within art to make the body sensual. Yet when I look at the statue of the Three Graces, I don't feel that it is necessarily about desire or dominance. Maybe it's because there are three of them. The work is more about one's place within the community.

The Roman sculptures represent, to me, the most vital information we need as human beings to live our lives to the fullest. Humans become larger than life in these sculptures. The gods depicted embody big ideas, and you can feel within your own body what it's like to be Hercules when you look at them. I love that drive and fantasy to be everything that we can be as individuals and as a society. It's so stimulating, and it enlarges the parameters of what our lives can be. I want my life to be as vast as their perception of what life could be.

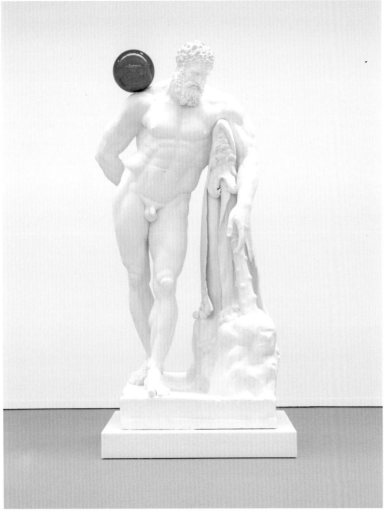

JEFF KOONS, *GAZING BALL (FARNESE HERCULES)*, 2013　　←

MARBLE STATUE OF A YOUTHFUL HERCULES, AD 69–96　　↗

This larger-than-life-sized statue was likely made as one of a pair with an older, bearded Hercules, also at The Met. Both probably decorated one of the large rooms of a Roman public bath, or perhaps even the imperial baths located near the Pantheon, which were originally constructed under the emperor Nero in 62 AD. The two statues are part of a collection of antiquities formed in Rome during the early seventeenth century when it was customary to restore missing portions of ancient sculpture. Despite its heavily restored condition, this heroic statue dramatically conveys the size and power of the Roman Empire at its height.

MARBLE STATUE GROUP OF THE THREE GRACES,　　→
2ND CENTURY AD

The Three Graces—Aglaia (Beauty), Euphrosyne (Mirth), and Thalia (Abundance)—were worshipped as minor deities in the Hellenistic world, becoming the subject of many works of art. In Roman times, sculptures such as this, which copied a Greek work of the second century BC, were very popular. Similar representations of the Three Graces are found on Roman mosaics, sarcophogi, personal items such as bronze mirrors, and even coins.

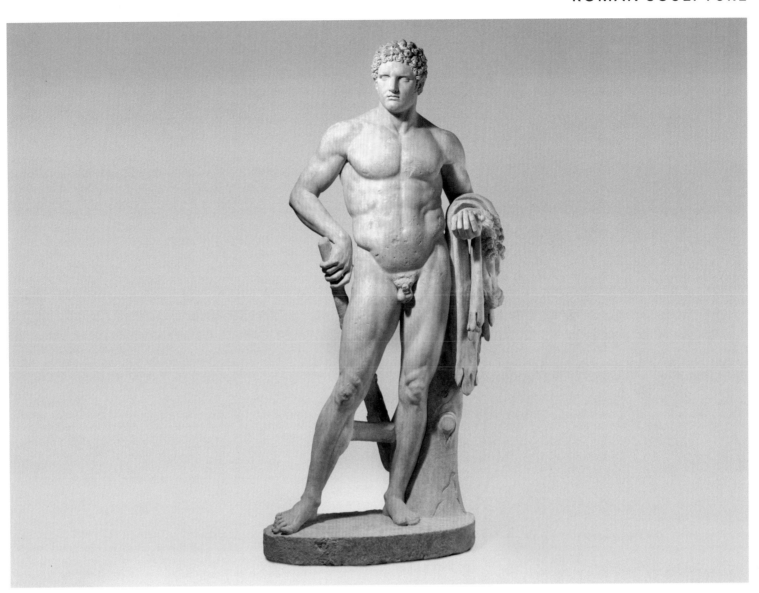

AN-MY LÊ

Cuisine is certainly not one of Eugène Atget's masterpieces, but I chose it because it resonates deeply with me in terms of my formative experience. The photograph is supposed to show Atget's kitchen, but it's actually a working area—there's no stove. This is where meals are prepared. Atget's work is so interesting because it's about the art of seeing. He's very connected to the description of the objects, the light, and the space, but at the same time he's able to suggest a sense of mystery.

I grew up in Vietnam, but we moved to Paris in 1968 during the middle of the war. Being in Paris was an incredible respite for me. I actually have a weird connection to the abundance of food in the image. I remember during war that was the first thing you thought of—is there enough food? It seems that this photo was not taken during the wars because of all the bread. I imagine the bags are filled with what we call *viennoiserie*—croissants, *pains au chocolat*—all of the goodies that you can find on Sunday morning.

Atget knew exactly where to place his camera—slightly above, so that you can see everything—but you never feel the heaviness of the camera. It's such a light touch, which infuses the picture with a certain poetry and intimacy. There's humility to the way he approaches everything, and that infuses the human condition into the work.

When you live in exile, you have memories of your culture that are very much tied to food. It's the sense of smell, the sense of touch; you're tied to love, you're tied to sustenance. There's a sense of care that goes into the preparation of a meal. There's a ritual that is important to me.

When we lived in France, I was experiencing French culture outside, at school, with my friends. Then I would come home, and my grandmother was there listening to Vietnamese music, smoking, and trying to re-create Vietnamese dishes in our small apartment in Paris.

Cuisine resonates with me in so many ways, and it's not necessarily comfortable. It brings up complicated feelings. It begs for a narrative that is beyond the edges of the frame.

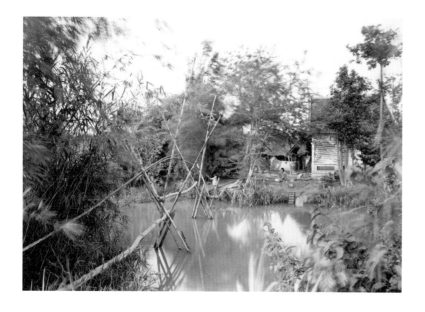

AN-MY LÊ, *DONG THAP, SOUTHERN VIETNAM*, 1994 ←

EUGÈNE ATGET, *CUISINE*, CA. 1910 →

Atget became obsessed with making what he modestly called "documents" of Paris and its environs, and with compiling a visual compendium of the architecture, landscape, and artifacts that distinguish French culture and its history. Except for a brief attempt to capture life in the streets early in his career, Atget rarely photographed people. He preferred the streets as well as the gardens, courtyards, and other areas—like this kitchen—that constituted the cultural stage.

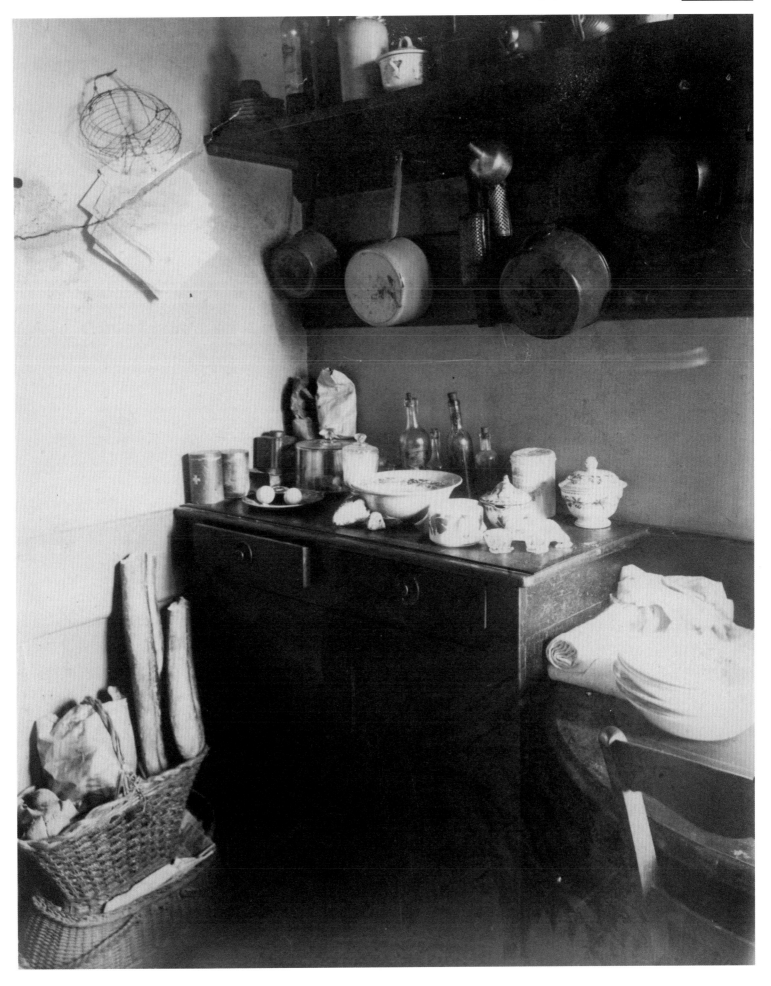

IL LEE

"I know that everybody loves the Rembrandt works, but to me, as an artist, my favorite part of the paintings is the background."

My fellow artists call me the "ballpoint-pen artist." I arrived in New York in 1977, and the next day I came to The Met. It was the first time in my life I saw those masterpieces. In the museum we see thousands of different people in paintings. However, the gallery with Rembrandt's paintings is very special. There is a much more personal relationship between the work and the viewer.

I know that everybody loves the Rembrandt works, but to me, as an artist, my favorite part of the paintings is the background. I love the quiet, clean, dark, open spaces, which allow me to reflect. There is a subtle sensibility, which evokes the way traditional Asian landscape paintings depict darkened forests with foggy streams set in dim mountains.

The backgrounds look like simple, dark spaces, but to create such a space requires a lot of mixing of different dark colors to achieve the perfect tone. Repetitive brushstrokes create layers and depth, and evoke deep, somber feelings and silence.

It reminds me of my paintings and drawings. For over twenty years, I have used only black ink. I overlay countless ballpoint pen lines to create depth and movement with repetitive gestures.

Rembrandt used dark colors to emphasize the bright face, hands, and ruffs. It's almost like a light is coming from within the figure itself. In this way, the painting gives a religious feeling. The simple composition of the picture, the somber mood of the figure, the bright face, even the black frame create the atmosphere of a shrine.

There is a connection, a personal connection that I bring to the painting or that the painting is able to stir inside of me.

IL LEE, *UNTITLED 303*, 2003 ←

REMBRANDT (REMBRANDT VAN RIJN), *PORTRAIT OF A YOUNG WOMAN WITH A FAN*, 1633 →

Rembrandt's early experience as a painter of dramatic history scenes and his close study of physiognomy and character prepared him to be the most original and successful portraitist in Amsterdam, where he arrived in the winter of 1631–32. This animated portrait has an accompanying work showing the sitter's husband rising from a chair. When seen together, the husband and wife seem to respond to each other, making these among Rembrandt's most inventive compositions of the early 1630s.

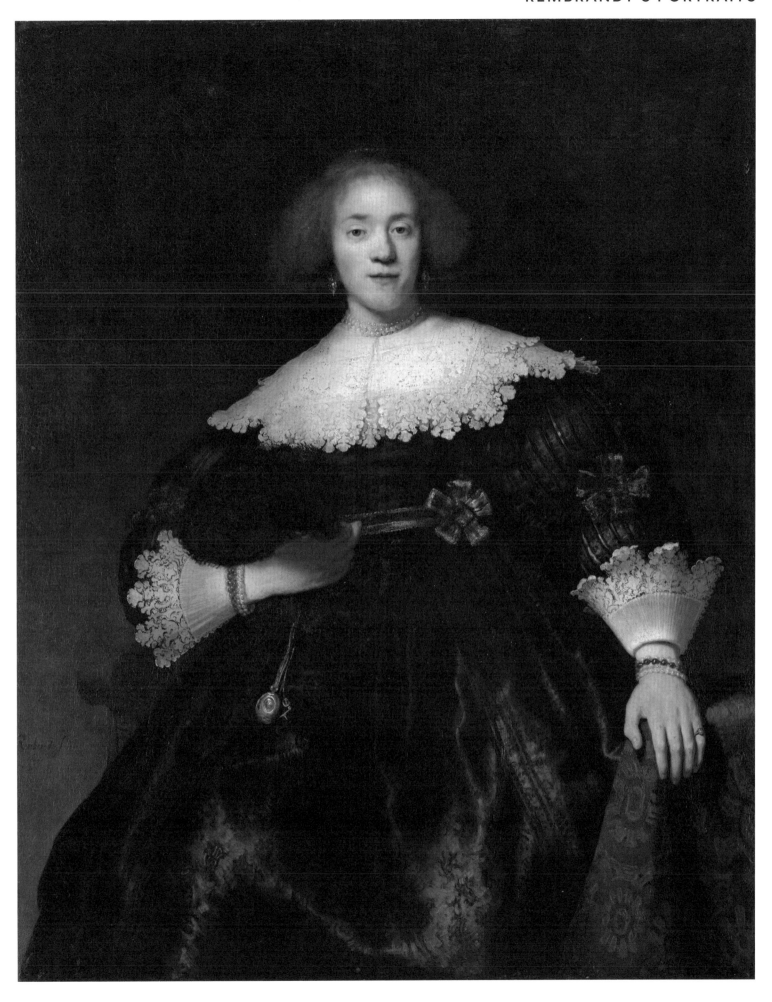

"You put on a different robe to change your skin and become a different person."

I was a weaver for many years before becoming a conceptual artist. Clothing—especially these magnificent Chinese ceremonial robes—is a signifier, almost like a second skin. You put on a different robe to change your skin and become a different person. It's like being a chameleon.

These two robes were used for imperial purposes. The symbolisms are very strict: you cannot wear anything that is above or even below your rank. The bluish, yellow-golden one, Woman's Ceremonial Robe (the Bat Medallion Robe), has a lot of flying bats on it, and Westerners might wonder, why bats? The reason is linguistic: *bats* in Mandarin has exactly the same pronunciation as *fortune* or *good fortune*. And here they are circling around this character *shòu*, which means "longevity," suggesting that the wearer is going to live forever.

The other robe is for the emperor, the Son of Heaven. It has a dragon, which is an even higher rank than the bat; the robe is for the emperor's use only. It also has these highly stylized waves, clouds, and fire. All the symbols are natural elements that have a mystical aspect to them, just like the person wearing the robe.

These robes were designed in such a way that they make you look bigger. Most of the people at that time were quite small, so these are designed not to show your body but to hide it, so you look magnificent when you walk into the hall.

Looking at these robes, it's quite impressive that in three to four hundred years, nothing has really changed that much. What I'm wearing right now is really their direct descendant. Even though not many people wear this type of robe anymore, when I'm in the West, it's what I wear because a different part of me comes out, and I like that. My body moves in a different way because the fabric catches the air; I have to walk in a stately way. It creates a character for the audience. I like that glance of admiration from someone from a different culture looking at my heritage. The message is very powerful: "You're my subject," says the emperor.

LEE MINGWEI, *SONIC BLOSSOM*, 2013–15 ←

VELVET TEXTILE FOR A DRAGON ROBE, 17TH CENTURY ↗

This rare piece illustrates the early stage of the design of dragon robes during the Qing dynasty. The size of the dragon in comparison to that of the robe, as well as its power and ferociousness, continues the design style of the Ming dynasty (1368–1644).

WOMAN'S CEREMONIAL ROBE (THE BAT MEDALLION ROBE), →
FIRST HALF OF THE 18TH CENTURY

Known as the Bat Medallion Robe, this renowned garment is a classic example of the elegant and exquisitely embroidered court robes from early-eigteenth-century China. *Bat (fu* in Chinese) is a homophone for "good fortune." On this robe, each medallion consists of five interlaced bats, symbolizing the five blessings of Chinese tradition.

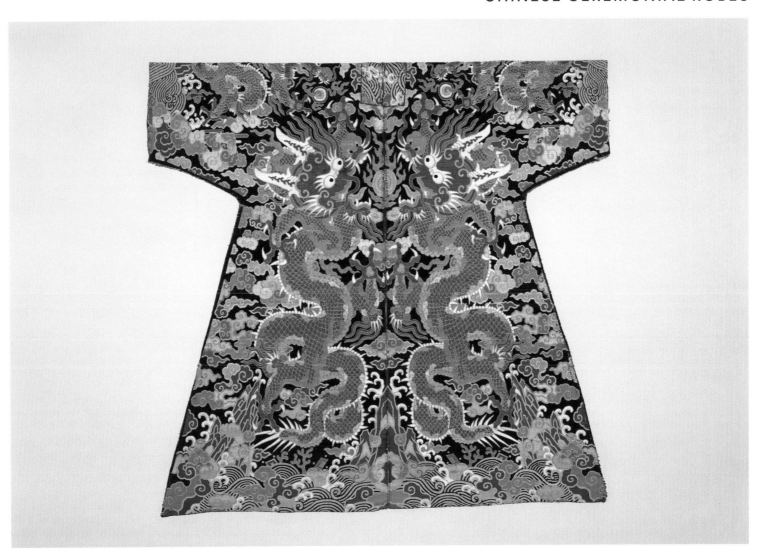

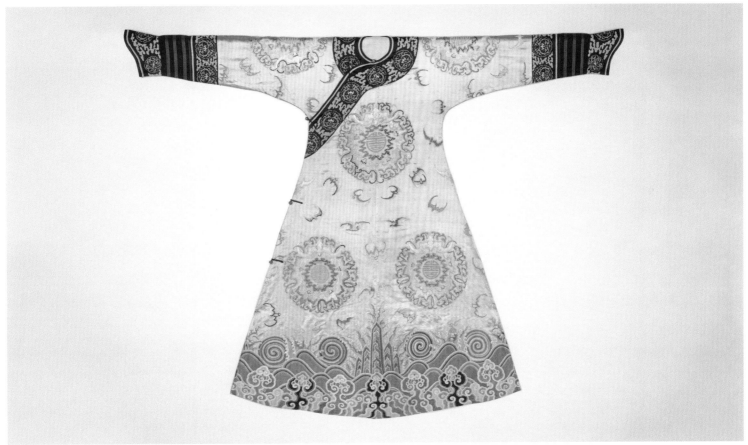

"The imbalanced imperfection is what allows you to see things in an unlimited and real-life way."

We don't know much about who created this moon jar in eighteenth-century Korea, as there isn't much data on it. But I chose it because there's an almost magical sense to it. The shape is not absolutely symmetrical—it's not completely round and it's not completely oval. Even the color is a little bit off: they call it white, but it's really almost an off-white, and there are tinges of earth and orange and blue. It's virtually indescribable. Did the artist do this on purpose? We don't really know. Maybe the heat created the little imperfections, and the artist was okay with it.

When you look at eighteenth-century Chinese pottery, it's almost too perfect. It's practically unreal in its perfection. Japanese artists tried to create perfection, too, but the Japanese also tried to show a humanness as well. Korean pottery is situated in between the two of them, and I think this vase represents that relationship. It doesn't try to reach perfection—instead, it's trying to achieve imperfection. It reflects life itself: your life is changeable; your life is imperfect. That's how people living in the Korean peninsula looked at life. This permits you to be more open and free. It allows for your own imperfection.

There's a Japanese word, 空気を読む, which means "reading the air." It means you have to be able to sense the atmosphere, sense the vibration of everything around you. That shows up in the way the artist was able to present the color and shape of this vase. He was trying to create a vibration through the imperfection. Even in my art, I use simple strokes, but I don't try to have that one stroke become the piece. I want the sense of that stroke to work together with the rest of the canvas, the space within the canvas, and the vibration of the whole piece. I think this artist is trying to do that also.

This vase, to me, is very feminine; it almost has an eroticism to it. It evokes a softness. In European art, there is Venus. I think this piece gives off that vibe of the voluptuousness of a woman.

People often look down at the imperfect and say, "Well, this is not perfect" or "This is a little bit imbalanced." The imbalanced imperfection is what allows you to see things in an unlimited and real-life way, and it also reveals the unlimited potential in us.

LEE UFAN, *FROM LINE*, 1974 ←

MOON JAR, SECOND HALF OF THE 18TH CENTURY →

In eighteenth-century Korea, large bulbous vessels known as moon jars became fashionable. So called because of its evocative form, the moon jar (Korean: *dalhangari*) is a distinctive type of porcelain from the late Joseon period that was usually made by joining two hemispherical halves. The peach hue of the glaze, unintentionally acquired during firing, adds to its charm.

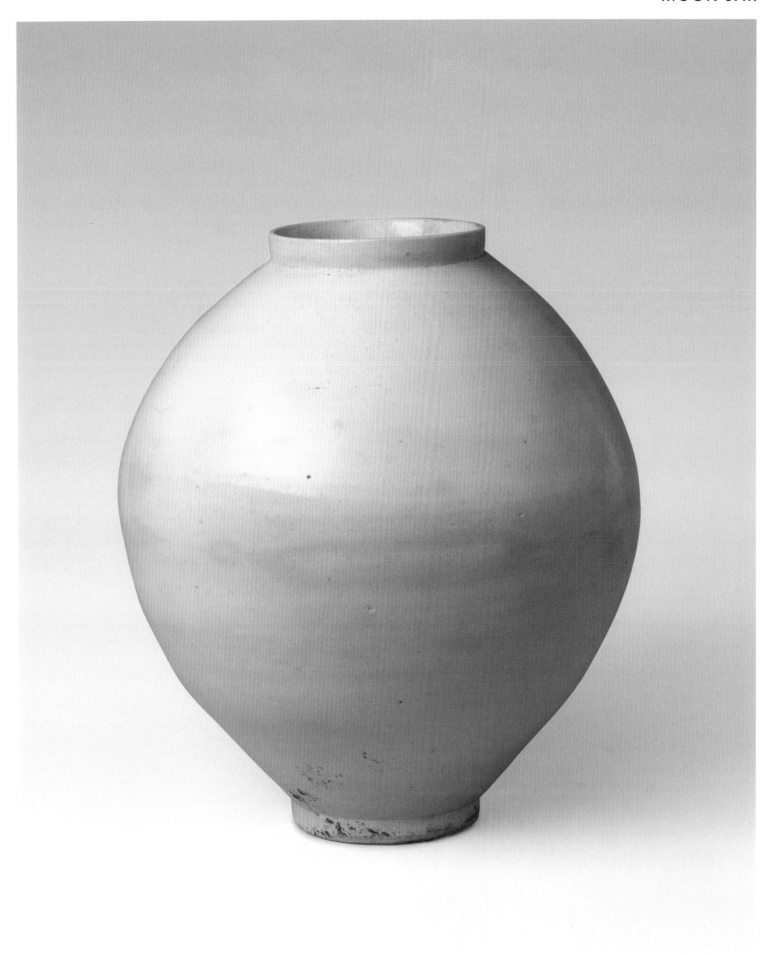

GLENN LIGON

"I love the idea that something so abstract can be so specific."

Much of my work is painting. It's hung on a wall; you look at it. I don't make sculpture, so the problems of sculpture are foreign and surprising to me, and I have to learn them. From African art, I'm learning how things operate in space.

It always amazes me that these *bieri* figures are carved out of one piece of wood. What's interesting about this head is that it's quite stylized in terms of the features: the enormous eyes, the arch of the eyebrows, the mouth, the nose. They're general signs for a face, but they are also very specific. This isn't a portrait in a direct sense, but it's a representation of what you want someone to do. For instance, the ears stick out, creating a conduit to the ancestors. The object speaks, but you also speak to it. The placement of the ears is about its receptiveness to one's prayers. The object speaks, but you also speak to it. I love the idea that something so abstract can be so specific.

Any work of art is an idealized representation. It's an idea about something; it's not the thing itself. Even though this figure doesn't fall under the heading of art with a capital *A* or sculpture with a capital *S* within its original community, it's beautifully proportioned. The oval shape of the head, the long straight neck— its aesthetic value enhances its spiritual value. It's a human trait: we worship beautiful things. It's part of what keeps us going back to these objects.

I don't approach my work with the idea of making a beautiful object, but beauty is often what hooks people into the other issues in the work. We're very interested now, in contemporary art, with what a viewer's experience is, a viewer participating in a work of art. For me, these objects have already done that. The relationship that people had to these objects was about activation. People didn't just stand there and look at them; they did things with them.

This sculpture was made to sit on top of a container for relics, so it has generations of engagement. At some point, though, the religious significance of the object dissipates, and it ends up in a gallery space. Museums often have objects that they want to conserve and not change, but these objects do change. You see the palm oil coming out of it from the libations that have been poured on it, and the palm oil is a subtle reminder that it once operated in a different system. Even though these objects are now in display cases, they're not fixed. Their meaning changes over time.

GLENN LIGON, *UNTITLED: FOUR ETCHINGS*, 1992 ←

RELIQUARY ELEMENT: HEAD (*THE GREAT BIERI*), 19TH CENTURY →

In the Fang society of Gabon, figurative sculptures produced for the ancestor cult, or *bieri*, were designed to complement reliquary containers. This sculptural creation distills the representation of a larger-than-life ancestral presence to a head with a penetrating gaze. It was originally placed at the summit of a portable family altar that held precious relics of at least nine generations of an extended lineage. While *The Great Bieri* is the largest of the known Fang heads, it is also the most formally succinct and pared down. This majestic work is among the most frequently reproduced works of African art.

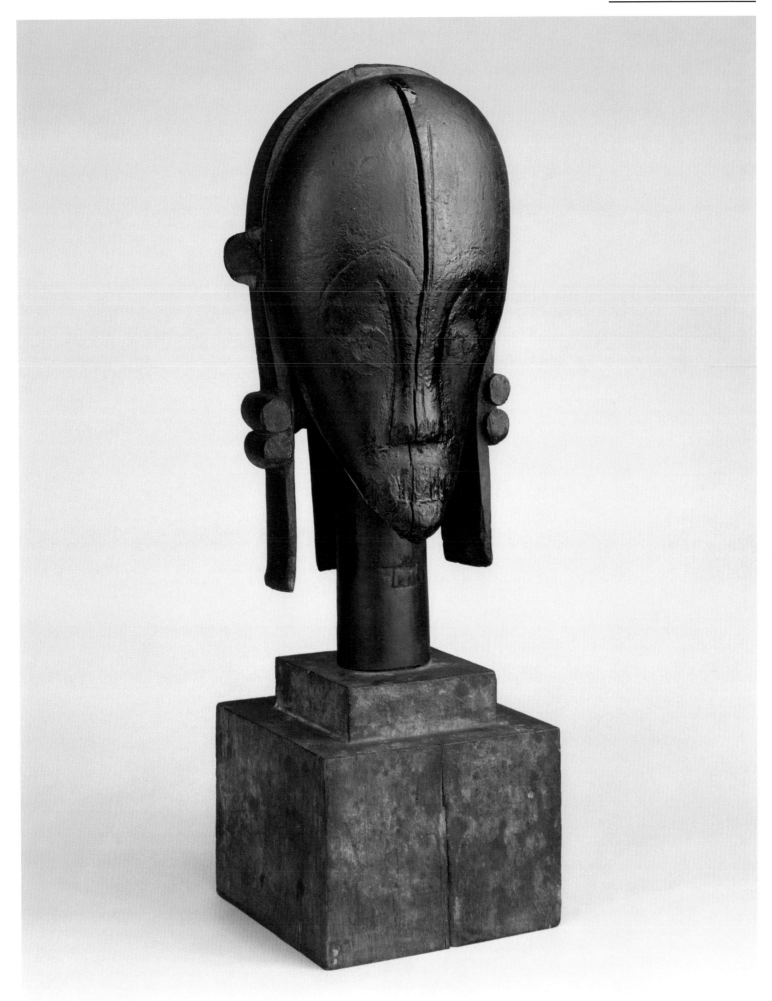

"He enlarges private life and makes it public, catching the most touching, the most revealing, the most hidden moment."

I'm from China, and when I first saw the work of Alex Katz in the eighties, I found his touch and the flatness of his work very similar to Chinese ink painting or Japanese woodblock prints. As in Chinese brush painting, the process itself seems very fast. Katz's brushwork is very simple. You can see, through the maneuvering of his brush, his passion. But it's a controlled passion.

There is a lot of consideration in Katz's details. He must have expressed himself on canvas only after he carefully thought these through, and only then did his brush follow his thoughts. With so much thinking behind it, he exudes confidence.

Looking at his work is like reading a poem that overwhelms you instantly and makes you feel stunned. It's rare in Western art to find a sense of poetry; Western art gives you a story. But Katz catches one split moment—a precious, precise moment.

Many of Katz's portraits are of people who are dear to him, so it's easier to capture the multidimensionality of the person. Katz's works appear traditional, but I don't think they are. I find behind his works a kind of spiritual communication between human beings.

I'm attracted to the precision with which he portrays psychology. His subjects appear very realistic, but they do not feel realistic. Even the complicated colors—like the color of the lips—he transforms to something otherworldly. He purifies the real world to such a degree that it becomes ethereal.

Katz's portrayal of materialistic middle-class life is spiritual and sensitive. What he portrays makes you feel peaceful. This, to me, is particularly precious. He captures our contemporary existence in a commercial society—for example, the influence of advertisements is visible. I'm also convinced that he's influenced by film. All viewers are somewhat voyeuristic, and he enlarges this voyeurism. He enlarges private life and makes it public, catching the most touching, the most revealing, the most hidden moment that you really don't want other people to see. He magnifies the face of the portrait to expose the spiritual elements. Only art can attain that degree of experience.

LIN TIANMIAO, *ROTATION-REVOLUTION*, 2016 ←

ALEX KATZ, *BLACK AND BROWN BLOUSE*, 1976 →

Katz came of age during the heyday of the New York School, and in the late 1950s he began to develop his mature style—characterized by stylized abstraction, simplicity, and elegance. Committed to depicting recognizable motifs, Katz minimizes details and shading and instead portrays his subjects with the help of bold contours and blocks of color. As much as they represent a person or place, Katz's works also depict the act of seeing itself, capturing the surprise and suspense, the desire and pleasure, which accompany the experience of spectatorship.

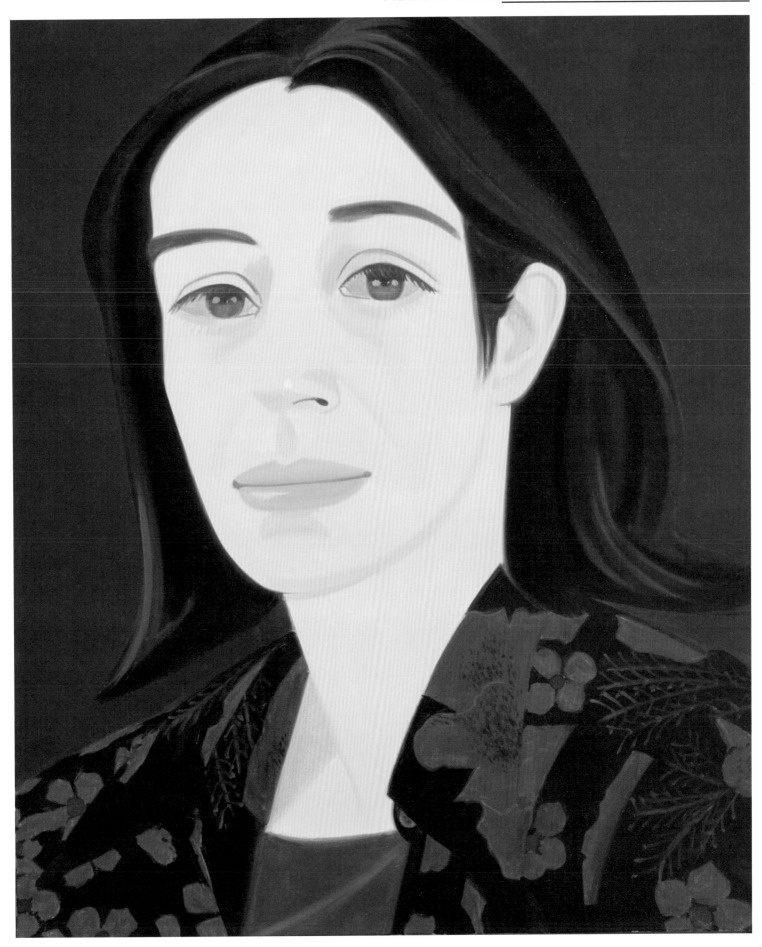

"What makes a thing art is the fact that it leaves room for the viewer to imagine."

I was drawn to Édouard Manet's paintings because I get so many questions about my work—"Why is this art?" "Is it entertainment?" "Is everything art?" "Is everything performance?" I think Manet's work is contemporary in terms of the artist's process.

Manet lived in Paris, but he was painting bullfighters. He mismatched things—the cape, for example, wasn't accurate—and he was experimenting. These scenes were created in his studio.

The woman in this painting and the man in another of Manet's paintings, *Young Man in the Costume of a Majo*, 1863, are wearing the same matador outfits. I'm not sure if there were female bullfighters at that time, but to me it seems like there is a play on gender. I love the idea of Manet having the clothes in his studio, and the models coming in and putting them on and posing as the characters. That sounds so contemporary to me because I have clothes in my studio that my performers come and put on.

Manet used this same female over and over again in several paintings. She's disguised here, so you have to look closely to realize it's her. But once you do, you can't help but think that there was a performance or some role-playing going on. You realize that this person was in and out of his studio and helping him create these performances that he painted. Although it's not kinetic performance where they're moving around, it is a performance because they have to keep the pose. You have to look at the posture and the gestures as a scene.

It makes it a little bit more real—he's not just in some isolated place in his imagination. There must be some type of dialogue and discourse or conversation going on.

When I see this painting, I think about when I prepare to play a role and have to research the gestures to get the body language down. I always—I don't want to say *wish*—but I imagine myself living in a different time period. I tend to go into old paintings and imagine myself in those spaces.

RuPaul once said, "We're all born naked, and everything else is drag." When looking at these Manet paintings, on a certain level I do think they're drag, but I don't know the whole history of that particular moment.

Today there are more mediums for an artist to use to express performance, but Manet's subjects had to perform in paintings on canvas. I imagine what they would be like if they were animated—how would this person move?

I've always felt that entertainment was art's bastard child. My cousins and I grew up pretending that we were in a soap opera, but when you get to art school, you imagine yourself playing the artist. What makes a thing art is the fact that it leaves room for the viewer to imagine. It leaves space for you to process things in your own way.

KALUP LINZY, *CONVERSATIONS WIT DE CHUREN V: AS DA ART WORLD MIGHT TURN*, 2006 ←

ÉDOUARD MANET, *MADEMOISELLE V. . . IN THE COSTUME OF AN ESPADA*, 1862 →

Manet depicted model Victorine Meurent in the guise of a male matador, borrowing her pose from a Renaissance print. Victorine's shoes are unsuitable for bullfighting, and the pink cape that she flourishes is the wrong hue, but she carries off her role with panache. The backdrop reproduces a scene from Goya's *Tauromaquia* series, celebrating the feats of bullfighters.

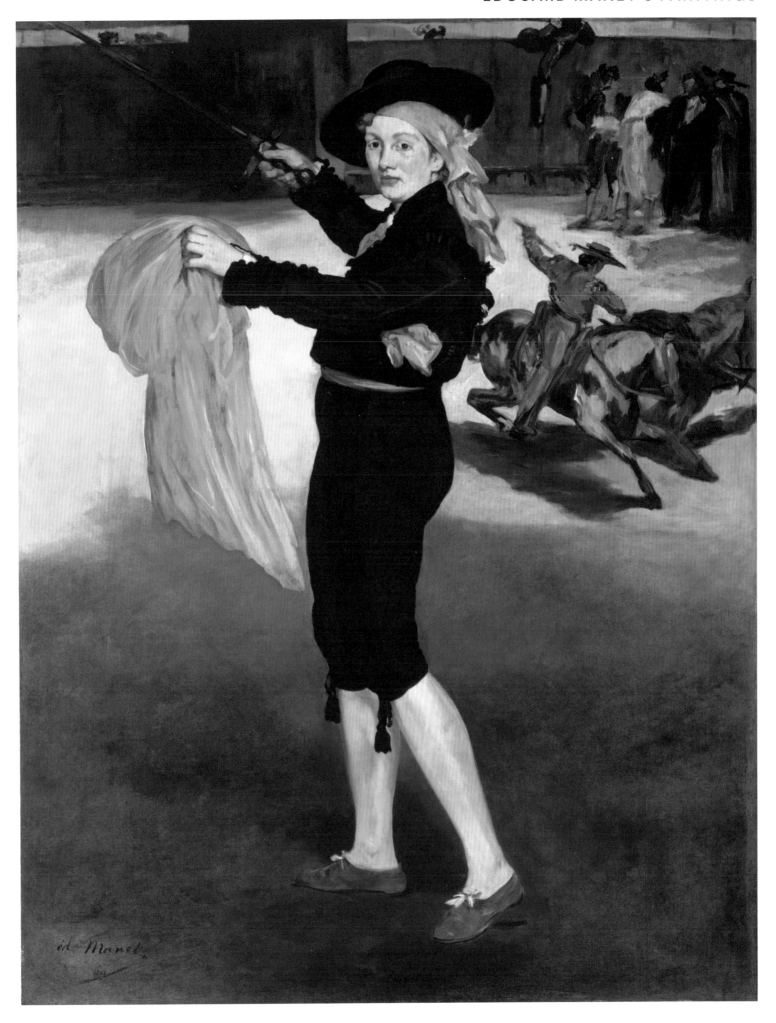

ROBERT **LONGO**

"Great art poses questions, and the more questions it poses, the better it is."

As Americans we grew up with this idea that "if it's big, it's good." I looked at Jackson Pollock's paintings as examples of why I wanted to work big. I wanted to compete with the world around me, and his paintings compete with movies.

Autumn Rhythm is a recording of a psyche, a kind of manifestation of a human being's presence. You can see Pollock's physical movements in it. I'm sure somebody could analyze this painting and tell you how tall he was and how much he weighed. It's a one-of-a-kind recording.

I think Pollock's subconscious was really activated. I've read and heard him talk about how he didn't make sketches or plans, but clearly he had a strategy. I think the painting was done in three distinct sections. There are these almost humanoid shapes—that's the initial black that he put down. Then he starts to bury it with the white and green, and he adds these bird shapes and V shapes—in the top you can really see them clearly.

As an artist, you're a reporter of the time that you live in. Pollock was dealing with making paintings after the world basically tried to destroy itself. It's also at the scale of the grand war paintings by Théodore Gericault or Jacques Louis David, but paint was no longer in the service of illusion. Paint became the picture. His paintings create a dead end. How do you extend after Pollock?

There's a democracy that exists in this work. You see it all at once, but you also get to choose to look at it however you want because there isn't any narrative structure in it. I may have looked at this painting a gazillion times more than I've watched my favorite movie.

I think Pollock realized that people would interpret things in his paintings, but great art poses questions, and the more questions it poses, the better it is. It's an attempt to try to understand, the way sciences or philosophy do, but art has a capacity to hold other ideas that may enable us to understand our own contemporary situation.

I really do believe in art. I think it's my religion. It's a form of believing. This painting carries all that intensity.

ROBERT LONGO, *UNTITLED (RUSSIAN BOMB/ SEMIPALATINSK)*, 2003 ←

JACKSON POLLOCK, *AUTUMN RHYTHM (NUMBER 30)*, →
1950 (WITH DETAIL)

From 1942, when Jackson Pollock had his first one-person exhibition at the Art of This Century gallery in New York, until his death in an automobile crash at age forty-four in 1956, Pollock's volatile art and personality made him a dominant figure in the art world. In 1947–48 he devised a radically new innovation: using pour and drip techniques that rely on a linear structure, he created canvases and works on paper that redefined the categories of painting and drawing. *Autumn Rhythm* exemplifies the extraordinary balance between accident and control that Pollock maintained over his technique.

NICOLA **LÓPEZ**

"The speed of the artist's hand is recorded in the paper in a way that not all materials can indicate."

Learning about works of art and seeing them has become less and less about the single work. What I now find more interesting is how an artist moves through their practice, how they've grown and changed. That's something that you see when you're looking at works in the drawings gallery because there is often a breadth of mediums. Even if someone doesn't have artistic training, they have made a mark with a pencil.

In some of these sketches, there is a little smudge, or something's been moved, or it's been erased and redrawn. You get an intimate view into the artist's process and practice and thinking—almost like a little glimpse into their studio.

I doubt that Eugène Delacroix actually intended to exhibit his sketches as finished works of art, but we can see what he was thinking. The sense of fluidity in that ink and then the weight in those lines: you see the trial and error and the process. There is not that same sense to be seen in a painting. It's a different language, and it might provide a different way into the work.

Then I was looking at a Jacques Callot print and drawing. They're the same image, except that in the print it's flipped, but the ink has this dreamy, fluid quality. You get the sense of light dissolving over the landscape. That same image, created in etching, is so hyperprecise.

Every medium has its own personality, and paper is a very sensitive surface. The paper dictates a part of what the image is going to look like in the end: the variation in lines, the depth, or even speed. The speed of the artist's hand is recorded in the paper in a way that not all materials can indicate.

One can see how the medium contradicts or pushes or questions the subject matter. A part of its content is about how these different layers interact. Through the medium there is definitely something that cuts across time.

As an artist, it's nice to feel as though I can have a conversation with artists who I really admire but who may have lived hundreds of years ago…and that there's still something that makes our work equate.

NICOLA LÓPEZ, *SCAFFOLD CITY*, 2008

JACQUES CALLOT, *MAY DAY CELEBRATIONS AT XEUILLEY*, 1624–25

Callot was one of the great graphic artists of seventeenth-century Europe. His oeuvre includes religious and military subjects as well as depictions of contemporary entertainments of the court and the countryside. Here, he depicts the May Day celebrations at a small village in Lorraine, where his family owned property. The subject gave Callot occasion to mix country folk with more elegantly dressed observers.

EUGÈNE DELACROIX, STUDY FOR *THE SULTAN OF MOROCCO AND HIS ENTOURAGE*, CA. 1832–33

This freely executed sketch records the reception of the French ambassador Charles de Mornay by Sultan 'Abd ar-Rahman at Meknes, Morocco, on March 22, 1832. Delacroix, who attended the ceremony as a member of the French diplomatic party, returned to this subject repeatedly throughout his career. Most notably, he depicted the meeting in his largest painting, inspired by his North African voyage, a twelve-foot-tall canvas that he submitted to the Salon of 1845. By that time, Comte de Mornay's mission was deemed a failure—although he appears at right with his interpreter in this drawing, Delacroix eliminated him from the painted composition.

"I'm attracted to Hindu myths because they are a language that links people."

I'm a narrative artist; I tell stories. I'm not a Hindu, but I'm attracted to Hindu myths because they are a language that links people. There are so many characters playing out complex psychological stories with universal truths—stories that have come down to us through the ages.

There is this one character, Hanuman (a deity in the form of a monkey/human), who is considered an icon of devotion. I find *Hanuman Bearing the Mountaintop with Medicinal Herbs* to be a very unusual work. It was created on cloth, with ink. It looks like it's meant to be seen from afar, but then there's an entire universe on the tail. If you start to count all those people, it's so fine, and it's perfect drawing. It must have been made with a reed pen, or maybe a bamboo one, sliced.

Hanuman was a very muscular creature. The curvature of the lettering gives a sense of his thick, muscular thigh. I'm also interested in the comic-book aspect of what's coming out of his mouth: his tongue is out, and he's saying a few things. Those letters completely encircle him, creating a kind of a tremulous agitation, as if he's moving. Another quirky thing is that the artist made a little cover for his tail. Can you imagine how Hanuman must have squeezed himself into those shorts? He must have put his tail in first!

For me, this work has three senses of time, which as a narrative device is crucial. There's the event: Hanuman has been asked to go to the Himalayas and pick medicinal herbs to help Rama because he has been wounded in battle. Hanuman travels across India, but then he forgets which herbs to collect, so he picks the entire top of the mountain with the hope that he found the right ones.

The second sense of time is the little Rama on his shoulder, like a little puppet. Rama is still in the battlefield; he's not really sitting there. It's a fantasy. So he carries the idea of God with him, as if saying, "I'm devoted to this little creature, and I will do everything possible to get this right."

Finally, there's one other sense of time, which is what you see around his tail. It is not the army fighting. It's more like a welcoming—it's a parade. Hanuman is already predicting that they will be victorious. They are going to win this battle.

I find this totally fascinating. If I were to use this iconography and narrative, I would add a lot of doubts and questions into the work. This kind of militaristic victory isn't really victory in the end. In our world today, we have too many conflicts happening. We're in a very ambiguous situation, and I don't know what victory would be.

NALINI MALANI, *GAMEPIECES*, 2003/2009 ←

HANUMAN BEARING THE MOUNTAINTOP WITH →
MEDICINAL HERBS, CA. 1800

This devotional image of the monkey general Hanuman celebrates his most famous heroic feat—carrying the Himalayan Mount Vindaya to Rama and Laskmana, who, gravely wounded in combat, were in desperate need of the medicinal herbs that grow on its upper slopes. Unsure which plants to gather, Hanuman breaks off the entire peak and carries it through the sky back to Rama. His army is seen parading along the length of his tail, bordered by devotional verses. This painting is a reminder of the significant cult devoted to Hanuman at the time it was painted; his supernatural strength, military prowess, and above all loyalty were qualities much admired.

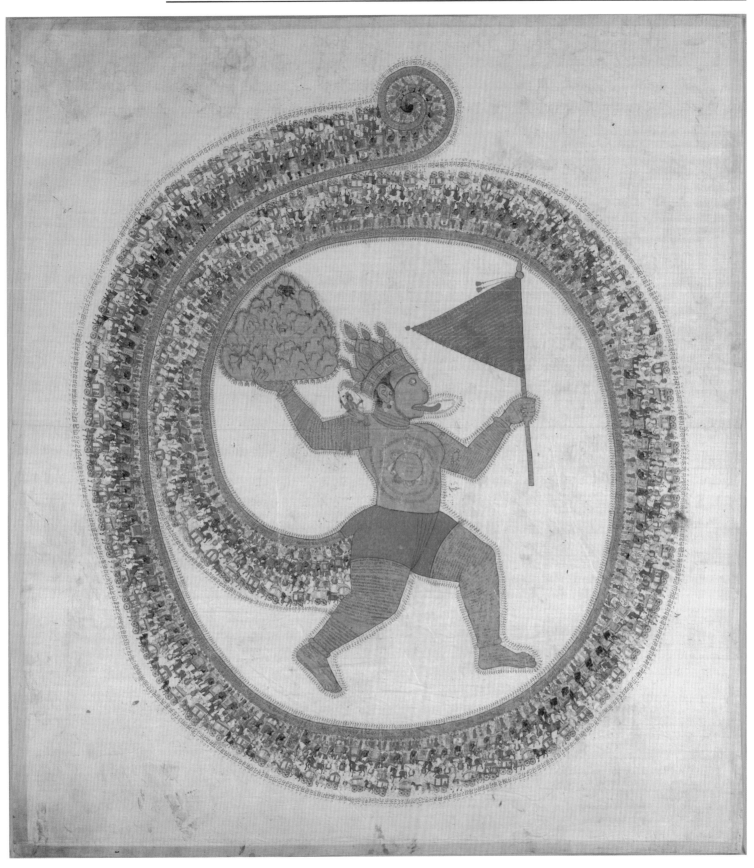

KERRY JAMES **MARSHALL**

"This particular picture strikes me as ultramodern because it exists as a pure image."

I'm a fan of Ingres as a painter, and the best is the portraiture. It's stunning in its pictureness, because we don't know any of the people—don't care, in some ways, who they are—but they look beautiful in a picture. I'm interested in the artifice of it all.

This particular picture strikes me as ultramodern because it exists as a pure image; it strikes me as conceptual art because we don't see the world in this tonal register. In grisaille (the gray scale) the image remains completely locked into the domain of pictureness.

There's a spectacular precision in the way Ingres made the picture. There are two different ways of thinking about precision. One is accuracy of line—or accuracy of form and of shape— but the other is precision in terms of choice. The level of detail, the treatment in the drapery, the flatness of the black space behind: these are decisions that the artist made. This is not something that just happened. I don't think anything is more important than having options. This is where I think the expression of true freedom exists.

In my work I'm interested in how pictures are made, and the only way I can make that explicit is to have multiple approaches within the same picture. When I paint a figure that has a crisp outline and then I make a gestural mark, I want people to know that each of those was a choice.

Ingres's image has been stylized to produce an effect. This body is built to be in a picture; there are things happening in it that wouldn't happen in a real person's body if you were just trying to be accurate. The way the upper part of the torso is turned, and that breast under her arm is in a mighty awkward place—it's almost right on the side of her body, as opposed to where it's supposed to be. If you follow the curve of the woman's back to her thigh and then down across her knee and to the foot that's at the bottom, there's a very nice rhythmic curve that goes all the way from the left side of the picture to the right. In order for that to work, though, the foot that is down at the bottom has to be smaller than it should be for its place in the space. It's smaller than the foot that's on top that's further away. Ingres must have done that on purpose because I know he knew better. If he had made that foot as big as it should have been, then it would have projected forward. He needed to keep the flatness of that plane so that the figure remains decorative.

We underestimate the level of interest in the art of abstraction for artists who are outside of modernist philosophy. This is really what abstract is: you have to deal with it against the recognition of something you think you already know.

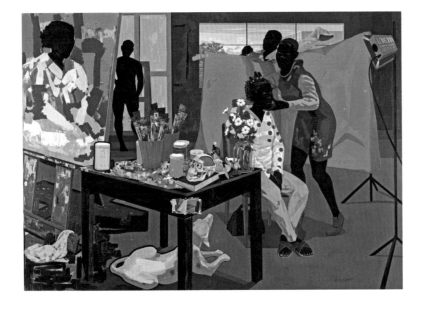

KERRY JAMES MARSHALL, *UNTITLED (STUDIO)*, 2014 ←

JEAN AUGUSTE DOMINIQUE INGRES AND WORKSHOP, →
ODALISQUE IN GRISAILLE, CA. 1824–34

This painting is an unfinished version, reduced in size and much simplified, of the celebrated *Grande Odalisque* of 1814, a work that was central to Ingres's conception of ideal beauty. Ingres cited this piece in a list of works he executed in Paris between 1824 and 1834. Paintings in shades of gray—*en grisaille*—were often made to establish variations in tone as a guide to engravers of black-and-white reproductive prints. As this work has not been linked definitively to known reproductions of the *Grande Odalisque*, its intended purpose remains uncertain.

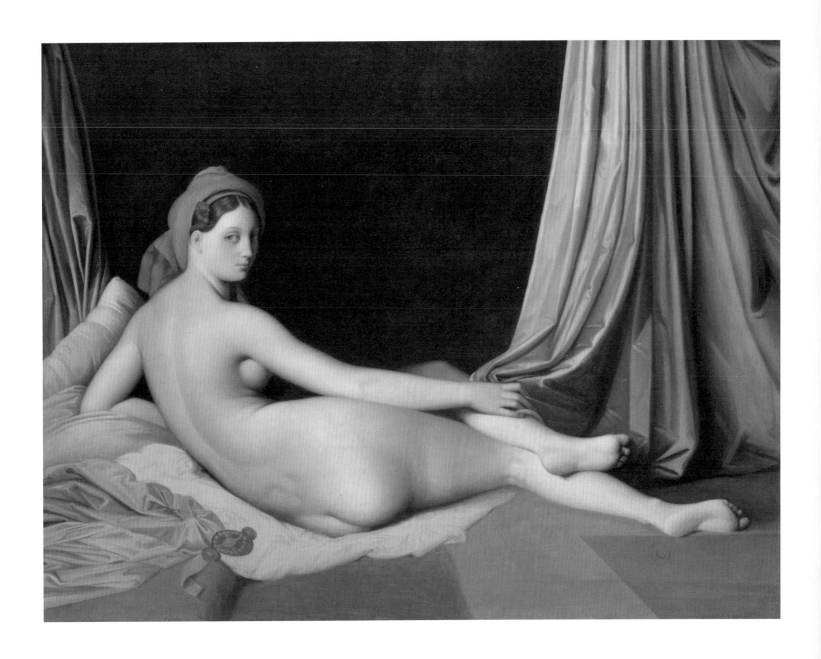

> ## "I believe Pippin is one of the greatest American painters ever; we may have forgotten that, but we can remember it now."

Most American painters throughout the history of this country have looked to Europe—to the grand, aristocratic painting traditions—as the model they needed to live up to. That's not the United States—that's not the land built by immigration nor is it the land built by the horror of slavery. Horace Pippin, as a painter who resonates with our national identity and history, showed us where we are and where we come from. Many Americans' experiences had been extremely constricted and far from grand.

I like the fact that the paintings are small—a kind of emblem of how many people have to live their lives. In a painting called *Asleep* (1943), the legs of the stove are broken and replaced with brick. There are also holes in the walls, so the kids have to have coats over them. And yet there's a warmth, an affection, in the painting. At the core is this relationship to memory: seeing and looking and remembering are amorphous. Pippin takes from his life, turning it into a set of symbols and a set of histories, and it becomes a beautiful vision in and of itself—that's where abstraction begins.

Pippin initially learned to be a painter as art therapy after the First World War. Some people would say that he is an outsider artist. In some sense his work has that freedom, but what makes him one of the greatest American painters is the way he began to play with his role. If you look at the history of painting, who's most often depicted? It's the very wealthy people. The self-portrait reveals Pippin thinking about his place in the world as a middle-class person, as an artist, as somebody who wants to put his face forthright in our vision. That's why it's a really important representation of American-ness. Who really makes up America? It's the people who have labored and toiled to build this country. We need to constantly return to that.

To me, despite their modest physical scale, Pippin's paintings are truly grand, and this self-portrait is a great example. The more you look at it, the greater depth you find in the unique way he uses color to show us space—in this case, the sculptural structure of his own image. I believe Pippin is one of the greatest American painters ever; we may have forgotten that, but we can remember it now.

Calling someone an outsider artist assumes that you only have insight if you are born in a very particular class of people. Every human being has the potential for great insight. Pippin's work shows us an aspect of society that's not normally focused on nor used as the source for a great aesthetic experience.

JOSIAH MCELHENY, *BLUE PRISM PAINTING V*, 2015 ←

HORACE PIPPIN, *SELF-PORTRAIT II*, 1944 →

Pippin's paintings typically depict everyday events, historical figures, and religious themes. This painting is one of only two self-portraits the artist executed during his career. The artist presents himself as a professional, middle-aged man. Dressed in a jacket, suit, and tie, he is poised and self-possessed. It seems clear that Pippin wanted this visual autobiography, created two years before his death, to suggest a chapter of his life during which he was deeply self-aware and utterly self-confident.

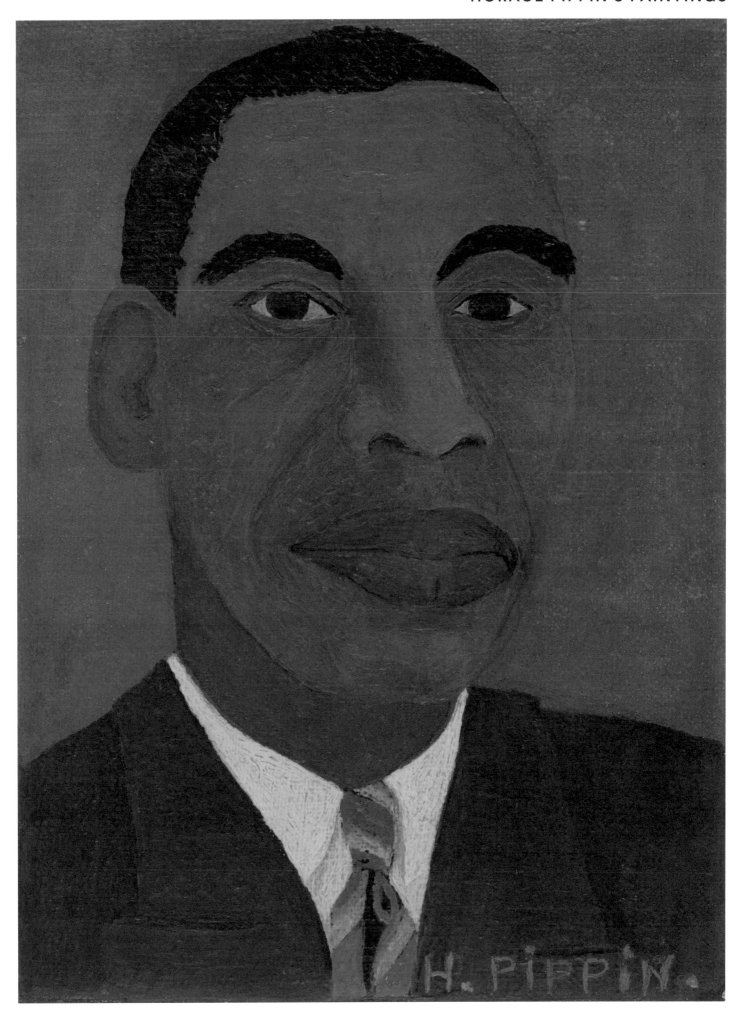

LAURA MCPHEE

"To have this whole symphony occurring in one image— that's fantastic."

The Harvesters by Pieter Bruegel the Elder anticipates photography. I work mostly in landscape with a large format 8×10 Deardorff camera, and this painting feels like you're out there with an 8×10 view camera, and the world is unfolding. He lets that tree sit right at the edge of the frame; and the road, too, as it moves away from you into the landscape, just kisses the edge of the frame— it feels very photographic. He's making a decision about where to put that edge. Also the resolution, the way the sharpness is sustained throughout the frame, feels photographic. The image shows a precise second. It's a sixtieth of a second because everything's still: the people in the foreground having lunch, eating cheese and bread, one guy with the spoon to his mouth, the woman picking up the sheaf of hay.

The peasants are working hard. The one man coming toward us is carrying the jar in a way that reveals fatigue. You're aware that all this wheat is not just for this little village. It's being taken down the hill and put on a cart that's heavily laden, and the cart is moving off in the direction of the ships, which will then take the hay to other parts of the world. These laborers are laboring in the interest of someone else.

Often when I'm thinking about photography, I think about the paradoxical nature of the world: that it's so intensely beautiful, and at the same time there are so many problems, many of which are self-inflicted. We're in concert with the land, we exploit it, and we protect it. What interests me is trying to comprehend that complexity and then communicating it. This painting is such an organized place, where, literally, the pears fall off the tree and the people eat them. But it's so complex. There are so many moments that build on each other.

Bruegel understands the idea of simultaneity and that these things are all seemingly disconnected: the people in the foreground are totally unaware of what the people in the middle ground or on the ships are doing, but he's drawing the links. To have this whole symphony occurring in one image—that's fantastic.

LAURA MCPHEE AND VIRGINIA BEAHAN, *THE BLUE LAGOON,* ←
SVARTSENGI GEOTHERMAL PUMPING STATION, ICELAND, 1988

PIETER BRUEGEL THE ELDER, *THE HARVESTERS,* 1565 →

This panel belongs to a series by Bruegel that originally included six paintings showing the times of the year. Apart from *The Harvesters,* which is usually identified as representing July and August, or late summer, four other paintings of the group have survived. The series was a watershed in the history of Western art. The religious pretext for landscape painting has been suppressed in favor of a new humanism, and the unidealized description of the local scene is based on natural observations.

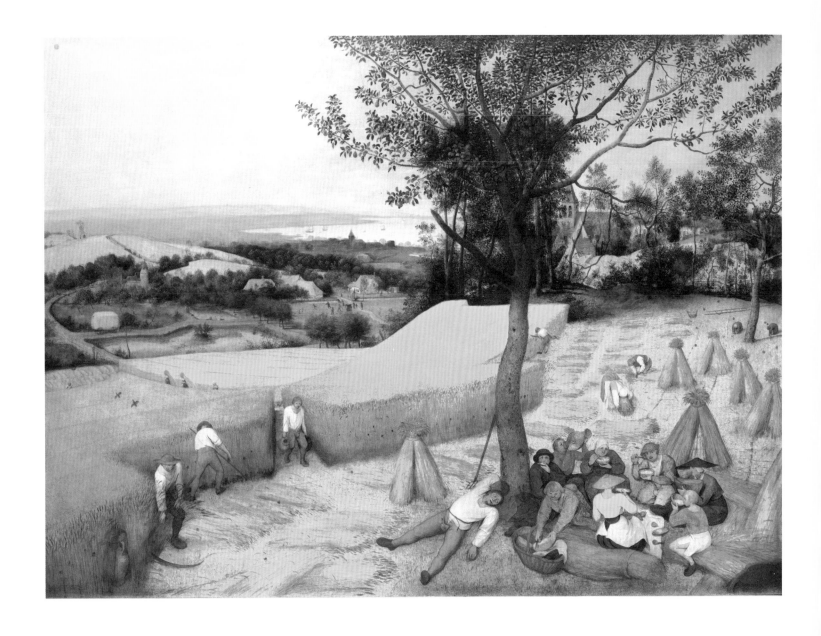

JOSEPHINE MECKSEPER

"Looking at art can really help to show you that there's a different reality."

This painting, titled *Government Bureau*, from 1956 by George Tooker, stands out in its simplicity and understated presence. It feels oddly personal and creates a combination of familiarity and fear, like standing in line at the airport or at the DMV. At that time, these big office buildings were going up everywhere. It was new to people; they didn't really know what their place was anymore. Tooker captures a moment of collective anxiety.

It's painted in a very peculiar, individualistic way to convey a sense of discomfort: sickly looking flesh under fluorescent lights. Whose gaze was he following when he painted this? Is it from the perspective of an innocent child looking at what the grown-ups are doing? Or is it us, as the viewers, who are being interrogated?

Tooker studied literature at Harvard, and his paintings really bring to mind Franz Kafka's novel *The Trial*: this dehumanizing society in which people are divided by architecture. You're not really confronted with a person anymore; you are becoming a number or a clone. Tooker's works show this dark side, the bleakness of what a human being is capable of.

Figurative painting is accessible to a viewer. This painting is almost a snapshot of a past reality, but getting that type of psychological interpretation through an artist's work is a whole other dimension. I think about how we look at Tooker's work now, in a time of global NSA surveillance, when there is a bigger power threatening us in order to justify imperialistic tendencies of control.

All of this really makes me think about the narratives that we form to create a sense of ourselves, and how we constantly create our own inner worlds within an outer world. Looking at art can really help to show you that there's a different reality.

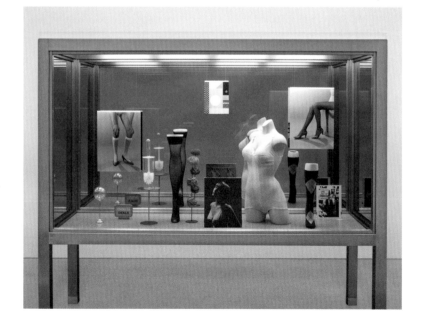

JOSEPHINE MECKSEPER, *BLOW UP (MICHELLI)*, 2006 ←

GEORGE TOOKER, *GOVERNMENT BUREAU*, 1956 →

While Tooker's paintings typically convey the artist's passionate desire for social harmony and justice, *Government Bureau* represents a darker, more pessimistic dimension of his art. The work takes the viewer inside a cold, starkly lit interior filled with anonymous bodies and cubicles. Eerily, the circular windows in the cubicle walls reveal only the tired, sad eyes of government employees, staring blankly. The scene's unsettling remoteness is accentuated by Tooker's fine and detailed technique, rooted in Italian Renaissance egg-tempera painting.

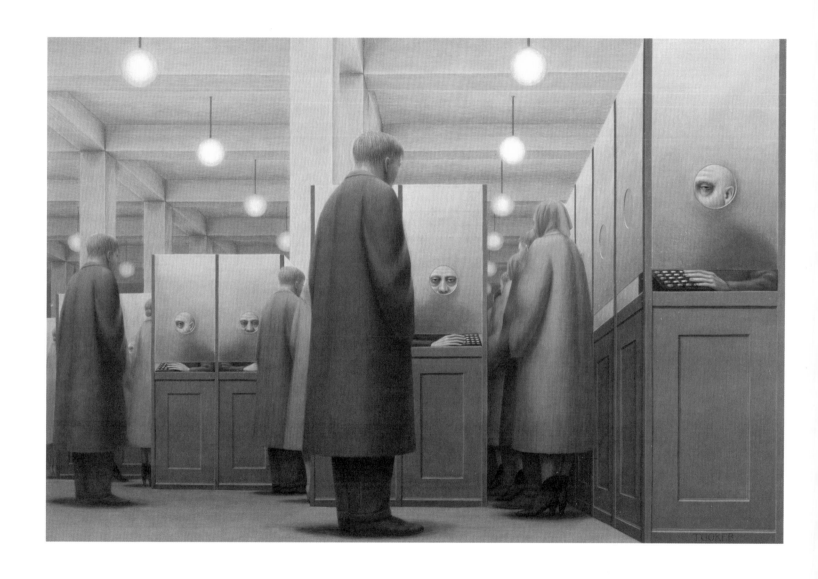

"Looking at his expression I'm moved, almost to tears. It's not often that a painting can do that."

There are certain paintings in a gallery that stand out and call you to them. Even with all the other Velázquez works in The Met, this is one of the paintings that has always haunted me. This work is a portrait, and I looked up the narratives surrounding it. Velázquez spent a few years in Rome preparing to make the portrait of Innocent X, and Juan de Pareja was with him at the time. He was one of Velázquez's primary assistants, and he was Velázquez's slave. I read this, and I thought, how do you paint your slave? The American slave narrative is very different from the European one, but this is still a person who did not have the rights to himself. There's such irony in that set up: the fact that Velázquez could capture the complex emotions that come from the position of owning this person, and what that denies this person.

Juan de Pareja stands there very proud and dignified. The slipping of his hand under his shawl pulls you to that part of him, just under his heart. The hair falls into the background and gives an illumination, a radiance, to the face. When you come up close to the painting, you can see the way the brushstrokes articulate the lace on the shawl—it's just incredible. I get goose bumps. The gentleness of the brush on his face, articulating his mouth, his lips, his nostrils—he's almost holding his breath. You feel like you're encountering a real human being.

To capture the complete humanity of someone you don't think of as completely human… There's an incredible contradiction there that blows my mind. Think of the political implications of painting a black man with copper skin and brown eyes with that piercing look. It's not a look of contempt; I don't read it as full of rage or anger. It's also not resignation, but a conflicted, implicit sadness described within that dignity.

There's honor in being painted by someone like Velázquez; but Juan de Pareja was a painter in his own right, from what I've read. In one narrative, Velázquez freed him to follow his own work. In another narrative, Velázquez didn't actually want him to paint, and he had to paint secretly without Velázquez's knowledge. The fact that there are these competing narratives is fascinating to me. Who knows what the story actually is and what the intention was behind the portrait. But the fact is that he wasn't freed for years after this painting was made. Looking at his expression I'm moved, almost to tears. It's not often that a painting can do that. It's hard to give language to the experience that happens when you're in front of a work like this that feels so alive. You walk back from it, and his eyes don't leave you. I leave and I still see his face.

JULIE MEHRETU, *CONJURED PARTS (HEAD), ALEPPO*, 2016 ←

VELÁZQUEZ (DIEGO RODRÍGUEZ DE SILVA Y VELÁZQUEZ), →
JUAN DE PAREJA (BORN ABOUT 1610, DIED 1670), 1650

Juan de Pareja was born in the province of Málaga to a Moorish mother and Spanish father. Of mixed race, he was enslaved and evidently inherited by Velázquez, who likely employed him for menial tasks in the studio, such as grinding colors. Velázquez chose this portrait of his proud, enslaved assistant for his public debut in Rome. The year the picture was painted, Velázquez signed papers freeing Pareja within four years. Pareja later enjoyed a reputation as an independent artist, though he painted in a style notably different from that of Velázquez.

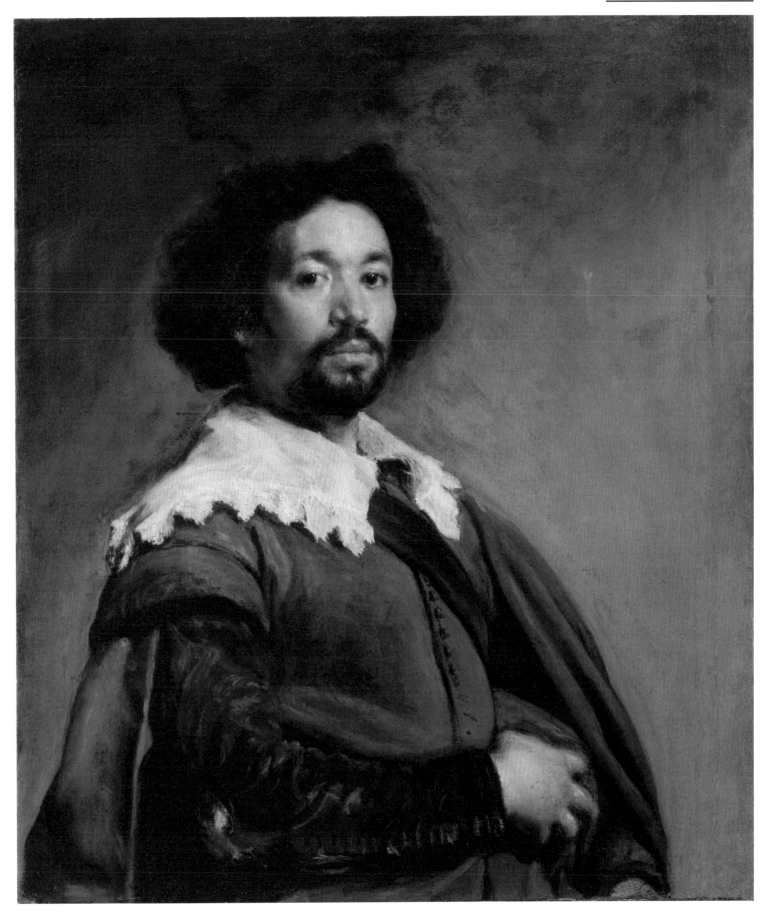

ALEXANDER MELAMID

"If there's no highest power, art doesn't make any sense: it's just decoration."

I try different approaches to understand the power of art, to understand how it works, why it is working. I worked in a psychiatric ward, and I showed my patients works of art because you have to look at art in a time of distress. It has a special power: something revealing, something that can change your life. If there's no highest power, art doesn't make any sense: it's just decoration.

The room in which this painting is displayed—not a room even, a long corridor—is kind of a fallen-heroes room. Ernest Meissonier was considered maybe the best artist of his time; he was famous for his incredible technique. But he's also a fallen hero: he was once so important, and he is not now.

This painting by Meissonier was done after the Franco-Prussian War, which the French lost miserably, but in this particular battle the French won, big time. It's a nationalistic boost, to reclaim the glory of France. It shows Napoleon's troops charging the Russian soldiers. I think Napoleon gave a sign, and they started their charge. Meissonier painted every detail, including the horse caught in the middle of a jump. It's like photography—the camera gets one-thirtieth of a second, something which we definitely can't see. And Napoleon is totally immune, he's not threatened. He was a godlike figure for France, but now this kind of nationalism is out of fashion. That's why this art failed, because the whole idea has changed.

Our judgment of art—of anything, but of art especially, of course—is totally arbitrary. It's a convention defined by a very small group of people who decide what is good and what is bad. But why do they believe that it's great? The point is to understand what was great, in order to understand what is great.

John Ruskin was looking at this with a magnifying glass, trying to find the secret, what makes it so great. There is something there; it's not just our imagination—there is some objective power that helps us. Maybe there's a special power, like radio waves, which influence us, which makes us appreciate art. Maybe it's all nonsense.

ALEXANDER MELAMID, *DEEP FRIED ANDY WARHOL (MEDIUM RARE)*, 2013 ←

ERNEST MEISSONIER, *1807, FRIEDLAND*, CA. 1861–75 →

This work, the largest and most ambitious painting by Meissonier, depicts one of Napoleon Bonaparte's greatest victories. Meissonier made hundreds of preparatory studies for it, including drawings and sculptural models. He conceived the picture as part of a cycle of five key episodes in the life of the emperor, only one other of which was completed, *The Campaign of France—1814*, an image of defeat. This painting gained notoriety in 1876, when the American department store magnate Alexander T. Stewart purchased it from the artist, sight unseen, for the then astronomical sum of $60,000.

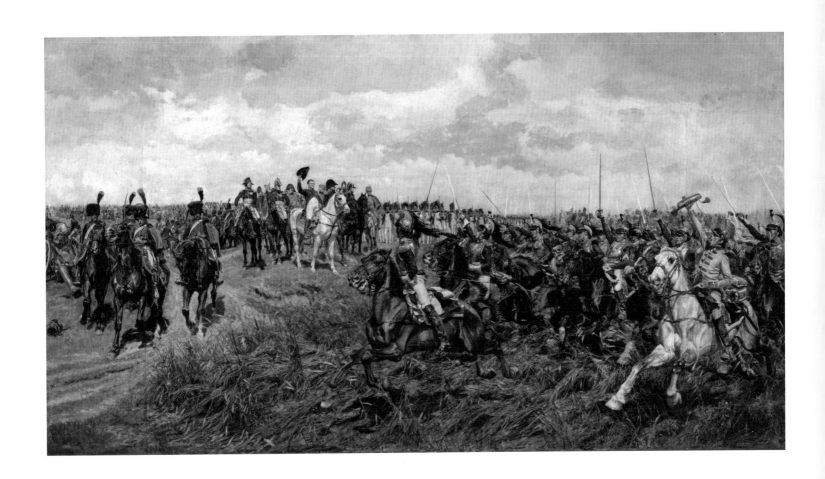

MARIKO **MORI**

"When someone bows to you, that reminds you of your own highness, the high quality of your being."

I've used different mediums, from drawing to large-scale, site-specific installations in landscape. When you make an artwork, the artwork decides the scale; the size doesn't determine the work. Botticelli's *Annunciation* might lose its tension if it were a huge painting, and I feel I'd become more of an outside observer.

For this subject of the Annunciation, the Virgin Mary is honoring the holiness of the Angel Gabriel, who in turn is also bowing and honoring the Virgin Mary.

When I saw this painting, I noticed a similarity to my own culture. In the tea ceremony tradition, the person who's making tea is a Buddha and the guest is also a Buddha, and they bow and honor each other—we respect each other. Seeing an angel and human honoring one another, respecting each other, I feel this sensation of being humble, but also of being blessed and honored. When someone bows to you, it reminds you of your own highness, the high quality of your being. Of course, the Virgin Mary—as you see her halo—is a blessed woman because she is going to receive the son of God, but I believe that every living being in the world has this blessed light.

Although the subject is religious, this painting goes beyond religion and becomes universal. I think there is a world that exists but is invisible to us. That beam of light represents something that's unseen—the holiness—and the artwork can challenge your imagination to see something invisible through the work.

In contemporary society we've lost the sense of respectfulness. Perhaps our ancestors had more of this beautiful nature of the human being. There is a lesson to be taken from this painting: if you can show respect to other people, if you can show respect toward nature, if you can show respect to everything, then the world can be better.

MARIKO MORI, *DREAM TEMPLE*, 1997–99 ←

BOTTICELLI (ALESSANDRO DI MARIANO FILIPEPI), →
THE ANNUNCIATION, CA. 1485

This representation of the Annunciation is set in an architectural interior using one-point perspective to give the illusion of deeply recessed space. In the center, a row of square columns divides the monumental space occupied by the Angel Gabriel from the intimate bedchamber of the Virgin. A drapery panel is drawn back, revealing the Virgin in a pose of humility. The panel was almost certainly commissioned as a private devotional image, not as part of a larger work.

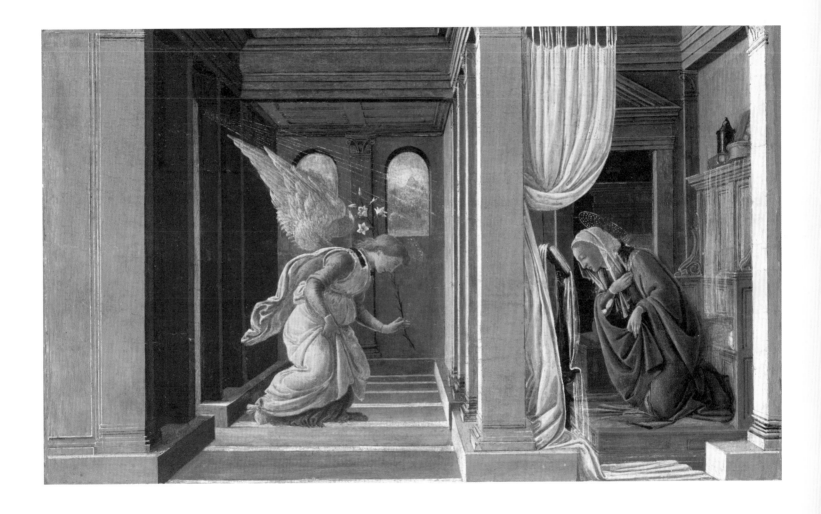

VIK MUNIZ

"The Luce Center is transgressive in that it empowers you."

I remember finding the Luce Center completely by chance. My first impression was that the entire place was some kind of weird contemporary art installation. I actually asked a guard about it, and he said, "No, this is storage that was all made visible so that the objects are always on view." Now I visit the Luce Center every time I come to The Met because it always gives me ideas. The connections between one object and another are very loose, and they are not preconceived. It's like you are at the vegetable market looking at the vegetables before they've been cooked. There are perfume flasks, Tiffany lamps, decorative paintings and sculptures, grandfather clocks and doorknobs, paperweights—it's a wealth of stimuli.

There is an area of the Luce Center filled with frames, which I think is a great metaphor for the museum as a whole. The museum itself is a huge frame, a huge pedestal. Outside the Luce Center, the rest of the museum suggests an idea of quality: What makes a work a high-quality object or an object that represents a certain point in history? When you see one piece by itself, separated from its context, all of a sudden it can become a masterpiece—something very precious and important. Perhaps because I come from Brazil and I grew up during a military dictatorship, I am very allergic to propaganda or any structured kind of information that comes my way.

At the Luce Center, the sheer accumulation of objects and their casual taxonomy make it like a semantic maze. You're trying to find meaning, and these things are not really leading you in any way, they're not asking you any questions—they just are. You have to look without prejudice. It leaves it up to you, the viewer, to make up your own narrative, to create your own story. You're not just looking at something because somebody told you it's good. You have to figure out how to find your way around a place where you have access to everything at once. It's like the Internet, but it's material. You feel its physical presence. I often say that art is only alive when there's somebody in front of it, so the visible storage is a beautiful idea.

The fact that you have a great percentage of the collection in the Luce Center makes you think. It prompts you to meditate on the idea that most of the information you receive is manipulated in one way or another, is somehow crafted, and is in a certain way biased. The Luce Center is transgressive in that it empowers you. It makes you think about the mechanisms of the museum: how things get shown, and how things do not get shown. It's quite refreshing. It's like the anti-museum.

VIK MUNIZ, *VALENTINE, THE FASTEST*, 1996 ←

THE HENRY R. LUCE CENTER FOR THE →
STUDY OF AMERICAN ART

The Henry R. Luce Center for the Study of American Art makes available for viewing the American fine art and decorative art objects that are not currently on display in the museum galleries. Objects in the Luce Center are arranged by material (oil paintings, sculpture, furniture and woodwork, glass, ceramics, and metalwork), and within these categories they are organized by form and chronology. With the exception of objects that are particularly sensitive to light, such as textiles or works on paper, most of the reserve items are continually on view.

"Schiele has clarity in his humanness, in his presentness: 'I'm here, right now, and not for long.'"

When I discovered Egon Schiele, I realized that actually a lot of his work was done on small sheets of paper. The power, the simplicity, and the clarity in his line are absolutely dumbfounding.

There's nothing easy about the pose in *Seated Woman in Corset and Boots*. In fact, it's very complicated to make it believable just with line. She's got her head twisted away, her hand is between her legs, there's no background, there's no seating. He can imply the delicacy in her fingers, this tension and movement, with this one simple, simple material.

I love accessories, shoes, stockings—the flourishes of human vanity, things that describe a person's choices after being born. What do they wear? How much money did they spend on their teeth, on their hair? These things say a lot about us as social beings. But I'm also fascinated by the nude female body, and I've been studying fertility emblems that express the power of female creativity. In the case of *Seated Woman in Chemise*—in the pose, in the line, in her coyness—it's tender; but then, of course, there's nothing coy about sitting in front of a man with your knees up in the air. Inside this woman is this sexuality and potency that Schiele is trying to draw out in the most humble, pared-down way. As a result, something massive happens.

Schiele really empathizes with poor people and women who don't seem like they have great status. I think he completed this in two minutes—how many people can do that and just move on to the next thing, and not worry about it or go back and try to improve on it? It's also an indication of a young soul and a young mind. This is an artist who died young; this is a person who was doubted as a master. He would draw even if no one ever knew who he was, but his signature is right up next to his work. He's almost like a graffiti artist; it's like a little tag. He's super territorial. He knows he's doing something special.

He's not full-on abstracting, he's not a Cubist, and he's not breaking up the figure violently. He's just giving the minimum amount of information to guide your eye. There's nothing proper about it. It's raw—the way sex is raw, the way relationships are raw.

I have noticed in my work that if I'm seeing things that disturb me, those things come out in my work in an unedited and unfiltered manner. In Schiele's work, he observes the cruelty humans have toward one another. In his emaciated self-portrait, I don't know if he was actually that skinny, but he's trying to think about that idea of the body pushed to its extremes. It's all about this human condition and asking, "Why are we here when life is so rough?"

These are not oil paintings; they're not being painted or drawn with the idea of infinite life. Schiele has clarity in his humanness, in his presentness: "I'm here, right now, and not for long."

WANGECHI MUTU, *ONE HUNDRED LAVISH MONTHS OF BUSHWHACK*, 2004 ←

EGON SCHIELE, *SEATED WOMAN IN CORSET AND BOOTS*, 1918 ↗

EGON SCHIELE, *SEATED WOMAN IN CHEMISE*, 1914 →

Before succumbing to influenza at the age of twenty-eight, Schiele created over three hundred oil paintings and several thousand works on paper. His numerous studies of young women—many shown nude or provocatively dressed, as in these two examples—are treated in a detached manner. Isolated on the page, without any reference to their surroundings, these figures are exquisite studies in line, composition, and gesture.

JAMES **NARES**

A lot of my connection with calligraphy is intuitive, although some of it is learned. My works reference these examples of Chinese calligraphy in different ways. Rubbings were a way of transmitting knowledge or an image. It's like an early form of printing, so in a way it is antithetical to the making of the calligraphy itself, which is a dance with a brush.

I've always been interested in manual events, and movements—transmitting a thought from the mind through the arm and into the hand. Calligraphy has always been, to me, a beautiful marriage of design and personality. You don't want the form to fall apart completely. It's very admirable when you see a perfect character. There are some scripts—some of the older ones—that are very bold. You sense a kind of methodical mind at work, but where it becomes very loose, you feel like you're present at the creation of the thought—as though you're discovering the image at the same time that the calligrapher made it. You share the discovery of the mark that he makes, and that connects you very deeply.

I love the concept of the "flying white" in calligraphy: the space that has no mark is still charged with the movement of the calligrapher. My paintings are all made with one movement of the brush, like a dance. I feel that a beautiful movement can convey a story—there's a beginning, a middle, and an end. If I don't like the brushstroke, my assistant erases it, and I do it again. I'm not very Zen in my practice. I don't meditate for hours and then make one mark, which I think was more in line with the cursive calligrapher's attitude, because they were doing it on paper and couldn't erase it. I love that nothing is hidden. There's no cover-up. This calligraphy is very pure in that way, but the room for maneuvering within each element is endless.

There's something very individual about the calligrapher's art. You're riding a knife edge between design and circumstance, and I'm searching for the best of both.

JAMES NARES, *STREET*, 2011 ←

WANG XIZHI, 東晉 王羲之 十七日帖 十三世紀拓本 →
(*ON THE SEVENTEENTH DAY*), 13TH CENTURY

On the Seventeenth Day is a selection of twenty-nine letters written by the "calligraphy sage" Wang Xizhi (303–61) and collected under the sponsorship of the Tang emperor Taizong (r. 627–49). Original manuscripts by Wang Xizhi and other early masters were already rare in the early Tang dynasty. To preserve and propagate these precious writing models, precise tracings and stone- and wood-carved reproductions were made. Rubbings taken from the carved reproductions provided the principal means for students to study classical models. Extant rubbings of the manuscript date to the Song dynasty (960–1279) or later, which were based in turn on Tang tracings or rubbings.

CATHERINE OPIE

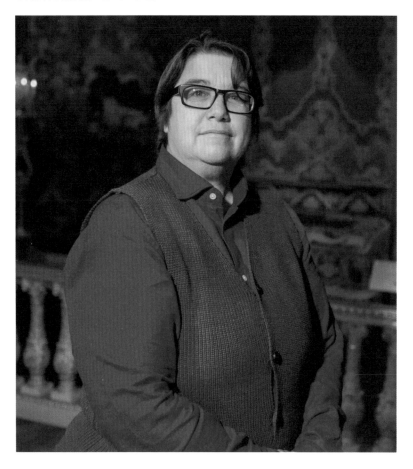

> ## "What caught my attention was this idea that there was a place of imagination that you could explore."

I grew up in Ohio, and I faced a cornfield across the street—that was my everyday life as a young kid. When I was nine years old, I read a book by E. L. Konigsburg called *The Mixed Up Files of Mrs. Basil E. Frankweiler*, and in the book the main character, Claudia, runs away from home to The Met. Being this kid in the Midwest, what caught my attention was this idea that there was a place of imagination that you could explore. I was watching a school group of young kids today walk through Louis XIV's bedroom, and even though the teacher was telling them to line up, you could tell that they just wanted to experience the room as it was to be lived in.

It's a staged space. The room is not just a bedroom, it's also a portrait. It's a portrait of multiple histories in relation to Louis XIV. This room tells a story about that period of time, with this opulence and wealth, and notions of what is valuable or what needs to be seen. For example, in one part of the room, incredible wine-pouring vessels depict mythological scenes, with serpents and a beheading.

Think of the privilege one had in owning these objects, which took a really long time to make. Things are gilded, they're inlaid, they have craft in them. *Craft* is a bad word in the art world right now—you don't want to talk about craft. I actually value that I have really tried to master my medium. The sixteenth and seventeenth centuries have always had a voice within my work, and I long for this time period because of the slowness of the handmade. Even though I make photographs and the hand isn't necessarily apparent in photography in the same way that it is in sculpture, painting, or other mediums, it's in what I choose to look at and how I frame it. Much like this room, the specific moment you decide to describe in a photograph is also a kind of a stage.

I treat these kinds of spaces as if I'm making photographs. I can look at paintings and objects thoroughly and with imagination, and I think that's because I read *The Mixed-Up Files* so many times as a kid. Unfortunately, that's how I also experience most of the world, which can be a problem. My partner's constantly telling me not to stare, to just experience. And I respond, "I am! I'm experiencing by seeing."

CATHERINE OPIE, *SELF-PORTRAIT/NURSING*, 2004 ←

BED VALANCES AND SIDE CURTAINS, CA. 1700 ↗

Known as the Sun King, Louis XIV was one of the longest reigning and most powerful monarchs in France. The arts of the day revolved around the king's personal taste and celebrated the magnificence and formality of his court. Royal symbols frequently served as decoration, and rarely has a style been more closely associated with the personality of a ruler.

PAIR OF WINE JUGS, CA. 1680 →

These jugs are decorated with scenes from classical mythology. On the jug at right, Mercury, commanded by the goddess Hera, prepares to behead Argus, the hundred-eyed guardian of Io, a maiden beloved of Zeus, Hera's husband. On the jug at left, Europa, a princess of Phoenicia, is carried off to Crete by Zeus, disguised as a tame and beautiful bull.

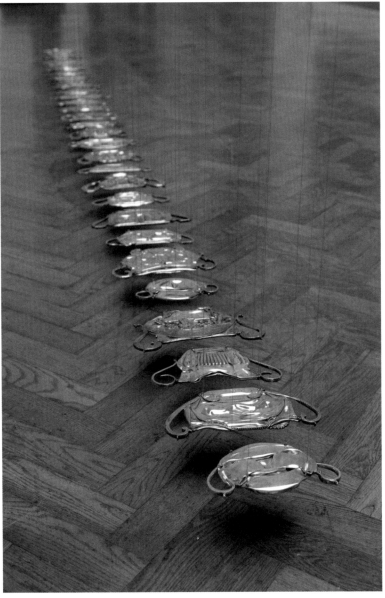

"It's as if you could rewind the film and a second later he'd be alive again."

Something that's very important in my work is the idea of suspension—of reanimating something that's met its end. Robert Capa captures in this image the essence of what I'm trying to do in my own work.

War photography then was pioneering—incredibly brave and foolhardy, especially during the Spanish Civil War. Photographers were not necessarily commissioned—they'd go out speculatively and just work alongside the soldiers. In the case of this photograph, the soldier was a loyalist who is not in much of a uniform—he's almost in everyday dress. To his right is a big empty space, the empty countryside. He looks almost at peace—his face isn't full of anguish. It's as if he is looking into the distance, but his eyes are closed. His arms are open. He's defenseless. He's not in any way protective. He's been caught unaware. He's been caught midflight.

There are very, very few images of people who are dead but still upright. There's no blood; there's not very much viscera. It's as if you could rewind the film and a second later he'd be alive again. But who he is and how he died we don't know. Was he in battle? Or was he posing for Capa and then was struck by a sniper? The more I know about it, the more fascinating it becomes and the more elusive it is. You can't really pin it down.

I've been drawn to images of war since childhood, having been born in 1956—eleven years after the Second World War finished. My mom had fled Germany—postwar there was nothing left there to stay for. She couldn't talk about it at all, but I did know she had been profoundly psychologically scarred by her experiences.

Photography allows us to examine a specific moment over a long period of time. We remember the frozen moment more than we do the moving footage—he's falling, but he's never going to land, and that is much more powerful.

Depicting an act of violence but making a quiet place out of it is what drew me to this photograph—it's captured a limbo between life and death. Is he dead yet or is he about to be dead or…? It's an ongoing moment and utterly contemporary because this is still happening. This man stands in for all the unknown soldiers who have fallen before and all those who are falling since. It's iconic. This could be the ultimate monument to war; it is certainly a monument to the futility of death in combat. People are prepared to risk their lives to defend something they believe in. Gravity only gets us in the end when we're dead.

CORNELIA PARKER, *ENDLESS SUGAR*, 2011 ←

ROBERT CAPA, *THE FALLING SOLDIER*, 1936 →

Arguably the most famous war photograph, this image is all but synonymous with the name of its maker, Robert Capa. Taken at the beginning of the Spanish Civil War and showing the moment of a bullet's impact on a loyalist soldier, this photograph is emblematic of the medium's unrivaled capacity to depict sudden death. It is also prototypical of the style of photojournalism that came to define the work of Capa and his colleagues at the picture press agency Magnum Photos in the late 1940s.

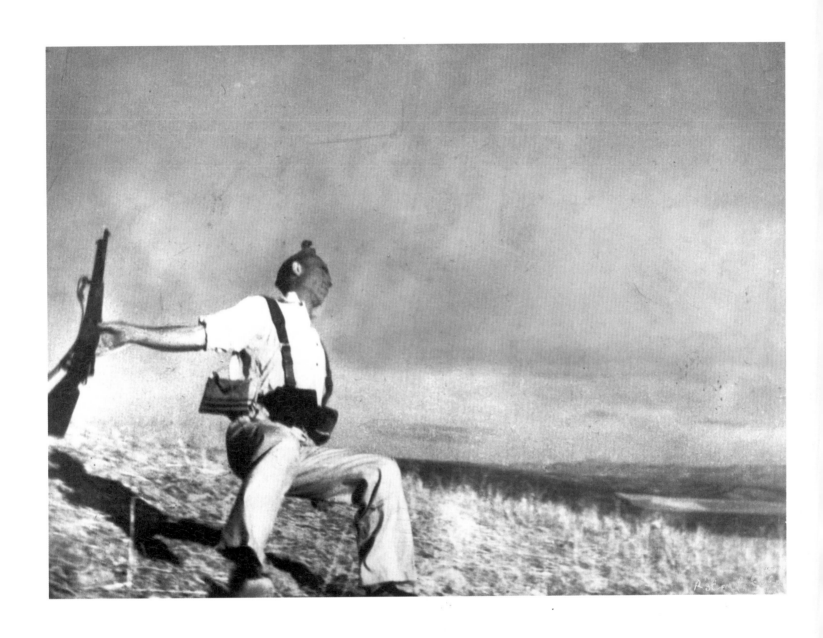

IZHAR PATKIN

"I don't have to believe in Shiva, but...I cannot ignore what this object was meant to be."

I first came to New York from Israel in 1977. Coming from a culture that doesn't have religious images, the first encounter with those images, which often represent not just deep faith but also power, is very unsettling.

A friend of mine was very sensitive to my dilemma. He came to me and he said, "There's something I'd like you to do: make me a Shiva." I said, "Why?" And he responded, "Well, that's the lesson I want you to learn."

I ended up making a sculpture of Shiva in his dancer posture as Nataraja, and mixed it with images of Josephine Baker and Carmen Miranda. It was made of Murano glass—very seductive, very transparent. As soon as it was finished, I called my friend, Pedro Cuperman, and he came over, and I asked, "What do you think of my Shiva?" He said, "You got it now! You learned the lesson I wanted you to learn." I asked, "Well, what was that?" He responded, "What did you leave out?" and I replied, "The word *sculpture*."

This was profound because the statue of Shiva, the god, is not a representation for the believer or an abstraction of the idea. It is a manifestation of the god, so the statue is the god. It's a statue of opposites: of destruction and rebirth, of stillness and of movement. Here I found myself being the vessel of an idea that did not have anything to do with my beliefs.

Walking into the dark gallery where *Shiva as Lord of Dance* is displayed, all of the sculptures look like spirits. The rebellious side of me says, I don't buy it, but if you look carefully, you can see cracks in the pedestal of a sculpture where someone inserted coins as an offering to the gods. There's something so fantastically transgressive there: We don't care we're in a museum. We don't care that the sculpture is presented here as a historical piece. We don't care if this is from whatever century. This is my god, and I'm making the offering.

This is a totally other relationship to the object of art. I don't have to believe in Shiva, but after that moment my relationship to all other statues has been touched by it. I cannot ignore what this object was meant to be.

I have learned that the things I resist the most are probably the things I should study the most, and it's often a good sign that there's a lot to be learned. I see today that the role of an encyclopedic museum cannot be underestimated. It's the one place that requires tolerance as the first rule of entering the institution.

IZHAR PATKIN, DETAIL FROM *THE BLACK PAINTINGS (NIGHT)*, 1986 ←

SHIVA AS LORD OF DANCE (NATARAJA), CA. 11TH CENTURY →

As a symbol, Shiva Nataraja combines in a single image Shiva's roles as creator, preserver, and destroyer of the universe and conveys the Indian conception of the never-ending cycle of time. Although it appeared in sculpture in India as early as the fifth century, its present, world-famous form evolved under the rule of the Chola dynasty (late ninth century–1279). The symbols contained in the sculpture imply that through belief in Shiva, his devotees can achieve salvation.

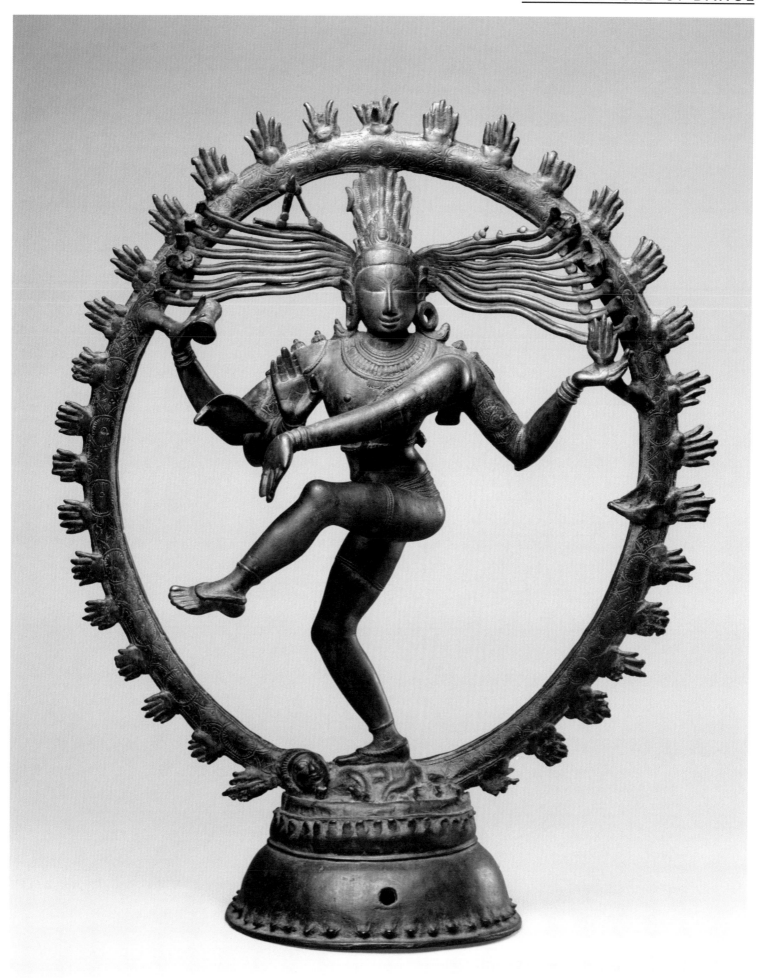

"I'm looking for—even in the hardest edges—a craftsman's relationship to the object that they're making."

For the past fifteen years, I've been crocheting and knitting monumental installations, most of which were ephemeral. This gallery of European armor is not a logical place for me. It's the antithesis of my work in so many ways: it's hard, it's made with a lot of fire, and it's about battle. But when I was younger, knights in shining armor had popular appeal. As a child, I had this obsession with Walt Disney's *Sword in the Stone*, and I would've projected myself into the space inside of the armor. Then as a young adult, after coming out, these works became a perfect place—for me— of-gender identification. I can't avoid that being a part of my own fantasy life about these works.

As a maker of things, I adore the metalwork, the engineering, the forms. It's a kind of fashion as well as a protective device. Later in their evolution, the armor became more fashionable—more exciting as fashion. The forms, especially the Germanic ones— the widening toe, some of the helmets—look like crazy animals.

Since I came to New York, the European armor gallery at The Met has been my default location to go to draw because these forms really articulate the moving body. They offer you all these machine parts to draw. All of the skeletal stuff is on the outside, but it's a different kind of skeleton: something that's machine, animal, and human—a kind of cyborg.

This gallery has helped me follow the stories of craft, of how things get made: the little gestures that the makers put in to talk to each other, which most people wouldn't notice, or the way that one thing gets attached to another, the way they would handle a hinge. There's a certain kind of handling of the metal that is just so lovely and loving. In a way that a viewer might follow the brushstroke on the surface of a painting, I'm looking for—even in the hardest edges—a craftsman's relationship to the object that they're making.

It's not a logical place for me. From a feminist perspective, these are really good symbols of how men fetishize war, but I'm also aware that I can fetishize it, too.

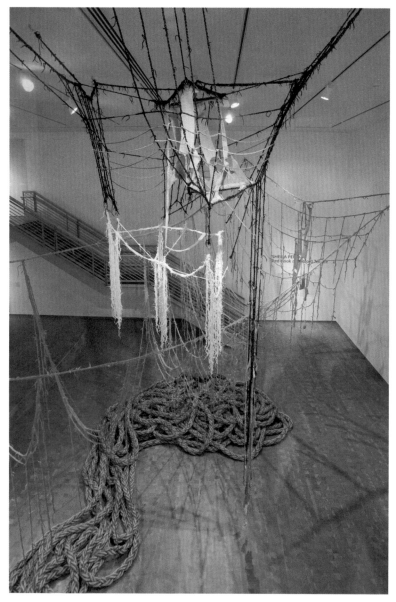

SHEILA PEPE, *RED HOOK AT BEDFORD TERRACE*, 2008 ←

KUNZ LOCHNER, ARMOR OF EMPEROR FERDINAND I, 1549 →

Emperor Ferdinand I owned this armor, as indicated by the heraldic emblems on the toe caps: the imperial double-headed eagle surmounted by a royal crown, which signifies Ferdinand's honorific status as king of the Romans and designated successor to his brother, Emperor Charles V. The image of the Virgin and Child on the breastplate was also used by Charles V on his own armors. The backplate is decorated with crossed staves and fire steels, the insignia of the Order of the Golden Fleece, an elite chivalric society of which Ferdinand was a member.

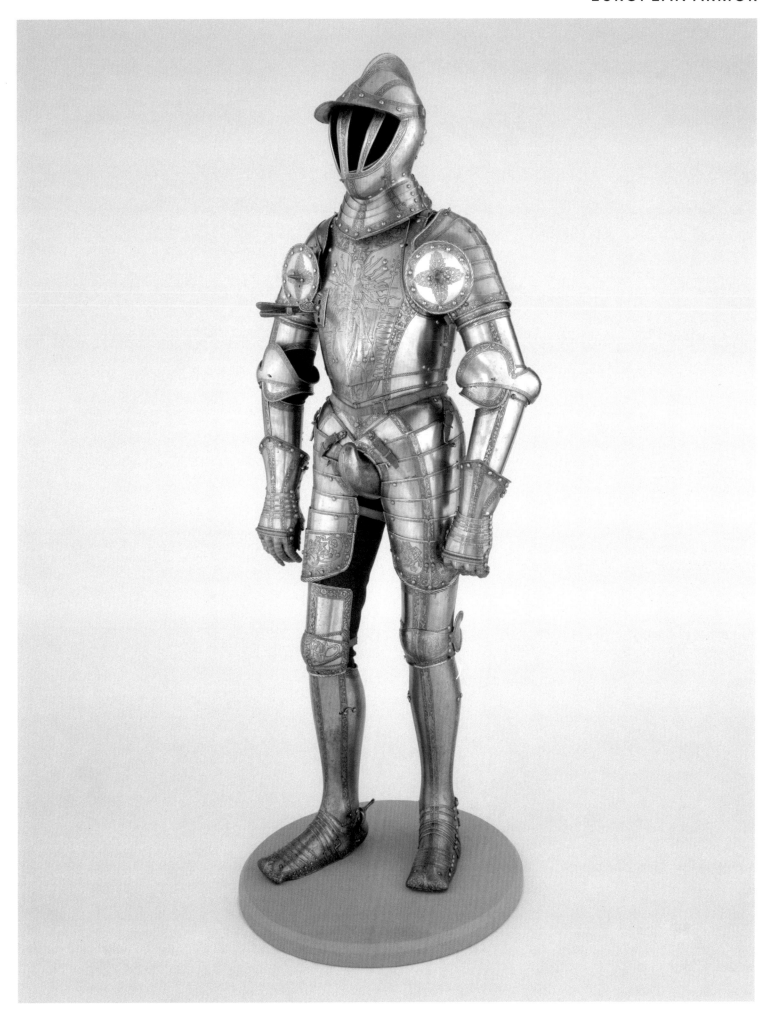

"I like art in which you can see the struggles of making the work."

There are great artists who learn their technique, come to a masterly point where they've reached their goal, and then their next paintings look much like the previous ones. Then there are artists like Joseph Mallord William Turner, who is, in a way, an act of nature. You don't know what he's going to do next. As the years went by, his interest in showing how well he could represent a subject lapsed, and he was won over by what paint could do on its own. He never made completely abstract paintings, but his work prefigured where painting was going many years later.

He could do graphic, realistic technique when he wanted to, as he showed in this scene of Venice. Venice can be merely picturesque in a cartoonish, glossed-over way, but with a work like Turner's you learn about painting. You can see the ship, you can see every sail, but when you draw away from the painting, it gets fuzzier and more loose. The reflection on the water is more painterly, or muddier. In a way, you put yourself in his position.

I don't have a good visual memory, nor am I particularly good at drawing from life. Nature has a tendency to be uncooperative. The sky, for example—ten minutes later it's an entirely different view. How would Turner draw this from life? In that sense this painting is not pure representation. The clouds, the shadow, the position of the boat—you almost experience it at its source. It recalls the story of Turner having himself lashed to the mast of a ship to experience firsthand what it's like to be in a storm at sea.

I like art in which you can see the struggles of making the work: the hits or misses, the faith you have to have to work with a loaded brush, to make a mistake, cover it up, and make it into something else. There are fits and starts; there are stops and new beginnings. When I do a painting, each is a process of learning, rather than me just cranking them out. The brush can be an extension of the arm and the self, and yet you're still extending yourself.

Any Joe Schmo with apprenticeship and focus can learn to paint, but they could never paint like Turner. It's a basic difference between slickness and really painting. It's unnerving. It's dealing with the sublime and nature at its highest point.

THEY WERE A COME-ON, DESIGNED MERELY TO GET THE READER OFF GUARD, SO THAT HE COULD BE KNOCKED DOWN.

RAYMOND PETTIBON, *NO TITLE (THEY WERE A)*, 1998 ←

JOSEPH MALLORD WILLIAM TURNER, *VENICE, FROM THE* →
PORCH OF MADONNA DELLA SALUTE, CA. 1835

Turner drew on his considerable experience as a marine painter and the brilliance of his technique as a watercolorist to create this view, in which the foundations of the palaces of Venice merge into the waters of the lagoon by means of delicate reflections. He based the composition on a rather slight pencil drawing made during his first trip to Venice, in 1819, but the painting is more directly the outcome of his second visit, in 1833. Turner exhibited this canvas to wide acclaim at the Royal Academy, London, in 1835.

SOPHEAP **PICH**

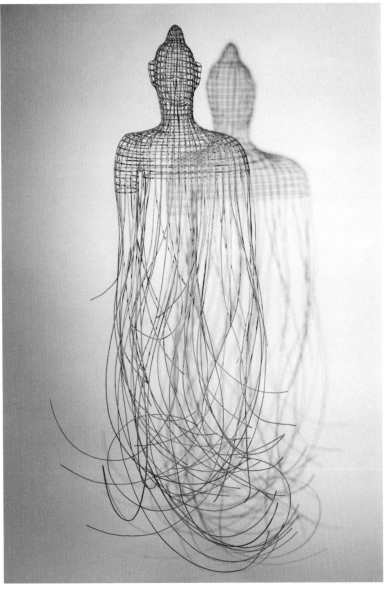

> ## "His drawings are about slowing down. They're about focus. They're about attention, but they're also about being free."

I didn't come to art until very late. My parents always said to me: "Don't be an artist. Be a doctor. Be somebody that can do something for the world. Artists don't do anything for the world." I wasn't convinced that was the truth. I thought that the world was rich and full of possibilities.

I've always said that Vincent van Gogh was a big influence on me. I didn't know how to intellectualize why when I was younger, but now that I'm making sculpture and dealing with line and with building, I see a direct relationship with Van Gogh because he built his paintings and his forms. He had a process of building up lines, which is what gives his works weight and substance.

A part of both of our artistic disciplines is drawing. Drawing is the essential aspect of the life of an artist. In Van Gogh's case, we see a gradual change. In his earlier drawings, he is figuring out how to portray a landscape, a branch, or a stick. In his later drawings, you can feel a sense of resolve. There's a sense of surrender, which I love. There's a sense that he is in front of something that tells him how to look, what to put down on paper—a kind of directness about how to see nature. His marks are telling you that it's interesting, even though it's just a simple landscape, but the line sings to you so you are consumed by it.

There's timelessness in Van Gogh's work. His drawings are about slowing down. They're about focus. They're about attention, but they're also about being free. They have a kind of playfulness. It's not so much about admiring this or that part as it's about admiring an overall being. You can't be in the studio making this kind of work; you have to be in nature.

When I think about Van Gogh, I don't think about the mad Van Gogh. That's not interesting to me. I don't read his biography and try to dig into his psychology. I'm not interested in the whys and wheres or in finding out that he was this and that. I'm interested in what he did. I'm interested in the product that he has produced. I'm interested in the evidence of what he's made. To me, a drawing is evidence of what you've done. This is my journey. This is the evidence that I existed.

SOPHEAP PICH, *BUDDHA 2*, 2009 ←

VINCENT VAN GOGH, *ROAD IN ETTEN*, 1881 →

In 1881 Van Gogh briefly resided in Etten in the Netherlands, where he produced a number of drawings of local peasants and laborers performing routine, humble tasks. This masterful work, in which a man with a broom is seen sweeping a street lined with pollard willows, is a characteristic example.

ROBERT **POLIDORI**

"This work reinforces the way that I see the world."

People say I photograph empty rooms, but I think of my work as portraits of the individuals who may inhabit—or at least use—the space, without them being present. I'm interested in the superego: how people want to project who they think they are and who they want to be.

This painting first caught my attention in late August or early September of 1969, just a few weeks after Woodstock. I came to The Met high on acid, and I was drawn toward her face. It's fitting because she's in an altered state herself. Even though she's looking outward, she's actually looking inside of herself, like inner visions and subjective states. It's about looking beyond.

I used to look at this painting and smile; I'll always have that memory of my initial beholding of it. Over time, though, I've taken it much more seriously. The first time I saw the painting, I didn't pay much attention to the fact that it is the historical figure of Joan of Arc. I was just taken by her eyes.

Joan of Arc claimed to have visions of saints that she identified with. The transparent saints and angels in the back—these are literal illusions that the painter made. The figure is holding a leaf. Her mind is not really on corporal or material things, but she's holding on just to stay on earth or she'll levitate away.

Most of the monotheistic religions look at nature as something to be tamed: an arrogance of monotheism that science has corrected. I see it as an affirmation that the chaos of nature is greater than man.

When you look at the best portraits, you either see love in the face or you fall in love with the face. Jules Bastien-Lepage's faces are not about that. Here when you gaze at her face, it unlocks your internal gaze of looking into your own soul. That's what I love about this painting. This work reinforces the way that I see the world. He was looking for an inner truth.

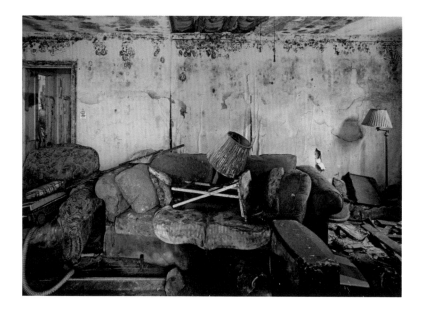

ROBERT POLIDORI, *5417 MARIGNY STREET, NEW ORLEANS, LOUISIANA*, MARCH 2006 ←

JULES BASTIEN-LEPAGE, *JOAN OF ARC*, 1879 →

Joan of Arc, the medieval teenaged martyr from the province of Lorraine, gained new status as a patriotic symbol after France ceded the territory to Germany following the Franco-Prussian War (1870–71). Bastien-Lepage, a native of Lorraine, depicts the moment when Saints Michael, Margaret, and Catherine appear to Joan in her parents' garden, rousing her to fight against the English invaders in the Hundred Years War.

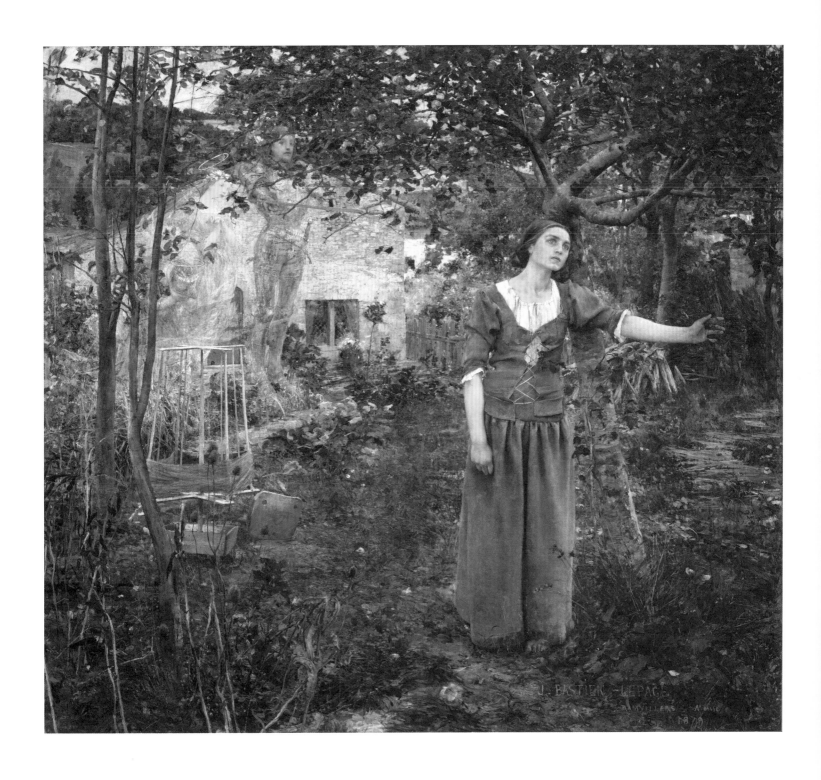

RONA PONDICK

"I look at the fractures as though they were intentionally made that way."

I'm an artist who has used body fragments in my own work for thirty years. I grew up in New York and spent my youth wandering the Egyptian galleries, not really knowing why I was so attracted to them. It's been almost like a love affair, and because I encountered them so young, it has the resonance of a first love.

There's no movement in Egyptian art. It's about a stance. It's not as if the figures are dead at all—they feel very alive. They're not frozen, but they're not moving. It's about internal tension; it feels like they're going to explode outward.

For example, there is a group of sculptural fragments, and the way they are installed shows how those negative spaces between the fragments are energized, and the whole display becomes choreographed like a dance. Each fragment is so resonant and powerful. What's not there informs what is there. The head, the disembodied hands, the torsos become more monumental by not being complete. Your imagination is activated; you become more engaged as a viewer.

I dissect it. I look at the fragments in the case, and I see forms repeat over and over and over again. If I compare just the lips, they feel as though they're the same set of lips. It's not about likeness—it's about capturing the essence of the form. It's so simple that it conveys so much so quickly. There's incredible refinement of form. Maybe the fact that you focus on the fragment with such concentration makes it more powerful. It's poetic. The head is worn away—I just accept it as something beautiful. Winds and rain will affect stone that's outside; it's inevitable. We all want things to never change, but it's not possible.

I look very differently at these fragments than an art historian does, because I'm a maker, so the first thing I ask myself is, how was this made? If I had to make this now, how would I make it?

I look at the fractures as though they were intentionally made that way, as if this didn't happen by a force of nature. Someone didn't just lop off its nose—it always looked like this. It looks perfect. It looks so strong and believable and magical.

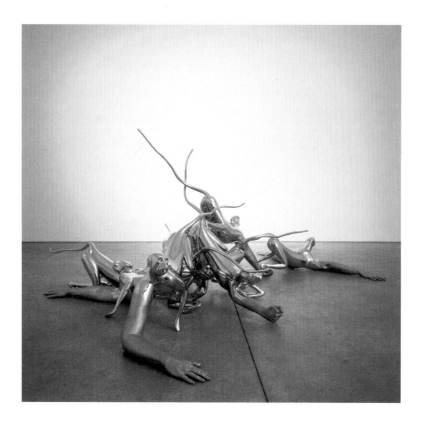

RONA PONDICK, *MONKEYS*, 1998–2001 ←

NOSE AND LIPS OF AKHENATEN, CA. 1353–1336 BC →

This fragment is believed to be a depiction of the pharaoh Akhenaten. The inner corner of one eye is visible alongside the nose. Although there is little to distinguish many representations of the king and the queen, particularly relatively early in the Amarna years, the especially long line alongside the nose and lips and the sinuous upper lip support this identification. The Met has many indurated limestone sculptural fragments from the Sanctuary of the Great Aten Temple, where they were broken up on site by the temple's destroyers. These fragments show considerable stylistic variability.

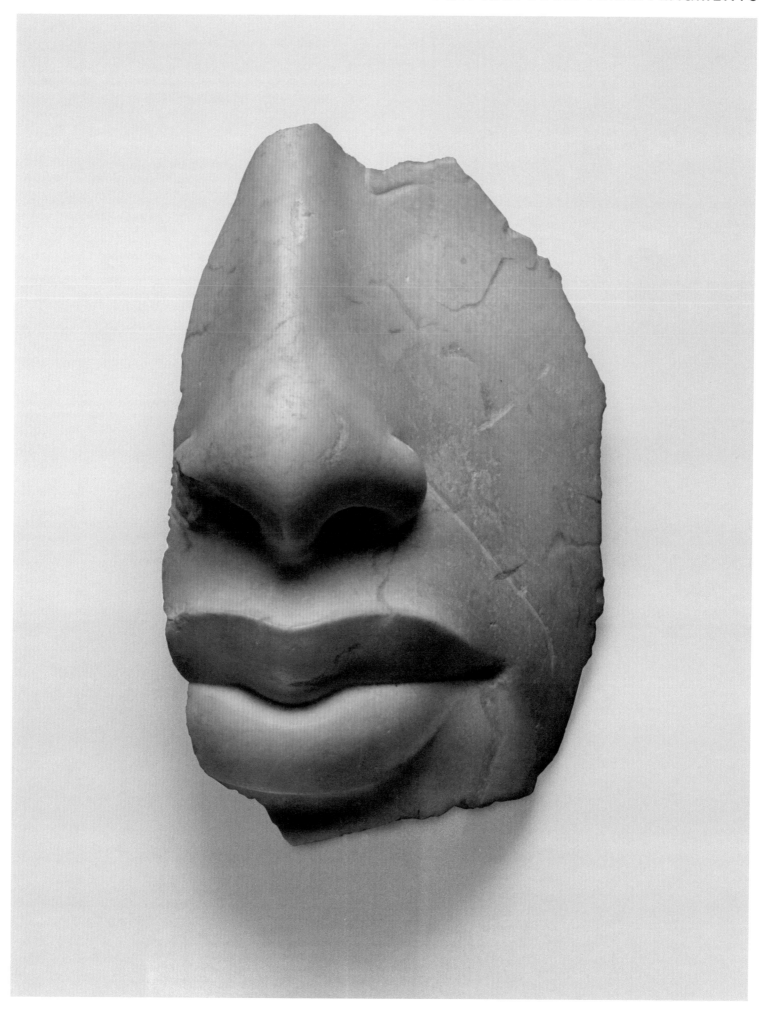

LILIANA **PORTER**

> ## "I like the idea of how it's possible to have something so close and yet so far, so familiar and yet so unknown."

I work with different techniques—printmaking, painting, video, even theater—but what is important to me is the subject matter because I'm interested in the ambiguous space between reality and representation. I'm always very moved by these types of portraits from the latter part of the fifteenth century because they are very, very precise. It's very difficult to see things from this period as they were seen in their original context. For instance, the dresses and hats—it's impossible not to romanticize them because they're so foreign to us now that they could belong in a fairy tale.

In this portrait, the face seems very familiar, which makes it more intriguing, and then you think, "Why does he have that hairdo?" It's a detail like this that reminds us that this is not somebody from the present. (I read somewhere that the hairstyle was very fashionable in Venice during the end of the fifteenth century.)

Yet, at the same time, he could be your neighbor or someone we know. He looks like a super average, normal person. His lips are not totally perfect, which makes him more human. He's not a prince. It doesn't matter who he is. The fact that there isn't a narrative leaves it open to all kinds of interpretations.

I like the idea of how it's possible to have something so close and yet so far, so familiar and yet so unknown. It makes me more aware that everything is like that, even the things we think we know. There is no description that completes the meaning of anything. For instance, the dictionary has the pretense of containing the meaning of every word, and so it appears that every definition is true and objective and can explain everything. But it's not true. It's almost a joke.

You can take, for example, a person, and count all their hairs and measure everything about them, but I think the more precise you are, for some reason, it's less real. There is something magical about this young man, who is still young after six hundred years. It makes you aware of the distances between the painting and the painter and the subjects who were real at one time. The concept of reality is such an ungraspable thing.

LILIANA PORTER, *DIALOGUE (WITH PENGUIN)*, 1999 ←

JACOMETTO (JACOMETTO VENEZIANO), →
PORTRAIT OF A YOUNG MAN, 1480s

A brilliant miniature painter working in Venice, Jacometto was also outstanding at portraits. He was very much influenced by the Sicilian painter Antonello da Messina, who worked briefly in Venice in 1475–76. Jacometto's portrait has a crystalline clarity, which is enhanced by the black background. The distinctive hairstyle—a *zazzera*—was fashionable in Venice in the 1480s and '90s.

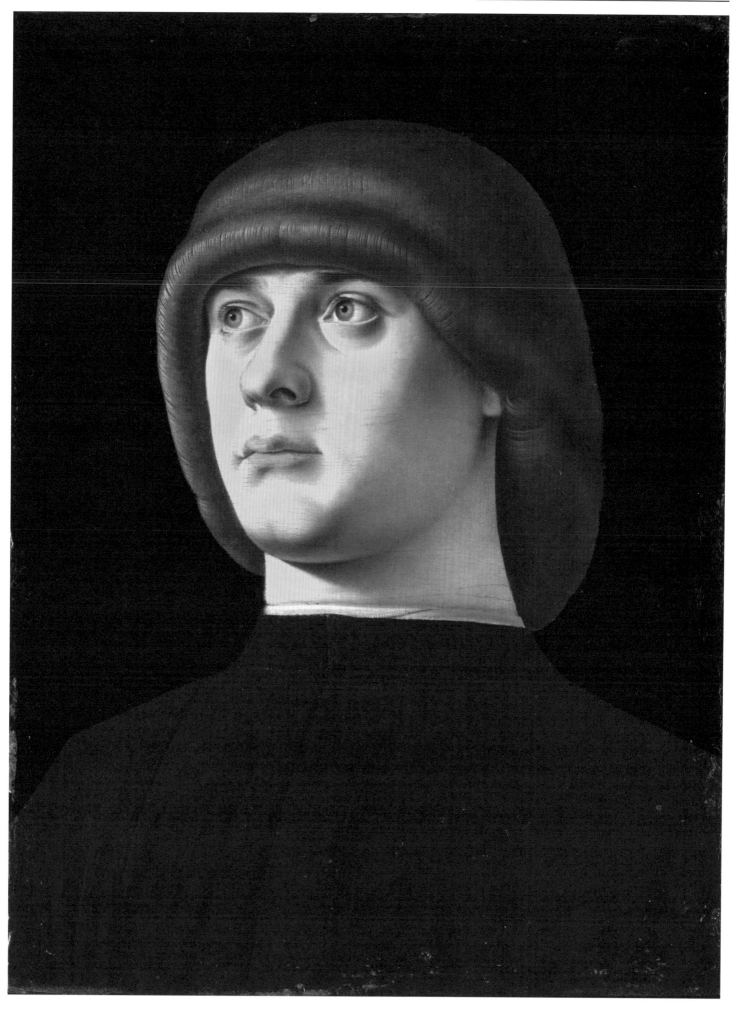

WILFREDO **PRIETO**

"You have to dominate the material, not let the material dominate you."

When artists develop their work, they look to their predecessors to learn what the masters did before, and then they try to create their own message. Auguste Rodin is one of those masters, and a revolutionary. It's a challenge to appreciate a work after you are familiar with it because you start defining it as a certain style. When I'm in a museum, I usually have to go through a process whereby I eliminate everything else that's around—kind of like Photoshopping all the external noise. Then I can see the sensibility of each work.

I know people often think of *The Thinker* and other better-known pieces when they talk about Rodin, but I'm more interested in the different sketches and experimental pieces leading to the final than I am in the finished sculpture. I relate to that as an artist—the process of translating your idea into that which is going to be communicated to the viewer.

I remember when I was eleven years old, I tried to create a hand, and it was such a challenge. The difficulty of creating a hand is a problem that all artists have. When you look at Rodin's work, your reaction is "Shit, I wish I was your student" because he had this enormous freedom with his expressions.

What touches me most is the expression in the materials. You have to dominate the material, not let the material dominate you. I always thought of it as similar to being a baseball player. He has to know the technique and the force with which to hit the ball, but he also has to think further and imagine where he wants to send the ball.

Rodin changes certain proportions in his sculptures, but it's a modification based on the knowledge of the proportions—that's what expresses his proficiency, his control. I've tried to create the movements of Rodin's hands, and I find it almost impossible. They don't look like they're broken or incorrect—they look real. I don't think it was about getting to perfection, like a mathematical equation, but getting to the point where you understand and feel it. Something as simple as a hand becomes the protagonist of some feeling that's essential.

Compared to other mediums, sculpture is a lot closer to reality because of its three-dimensionality. Rodin created a revolution in sculpture because his sculptures reflect something that is closer to living. I imagine Rodin in that moment—with that power and that courage that exist when you're creating a piece and you approach your own way of thinking, your own ideas.

WILFREDO PRIETO, *YES/NO*, 2002 ←

AUGUSTE RODIN, STUDY OF A HAND, →
PROBABLY MODELED CA. 1895

Despite stirring up controversy with the eroticism of his sculpture and the scandals of his personal life, Rodin was nevertheless recognized during his own time as a major artist. He probably modeled the original study for this plaster cast around 1895. It was intended for one of the figures in the monument to the Burghers of Calais but ultimately was not used in the final version of any of the Burghers.

RASHID **RANA**

"A good work of art keeps on becoming new regardless of the time and era."

Unique Forms of Continuity in Space by Umberto Boccioni is still so relevant—and it's been over a hundred years since it was made. The quality this work has transcends its time. It's about the dynamism of speed and everything that the Futurists believed in. Some of the Futurists became involved with the fascist movement, although Boccioni died before that happened. One can always read up about a piece—its historical context and the backdrop against which it is produced—but a good work of art always has more to offer than what the artist intended.

This work is a great example of how the form leads the way. It breaks away from tradition as a homogenizing force: a painter who is making paintings with a Cubist influence decides to make a three-dimensional piece, which takes the same agenda forward into three dimensions. To me, Cubism seems to be a subject matter rather than a visual device. The piece is about time: even if you're looking at it from one viewpoint, the views multiply.

The form is being deconstructed here into different planes beyond the limits of the corporeal body, the muscles and its different facets flowing into space. Not including arms was a smart choice—it's not complete. If Boccioni had introduced arms to this figure, it would have been unnecessarily complicated and the piece would have become too descriptive. Formal qualities—what a work of art or an object offers in itself—are timeless. This may seem historically irresponsible not to look at the fascist agenda, but maybe for a few moments one can give the form and the work itself a chance to show what they may have to offer—perhaps something the artist did not intend but by some virtue is present.

My interest in time and location and its disintegration is a kind of liberation, making the viewers realize the borderlines that exist in our minds. This is a work from the past, and this is a work that can be about future. A good work of art keeps on becoming new regardless of the time and era.

RASHID RANA, *DESPERATELY SEEKING PARADISE I*, 2007–8 ←

UMBERTO BOCCIONI, *UNIQUE FORMS OF CONTINUITY* →
IN SPACE, 1913

The Futurists' celebration of the fast pace and mechanical power of the modern world is emphasized here in the sculpture's dynamism and energy. The figure's marching silhouette appears deformed by wind and speed, while its sleek metal contours allude to machinery. The First World War broke out the year after Boccioni created this work. Believing that modern technological warfare would shatter Italy's obsession with the classical past, the Futurists welcomed the conflict. Tragically, Boccioni was killed in action in 1916, at the age of thirty-four.

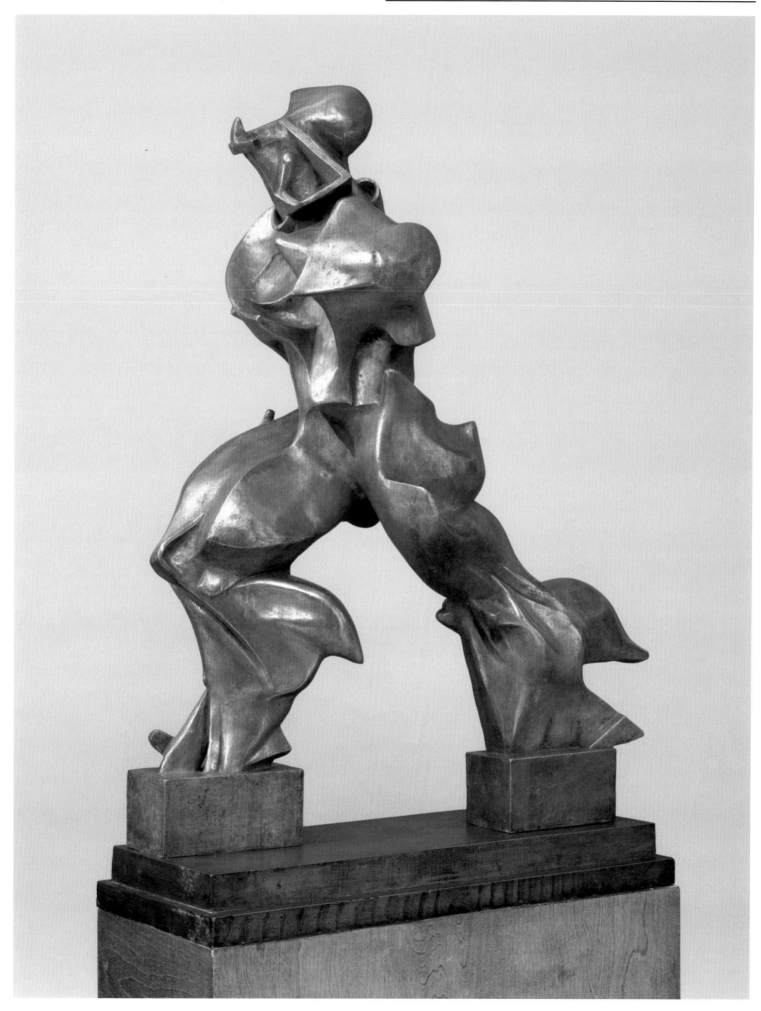

> ## "If we can express ourselves genuinely, it touches; it is universal."

Seeing all these sculptures by Henry Moore is like a dream for me. I'm nearing one hundred now, but I am still struggling and producing. I lived in Paris almost forty-five or fifty years ago. At that time all the great artists were there. There was one tiny street where these masters had studios. All the artists gathered and discussed art. As a young man, I learned a lot from these masters. They were thinkers. They were oriented to Eastern thinking, and this opened up another dimension for me. I just wanted to know more.

In London I met Henry Moore. I was in his school. He brought me to his studio, and I was taken by his sculptures. They were genuine—totally felt. I grasped what he was doing with sculpture. The feeling that flows through the artist into the work—that moment is freedom. That type of experience isn't taught in an ordinary education.

Moore was trying to build his sculptures from reality. His sculpture of the figure lying down—it's simple. It's pure existence, and that's enough for me. It's a question of life, and the deeper the artist goes, if it is from the soul, the work flourishes.

Art is an excuse to try to capture a spirit struggling. That is a feeling that cannot be described. It extends into a very spiritual area. Art is a mystery, but it has tremendous meaning. You want to touch that clay, take it out or put it back—it's child's play. If we can express ourselves genuinely, it touches; it is universal.

KRISHNA REDDY, *MATERNITY*, 1954 ←

HENRY MOORE, *RECLINING FIGURE, NO. 4*, 1954–55 →

This expressive bronze, with its mottled green patina, is typical of Moore's work from the 1940s and '50s. Capturing the physicality of the human body without succumbing to exacting realism, Moore exaggerates the woman's relaxed pose and the shape and relative sizes of her limbs, head, and torso. The drapery cascading over her thighs recalls a recent trip to Greece, where the artist was inspired by classical sculpture. Here, as in those ancient sculptures, the woman's head and long neck are held regally, her features abbreviated into a generalized mask.

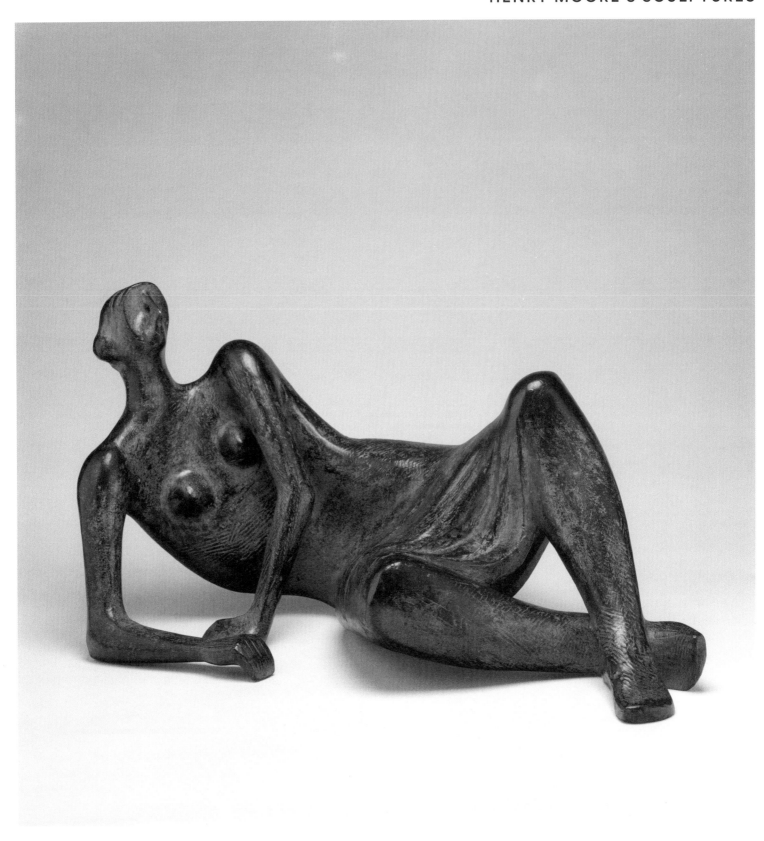

"As soon as you see it, you're caught in a web of meanings and terms."

I love the flat spaces of medieval art. Although this tapestry, *The Triumph of Fame over Death*, was made after the medieval period, it still has that flatness, which is very different than the so-called naturalistic space of later Renaissance art. Its designer was trying to fit as much information as possible into the picture space; as soon as you see it, you're caught in a web of meanings and terms.

In many ways this tapestry is a picture of time. It's based on *The Triumphs (I Trionfi)*, a poem written by Petrarch about the great rotational cycle of life. The words woven into the tapestry are an effective, simple way of stating to the viewer, "Decode this."

This work serves as a diagram of the states of being. Fame is shown as a lady with an enormous trumpet, although what the tapestry celebrates is not fame but renown, which continues after death. Alexander the Great, depicted in the center of the tapestry, is most famous even though he died young. At the bottom of the tapestry is the mythological figure of Atropos, the oldest of the Three Fates, who is the cutter of the thread of life. I imagine this would have had special significance for the tapestry's makers, who were literally weaving the thread of life.

The two elephants, traditional symbols of fame, are shown being pulled by a rooster and a bat. The rooster symbolizes day, and the bat symbolizes night or envy. Charlemagne's hand holds the symbol of the world surmounted by the cross because he was the first revitalized Holy Roman Emperor.

These were the subjects everyone talked about at this time, and they would have been as familiar to people then as our knowing who's who in *Game of Thrones*: "Is this king as good as Charlemagne, or is he going to destroy us like that last king we had?"

The picture plane has to be tilted up so that you can see everything and the multiple hierarchies of meaning within the work can be illustrated. This creates very peculiar, abstract spaces. For me, it's similar to the screen of a computer, which is a flat space filled with lots of pieces that you keep moving around until everything fits.

We can only imagine the level of correspondence and careful diagrammatic reasoning that went into assembling the tapestry. This might have taken a year of work—different hands coming in and doing a little bit here, a little bit there—and somehow it all had to work out. It incorporates a lot of different ideas. It doesn't insist on one reading; in fact, it insists on multiple readings.

I don't know that I could have held all of that information together without making a diagram of the diagram to engrave it in my brain, which is what I do with my own practice. But I think my practice is very postmedieval as it is. I feel tremendous sympathy for the makers of this tapestry, trying to piece together a tremendously disparate group of ideas but nonetheless poignantly committed to a kind of whole.

MATTHEW RITCHIE, *THE HIERARCHY PROBLEM*, 2003 ←

THE TRIUMPH OF FAME OVER DEATH, CA. 1500–1530 →

In this tapestry—the theme of which derives from *The Triumphs (I Trionfi)*, by the fourteenth-century Italian poet Petrarch—a team of white elephants pulls a chariot in which the winged figure of Fame rides. Dressed in brocade and ostrich feathers, Fame sounds a trumpet, heralding the appearance of two philosophers, Plato and Aristotle, and two rulers, Alexander the Great and Charlemagne. Alexander bears the emblems of the kings of France, while Charlemagne wears the crown of the Holy Roman Emperor and the fleur-de-lys of France. Female figures symbolizing Death are trampled underfoot.

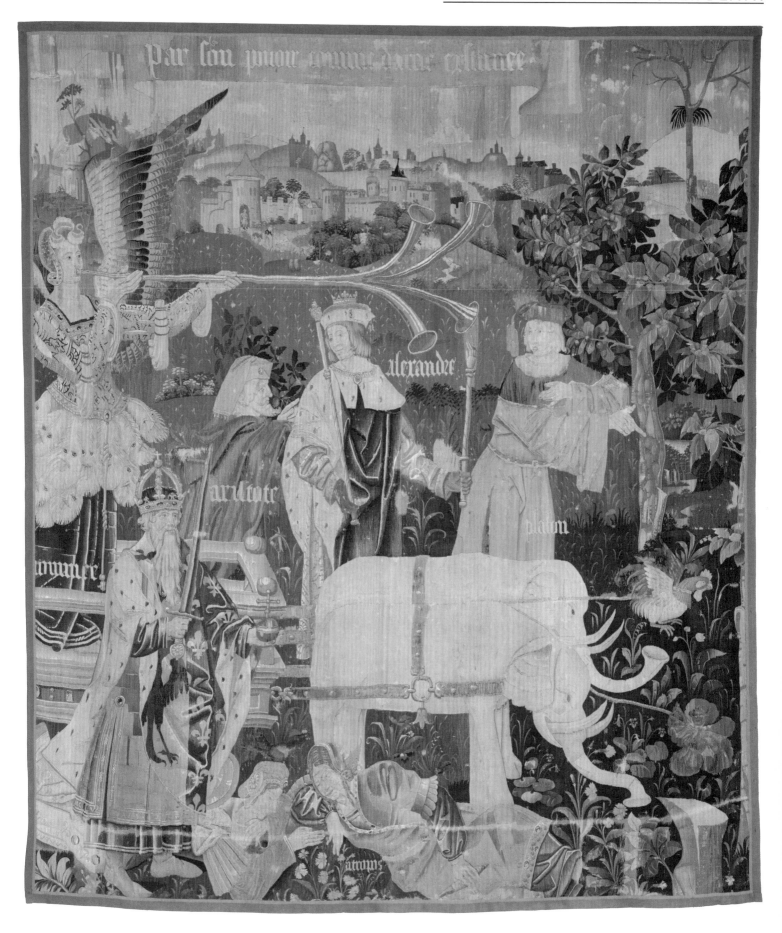

DOROTHEA **ROCKBURNE**

"Art does not exist in singular units—it is a part of its culture."

I have always had an interest in ancient civilizations, so it was natural for me to visit The Met when I came to New York. I saw this head and felt magnetic energy between it and me. We all approach art with our own prejudices, and mine is against the large and rambunctious. What struck me about this head is that there is a kindness to the face. It shows the majesty of a true ruler.

I find that the eyes—even blank—contain a gentleness, but nothing weak. If hollow eyes can be piercing, these are piercing. They project; they look at you. There's something about the way the upper line of the mustache falls, and about the line that is created by the way the lips join: it's giving. Nobody likes to have protruding ears, but this sculptor made these the ears of the person he was portraying. That's unusual—typically in ancient art, representations are cleaned up to fit the current style.

This is a portrait of somebody. Art does not exist in singular units—it is a part of its culture—so I can't help but think, where the hell did he come from?

His head aroused the curiosity I have about everything. I ask myself the same question: Where do I come from? If I wasn't an artist, I would have been a scientist. I have never been interested in the latest thing in art. I'm interested in the historicity of art.

I realized a long time ago that art is not like science; it's not like mathematics. It doesn't improve. The work that was done in 2000 BC is still relevant as art today. That's fascinating to me; it's a conundrum. There is no new invention in art. You can make abstract art, you can use modern materials, but it doesn't compete with ancient art. Not that ancient art is better, but this work is still relevant, and that makes my soul itch. It makes me want to work.

DOROTHEA ROCKBURNE, *STUDY FOR SERAPHIM: LOVE*, 1982 ←

HEAD OF A RULER, CA. 2300–2000 BC →

The identity of the person depicted by this life-size head, created in ancient Mesopotamia, remains a mystery. The expert craftsmanship and innovative technology involved in shaping it and casting it in copper alloy, a very costly material, indicates that it represents a king or elite person. The head's unusually individualized features suggest that it might be a portrait. Were that to be true, the head would be a rare example of portraiture in ancient Near Eastern art. Recent examination has revealed that the head, long thought to be virtually solid, originally contained a clay core.

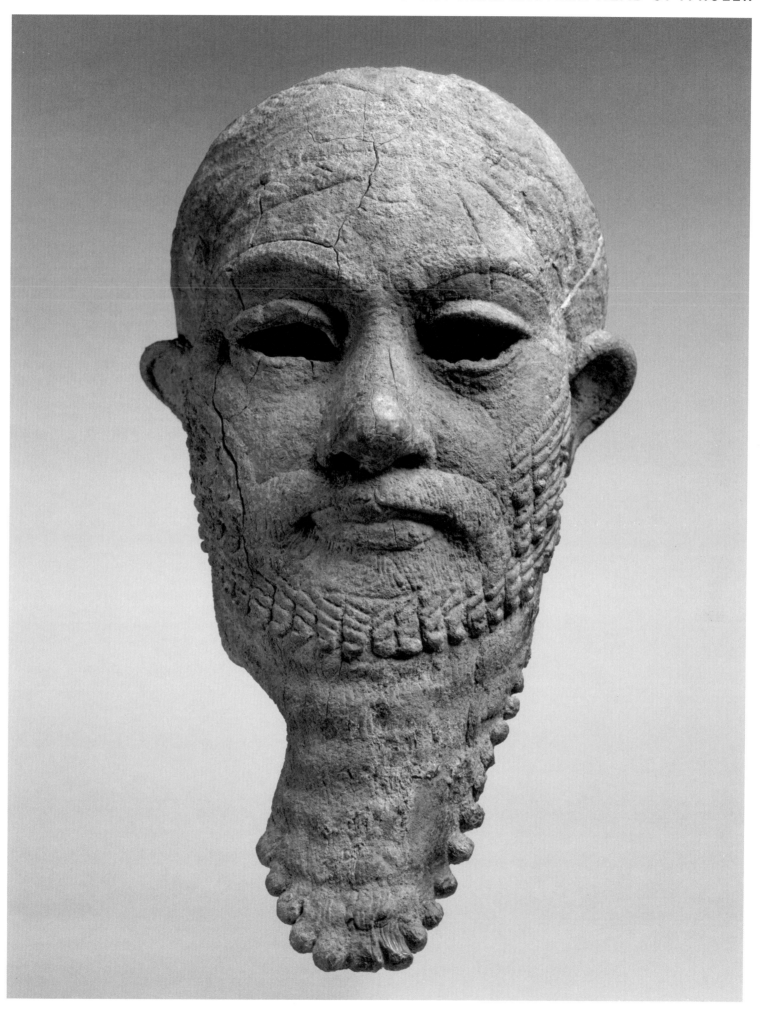

ALEXIS **ROCKMAN**

"This picture is a time capsule and a heartbreaking artifact."

I'm very aware of the fragility of civilizations and how many have come and gone—my mom is an archaeologist. I grew up in Manhattan, but I've always had a sense that we're just like a little eggshell that's waiting to crack.

This painting is a great example of Martin Johnson Heade's travels to Brazil and his ability to construct highly romantic but scientifically accurate paintings of exotic travel. Someone described Heade as a romantic masquerading as a realist. This picture is a time capsule and a heartbreaking artifact, and that attracts me to it because, as a result of deforestation, it could be the only record of the black-eared fairy hummingbird. Heade originally wanted these paintings to be a field guide, and as a generalist, an artist at that time could actually contribute to scientific knowledge. This is virtually impossible now because we live in a culture where everyone is very specialized.

Heade was aware of Charles Darwin and the idea of sexual selection. Passionflowers are about seduction—it's visual and olfactory. What's more fun and interesting and amazingly challenging to paint than a flower? It's high chroma; it's symmetry; it has space but it's also almost abstract. The fact that he's privileging things that weren't ordinarily privileged in art history is fascinating to me.

This was painted during the time when dioramas were popular, and this work might have something to do with that as well. Dioramas are very theatrical—they're right in your face—and the background isn't incidental because it's atmosphere and theater.

Think about the Grand Tour—if you were an educated gentleman, you had to visit various places around Europe. I see this painting as part of that tradition: it shows treasures of the Americas and their natural resources and about how you can find the sublime in those things. The fact that Heade went to these places gives his work credibility and authenticity.

Until the 1990s, people were buying these kinds of paintings in garage sales. People didn't care about Heade's work. Various figures throughout the twentieth century frowned on the idea of illusionism, but I identify with the underdog. No one in Heade's time could have fathomed that the vastness of South America could be in peril, and that's heartbreaking. This work shows that these subjects are worth considering.

ALEXIS ROCKMAN, *HOST AND VECTOR*, 1996 ←

MARTIN JOHNSON HEADE, *HUMMINGBIRD AND PASSIONFLOWERS*, CA. 1875–85 →

From 1880 to 1904, Heade, an ardent devotee of natural history, contributed over one hundred letters and articles on hummingbirds and related topics to *Forest and Stream*. Although he became fascinated with painting hummingbirds as early as 1862, the majority of his compositions date between 1875 and 1885, after his final trip to South America. The particular species of the hummingbird represented in this painting is the black-eared fairy, whose habitat is the lowlands of the Amazon basin, as is the passionflower's.

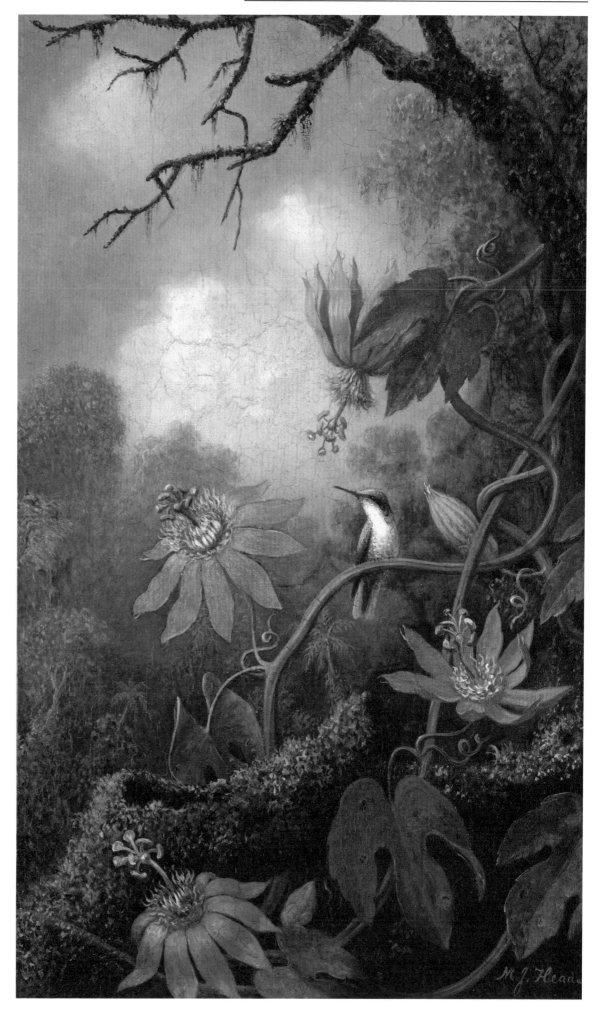

"Each one is different because of the mere influence of the human hand that painted them."

The art I love doesn't have to be to my taste or my style. It can be like other things we love and know well, like certain workaday world objects that give us joy. I don't even have to go to the museum; I can go to the market and look at the rows and stacks of things and get fueled by the experience. Ceramics have that effect. I make sculpture, I've always worked in clay, and as an artist who makes tangible objects, I don't think there's any greater satisfaction than making something that you can use in the real world. This closes the gap between the visual and the sensual.

The goddamn Metropolitan Museum! Every exquisite example of a treasure—the epitome of greatness in terms of culture and art—exists here. This doe—she's small and insignificant until you really catch her eye. Then there's this kind of connection. I love to believe the fiction of her—a somewhat woeful and desperate attempt by the artist to replicate something in nature.

It's remarkable that there are two examples here from the same mold. They're fabricated, but each one is different because of the mere influence of the human hand that painted them. Someone paid close attention to the nature of the materials, which they knew behaved in different ways. They applied the glaze on the doe's neck differently than they did on its body. If you only had one example, you would assume this was an anomaly that occurred in the kiln.

I like the brown one better. There's a cruder, less seductive quality about her because she's so plain, but that makes her even more powerful. We build myths around animals and project our symbolic selves onto them.

I don't think of these pieces in terms of great art. I think of them—and all of the works in the museum—in terms of how they can be useful to me as an artist, and what we learn about ourselves from the objects, and how culture is propelled forward by the pieces that we make.

I really don't know why we're compelled as humans to create, but I'm equally seduced and compelled by art.

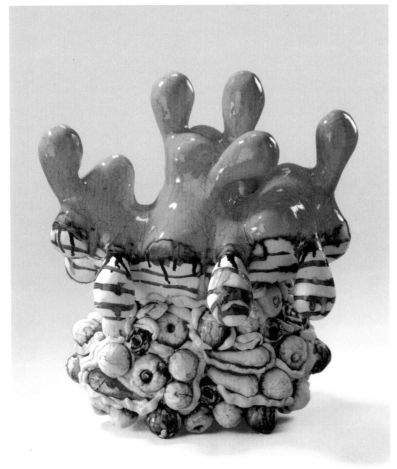

ANNABETH ROSEN, *VELO*, 2006–7 ←

FIGURAL SPILL VASE, 1830–70 ↗

FIGURAL SPILL VASE, 1849 →

The middle of the nineteenth century witnessed a proliferation of relief-molded earthenware covered with an allover mottled brown enameled glaze—often referred to as Rockingham ware, in homage to similar ware first produced in England on the property of the Marquis of Rockingham. These two examples of a figure of a reclining doe were likely intended as a mantel ornaments. The hollow tree trunk behind the doe was used to hold paper or wood spills for lighting candles or oil lamps.

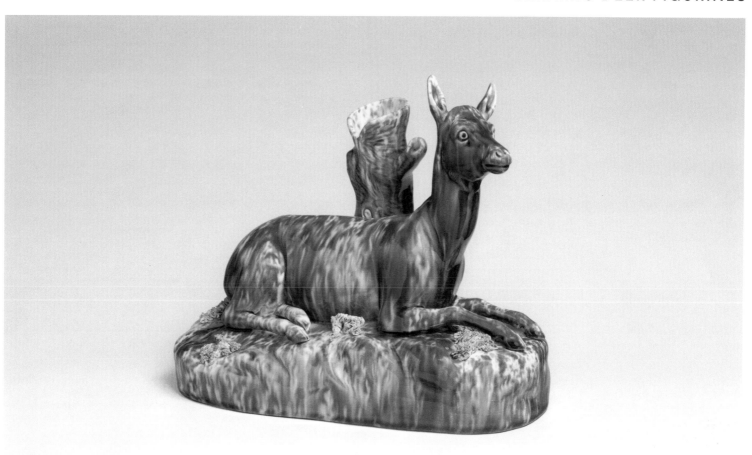

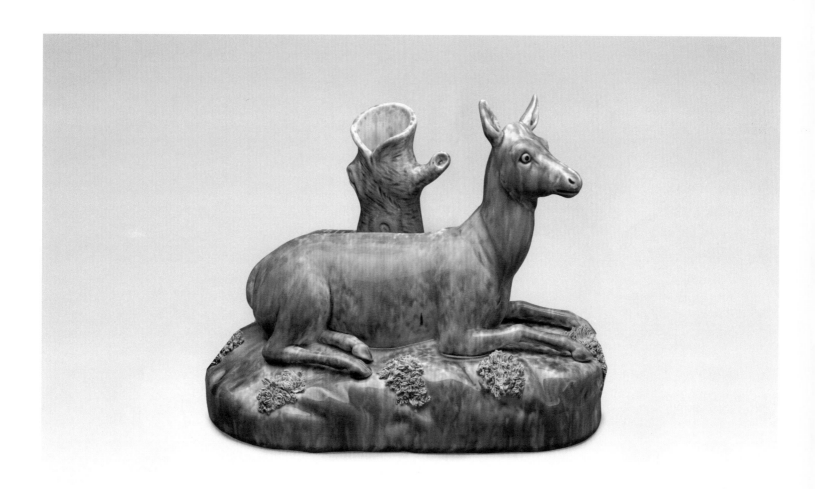

MARTHA ROSLER

"It's like another world floating in the clouds."

I have always gone to The Met Fifth Avenue to sit and think and look at work, but The Met Cloisters is, in itself, a work of art. Even in its name: it's cloistered, set apart, and self-enclosed. It's like another world floating in the clouds. I'm from Brooklyn, and when I was growing up, the Cloisters might as well have been in the clouds. In those days Brooklyn was nowheresville. It was where you wanted to get away from, to move toward high culture. And what could be higher than a medieval setting way up at the top of Manhattan?

My first exposure to the Cloisters was in the early sixties, when the medieval world was very much upon us. Monotonal music was important, and medieval representation suggested the flatness we were taught to seek in Abstract Expressionist painting, which was what I was doing as a student. It was immensely satisfying seeing the way that edges and corners were dealt with in medieval art versus the focus on centrality of later works. For example, a millefleur background where everything is clear and individual, like those often found in medieval tapestries, forms a whole field of representation with potentially limitless boundaries.

Medieval art also opened a space forbidden in Abstract Expressionism, which was the narrative. As a first-generation Brooklyn Jew, I was trying to see where I fit in with the medieval religious narrative. I had a religious upbringing, and the only way to really understand Christianity without feeling alienated or overwhelmed by it was to look at its representations. Medievalism provided a way to think about roots, origins, and community. Tapestries were produced by crews of artisans working together, creating a communal product. They were artists creating in a humble, as opposed to a singular genius, way. What we projected onto the medieval world in the sixties—simplicity and harmony— most distinctly wasn't there. This is what we were craving, after experiencing the Second World War and the fifties and McCarthyism and the realization that civil rights were only enjoyed by white people. Looking at a world where those things appeared to be under control was reassuring.

I love the Cloisters for its retreat quality, but it's not a spa! The great chain of being is apparent in the works on display there. You go there to be exposed to ideas, and I hope that's what we want from art.

MARTHA ROSLER, *SEMIOTICS OF THE KITCHEN*, 1975 ←

CUXA CLOISTER, CA. 1130–40 →

The Met Cloisters, which opened to the public in 1938, is the branch of The Met devoted to the art and architecture of medieval Europe. Located in northern Manhattan on a four-acre lot overlooking the Hudson River, the museum building is an ensemble informed by a selection of historical precedents and a combination of ecclesiastical and secular spaces held together by modern architecture. Architectural elements from medieval cloisters, including Saint-Michel-de-Cuxa, Saint-Guilhem-le-Désert, Trie-sur-Baïse, and Froville, and elements once thought to have come from Bonnefont-en-Comminges, as well as from other sites in Europe, are woven into the fabric of the building.

"To me it's important to be able to say, 'Hey, someone was here making this thing,' when you look at the object."

The more I build things, the more I develop different techniques and idiosyncrasies that I try to repeat that are, in a way, a reflection of me. I feel like I'm successful when my work is a clear expression of my beliefs.

The Shakers' work is a clear expression of their ideology: their austerity and dedication to work and belief that to work is to pray. That's something I live for. I don't take vacations. I consider them to be a waste of resources. The only true resource that we have as human beings is time.

Look at every object in this space and imagine every object in your bedroom, and you realize all the crap that you deal with. Everything in this room is there for a purpose; there's no decoration. You hang your coat on a hook on the wall. You hang your chair on a hook on the wall. The bed: the wheels turn sideways so that you can move it to clean it. These were people who, through the narrow focus of their beliefs, invented incredible things, like little tilters on the backs of the chairs, which always seems ironic to me because the idea in this context of leaning back in a chair seems so decadent and indulgent.

The materials the Shakers used are as brilliant an innovation as their designs. Most of the furniture was made of pine because it was abundant, cheap, and very easy to cut. There's also a humility with pine. Much of this furniture is unpainted. We have a saying in the studio: "Never paint a ladder." That's a rule, because you can't see cracks develop if there's paint. It's also a nod to the idea of never covering up your past: embrace your road. I think this idea is especially important in our time, when we have things like iPhones that have no representation of how they're made; there's no evidence that a human being was involved. In the Shaker pieces, you can see the joinery. You can see where someone wove cotton webbing for the seat, and that someone filed down the chair—very carefully. You can see that it's handmade.

To me it's important to be able to say, "Hey, someone was here making this thing," when you look at the object—to embrace the individual. It's a very American idea, and it's interesting to say that in a communal society like the Shakers'. I think that's the one real advantage that art has over industry—it's an expression of the individual.

TOM SACHS, *UNITÉ*, 2001 ←

ARCHITECTURAL ELEMENTS FROM NORTH FAMILY →
DWELLING, NEW LEBANON, NEW YORK, CA. 1830–40

The Shaker Retiring Room is from the North Family Dwelling in New Lebanon, New York. The room served as both a bedroom and, as proscribed by the Shaker Millennial Laws, a place to retire to "in silence, for the space of half an hour, and labor for a sense of the gospel, before attending meeting." The clean, white plaster walls, scrubbed pine floor, and simple stained woodwork aged to a warm ocher reveal three of the most typical characteristics of Shaker design: utility, simplicity, and beauty.

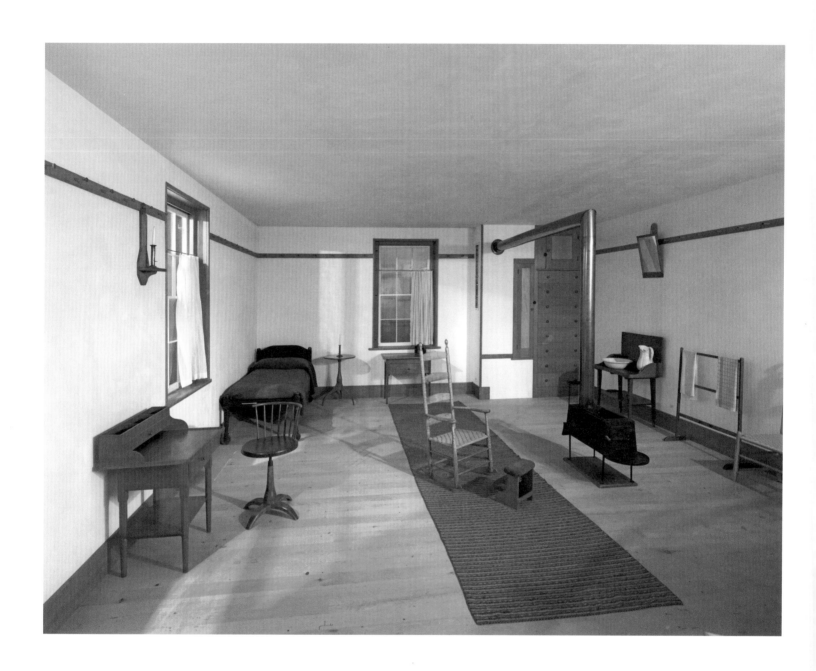

"It's always a great mystery how a painter conveys feeling."

Marsden Hartley approached the world with a pictorial imagination and a receptivity that were in alignment with his subject matter. It's always a great mystery how a painter conveys feeling. How does it work? From where does the feeling arise? Hartley embodies that enigma; it's hard to put your finger on why his paintings have such emotional force. The work resists any kind of sentimentality or easy, illustrative relationship to narrative. Hartley's pictorial imagination and his feeling for his subject matter impact each other in a way that makes the pictures feel immediate.

In Hartley's painting *Mt. Katahdin (Maine), Autumn #2*, the mountain is painted as a single, massive black form; it's a pictorial anchor, and the clouds and sky behind the mountain seem to be hacked out of the same material as the mountain itself. They look as though they were cut out with a jigsaw. Despite their density and mass, they rise and sail; you can feel the *lift* of clouds on a sunny day.

The painting *Lobster Fishermen*, with a very different subject, also has a strong internal architecture: massed forms weighing heavily at the center of the painting are reinforced by black outlines that alternate between fluid and choppy. This alternation has a rhythm; it's instinct plus intelligence. Hartley internalized an idea of painting as an *armature*—something that can support weight, something on which to build forms. As a colorist, Hartley doesn't have great range, but with the palette he does have, he's *all in*. The intense red that happens where the setting sun hits the side of the mountain seems to catch fire—it looks like flames. The red shirt of the lobsterman is heartbreaking in its redness and its pinkness. Hartley understands that when light hits red it becomes pink—the incongruity of that within its rough-hewn setting gives the picture an almost operatic feeling.

You feel that Hartley had enormous empathy for whatever he's painting, whether it's a portrait or a rock. There's a sense that the subject is a container, or conduit for a bigger feeling about life, about life's grandeur, and also about its suffering. These are paintings that could have been painted only by someone hardened to the working-class New England life: the harsh weather, the taciturnity. You can sense a coming to terms with life as something precarious, not benign.

It's the paradox of the tragedian's art: that he can depict tragic events or express a tragic sense of life in a way that is piercingly beautiful. Hartley's art is such *American* painting. It feels so much of its time and place, and also offers such vitality in the present tense.

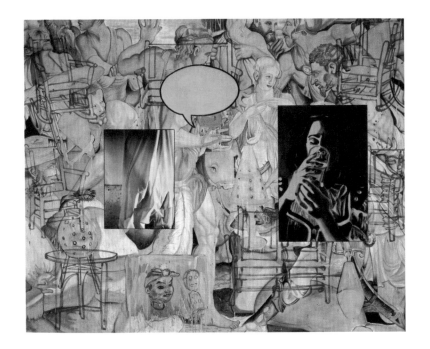

DAVID SALLE, *MINGUS IN MEXICO*, 1990 ←

MARSDEN HARTLEY, *LOBSTER FISHERMEN*, 1940–41 ↗

MARSDEN HARTLEY, *MT. KATAHDIN (MAINE), AUTUMN #2*, 1939–40 →

In the midthirties, Hartley proclaimed himself the "Painter from Maine." From 1940 to 1941, in the small coastal town of Corea, he painted men gathered on a wharf with their lobster traps, a scene that conveys the profound integration of man and nature. Between 1939 and 1942, Hartley created more than eighteen paintings of Mount Katahdin, a peak that, as the northernmost terminus of the Appalachian Trail, evoked both regional and national symbolism. Hartley's flat and rough-hewn depictions of form align his work with folk art, which audiences and critics embraced throughout the period as inherently American.

CAROLEE **SCHNEEMANN**

"They have a sense of fluidity, of the islands being interconnected. That's the feeling of poetry in them."

I have been deeply moved by and rather obsessed with early Cycladic figures. Their significance to us today is poignant. They provide historical context about the destruction of ancient pastoral and goddess-identified cultures and traditions to which we never revert back. They are the symbolic remains that are deeply, physiologically connected to women's sense of their own bodies. The figures are not traditionally sexualized, even though they consistently have a defined vulva.

It's important to me to try to enter these depictions by mimicking their position, their folded arms. Their pose is extremely reverential; it's contemplative, self-contained, and very peaceful. Many of these little figurines are concerned with pregnancy and maternity, and also with death. They always have breasts, and they're rather adorable and simplified. All of these figures have an elegant simplification, a gracefulness: their composed legs and elongated necks that form very interesting phallic shapes. Some of the figures seem protective and pulled in around the body, and you can sense an unease in the position.

I identify deeply with these aspects of physicality. I assume that these figures were all carved by women. I don't feel any sense of a masculine construct. It wasn't until the ancient Greeks, with their masculine gods, invaded the Cycladic islands that the arms open up. Their subtlety—and their sense of safety— is completely transformed.

These sculptures have a tactility and dimensionality that allows us to imagine putting our hands around them or on them. They have a sense of fluidity, of the islands being interconnected. That's the feeling of poetry in them.

CAROLEE SCHNEEMANN, *CYCLADIC IMPRINTS*, 1991–93 ←

ATTRIBUTED TO THE BASTIS MASTER, *MARBLE FEMALE* →
FIGURE, 2600–2400 BC

The function of Cycladic marble sculptures, which predominantly depict women, is unknown. They were likely connected to fertility and were intended to lay horizontally rather than standing vertically. The sculptors' mastery of the brittle stone is extraordinary, and considerable evidence indicates that they were painted. Recurring systems of proportion and details of execution have allowed for the identification of distinct artistic personalities.

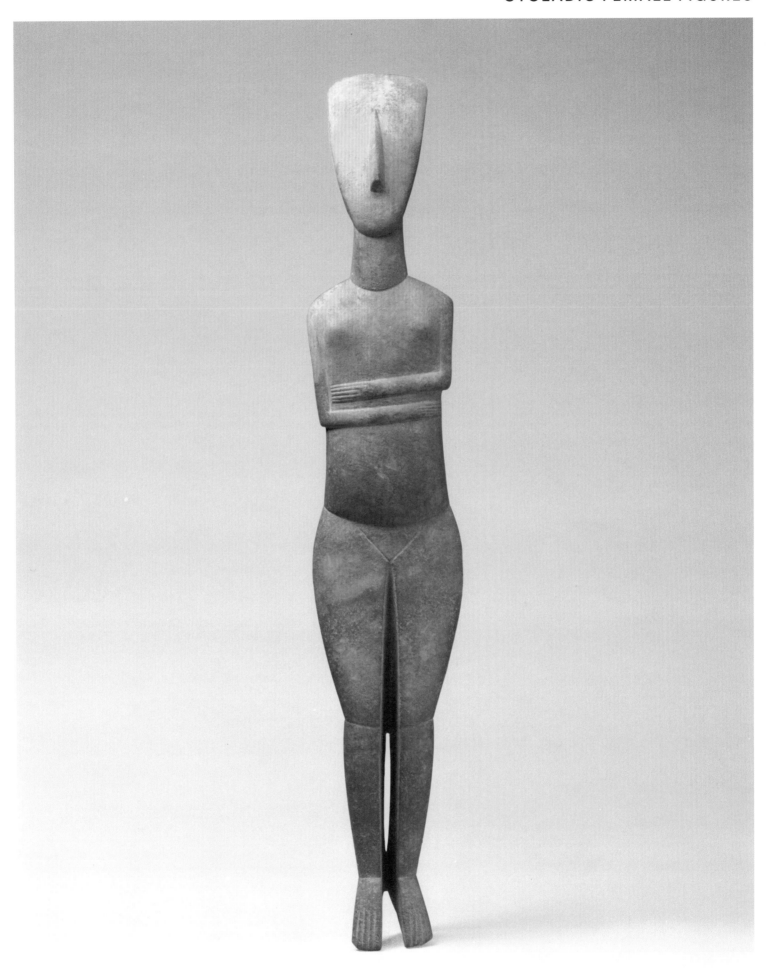

DANA SCHUTZ

"Sometimes you can actually get more from the paintings that bother you."

I mostly make paintings that depict imaginative subjects in hypothetical situations. Balthus's *The Mountain* is a painting that I think about often. It's not a painting that you initially love because it comes off as very stiff and normal. But the longer you look at it, the more psychotic it becomes.

The sense of scale and underlying terror in the painting struck me. The landscape is big and vast, and it feels like the sun is going down and the figures could all die out there. It feels very ominous. Another part of the terror is, you can't tell if the figure who seems dead or struck down is foreshadowing what's going to happen to the others. And then there's a figure in the back who's abandoning the scene altogether.

What's interesting about landscape painting is how time can work between the foreground, middle ground, and background, and Balthus set this up so the further back you look in the painting, the further you can go back in time. But, there's a moment in this painting where time becomes untethered.

Balthus usually uses light to reveal the subject or invoke shame or judgment. In this painting, the light is more about desire. It is used as a way to tie these otherwise-disconnected figures together. The whole symbolic narrative in the painting is happening in the light. There is a couple in the background, showing companionship, and the man in the middle ground wants the woman in the foreground but can't access her.

Not every painting is narrative, but with the ones that are truly narrative, you care about what's happening in them. You wonder what's going on with the characters. This is rare because it's not painting's strong suit.

There's a stuffiness to Balthus—for example, the figures are frozen and there's a certain amount of information that's left out of the paintings; something is missing—but that adds to the tension.

The thing with Balthus is that his work starts to feel creepy. At first it's, "Oh, what a dry painting." But the longer you look, it becomes totally sick, in a way. In this painting, there are hills in the back—they look like they could be breasts—and there's a rock formation that looks like a weird, mangled penis. With Balthus's work, you feel like you're entering the author's head. Whether you like it or not, you're somehow involved with what is going on, with the author's vision. That's really interesting.

It's not my favorite painting in The Met, at all—not by a long shot—but sometimes you can actually get more from the paintings that bother you.

DANA SCHUTZ, *PRESENTATION*, 2005 ←

BALTHUS (BALTHASAR KLOSSOWSKI), *THE MOUNTAIN*, 1937 →

Painting in his austere Paris studio, Balthus imagined and depicted in this monumental canvas an escape from the congested city to the open landscape of Niederhorn Mountain, near Beatenberg, Switzerland. A hiking party of seven explores the mountainous terrain together, yet the figures are strangely isolated from one another, a persistent characteristic of Balthus's work. Invoking life in summer, *The Mountain* is one in an abandoned series of four canvases meant to symbolize the seasons.

ARLENE **SHECHET**

> "When an artist is in love with a piece, the love communicates over time. Thousands of years later, we can still feel it."

When I was in art school, I would go to the library and read books that happened to have been left out on the table instead of choosing one from the shelves. Not surprisingly, my favorite thing to do at The Met is to wander, undirected. It's like being in nature: it's just a wild field, and every once in a while I can bend down and smell a flower.

I've come back to this work over and over again for fifteen or twenty years. The first time I saw it, it struck me as a perfect small sculpture. It's harder to make a small sculpture than it is to make a large one because it's completely unforgiving. Every little gesture, every little crease matters enormously.

I feel that sculpture and dance are aligned practices. A sculptor is also a choreographer, and sculpture is all about body-to-body. When a sculpture is leaning, for example, the viewer will feel that in their own body. This dancer is turning and the work makes you walk around it. As you move around it, you see lines that are created by the textiles. There's no hierarchy in terms of the front and the back. There is no side that's better. Yet somehow we still understand this as a single form.

The weight goes in a single direction at the bottom of the skirt, but then her pointed foot does not touch the ground. From a geeky sculpture point of view, that's a great device. It's brilliant! It gives the piece an emotional availability that it wouldn't have if it were settled. If it weren't for the drapery supporting her, she wouldn't be able to lift her foot and it would be less tantalizing.

The dancer has a come-hither posture, but it's also a don't-get-near-me-I'm-doing-my-thing posture. She is in control and flaunting her female power, not just her availability. In her eight inches, she functions with the power of the eight-foot-tall marble guys wearing flayed lion skins. And this woman is just wearing her clothing.

The original sculpture was probably carved in plaster or clay first and then cast in bronze. That extra process of bronzing gives it a message of preciousness. Here is something that is celebrated, and it's a woman.

It gives me chills because it's so felt—when an artist is in love with a piece, the love communicates over time. Thousands of years later, we can still feel it.

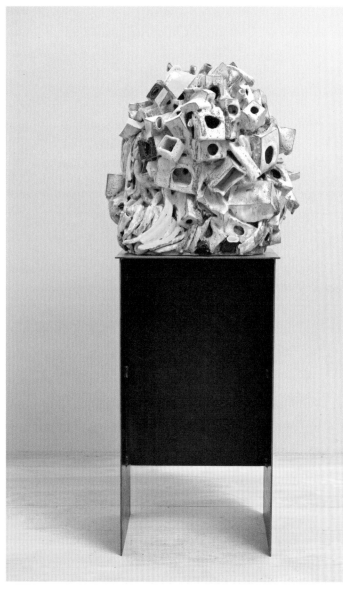

ARLENE SHECHET, *SEEING IS BELIEVING*, 2015 ←

BRONZE STATUETTE OF A VEILED AND MASKED DANCER, → 3RD–2ND CENTURY BC

The complex motion of this Hellenistic dancer is conveyed exclusively through the interaction of her body with several layers of dress. Over an undergarment that falls in deep folds and trails heavily, the figure wears a lightweight mantle, drawn tautly over her head and body by the pressure applied to it by her right arm, left hand, and right leg. This figure has been convincingly identified as one of the professional entertainers, a combination of mime and dancer, for which the cosmopolitan city of Alexandria was famous in antiquity.

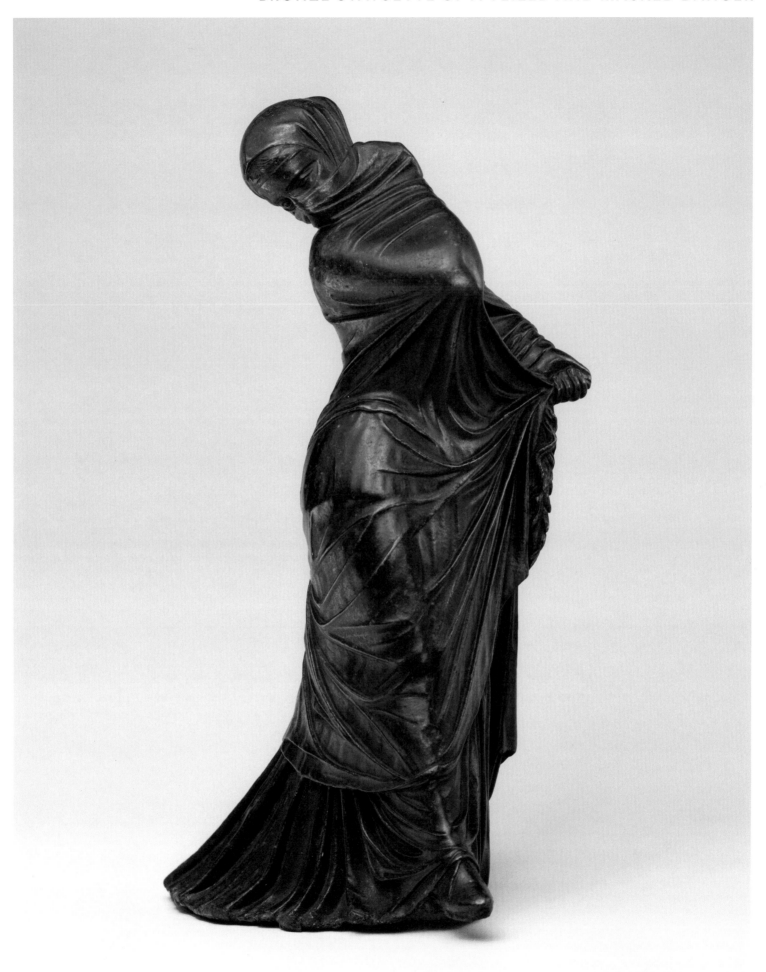

JAMES SIENA

"Art can be a time machine. To have such a direct experience of the past is very moving. The past doesn't feel like it's that far away."

When I was a young artist and a little rapscallion, I thought Jackson Pollock's paintings were too big: they just took up too much real estate. None of those paintings seemed as outrageously deserving of being as large as this mural. My work is small. Even my biggest pieces are small—postage-stamp-sized next to this. This mural blows away the more pretentious work in the contemporary art world. The ambition behind this "Buddha" was tremendous, and today we take it for granted because of the religious subject. This painting was in a temple and served a function, and you see that it had to be disassembled and then put back together. It feels like it's traveled a long way, not just physically from China to New York, but temporally. Art can be a time machine. To have such a direct experience of the past is very moving. The past doesn't feel like it's that far away.

The painting has a pageant composition, so you really can't take the whole scene in at once. You can look at some characters and see their relationship to the central figure, the Buddha of Medicine. It challenges the viewer to really look hard.

The different scales of the characters are remarkable. At eye level the figures are human size, but as you cast your eye upward, they appear larger and larger. I think that whoever painted it expressly intended to make you feel like you were a part of the tableau.

I'm struck by the expressions on the faces of these personages, the calm forbearance in their gazes. Their calm expressions have a physical effect on the viewer: your heart rate slows down or something. I don't consider myself a spiritual person—not because of cynicism or anything—and I may not believe spirituality exists, but the makers of this work did, and more power to them. Do I wish I could feel that? Sometimes I do, but I wouldn't be me if I did. I'm a secular humanist: I believe in science, and I think the mysteries of existence are as thrilling as any faith-based perceptions of the world.

In the case of this mural, the change of context works. What is a museum? A museum is a temple of the human condition. To me, it's just as close to the sacred as I can ever get.

The idea of visiting a work and looking at it again and again—that's an important kind of viewing. It's one of the things I live for. There's something new that I see every time I look at this. But I change, you know? I travel through time, too.

JAMES SIENA, *SQUA TRONT*, 2005–10 ←

BUDDHA OF MEDICINE BHAISHAJYAGURU (YAOSHI FO), →
CA. 1319 (WITH DETAIL)

Healing practices, both physical and spiritual, played an important role in the transmission of Buddhism throughout Asia. In this mural, Bhaishajyaguru (Yaoshi fo), the Buddha of Medicine, is attended by a large assembly of related deities, including two seated bodhisattvas, who hold symbols for the sun and the moon. The twelve warriors, six at each side, symbolize the Buddha's vow to help others. The robust, full-faced figure and the shallow spatial construction are characteristic of the work of Zhu Haogu, who was active in the early fourteenth century.

KATRÍN SIGURDARDÓTTIR

"You can pour your fantasies into it; it is like a compartment for imagination and memory."

I make sculptures. For many years I have been interested in segmentation and partition in sculpture. I have made works that function very much like puzzles, and this is what interests me in the period room. It is originally created as disparate parts, each made by a different artisan—the panels, furniture, drapery, fixtures, carpets—which are then brought together into a composition that represents the lives of both the people who made the room and the people who lived with it. Then, like every work that is collected and brought into the museum, the pieces are reassembled as a memory of their original functions.

One can begin to make a distinction between the room that was and what this room is today. It was originally made for a very private, functional purpose. It was not made for the purpose of being looked at as an artifact.

The museum display is a profoundly public experience, but the period room suggests a more private, embodied one. The visitor is allowed into a very intimate space, meant for one person or maybe two, like a dollhouse in full size. You can pour your fantasies into it; it is like a compartment for imagination and memory. Of course, the illusion is only as thick as the panels, behind which are not the walls of the building in France—you are not in Grasse, you are not in Paris, you are not in the eighteenth century; you are in the museum.

I don't think it's interesting in and of itself to simply deconstruct the idea of the period room and say you are having an inauthentic experience. That's not what I'm trying to do in my work. We read history through the dominant culture, and that's what ends up being preserved. There is so much history of what life was like for most of the world that we just don't have examples of anymore.

You could say the lure or the romance or the dream of the period room is that you are actually transported in time and space. What I see as the purpose of art and the necessity of art is that we are able to get closer to a truth about our life, which we cannot necessarily see or frame through an ordinary experience.

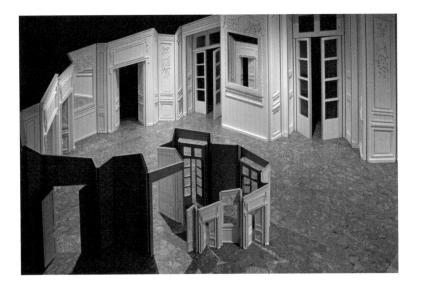

KATRÍN SIGURDARDÓTTIR, *BOISERIE*, 2010 ←

BOISERIE FROM THE HÔTEL DE CABRIS, → GRASSE, FRANCE, CA. 1774

This oak paneling was commissioned in Paris for the new residence of Jean-Paul de Clapiers, marquis de Cabris (1749–1813), and his wife, Louise de Mirabeau (1752–1807). When installed, it lined the walls of a considerably smaller space than it does today. Originally, the room had five sets of double doors (now reduced to four) and an equal number of mirrors (now three). A wonderful harmony must have been achieved by alternating the carved and gilded woodwork with the reflective glass surfaces.

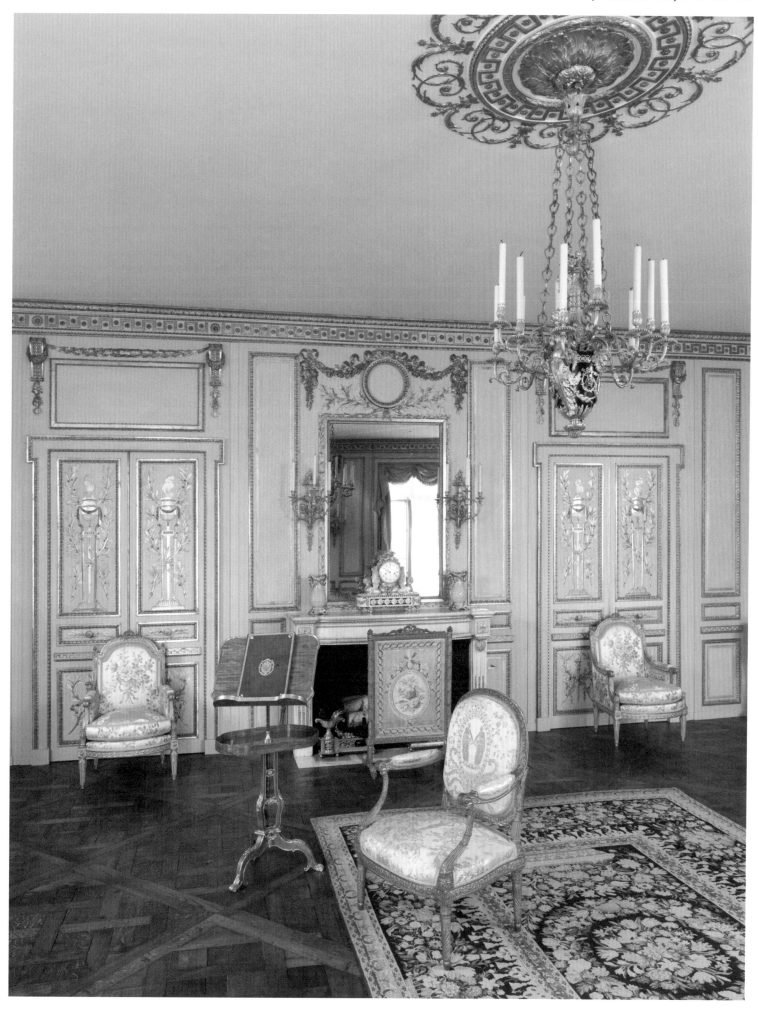

SHAHZIA SIKANDER

"Five hundred years later, this painting still seems so fresh and alive."

I have a very deep bond with miniature painting. I studied it for years as a teenager in Lahore, Pakistan, where I had an apprenticeship to learn the traditional techniques and crafts of the medium. My interest was in understanding the social construct of the so-called traditional genre. Why was it considered a traditional form or a culturally specific form?

I studied Indian and Persian miniature painting at a time when it was not popular, since they were primarily created for tourist consumption. It was a medium burdened with notions of low versus high art, illustration versus fine art, tradition versus the avant-garde. It was really not hip. And that was good! I did not want to be hip—I wanted to learn something. I was trying to cast my own relationship with this genre.

The illuminated folio *Laila and Majnun in School* is from a book that illustrates a poem by the poet Nizami about Laila and Majnun and their story of unrequited love. There are many poems and many miniatures about Laila and Majnun's love epic because private stories are the ones that connect with us the most—they capture our attention, they are retold, and they remain in our memory.

This painting brings to mind a very powerful notion about provenance. What is the original? How does an artist create their own versions of the romance within the challenges of their medium?

For this genre there is intricate stylization: rigor, detail, small scale, stacked-up perspective, complex geometry, color. The style becomes the language, and that language is then passed on to the next generation of miniature painters. All traditional artists had to learn the alphabet, the technique, and the skills, and then regurgitate it.

The dense geometric patterns are, for me, at a stalemate because they provide no release. But when you plunge into the detail with a magnifying glass, it opens up. Looking into the work, not necessarily looking at it, you can see the vastness. It's heroic in scope.

Five hundred years later, this painting still seems so fresh and alive. I see it as a map through which history passes.

SHAHZIA SIKANDER, *ORBIT*, 2012 ←

LAILA AND MAJNUN IN SCHOOL, FOLIO FROM A *KHAMSA* →
(QUINTET) OF NIZAMI, AH 931 / AD 1524–25

One of the best-known stories of Nizami's *Khamsa* (Quintet) is that of Laila and Majnun, a tale akin to that of the star-crossed lovers Romeo and Juliet. This folio illustrates their meeting at the madrasa (school), where they fall in love at first sight. In addition to the young lovers, this highly detailed painting depicts activities typical in the sixteenth-century schoolyard—children burnishing paper, practicing their penmanship, and reading various types of books. Although the story takes place in Arabia, the architectural setting is quintessentially Persian.

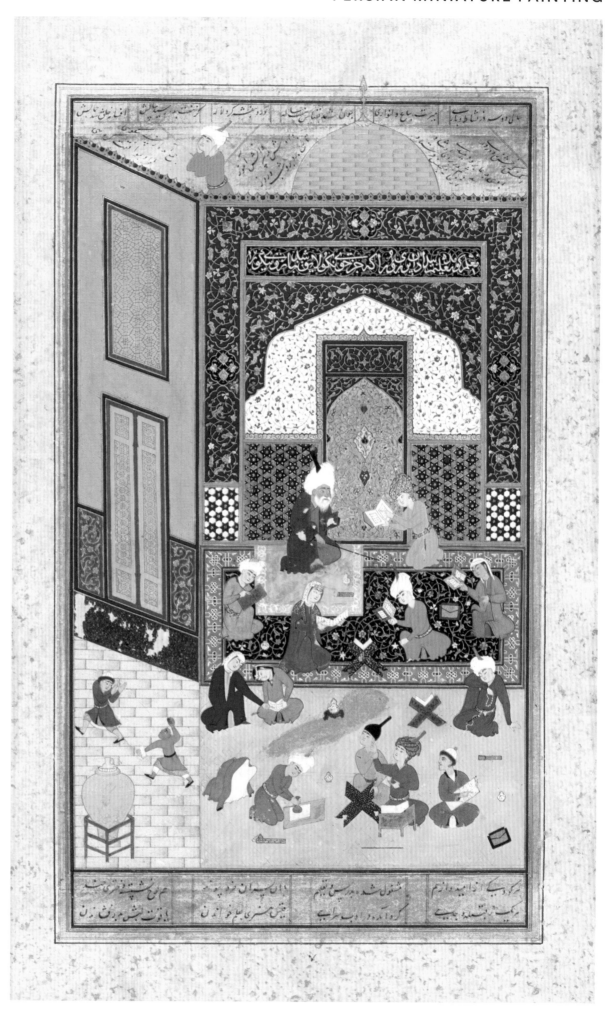

"She had almost a cinematic sensibility; she wanted to tell the whole story."

I've always loved the work of Florine Stettheimer. It's fascinating to me that this woman was so wealthy and yet she made these innocent, gorgeous, complicated paintings. She didn't want to show them to anybody and was very private, which is pretty much the opposite of most artists. Before she died, she asked her sister to burn all her paintings or bury them with her. Fortunately, neither happened, and we get to see all of her work. They're so absolutely beautiful!

Her four paintings, *The Cathedrals of Art*, *The Cathedrals of Broadway*, *The Cathedrals of Fifth Avenue*, and *The Cathedrals of Wall Street*, are often displayed together. They're her iconic works.

Stettheimer was from the "more-not-less" school. She had almost a cinematic sensibility; she wanted to tell the whole story and was like a reporter, watching everything in order to put it down on the canvas.

In *The Cathedrals of Art*, the figures all have an attitude. The guard stands with his arms folded, looking askance. The art dealer sits with his feet on a lounge chair. There's even a journalist with a flashlight on his head, kneeling down, and he's typing. Stettheimer mocked the world that she lived in through these paintings. She was an insider and also an outsider. She had a hard time with the art world. You know, a lot of us have a hard time with the art world. It's a very difficult place.

Charlie Parker always said that it took a long time to play like Charlie Parker. You work and you work and you work, and then you become who you are. It's hard to paint this simply, but that's who Stettheimer was when she went into the studio. She made lots of choices about how delicate to be and how outrageous to be. And even though her figures are flat and very simply painted, they come alive.

The color is absolutely exquisite—her use of darks and lights and pinks, and the way she uses gold. If you look closely, you see that she put down thick paint and then carved into it. She put writing in her paintings. When I write in a painting, they call me a feminist—and it's a dirty word. Stettheimer didn't have to worry about that. I'm sure that no one said to her: "You're a feminist. You can't write in paintings. Don't write in that painting."

But I think that Stettheimer—in her palette and her narrative style—has a female sensibility. She put herself in her paintings. They are so personal and so intimate. These are all techniques that I've been using in my paintings. It was an innate practice of young women making work in the late sixties and early seventies when we said, "We're gonna just do it our way."

JOAN SNYDER, *HEART ON*, 1975 ←

FLORINE STETTHEIMER, *THE CATHEDRALS OF ART*, 1942 →

One in a series of four monumental paintings that depict New York's economic, social, and cultural institutions, *The Cathedrals of Art* is Stettheimer's fantastical portrait of the New York art world. Microcosms of three of the city's major museums and their collections are watched over by their directors: the Museum of Modern Art (upper left), The Metropolitan Museum of Art (center), and the Whitney Museum of American Art (upper right). A gathering of art critics, dealers, and photographers of the day, including Stettheimer herself (lower right), appears around The Met's grand staircase.

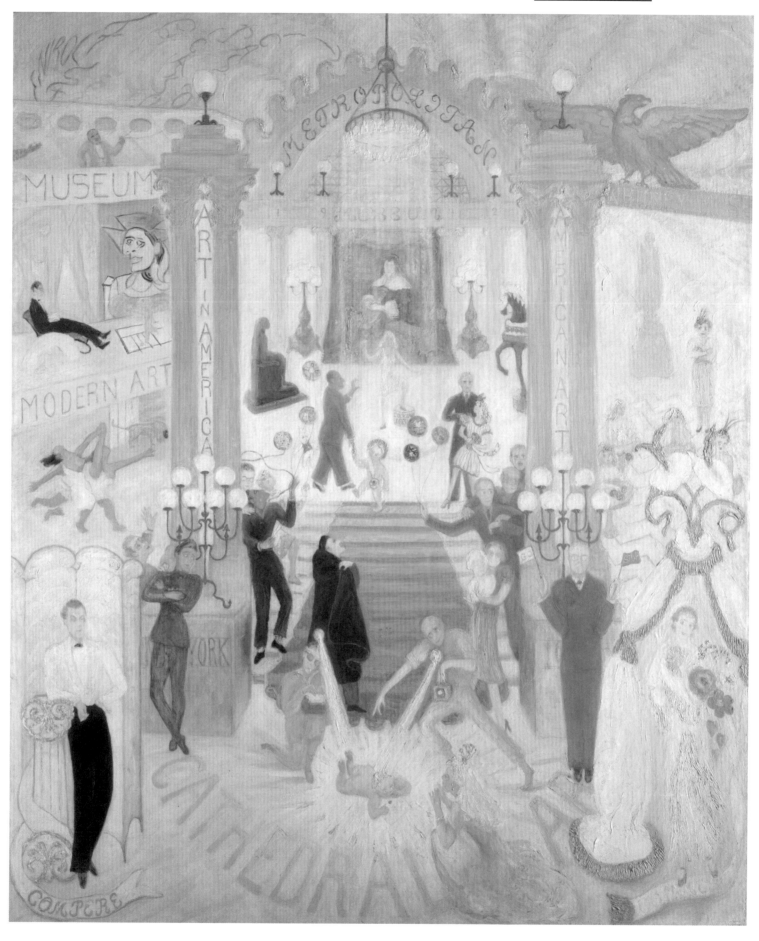

PAT STEIR

"I love the parts where he's broken as much as the parts where he's complete."

There's nothing in the discussion of art today about soul or heart. We're not permitted to talk about it—you're considered a soggy old sap if you do. I can name the pieces of art that bring tears to my eyes, and this sculpture does it. This power figure is an object that has specific magical powers, made by one person and a spiritual guide that directed him to do exactly that and nothing else. I always visit this power figure when I come to this museum, and I'm not joking when I say that the one time I didn't visit him, I fell and broke my foot…so he does scare me.

He's obviously the boss. The nails stuck into his body are symbols of power, not of pain. When I first saw him, I thought, "Oh my God, he's absorbing everybody's pain!" That's not true. He was made to protect a village. He's defensive; he's aggressive. He's screaming, not only at the people who are going to come in and hurt his people, but at the universe. We don't know if the artist made the decisions. It could be that the spiritual advisor said, "He has to stand this way. He has to have his head looking upward."

The figure is so eloquent in its form, and yet he's also sorrowful. He's not out in a little village—the big guy around, beating his chest—but he's doing his best here in the museum, guarding his newfound family in the gallery around him, all from different times and places. He's like a retired football player: he's not what he was, and I love him for that. That's what's so touching about him.

I love the parts where he's broken as much as the parts where he's complete. He was once outside: you can see it from his worm-eaten feet. He's lost the magic medicine that was embedded in his stomach; he lost his power when he lost that. He expresses humanity and human desire and endeavor. Because he's lost so much, he seems human, a friend—protecting my family, protecting me, defending my art.

Even though this power figure is outside of his original period and place of creation, he carries himself through time. A work of art that hits its mark changes the person who sees it: it adds to you. Art doesn't have to be figurative to impact me. This power figure touches me through his figure but also through the creator's intention, because there's part of the heart of the artist in him—more than just intellectually.

PAT STEIR, *SIXTEEN WATERFALLS OF DREAMS, MEMORIES, AND SENTIMENT*, 1990 ←

POWER FIGURE (*NKISI N'KONDI: MANGAAKA*), 19TH CENTURY →

Central African power figures are collaborative creations of Kongo sculptors and ritual specialists. They were conceived to hold specific mystical forces. This example is attributed to the atelier of a master who was active along the coast of Congo and Angola at the end of the nineteenth century. The various metals embedded in the figure's expansive torso document vows sealed, treaties signed, and efforts to eradicate evil—all attesting to the sculpture's central role as witness and enforcer of affairs critical to its community.

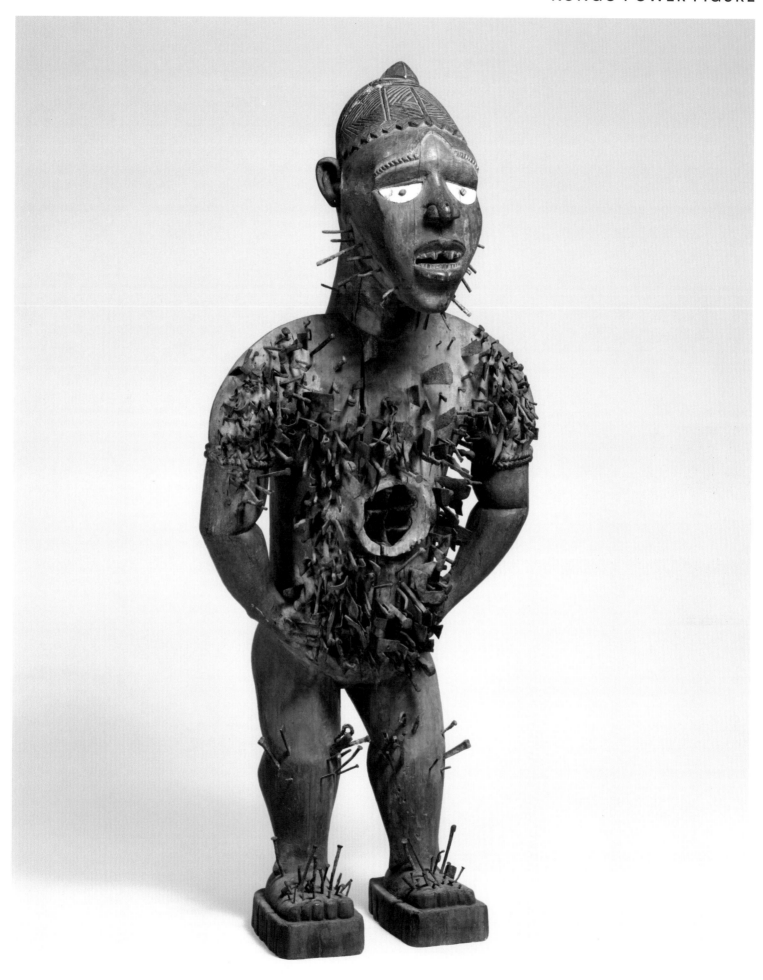

THOMAS **STRUTH**

"You look at an artwork but also look inward, trying to figure out what it means. Can this artwork change my life?"

Manhattan is like a city of dreams—the dreams that people had are present in the architecture of the city. It is not easy to find a silent place, but the Chinese Buddhist sculpture gallery is like an oasis because it's a space of silence. You come to terms with your observations. The way the pieces are installed is quite minimalist, a bit like a typology of Chinese Buddhist sculpture, with five pieces on either side of the room so you see them in perspective, lined up, all facing into the space. It's beautiful.

I grew up Christian. I'm not a believer anymore, but I'm still attracted to spirituality. It's easier for me to identify with the stillness in these Buddhist works than with sculptures of Jesus on the cross. A moment of stillness is in the Bodhisattva Manjushri's gaze: the eyelids are half open, a little bit down. The figure is looking outside but also looking inward.

It's interesting to see how differently each sculpture is portrayed, to read what the sculptor wanted to depict. There's one piece that looks almost like the face of an emperor—it's a little authoritarian. There's one whose expression is extremely mild and focused inward. There's another, which depicts a child who smiles, turns his head around to the side, and seems to be playing.

These sculptures are almost life size, and they're old, so you could say that you're seeing the human figure, aged and humble. I'm interested in the notion of humility. Can we afford to be humble these days?

These pieces were made for temples, as signs of meditation. Meditation also happens in a museum. You look at an artwork but also look inward, trying to figure out what it means. Can this artwork change my life? Can it transform my opinion or my existence in some small or larger way? Does it clarify anything? In general, today artworks don't have a defined purpose—it's an open field.

Any belief is debatable. I'm not a Buddhist, but I find this contemplative space of silence—especially in the times we live in—attractive and recommendable. It's extremely beautiful.

THOMAS STRUTH, *THE RESTORERS AT SAN LORENZO MAGGIORE, NAPLES*, 1988 ⟋

BODHISATTVA MANJUSHRI (WENSHU), ↗
LATE 10TH–EARLY 12TH CENTURY

BUDDHA, PROBABLY AMITABHA (AMITUOFO), EARLY 7TH CENTURY ↗

GALLERY 208 INSTALLATION VIEW →

The Met's collection of Chinese Buddhist sculpture illustrates China's complicated adaptation of Buddhism. Buddhas are beings that have achieved a state of complete spiritual enlightenment, no longer constrained by the phenomenal world. The position of the Buddha's arms (at above right) indicates a gesture of meditation and suggests Amitabha, a celestial Buddha who presides over his Western Paradise. Devotion to Amitabha was a major component of Chinese Buddhist practice beginning in the sixth century. Bodhisattvas are also enlightened but choose to remain accessible to others. The scroll that this bodhisattva holds in his right hand (at above left) identifies him as Manjushri (Wenshu), the personification of profound spiritual wisdom.

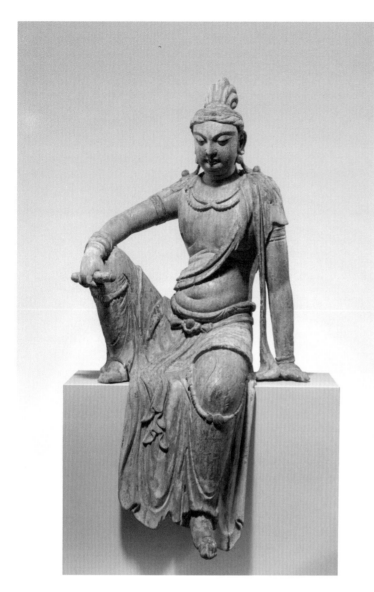

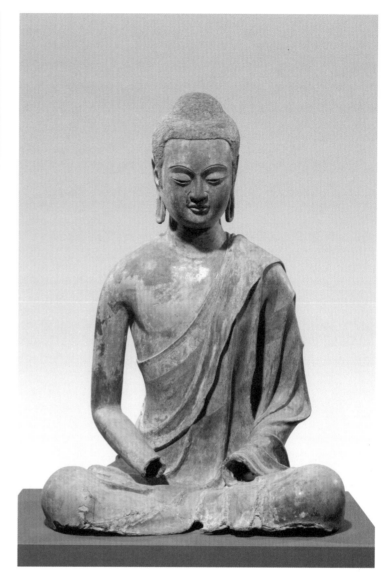

HIROSHI **SUGIMOTO**

"It's like conceptual art to me, even though it was painted in the fifteenth century."

The passage of time is a very important factor in my art as a photographer. Although photography seems to stop time—showing a moment—I capture its passage by using long time exposures. That's why I'm very interested in this fifteenth-century bamboo-screen painting: I'm concerned with the passage of history.

The screen depicts the four seasons in the life of bamboo. Starting from far right and moving to the left, it shows early spring scenes of bamboo with tiny violet flowers. Moving further left, early spring becomes early summer and the bamboo is growing. From early summer, the painting jumps to fall—because the Japanese don't like hot midsummers—with nice red ivy hanging around the bamboo. Then, finally, snow.

The bamboo is a symbol or signature in Japan that invites the spirit of the gods to descend on this bamboo tree. That's a Shinto concept.

There's also beauty in the aesthetics of the painting. Not just in the composition but also the spirit and the sense of the space: the space between one bamboo and the bamboo shoots, the very naïve sense of the color. Sometimes paintings are decorative and very busy, but this is sensitively composed, which is not very easy to accomplish.

Any strong work of art—it doesn't matter whether it's contemporary or classical—has a strong concept behind it. To show the passage of time in a painting in the fifteenth century was a very unique idea. It's like conceptual art to me, even though it was painted in the fifteenth century. This influenced how I became a contemporary artist.

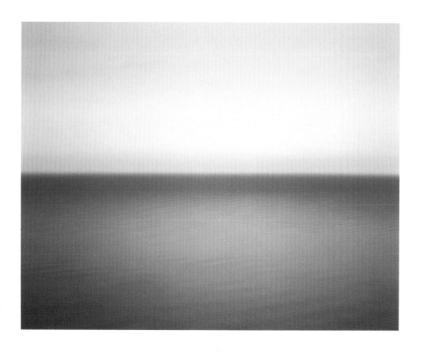

HIROSHI SUGIMOTO, *BODEN SEA, UTTWIL*, 1993 ←

ATTRIBUTED TO TOSA MITSUNOBU, *BAMBOO IN THE* →
FOUR SEASONS, LATE 15TH–EARLY 16TH CENTURY (WITH DETAIL)

This pair of Japanese six-panel screens combines the traditional Chinese subject of bamboo with the four seasons. An inscription on the left screen attributes the work to Tosa Mitsunobu, who is considered the founder of the Tosa school of painting. The rhythmic cadences of the bamboo, arranged with reference to a ground plane, typify the decorative approach to screen composition practiced by artists of the Tosa school.

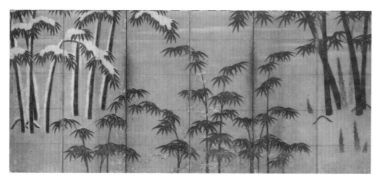

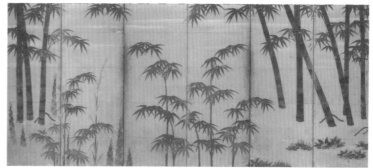

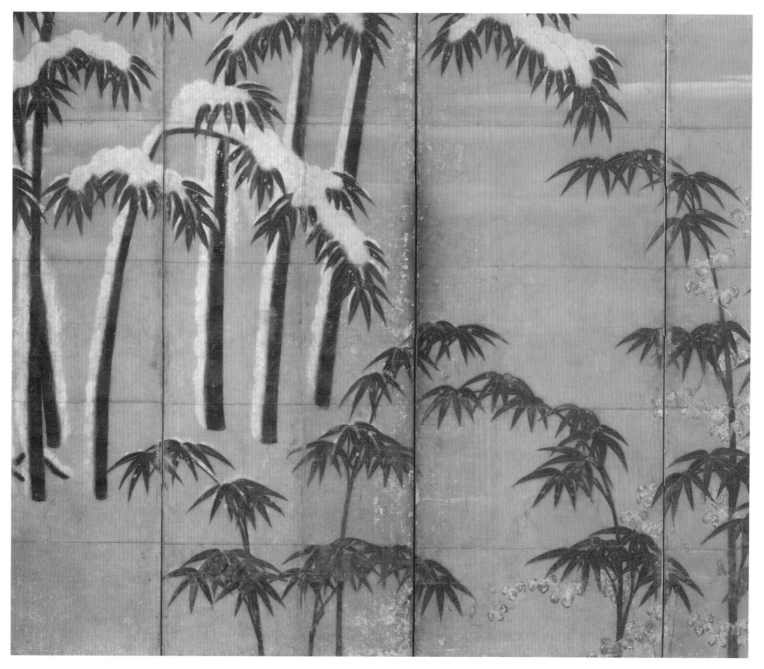

EVE **SUSSMAN**

"The things that defy history and technology are powerful."

I've been amazed by William Eggleston's photography since I was in college. Sometimes when you like a certain work or artist when you're younger, you mature out of it after a while. With Eggleston, it's the opposite. I'm more enamored with his work now than when I was in my twenties.

The main appeal for me is the mix of banality and ominousness in his work. His photographs are so full of mystery—you don't know if he was looking for that ominousness because they're so everyday, all about the daily. There couldn't be anything more common than an oven or the shower or the television in a corner, or even this coiffed, well-put-together woman, who looks like she's got a set of legal briefs but is sitting on this crappy curb. It's just incredibly poetic and genius. The inanimate things become almost anthropomorphized, and the architecture takes on personality— like window shades, which almost become gigantic eyelashes. A lot of the time when you see really beautiful formal photography, it feels slightly overconsidered, but this image has a weird spontaneity.

The photographs are shot in natural light without anything set up beforehand. He does it by noticing and by being aware. It's about seeing what's in front of you. He frames his subjects quite tightly. He's captured them, in a way. You feel this capturing, you feel this framing, and you know there's something beyond the frame that you're not allowed to see. That's a part of what makes you more interested in it and what makes you think, "I've seen this a million times, but I've never seen it like this."

That's something I'm very interested in: treating a still image as a frame and imagining what happened in the frame before and the frame after. Eggleston insinuates that in other photographs. There's one of a hotel room that makes you wonder, what's going on in the rest of the room? There's a suitcase visible, but there has to be stuff off to the left and to the right of it that we're not allowed to know about. There's an anxiety present. In another photograph of an oven, it's almost impossible not think of Sylvia Plath. You feel this emptiness that's just pervasive.

Eggleston's photographs encourage you to empathize with them, and that's a human reaction that continues moving forward and moving backward. The things that defy history and technology are powerful—they keep you questioning. Eggleston's not telling you what any of this stuff is. You know, it's just a house—yeah, right, it's just a house, okay—but you know it's not just that. You have to assume that you can figure it out.

EVE SUSSMAN / RUFUS CORPORATION, STILL FROM
WHITEONWHITE:ALGORITHMICNOIR, 2009–11 ↙

WILLIAM EGGLESTON, *UNTITLED (MEMPHIS)*, 1971 ↗

WILLIAM EGGLESTON, *HUNTSVILLE, ALABAMA*, CA. 1970 ↗

WILLIAM EGGLESTON, *UNTITLED (MEMPHIS)*, CA. 1970 →

WILLIAM EGGLESTON, *UNTITLED (MEMPHIS)*, CA. 1972 →

Eggleston emerged in the early sixties as a pioneer of modern color photography and today remains its most prolific and influential exemplar. Through a profound appreciation of the American vernacular (especially near his home in the Mississippi Delta) and his confidence in the ability of the dye-transfer printmaking process to reveal the region's characteristic qualities of light and saturated chromatics, Eggleston validated color photography as a legitimate artistic medium. His iconic photographs of commonplace subjects have become touchstones for generations of artists, musicians, and filmmakers, from Nan Goldin to David Byrne, the Coen brothers, and David Lynch.

SWOON

A thread weaving through art history that I have always gravitated toward is daily life and the simplicity of one human observing another. This painting was so important to me when I was fifteen or sixteen. It rushes through my whole nervous system. Honoré Daumier created a portrait of the time: you see the train, the rows of passengers, and the social landscape, but for me it's so much more than the sum of its parts.

You see the relationship between the breastfeeding mother, the grandmother, and the kid who's leaning on her, and it gets you. When you look more closely, you see that it's got all this roughness and approximation, but you also see a grid—what's that doing? And how is it that the intimacy of the mother's expression is formed by a couple of rash, simplistic brushstrokes? I think Daumier, because he was a caricaturist, had this cartoonish way with his lines. But when he took that energy into painting, he had this immediacy and this quickness and this roughness—letting the forms be simple—that was really radical for painting at that time.

Some people have said that this painting sentimentalizes poverty, and I disagree. I think he's getting at the complexity of life here. There's something warm and rough, and something beautiful and difficult. There's compassion in this piece.

Daumier is interesting as an artist and also as an activist. He was a relentless social observer; he was always expressing his point of view in his work. That type of social observation has always had a tenuous place within academically recognized art circles, so it's natural to want to sell him short and say, "Oh, he's a satirist" or "He was always hitching his political ideals to this work." But there's strength in doing that, which shows up in this painting. There was something deeply antiauthoritarian about just looking, observing, and telling the truth as you saw it. You can feel the love that is contained within looking. A painting can convey an entire emotional outlook on the world.

Artists are always asking themselves, "How do I make something unique? How do I make something relevant?" Daumier's position as seen through this work is: just look at people. Observe what's going on, record that, and give it fidelity in its simplest truth. One of the highest functions of art I have identified within my own work is to be a vessel for empathy. When I see this painting, it just strikes the flint. I try to walk in those footsteps.

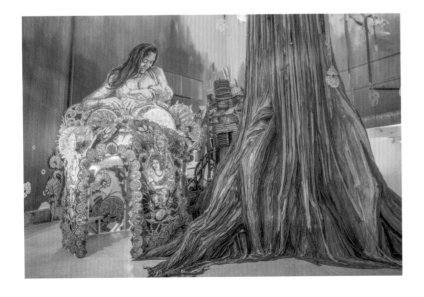

SWOON, *DAWN AND GEMMA*, 2014 ←

HONORÉ DAUMIER, *THE THIRD-CLASS CARRIAGE*, →
CA. 1862–64

As a graphic artist and painter, Daumier chronicled the impact of industrialization on modern urban life in mid-nineteenth-century Paris. Here, he amplified the subject of a lithograph made some ten years earlier: the hardship and quiet fortitude of third-class railway travelers. Bathed in light, the nursing mother, elderly woman, and sleeping boy emanate a serenity not often associated with public transport. Unfinished and squared for transfer, this picture closely corresponds to a watercolor of 1864 (Walters Art Museum, Baltimore) and a roughly contemporary oil (National Gallery of Canada, Ottawa).

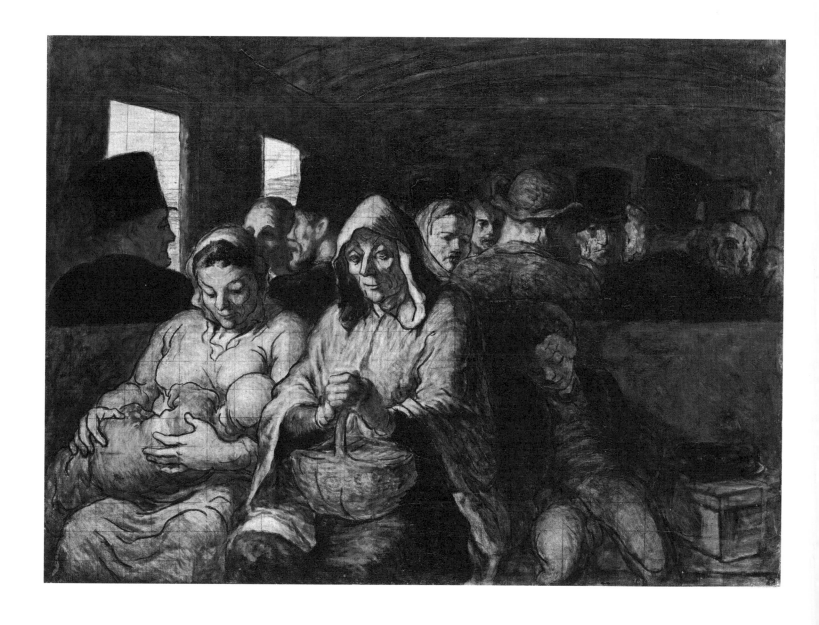

"The idea of an offering is essential to any work of art."

I often think about how an inanimate object can somehow be alive—how you can breathe life into an inanimate object—which is a very old sculptural idea. I think of my works as graves: they're dead, but they remind you of having been alive.

The Tomb of Perneb is a completely inanimate stone that tells you how to act; it's instructions. When you walk into the tomb, there is a wall with a depiction of Perneb and the people giving him objects. There's a list in hieroglyphics of all of the offerings, almost like an Excel spreadsheet of what to bring. Above this scene, an abundance of pheasants and bulls and bread are illustrated, piled right up to the ceiling. The walls are packed. The tomb is like an animated film, conjuring what happened on that very site, in between the tomb's walls.

In the next hallway, there's a bizarre window and a figurative sculpture enclosed within a second room that you can't get to. It's a shock. There is one vitrine on the side that holds bowls and other objects that were found at the original site of the tomb. One of the very beautiful features about these bowls is how pedestrian they are. They were like the Styrofoam coffee cup of the time, but they speak so much about the hand that held them, the mouth that drank from them.

There's also one little necklace. It's not particularly valuable or beautiful or important, but the juxtaposition of the necklace's delicacy with the majesty of the surrounding architectural structure and its incredible stones—which have lasted so long—makes you feel the fragility of even standing there, knowing that you won't be standing there forever.

People come into this room and leave quite quickly. I think a lot of people panic, and it's not just claustrophobia; it's the intensity of the experience. You feel something alive there. That's why you leave it so quickly. The architecture's so tight it makes you aware that you are filling the negative space. You are somehow an object that's being watched or is expected to perform.

Because it's a grave, Perneb's tomb self-consciously incites a conversation with a different place and a different time through the act of offering. I think it is very beautiful seeing this in the context of a museum because the idea of an offering is essential to any work of art. Artworks are really offerings from artists trying to contribute to a conversation that transcends their own lives.

SARAH SZE, *360 (PORTABLE PLANETARIUM)*, 2010 ←

MASTABA TOMB OF PERNEB, CA. 2381–2323 BC →

By the beginning of Dynasty 1 (ca. 3100 BC), the ancient Egyptians had developed a formalized building type for graves that Egyptologists call a *mastaba* (from the Arabic word for "bench"). Museum visitors experience Perneb's mastaba tomb much as ancient Egyptians did: passing through a small entrance chamber into an interior courtyard. The external wall of the courtyard was originally created by an adjacent mastaba and is partially re-created here. Accessed from the courtyard, the interior rooms were places for the performance of life-renewing rituals. Eternalized in the wall decorations, these rituals and the offerings that accompanied them provided the deceased with everlasting sustenance.

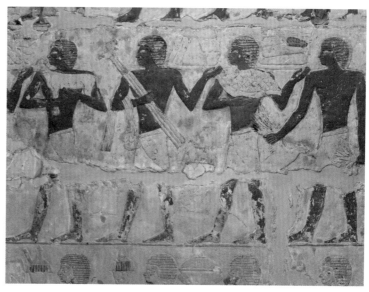

PAUL TAZEWELL

"There's great attitude and affectation in how he's staging each of his portraits. It's like theater."

Designing costumes gives me an opportunity to live vicariously through different characters. The design choices I make support the characters from the first time they step onstage, before they speak a word. That's exactly what's happening here. Anthony van Dyck is so good that he's able to step into a person's character and figure out how best to show completely who they are. Because of his skillfulness in rendering the fabric, the clothing, and the person wearing the clothing, all of the details come through in his portraits.

At the time in history when Van Dyck was painting, clothing was significantly more feminized than what we're used to today. It was a completely different way of showing power. I do wonder: How was the clothing chosen for each of these portraits? What was Van Dyck's input, and what did the sitters choose themselves? How has he made the sitters more beautiful? Has he gotten rid of blemishes, and has he made the person more enticing? You know nothing could have been an afterthought.

In his self-portraits, Van Dyck dressed himself in the style of the aristocracy he was painting. He envisioned a very elegant lifestyle, with pom-poms on shoes, knee-high hosiery, and vast amounts of fabric going into the garments. When you look at the way the light plays with the black and the charcoal gray and the lighter gray and the silver in his paintings, you see that he's creating the effect of light reflecting off of metallic and off of black, and showing how it crunches and forms a sculpture of its own.

There's great attitude and affectation in how he's staging each of his portraits. It's like theater, and it's theater that I gravitate toward.

PAUL TAZEWELL, COSTUME DESIGN FOR ELIZA FOR THE ←
BROADWAY PRODUCTION OF *HAMILTON*, 2014

ANTHONY VAN DYCK, *JAMES STUART (1612–1655), DUKE OF* →
RICHMOND AND LENNOX, CA. 1633–35

Van Dyck probably painted this majestic portrait shortly after James Stuart's investiture into the Order of the Garter in November 1633. The silver star, the "Lesser George" medal on a green ribbon, and the garter itself (below the left knee) are the order's insignia. The greyhound suggests nobility by alluding to their hunting privileges, and perhaps the virtue of fidelity.

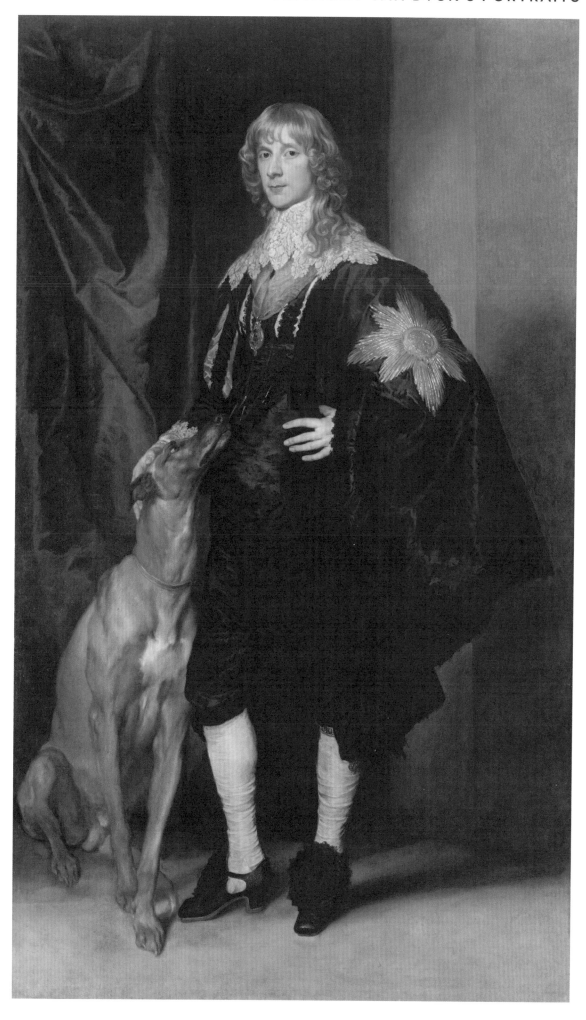

WAYNE THIEBAUD

"Think how much you'd have to know to paint all of those forms."

This painting depicts a marvelous horse show. You might compare it to a car show today, where you go to find the latest model. I first saw this painting when I was about seven years old, as a black-and-white photographic reproduction hanging over my grandfather's desk. I told him, "I love that photograph," and he said, "Wayne, that's not a photograph. It's a painting, and it's much bigger than this: eight feet high by sixteen feet long."

It's absolutely astounding what Rosa Bonheur has done, and it's particularly interesting to me as a teacher because she's used almost every painting convention. There's classicism, realism, romanticism, beautiful kinds of impressionism. Way up in the upper right-hand corner, there's a group of about ten or fifteen people looking at this thing going by. There is this marvelous circular motion—you could almost put some poles on that damn thing and have a merry-go-round.

Every kind of horse is pictured: blacks and whites, grays, spotted, even a little sorrel horse, who seems to be the only one that doesn't have an attendant. It's like she's broken loose. Maybe it's Rosa Bonheur, who was a kind of renegade herself, and she wants to ensure that there's always an out.

All those legs, both those of the humans and those of the horses: what an amazing kind of choreography it is. Think how much you'd have to know to paint all of those forms.

She's used every kind of light—glowing, glinting, all the way to no light. She expresses about three or four miles of space. That is not easy to do. You'll notice that it's a challenge to find lines in the painting—they're all inferred here. Line is an abstraction, so she's avoided that, but she's built into the painting all of the things she needs for that marvelous three-dimensional, illusionistic space.

People like Paul Cézanne, who painted nuanced little strokes that take you on a space ride—it's the same with Bonheur. Look at that manure dust, the way she's kicked that up. The empathy factor is also crucial here. You can really identify and walk up to those horses because the space is so real.

They're all cheap tricks, in a way, made into a masterpiece. This is what you have to do if you want to be a painter: employ all the heritage we have as painters. It's a wonderful challenge, and we're damn lucky to be in that business.

WAYNE THIEBAUD, *PIE COUNTER*, 1963 ←

ROSA BONHEUR, *THE HORSE FAIR*, 1852–55 →

This, Bonheur's best-known painting, shows the horse market held in Paris on the tree-lined Boulevard de l'Hôpital, near the asylum of Salpêtrière, which is visible in the left background. For a year and a half, Bonheur sketched there twice a week, dressing as a man to discourage attention. Bonheur was well established as a painter of animals when this painting debuted at the Paris Salon of 1853. In arriving at the final scheme, she drew inspiration from George Stubbs, Théodore Gericault, Eugène Delacroix, and ancient Greek sculpture. She referred to *The Horse Fair* as her own "Parthenon frieze."

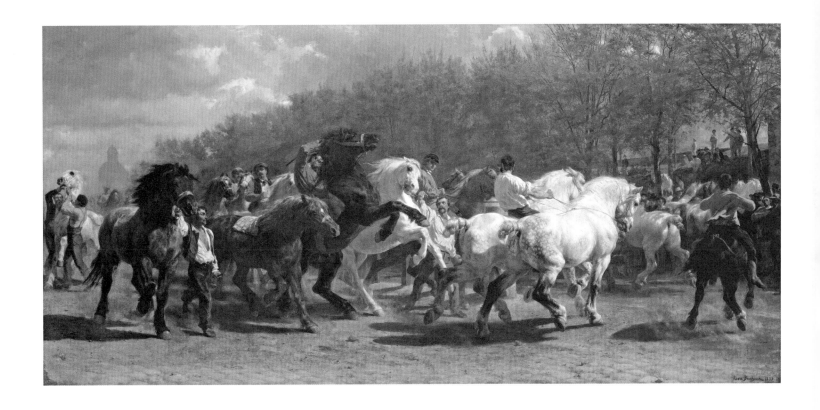

HANK WILLIS THOMAS

"There is that magic of visibility/ invisibility and meaning, and that ambiguity is what makes most art both legible and eternal."

As an artist, I'm interested in trying to bring things we've packed away back out for discussion. I'm fascinated with how our history and our understanding of the world shifts, so I think of history as a moving target.

This is a daguerreotype button, and there were long-standing questions about whether or not it was an abolitionist pin because there appears to be a "white" hand and a "black" hand holding a Bible. We now believe that the two hands belong to one person, and we're unsure as to whether or not they're holding a Bible. That's really fascinating to me because I made a replica inspired by the original definition.

When a person wears a button, they're essentially wearing a question that they want to activate in others, but you'd have to be so close to them to even really see what it shows. To create a level of detail this small really speaks to the daguerreotype medium, which is a nineteenth-century process that involves coating a piece of metal with emulsion. When you look at it, you're looking at both the reflective metal and the image, which can seem to disappear before your eyes, depending on the angle of light and where you're holding it.

These look like young-adult hands—maybe someone who did manual labor for a living. I think the cropping is intentional because the subject becomes anonymous; the hands become symbolic. The way in which they're clasping the book is really about intimacy and protection and coveting the subject. The photographer also wanted us to know that this person reads and was engaged intellectually. Many photographs that were taken of African Americans during that era feature them holding books to contradict the myth that "black" people were inferior.

Today people wear pins and buttons to align themselves with political movements; I am really excited that these are long-held traditions. The fact that we don't know if it is a "black" person's hand or a "white" person's hand, or what happened to those hands later, is great because that means they're our hands. There is that magic of visibility/invisibility and meaning, and that ambiguity is what makes most art both legible and eternal.

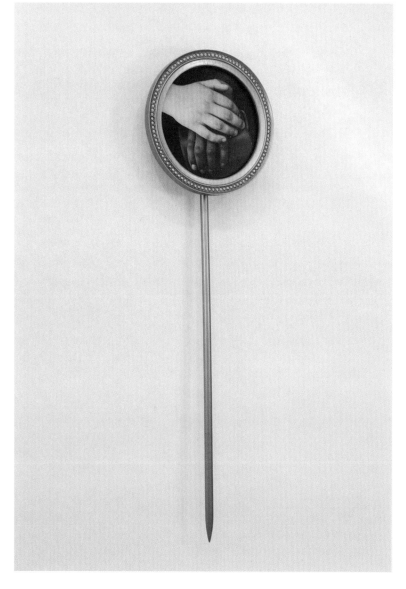

HANK WILLIS THOMAS, *THENCEFORWARD AND FOREVER FREE*, 2012 ←

BUTTON, 1840s–50s →

This miniature daguerreotype shows two hands resting on a book. The photograph is set into a two-piece gold-washed brass frame with a loop on the reverse for sewing to a garment. The case design with its simple, raised ornamental border is typical of the gilt-metal buttons mass-produced from 1830 to 1850 in several New England factories. Buttons developed into a characteristically American means of both political advertising and personal expression. This example was discovered in the early 1980s in a flea market in Massachusetts.

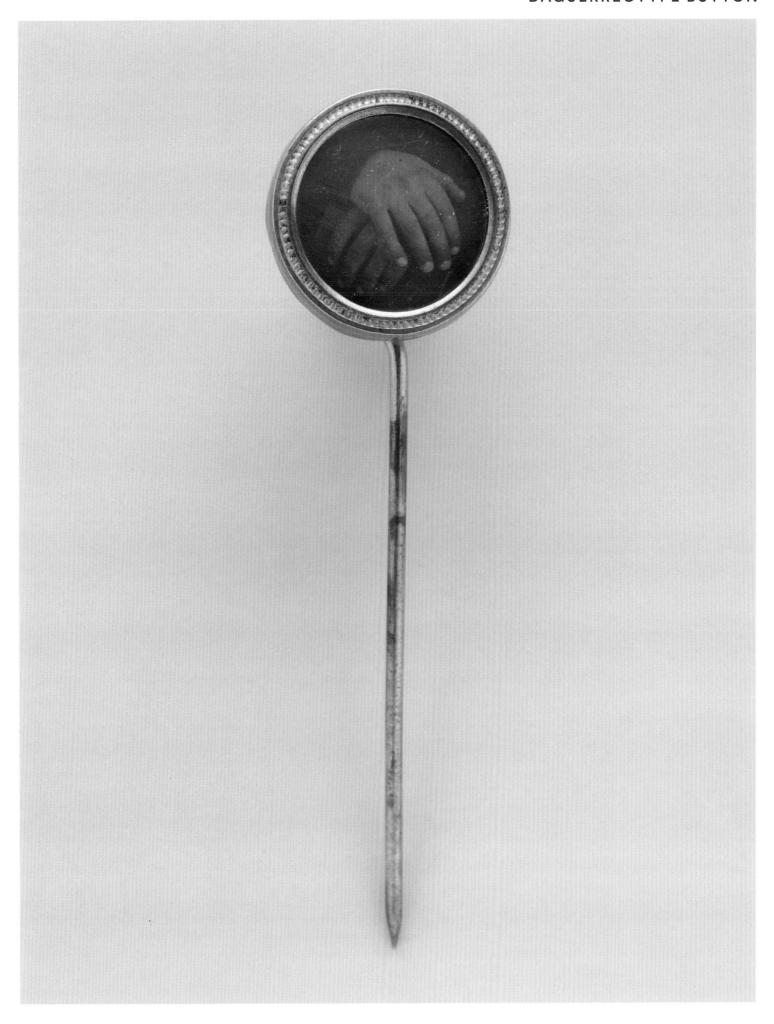

MICKALENE THOMAS

"He's the catalyst to give a voice to the people."

I wasn't trained as a photographer, but photography has always been a resource for my paintings. I'm always looking at Seydou Keïta's work and thinking, how did he do that? I loved his work when I first saw it because it was everything you didn't see in photography.

I studied as an abstract painter and was really excited about how the different fabrics in Keïta's image [*Untitled*, 1953–57] collided but made sense. They created chaos, but then there's a quiet moment with the figure. The resting spot is her face, her skin. You are looking at her, the softness of her lips. That pause brings you to the gaze of her eyes and holds you there.

Keïta has a great awareness of the gray scale. If you look at the gentleman in *Man Leaning on Radio* (1955), some of the blacks in the jacket fall apart, but it becomes a beautiful form. Even though it's black and white, you can feel all the color in the image. The black of the skin, the black of fabric—those are different because there's variation of the blackness of the skin. One woman compared to another woman, the color difference is far and between. Our skin has so much life to it, a glistening light and energy that fabric does not have.

He breaks the mold. He uses a photo studio but also works within a cultural language that he knows, using what's around him. There's a sense of ownership and awareness—you don't have a photojournalist coming and telling your story to the world. You're claiming that space yourself. Some of these feel like a great collaboration between the sitter and the artist.

I like the images where you can tell that it's a photo studio. Keïta used props and costume to create an elegance. For example, there's a cloth hanging behind the four individuals in *Untitled (Two Unidentified Couples. Women in Same Dress)* (1959–60). They're obviously outside. Maybe they were on their way to a function or maybe he dressed them to create a moment that is not necessarily real but that's believable.

As an artist, what you make is an extension of yourself. It comes from your experiences and how you see the world. There is a lot of Keïta in these photographs. It's what he loved—the smell, the cloth, the people he grew up with. The images are so powerful because he's connected to them. He's the catalyst to give a voice to the people. We see ourselves when other people see us. These photographs validate the moment that these people were here.

MICKALENE THOMAS, *A LITTLE TASTE OUTSIDE OF LOVE*, 2007 ←

SEYDOU KEÏTA, *UNTITLED*, 1953–57 →

From 1949 to 1977, Keïta was the most popular portrait photographer in his native Bamako, Mali, producing thousands of commissioned portraits of politicians, government workers, shop owners, and ordinary citizens that comprise an outstanding visual record of a modern society. In this contemplative portrait, Keïta emphasizes the syncopated clash of patterns and rhythms—the swirling arabesques of the backdrop, the floral print of the woman's traditional boubou, and the bold black-and-white checks of the blanket. His subject has a dignity that is enhanced by details: marks of tribal scarification on her forehead and long slender fingers were a sign of high social standing.

FRED TOMASELLI

"There's art that's easily exhaustible, but the longer you look at this work, the more mysterious it becomes."

I'm a collagist and I work with the language of others, so this painting appeals to the notion of the collective that's part of my art. Its iconography is a shared heritage of images passed down through generations. Guru Dragpo, from what I understand, is the protector of dharma, the way of Buddhism. This is somebody that you don't want to mess with. A guy with a garland of severed heads, a crown of human skulls, a fanged mouth, and three eyes—he's tough! The fire emanating from his body symbolizes divine wisdom. The two bodies he's trampling are ignorance, which makes him a violent protector of beauty, inner peace, and tranquility. This is one of the contradictions that's fantastic about the piece.

Within all of this brutality and carnage and along the top are Buddhist saints who emanate complete calm and peace. This painting acknowledges an absolute of the world: unspeakable cruelty is occurring at all times, but there are places where one can find peace and beauty. That dualism of the world is encapsulated in this work. So much of Tibetan Buddhism is about moving into this other place and not being afraid of death or of confronting it.

I'm basically an atheist, so I look at this as an object removed from the ideology that was once its foundation. Yet it still holds a lot of power for me. Buddhist iconography was hijacked by hippies, and so maybe it frightens me a little less since it seems almost familiar. I grew up in a sort of metal, stoner, biker, punk rock world. It was through bastardized, kitsch versions of this that I ended up finding my way to the original works. Obviously, this is infinitely better, but thankfully I had a gateway.

This piece does have a hallucinogenic quality. Even though everything is hard edged and very, very finely made, the work seems to be in a constant state of movement. The central figure is dancing and the flaming hair pushes to the left side of the picture while fire emanates from the body and swirls out to the right.

There's a difference between being pretty and being beautiful. A pretty thing traffics in a language that we already know and are comfortable with. Beauty is a little strange. This work is more than a little strange. And it's beautiful.

There's art that's easily exhaustible, but the longer you look at this work, the more mysterious it becomes. It just keeps opening up and opening up, and that's something that I aspire to in my own work.

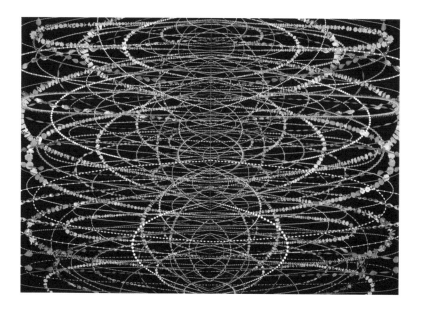

FRED TOMASELLI, *ECHO, WOW AND FLUTTER*, 2000 ←

GURU DRAGPO, 18TH CENTURY →

In this wrathful meditational form, Guru Dragpo—a fierce emanation of the guru-saint Padmasambhava—was an important protector deity of the Nyingma School of Tibetan Buddhism. He stands astride a flaming aureole, holding a ritual tool—the vajra—and a black scorpion. The skin of a tiger is drawn around his waist, while the flayed skin of an elephant is draped over his shoulders. He wears a crown adorned with skulls and a garland of severed heads.

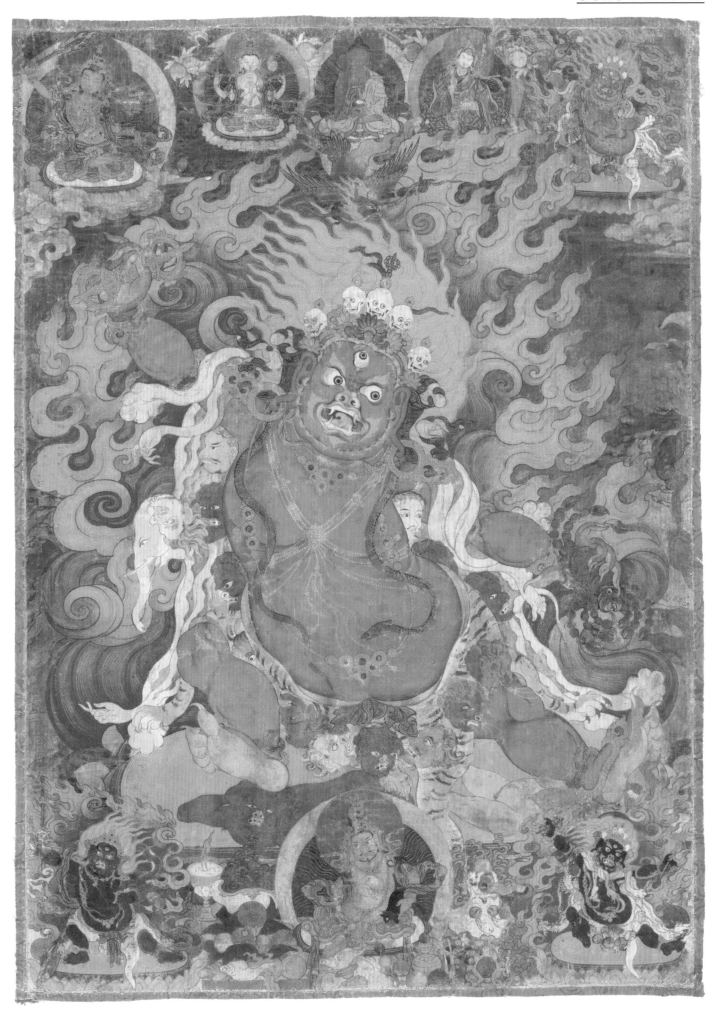

JACQUES VILLEGLÉ

"Braque's and Picasso's paintings were fresh and new and shocking to me."

I've often been accused of making art against art, but I feel my work is very much a response to the paintings of the past and paintings of the present. I feel at home in the tradition of painting. I discovered these paintings by Picasso and Braque by chance at a bookstore during the middle of the Second World War, when it was not possible to actually see original works by modern artists. I was stunned by these paintings that I did not understand, but I recognized something in them that interested me and that was familiar to me: typography, which I mainly knew from posters. As a young painter, I struggled with the question of what to choose as a subject, and from these paintings I found that typography could be a subject of my art.

I've always been fascinated by Chinese characters, Latin letters, and the social and political context that letters can have. Typography is something that speaks, even if you don't understand it. The letters spoke to me because I recognized them—as individual characters, as signs, as having a meaning. I don't try to read the words as one would read a text; I see them as part of the construction of the painting. There is the sense of volume even if you don't completely understand the space.

What I recognize in Braque's work is that he's from Normandy, a part of France that is not the most inspiring, and maybe not the most culturally rich, but a peaceful region—that is something I sense and appreciate in Braque's painting. In contrast, Picasso came from a Mediterranean background and worked in Paris, where there is much more going on. That's immediately reflected in these paintings. Both of these works are very much paintings, not collages. The objects, letters, and forms are all integrated into one composition, and they float there, in the specific place that the artists wanted.

Braque, for me, was a revolutionary artist when I was growing up under the German occupation of France and was shut off from a lot of new things that were happening elsewhere. I received a very traditional education, but outside of school, where I was very unhappy and a bad pupil, I tried to find my own education. This was a kind of new art, art I had never seen before and did not at first understand. Braque's and Picasso's paintings were fresh and new and shocking to me when I discovered them in 1943, and they are still alive and interesting to me today.

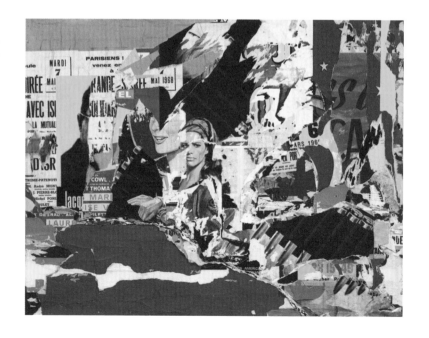

JACQUES VILLEGLÉ, *122 RUE DU TEMPLE*, 1968 ←

GEORGES BRAQUE, *STILL LIFE WITH BANDERILLAS*, 1911 ↗

The complex arrangement of intersecting planes, letters, and fractured objects in Braque's work is virtually indistinguishable from Picasso's paintings of the same time. The two spent the summer of 1911 together in Céret, a small town popular with artists in the French Pyrenees, where they explored the formal elements of what later became known as Cubism. The banderillas of the title—the wooden sticks with steel barbs used in bullfights—may have been included as a tribute to Picasso, since Braque himself was not a bullfighting enthusiast.

PABLO PICASSO, *STILL LIFE WITH A BOTTLE OF RUM*, 1911 →

Picasso painted this work in Céret. Made during the most abstract phase of Cubism, known as "high" or Analytic Cubism (1910–12), this work, which depicts a round tabletop with a stemmed glass at left, the bottle of rum at center, and a pipe in the right foreground—is among the first of Picasso's pictures to include letters.

MARY WEATHERFORD

"There's more in the painting than you ever could have imagined, and it comes to life."

I was given a book titled *Famous Paintings* when I was born, and my very favorite painting, which lived with me in my dreams and my imagination, is Goya's portrait of Manuel Osorio Manrique de Zuñiga, the little boy in a red suit. I wanted him to come to life and be my friend. I always felt a little sorry for him because I knew he was rich, but he looked like he didn't have many friends around him, although he did have a lot of pets. What child wouldn't want to be friends with a little boy who had three cats, a cage full of finches, and a bird on a leash? Part of the childhood imagination, which you can only remember as an adult, allows you to hear the sound that Goya has put into this painting. I can still remember the soundtrack, "Tweet, tweet, tweet, tweet, tweet."

The cats, with their mouths watering, look at the little bird. But the boy is a little bit sad; he's not smiling, even though it's easy to make a painting of a happy child: you just turn their mouth up a little bit. The boy is also clearly doing what he's been told to do. This is his official portrait; he's not captured in a moment of levity—instead, his attributes surround him like a saint. His hands are in a beautiful, outstretched manner in a kind of surrender or blessing. He's a holy being that's disguised as a little boy holding a bird.

I love the colors—that red—and his satin belt that's painted with all kinds of grays and whites. The background is greenish. The boy's pale, pale skin and his pink cheeks and those deep, big brown eyes—they're just like big black marbles. But the funniest thing about this painting is his little left hand where the string for the bird starts. The foreshortening is fantastic—it looks just like a little flower. The string is painted so well—I love it—with the light brightening it in different places.

The cat is just staring, staring, staring: almost dizzy with anticipation. When I was young, I had a little baby finch; his name was Christopher. One day I came home and all that was left of Christopher was a little red foot. This is the real thing, that cat in the painting is waiting!

The experience of having a picture—an image in a book—be so important to your very being, and then walking into a museum and seeing it for real right in front of your eyes… There's more in the painting than you ever could have imagined, and it comes to life.

MARY WEATHERFORD, *CONEY ISLAND II*, 2012　　←

GOYA (FRANCISCO DE GOYA Y LUCIENTES), *MANUEL*　　→
OSORIO MANRIQUE DE ZUÑIGA (1784–1792), 1787–88

The sitter in this painting is the son of the Count and Countess of Altamira. Outfitted in a splendid red costume, he is shown playing with a pet magpie (which holds the painter's calling card in its beak), a cage full of finches, and three wide-eyed cats. In Christian art, birds often symbolize the soul, while in Baroque art, caged birds symbolize innocence. Goya may have intended this portrait as an illustration of the frail boundaries between the child's world and the forces of evil, or as a commentary on the fleeting nature of innocence and youth.

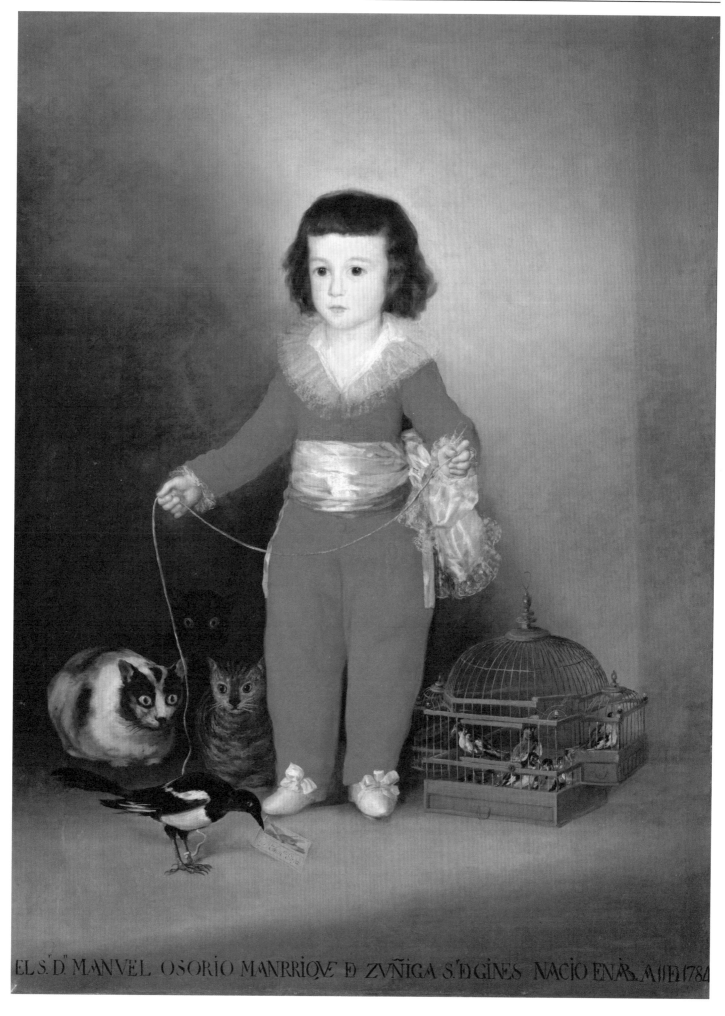

"Something will catch my eye, and I'll spend more time than I ever expected I would looking at it."

I've amassed an enormous collection of postcards. I like the format size—they're all about four by six, and that makes them interesting as a category because you can compare and sort through them. So I was interested in looking at the postcard collection of Walker Evans. It's interesting to me that Evans loved and related to things from his childhood, when the picture postcard first became popular, before he started to practice photography.

I'm haunted by his clarity in what he liked. He cherished and was probably influenced by the ones he termed "lyric documentary." Evans disliked color photographs. More charming to him were the ones colorized by lithographers. He found those much more enchanting, and I do also.

There are four postcards of the Albany state capitol building in the collection that look very different from each other, but if you look closely, you see the same people and the same cars, and the flag is moving the same way, and so forth. They are, in fact, the exact same image, but the different degree of colorization in each makes them look like completely different cards.

The other interesting thing about the early cards is the way the smoke and fire was retouched, and the clouds are never like any clouds you've ever seen—they're postcard clouds. They're a kind of cerulean blue mixed with a pale orange that was used for the skyline over and over again.

I'm also really interested, as Evans was, in the messages on the back. I feel a little bit like I'm eavesdropping. I heard that if Evans sent someone a card, he would ask for it back. I wonder if he planted his messages, knowing that he would have it back in his collection.

Postcards don't really exist anymore now that everyone has e-mail. If you visit some amazing place, you take a picture on your phone and you send it to somebody. I never was a postcard sender, but I am sad when I look at a postcard rack and don't see any good ones anymore.

People have given me entire suitcases filled with postcards, and I've tried to group them into categories, but there are too many. When I do find a beautiful one, I think back to Evans's collection. He was inspired by them, so they're his source material, in a way.

I don't really think of postcards as works of art. Something will catch my eye, and I'll spend more time than I ever expected I would looking at it, in the same way that I would in a museum. I'll see one thing that'll just floor me, unexpectedly—I like that about having too much.

WILLIAM WEGMAN, *LOBBY ABSTRACT*, 2015 ←

145 POSTCARDS OF RAILROAD STATIONS COLLECTED BY → *WALKER EVANS*, 1900s–1930s

In 1994 The Met acquired nine thousand picture postcards amassed by American photographer Walker Evans. In the early twentieth century, picture postcards, sold in five-and-dime stores across the United States, depicted small towns and cities with realism and hometown pride—whether the subject was a local monument, depot, or coal mine. Evans believed these postcards captured a part of the United States that was not recorded in any other medium. For him, their appeal lay in the commonplace subjects, humble quality of the pictures, and uninflected style, which he borrowed for his own documentary work with the camera.

"I'm interested in using the past in order to break open into the present day."

I make paintings—portraits, primarily—of young African American men and women. My work and John Singer Sargent's intersect in addressing some of the problems surrounding class. In his day he was commissioned to make portraits by some of the most celebrated families in the world.

I'm a young black man trying to deal with the ways in which colonialism and empire are present in these pictures—but they're fabulous! It's a guilty pleasure. The seduction is there. Sargent is probably one of the best painters because he's able to make it look so effortless.

There's no doubt that these paintings of Sargent's are high-priced luxury goods for wealthy consumers. You look at these amazing sisters in the foreground, but what we see in the back-ground is a family portrait that points back to their history. So the painting becomes about convincing us of our undeniable place in the world.

There's also a power relationship here. You're standing in front of these gorgeous women at this insanely large scale. Where would you be if you were in that room? You'd be on your knees.

Many of Sargent's paintings show incredibly important social occasions. You get the best gowns made; you have your hair done to the nines. The powdered faces and pearls and all of that regalia become part of this grand show. These people have been preparing their entire lives for this moment, and here it is.

If you look at the eyes, there's a desire to please the artist himself. As opposed to correcting that, Sargent paints the perfor-mance. The volume's turned up too high on so much of this stuff, to the point where we can almost recognize the absurdity of it.

Generally, I enjoy painting the powerless much more than the powerful. My relationship with the art-industrial complex is a very troubled one. Many of the people who are in my paintings can't afford my paintings. There's a conundrum there.

I try to establish a kind of cold neutrality. The cruel indifference of history itself has to be echoed in the enterprise of painting, the strange history in which so many people who are black and brown don't happen to be in the great museums throughout the world.

My work is not about opining; it's not about looking at the past and longing for that to be something different. I'm interested in using the past in order to break open into the present day.

So many people will look at a simple portrait like this and say, "You're making so much out of nothing." And I disagree. I think there's a universe being pointed to here. It's something that you can see if you're interested in looking that way.

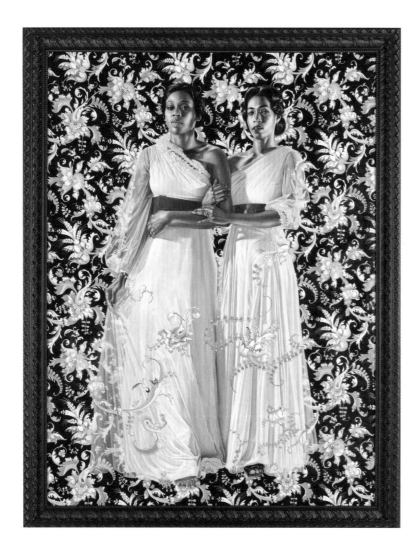

KEHINDE WILEY, *THE TWO SISTERS*, 2012 ←

JOHN SINGER SARGENT, *THE WYNDHAM SISTERS:* →
LADY ELCHO, MRS. ADEANE, AND MRS. TENNANT, 1899

The three daughters of the Honorable Percy Wyndham, a wealthy Londoner, appear in this monumental canvas. From the left, they are Madeline Adeane (1869–1941), Pamela Tennant (1871–1928), and Mary Constance, Lady Elcho (1862–1937). Sargent painted them in the drawing room of their family's residence on Belgrave Square. On the wall above them is George Frederic Watts's portrait of their mother, which establishes their genealogy and reminds viewers of Sargent's ties to older artists.

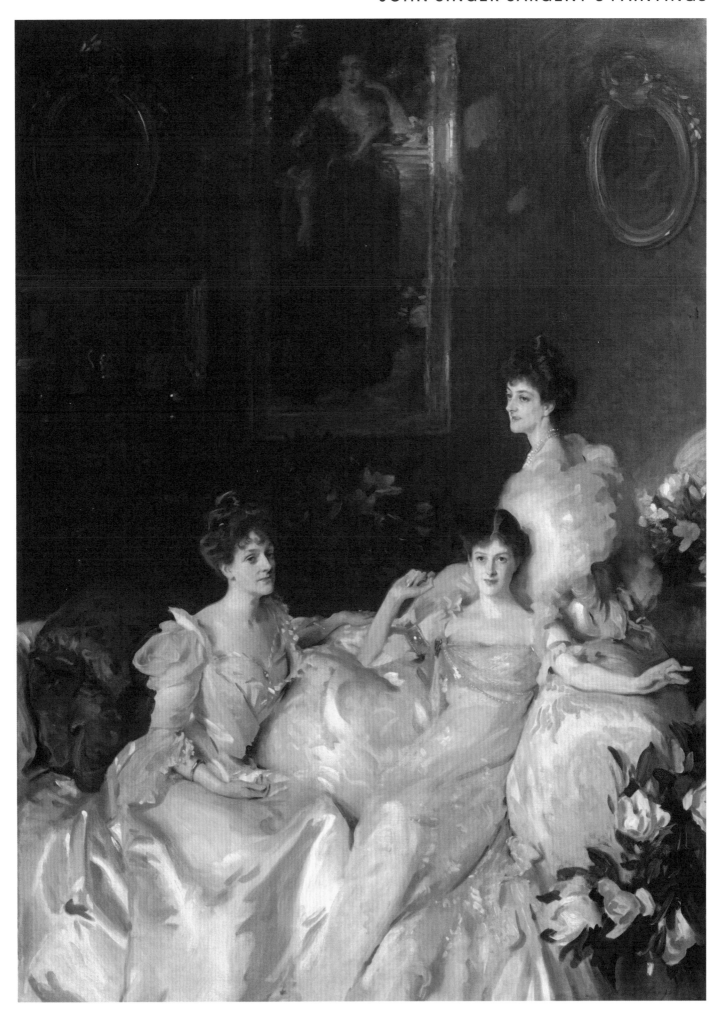

BETTY WOODMAN

"When you paint on something, you change your perception of what it is."

I've been working with clay pretty passionately for over sixty years. There are so many different clays and they can create so many different things, functional or not. It's a very rich material. This terracotta larnax is full of lessons that I've learned from creating my own work but that I was not taught when I was a student. At that time, the interest was about the purity of the form, not about painting, but I think there's a lot to be learned from both—it's the marriage of painting and form. When you paint on something, you change your perception of what it is.

This piece is a sarcophagus, and its form is articulated by the way that it has been decorated. So why was it decorated anyway? It's in a tomb. It reminds me of Pablo Picasso's work. As you move around it, there are very different things happening to the articulation of the shape and to the kinds of marks that were made on it. It's very simple, and very fresh and sure.

The marks also reflect that the clay was fired and the way the atmosphere in the kiln changed the color of the decoration, so that it goes from a red rust color to a black color. The lid of the vessel is melted, and that's because the kiln was too hot and warped it. Anyone who's done ceramics for any length of time has had this experience, but this piece was made thirteen centuries before Christ. As a human being, it's moving to have a sense of belonging and of being a part of this artistic continuum.

I don't think you can make a piece like this anymore. It doesn't feel contemporary. But one can look at it today and get a great deal of pleasure from it. When making new work, I try to capture something about the history that brings the past to mind but in a way that isn't trying to reproduce it. One may wish to reproduce it, but I think you kill it if you try.

This piece is so much about the essence of clay and, in a sense, my love affair with it.

BETTY WOODMAN, *THE MING SISTERS*, 2003 ←

TERRACOTTA LARNAX (CHEST-SHAPED COFFIN), →
MID-13TH CENTURY BC

The larnax was the standard coffin type in Crete from the early fourteenth century to the twelfth century BC. The structure—with recessed panels on each side—suggests it was based on a wooden prototype, and recent scholarship has identified Egyptian chests as the probable models. The decoration on each side consists of geometric and vegetal ornaments, motifs that were often used on pottery of the period.

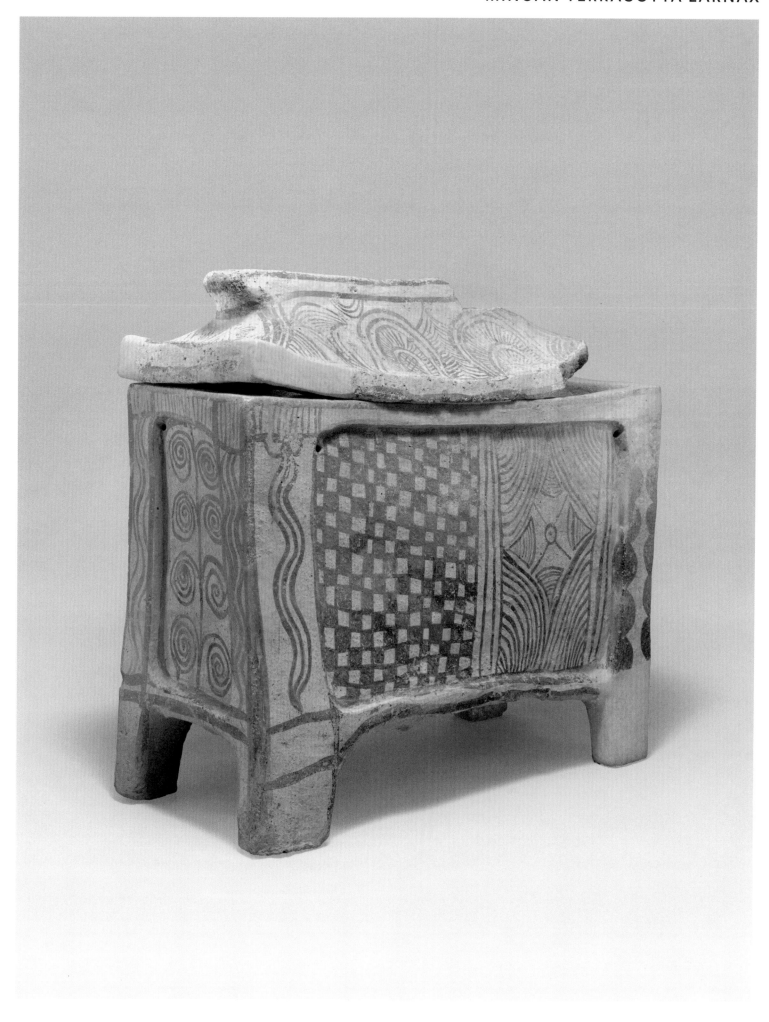

"I like those landscapes that people have in their everyday lives but don't take notice of, that have traces of human activity and human life."

I've painted many landscapes, and I don't really like to paint people. Painting people is very specific. I like those landscapes that people have in their everyday lives but don't take notice of, that have traces of human activity and human life.

When most urban dwellers see a painting like this by Jean-François Millet, their thoughts might run towards, oh, this is how peasants lived. But I go back to the scene that's depicted—a scene that I personally experienced for three years in the countryside.

I received my arts education in China. Part of our training was to go to the rural parts of China, into factories, to live alongside workers and peasants and experience their lives, and to paint from that.

One of the things I find so admirable about Millet's painting is that he paints the human subject, the animal world, haystacks, and farmhouses with equality. We see a passion and a respect for the farmer, for the peasant, and that passion and respect is actually a passion and respect for nature. That comes from Millet's real understanding of their lives. It's almost like you've been injected into this very dramatic scene with emotion, and you're feeling these natural changes that are about to take place.

In autumn, you have to do all the harvesting work before the expected arrival of rain. You see these clouds, and if you understand the life and the rhythms of a farm and of a farmer, you share their anxiety. The farmhouses in the background are still captured in the warmth of this very pure light. It's a really interesting expression of both the warmth of farm life and the difficulties of being a farmer.

That connection between man and the natural environment is something that has been dismissed or not really given proper attention in the past. A lot of art has been about the relationship between man and God or between aristocracy, between power, between politics and the people. Unlike many artists and painters who use the farmer or the peasant or even just the human figure as a prop, Millet's farmers are farmers who I know would experience that really genuine connection with nature.

XU BING, *BOOK FROM THE SKY (TIANSHU)*, CA. 1987–91 ←

JEAN-FRANÇOIS MILLET, *HAYSTACKS: AUTUMN*, CA. 1874 →

This painting is from a series depicting the four seasons commissioned in 1868 by the industrialist Frédéric Hartmann. Millet worked on the paintings intermittently for the next seven years. In autumn, with the harvest finished, the gleaners have departed and the sheep are left to graze. The loose, sketchlike finish of this work is characteristic of Millet's late style: patches of the dark lilac-pink ground color are deliberately exposed, and the underdrawing is visible, particularly in the outlines of the haystacks and the sheep.

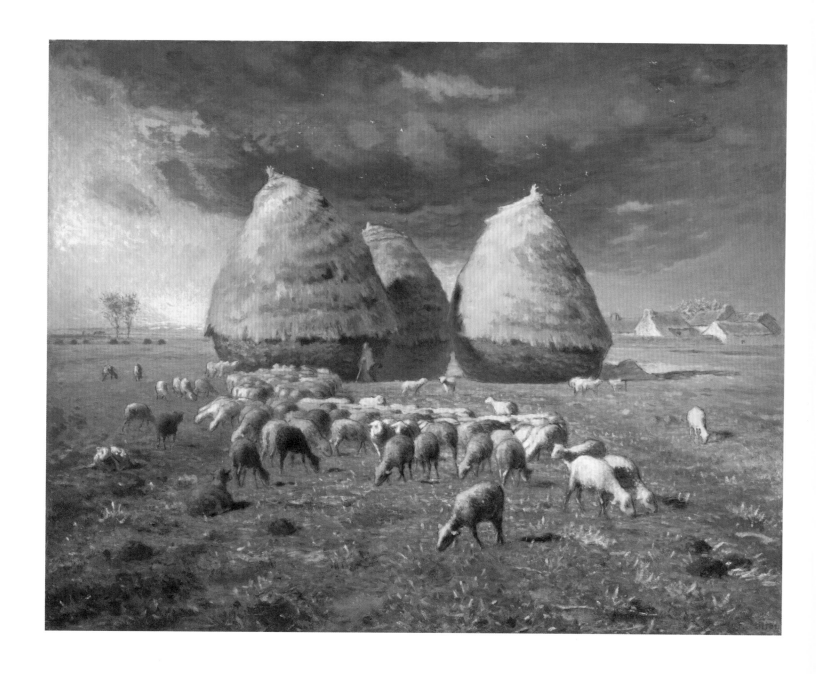

DUSTIN YELLIN

"I think it's possible to have access to the past, the future, and the present simultaneously."

I used to work in a rock shop, and I still go hunting for rocks. When I go to the beach, I can touch the rocks for hours. The people I'm with always react the same way: "What's wrong with you?" But rocks are the most beautiful artifacts in the world to me.

I came to cylinder seals because they start as rocks, which are so raw, and become these carved miniatures. Some of the rocks are hematite, some are quartz. They are probably millions of years old and the carvings are probably about three thousand years old. I like the idea that you don't look at a picture, but rather you read a picture. Until you actually had a piece of clay and rolled out the seal on it, you couldn't see the full picture. That moment must have been mind-blowing. It's as if there are messages that have been hidden for thousands of years within the cylinders. Some of them are straightforward; for example, there is a hunting scene, there is a prayer scene, or there is a conflict—you see battles of the gods.

I don't believe that time exists in a straight line. I think it's possible to have access to the past, the future, and the present simultaneously, but I don't think that the impression we roll out today is the same as the picture they looked at thousands of years ago. Think of the state of their consciousness: they were trying to understand their relationship to the cosmos and their place in nature.

When I make work, I think of everything as an artifact. I think of humans being gone. When I see these cylinder seals, I think about the future. If I could live for three thousand years—that would be my dream. I think about how things have changed in the last hundred years and how they're going to change in the next hundred years. It's bananas.

We look at the past because it's the future. These cylinder seals are bridges. They come from the birthplace of one of the centers of the history of civilization. The invention of the wheel, the invention of agriculture, and the invention of writing were all surfacing during this period. Cuneiform was a huge evolutionary change for our species. We were getting inner thought patterns out, literally, into patterns. Cylinder seals are still sophisticated when you compare them with the technology and art from the last hundred years.

What was being channeled through the seals? The fact that you could have a hidden message in code on a rock is so innovative. These are almost early computers. This is like the first analog-digital moment. But the cylinder seal is more technologically fluid than modern technology because it can last, to pass on its message, its story, through history.

DUSTIN YELLIN, *THE TRIPTYCH*, 2012 ←

CYLINDER SEAL: WORSHIPPER WITH AN ANIMAL →
OFFERING BEFORE A SEATED DEITY, CA. 1480–1450 BC (WITH
MODERN IMPRESSION AND ENLARGED MODERN IMPRESSION)

Cylinder seals, first used in Mesopotamia, served as a mark of ownership or identification. Often made of precious stones, they were either impressed on lumps of clay used to close jars, doors, and baskets, or rolled onto clay tablets that recorded information about commercial or legal transactions. This seal shows a seated deity holding a rod and ring with a worshipper standing before him carrying a horned animal. To the left, a lion stalks a horned animal above a worshipper who stands before a deity clasping a staff. The modern impression of the seal is shown so that the entire design can be seen.

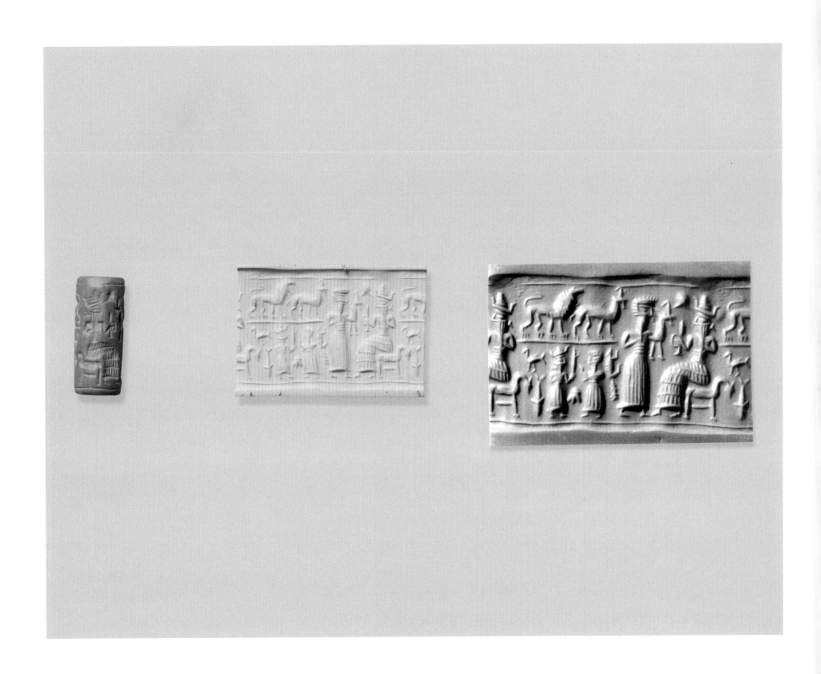

LISA **YUSKAVAGE**

"The more you look at them, the more quietly provocative they are."

"The more you look at them, the more quietly provocative they are."

I would not be considered a modest painter, I suppose, because of the scale and subject matter of my work. One of the things I really love about Édouard Vuillard is that his paintings are often small, with domestic and rarely provocative subjects, but the more you look at them, the more quietly provocative they are.

You could say that the content of this painting is not that interesting—his mother is darning in a green room. What makes the painting truly interesting is how it's painted. The painting is screaming, that color is screaming. It feels like the green is advancing. I think you actually turn green, you're illuminated before it.

The mother creates the contrast to the illumination. She holds the picture together and gives weight to the picture. You could imagine that she is not a pleasant figure. I mean, it would never be that pleasant to live with your mom until you're an old man, but it seems like they had a pleasant relationship. But this picture is ominous. That color is never a good omen.

Vuillard's paintings are often about voyeurism. Those two panels—we assume they are windows—just hover there, kind of like eyes looking at us. They become confrontational.

There's also the sense of touch, the sensitivity that he has to putting the paint on—that piling up of various related colors definitely creates a buzzing. Space is created through the overlap of shapes, like the way her knee overlaps with that green thing laying on the floor. That type of tiny overlap creates an incredible amount of depth in this painting.

Paintings are silent: a thing that has to be taken in through the eye. I think every artwork deserves to be looked at in person. It's like when the person in the front row who's asleep the whole time I'm giving a lecture wakes up during the question and answer to say, "I hate your paintings." I'll say, "Well, have you ever seen one in person? It's like a human being. You can tell me you hate them after you've been with one."

You're peering into another world, but it's an otherworldly experience that doesn't exist anywhere else but there.

LISA YUSKAVAGE, *WRIST CORSAGE*, 1996 ←

ÉDOUARD VUILLARD, *THE GREEN INTERIOR* →
(FIGURE SEATED BY A CURTAINED WINDOW), 1891

In 1891 Vuillard rented a tiny studio with fellow Nabi artists Pierre Bonnard and Maurice Denis. It is likely that this studio is the setting of the painting. Abandoning perspective and emphasizing surface texture, the artist embeds the shadowy figure in a thickly painted apple-green surround. Only the light-filled patterned curtains relieve the dense green palette. An air of mystery, of refusing narrative explication, pervades Vuillard's *intimiste* small interiors.

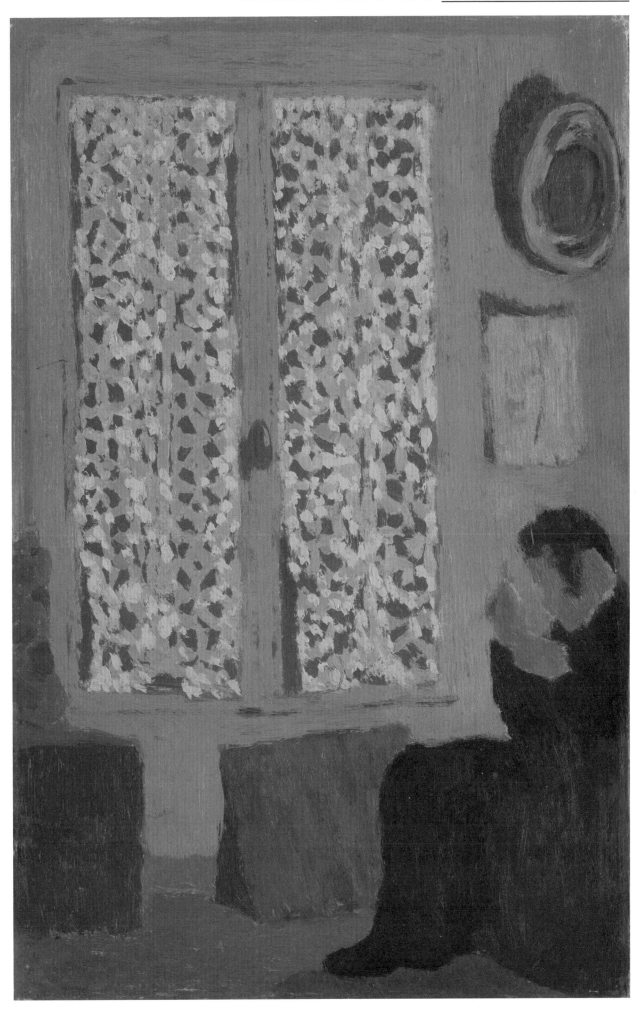

ZHANG XIAOGANG

"Art should express what is inside someone. It should express a person's unique perspective."

Many artists have inspired me—some with their techniques, some with their ideas, and some with their artistic language. I believe that at every stage of an artist's development, he or she finds an artist of particular interest to them. El Greco has been, from the beginning, the one artist I haven't been able to let go of. There's a kind of spiritual power to his work. Living as he did in a strict theocratic society, he portrayed people's pain, yearning, and fear—all sorts of deeply complicated emotions. His works convey a sense of despair about the world that he lived in—an almost neurotic longing for God.

The angle of this composition would have been very difficult to paint because the perspective is so exaggerated. El Greco always placed his vantage point at the bottom of the composition, as if looking up at the sky. The figures hover above as if they're in the process of rising, and he's looking up from below. This vantage point is different than those of most other artists. It seems to me that this perspective might be an embodiment of the artist's own wishes: the hope to leave this world for something higher up.

There's very strong subjectivity in El Greco's palette—it's not composed of colors we see in real life. In his use of light he seems to prefer a kind of backlit effect, which can sometimes give the impression that he's looking at the world underwater, the light being a kind of transparent reflection. This makes his sense of light very special; it feels as if it's coming from multiple sources. This is a sacred light.

El Greco found a common language in how he portrayed drapery folds, clouds, sky, and even the setting. Everything twists, empowered by something spiritual. I see a kind of madness in his work. The drapery folds aren't really indications of physical folds or creases; rather, he uses them to express an inner psychology.

El Greco paid attention to human psychology—something that otherwise didn't appear in art until the nineteenth century. This could be another reason why I find him appealing—because when I was a student in China, art was all about socialist realism. Nobody studied or suggested how to express psychological idiosyncrasies. When I saw El Greco's works, I felt that he expressed something terribly important—namely, that art should express what is inside someone. It should express a person's unique perspective. This goal of expressing a person's interiority was difficult to realize when I was a young artist in China.

El Greco's perceptions and his unique way of expressing them through art transcend his own time. I feel something different every time I look at his works, and they continue to move me.

ZHANG XIAOGANG, *COMRADES NO. 13, 1996*, 1996 ←

EL GRECO (DOMENIKOS THEOTOKOPOULOS), →
THE VISION OF SAINT JOHN, CA. 1609–14

This painting is a fragment from a large altarpiece commissioned for the church of the hospital of Saint John the Baptist in Toledo, Spain. It depicts a passage in the Bible, Revelation 6:9–11, which describes the opening of the Fifth Seal at the end of time and the distribution of white robes to "those who had been slain for the work of God and for the witness they had borne." The canvas was an iconic work for twentieth-century artists. Picasso, who knew it in Paris, used it as an inspiration for *Les Demoiselles d'Avignon* (1907).

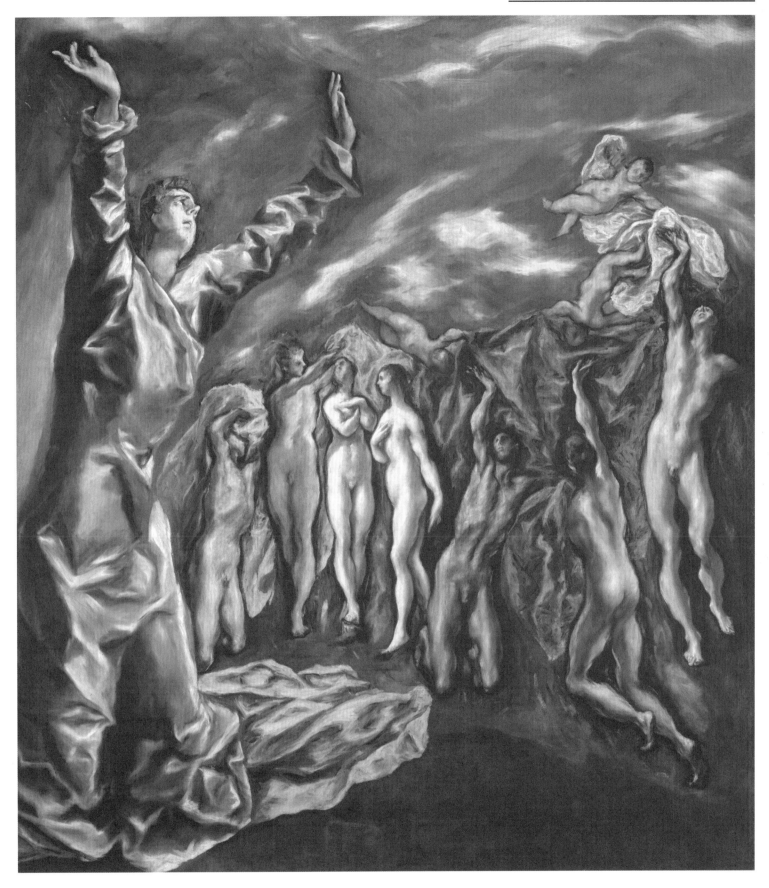

ARTIST BIOGRAPHIES

VITO **ACCONCI** (1940–2017) was an American multimedia artist and architect known for body works, performance pieces, films, videos, installations, and architecture.

ANN **AGEE**, born in 1959, is an American visual artist who works mainly in ceramics. She lives and works in Brooklyn.

NJIDEKA **AKUNYILI CROSBY**, born in 1983, is a Nigerian American mixed-media artist who combines drawing, painting, and collage on paper. She currently lives and works in Los Angeles.

GHADA **AMER**, born in 1963 in Egypt, is an artist who lives and works in New York. She works in a variety of mediums, including sculpture, painting, drawing, and installation.

KAMROOZ **ARAM**, born in 1978 in Iran, is an American artist who works in a variety of mediums, including painting, collage, drawing, and installation. He currently lives and works in New York.

CORY **ARCANGEL**, born in 1978, is an American artist based in Brooklyn who works in a variety of mediums, including drawing, music, video, performance art, and video game modifications.

JOHN **BALDESSARI**, born in 1931, is an American conceptual artist who lives and works in Santa Monica, California.

BARRY X **BALL**, born in 1955, is an American sculptor who creates artworks that are simultaneously contemporary and classical. He lives and works in New York.

ALI **BANISADR**, born in 1976 in Tehran, Iran, is a painter who currently lives and works in Brooklyn.

DIA **BATAL**, born in 1978, is a Palestinian multidisciplinary artist whose work is mostly context specific. She currently lives and works in London.

ZOE **BELOFF**, born in 1958 in Edinburgh, is an artist who works primarily in installation, film, and drawing. She currently lives and works in New York.

DAWOUD **BEY**, born in 1953, is an American photographer renowned for his large-scale portraits. He currently lives and works in Chicago.

NAYLAND **BLAKE**, born in 1960, is an American mixed-media artist. He currently lives and works in Brooklyn.

BARBARA **BLOOM**, born in 1951, is a conceptual artist who works in a variety of mediums but is best known for her installation work. She currently lives and works in New York.

ANDREA **BOWERS**, born in 1965, is an American feminist artist who works in a variety of mediums, including drawing, video, and installation. She currently lives and works in Los Angeles.

MARK **BRADFORD**, born in 1961, is an American abstract painter who lives and works in Los Angeles.

CECILY **BROWN**, born in 1969, is a British painter who creates paintings that combine figuration and abstraction. She currently lives and works in New York.

LUIS **CAMNITZER**, born in 1937 in Germany, is a Uruguayan conceptual artist who works primarily in printmaking, sculpture, and installation. He currently lives and works in New York.

NICK **CAVE**, born in 1959, is an American artist based in Chicago. He works in a wide variety of mediums, including sculpture, installation, video, sound, and performance.

ALEJANDRO **CESARCO**, born in 1975 in Uruguay, is an artist whose work is influenced by literature and literary theory. He lives and works in New York.

ENRIQUE **CHAGOYA**, born in 1953, is a Mexican-born painter and printmaker who currently lives in San Francisco.

ROZ **CHAST**, born in 1954, is an American cartoonist who currently resides in Connecticut.

WILLIE **COLE**, born in 1955, is an American sculptor who lives and works in New Jersey.

GEORGE **CONDO**, born in 1957, is an American painter working in the mediums of painting, drawing, sculpture, and printmaking. He currently lives and works in New York.

PETAH **COYNE**, born in 1953, is a contemporary sculptor and photographer known for her large-scale hanging sculptures and floor installations. She is based in New York.

JOHN **CURRIN**, born in 1962, is an American figurative painter. He currently lives and works in New York.

MOYRA **DAVEY**, born in 1958 in Canada, is a visual artist who works in a variety of mediums, including photography, writing, and video. She lives and works in New York.

EDMUND **DE WAAL**, born in 1964, is a British artist and writer. He currently lives and works in London.

THOMAS **DEMAND**, born in 1964, is a German photographer and sculptor. He currently lives and works in Berlin and Los Angeles.

TERESITA **FERNÁNDEZ**, born in 1968, is an American sculptor and installation artist who lives and works in New York.

SPENCER **FINCH**, born in 1962, is an American artist who works in a variety of mediums, including watercolor, photography, glass, electronics, video, and fluorescent lights. He currently lives and works in Brooklyn.

ERIC **FISCHL**, born in 1948, is an American painter, sculptor, and printmaker. He currently lives and works in Sag Harbor, New York.

ROLAND **FLEXNER**, born in 1944 in France, is an American artist who specializes in drawings. He currently lives and works in New York.

WALTON **FORD**, born in 1960, is an American painter and printmaker who lives and works in New York.

NATALIE **FRANK**, born in 1980, is an American artist who works in painting and drawing. She currently lives and works in New York.

LATOYA RUBY **FRAZIER**, born in 1982, is an American artist working in photography, video, and performance arts and currently lives and works in Pittsburgh and Chicago.

SUZAN **FRECON**, born in 1941, is an American abstract painter. She lives and works in New York.

ADAM **FUSS**, born in 1961 in London, is a British photographer who lives and works in New York.

MAUREEN **GALLACE**, born in 1960, is an American landscape painter. She lives and works in New York.

JEFFREY **GIBSON**, born in 1972, is a painter and sculptor of Choctaw and Cherokee heritage who lives and works in New York.

NAN **GOLDIN**, born in 1953, is an American photographer. She lives in New York, Berlin, and Paris.

WENDA **GU**, born in 1955 in Shanghai, is an artist who works in a variety of mediums, including painting and installation. He has become known for his use of bodily materials, human hair, and blood. He currently lives and works in Brooklyn.

DIANA AL-**HADID**, born in 1981, is a Syrian American artist who creates sculptures, installations, and drawings. She lives and works in Brooklyn.

ANN **HAMILTON**, born in 1956, is an American multimedia installation artist who also works in video, sculpture, photography, textile art, and printmaking. She lives and works in Columbus, Ohio.

JANE **HAMMOND**, born in 1950, is an American painter, printmaker, photographer, and sculptor. She currently lives and works in New York.

JACOB EL **HANANI**, born in 1947 in Casablanca, Morocco, is an Israeli artist who creates micrographic drawings. He lives and works in New York.

ZARINA **HASHMI**, born in 1937, is an Indian-born artist who works in a variety of mediums, including printmaking, papermaking, and sculpture. She currently lives and works in New York.

SHEILA **HICKS**, born in 1934, is an American textile artist. She currently lives and works in Paris.

RASHID **JOHNSON**, born in 1977, is an American sculptor and photographer who works with everyday found objects. He lives and works in Brooklyn.

Y. Z. **KAMI**, born in 1956, is an Iranian painter who currently lives and works in New York.

DEBORAH **KASS**, born in 1952, is an American artist who currently resides in Brooklyn.

NINA **KATCHADOURIAN**, born in 1968, is an American conceptual artist, who works in a variety of mediums. She is currently based in Brooklyn.

ALEX **KATZ**, born in 1927, in an American figurative artist known for his paintings, sculptures, and prints. He currently lives and works in New York.

JEFF **KOONS**, born in 1955, is an American artist known for working with everyday objects. His artwork revolves around themes of self-acceptance and transcendence.

AN-MY **LÊ**, born in 1960 in Vietnam, is an American photographer. She currently lives and works in New York.

ARTIST BIOGRAPHIES

IL **LEE**, born in 1952, is a Korean painter who currently lives and works in Brooklyn.

LEE MINGWEI, born 1964 in Taiwan, is an artist who creates participatory installations. He currently lives and works in Paris, New York, and Taipei.

LEE UFAN, born in 1936, is a Korean minimalist painter and sculptor. He lives and works in Paris and Kamakura, Japan.

GLENN **LIGON**, born in 1960, is an American conceptual artist who works in a variety of mediums, including painting, installation, neon, and video. He currently lives and works in New York.

LIN TIANMIAO, born in 1961, is a Chinese artist who works in a variety of mediums, including installation, sculpture, and photography. She currently lives and works in Beijing.

KALUP **LINZY**, born in 1977, is an American video and performance artist who lives and works in Brooklyn.

ROBERT **LONGO**, born in 1953, is an American artist who works in a variety of mediums, including drawing, painting, sculpture, performance, film, and photography. He is currently based in New York.

NICOLA **LÓPEZ**, born in 1975, is an American artist based in Brooklyn who works in installation, drawing, and printmaking.

NALINI **MALANI**, born in 1946, is an Indian painter and multimedia installation artist. She lives and works in Mumbai.

KERRY JAMES **MARSHALL**, born in 1955, is an American painter and sculptor. He lives and works in Chicago.

JOSIAH **MCELHENY**, born in 1966, is an American artist best known for artworks combining glass with other materials. He currently lives and works in New York.

LAURA **MCPHEE**, born 1958, is an American photographer. She lives, works, and teaches in Brookline, Massachusetts.

JOSEPHINE **MECKSEPER**, born in Germany, uses commercial forms of presentation, such as vitrines, window displays, and magazines, to demonstrate inextricable influences of consumer culture on society. She lives and works in New York.

JULIE **MEHRETU**, born in 1970 in Addis Ababa, Ethiopia, is an abstract painter and printmaker. She currently lives and works in New York.

ALEXANDER **MELAMID**, born in 1945, is an artist who was raised and started his artistic career in Moscow. Since 1978 he has lived and worked in the United States.

MARIKO **MORI**, born in 1967, is a Japanese multidisciplinary artist interested in history and science. She is based in London, New York, and Tokyo.

VIK **MUNIZ**, born in 1961, is a Brazilian mixed-media artist and photographer. He currently lives and works in New York and Rio de Janeiro.

WANGECHI **MUTU** is an artist and sculptor. She lives and works in Brooklyn and Nairobi, Kenya.

JAMES **NARES**, born in 1953, is a British artist based in New York who works in a variety of mediums, including painting, photography, film, and video.

CATHERINE **OPIE**, born in 1961, is an American photographer. She currently lives and works in Los Angeles.

CORNELIA **PARKER**, born in 1956, is a British sculptor and installation artist. She currently lives and works in London.

IZHAR **PATKIN**, born in 1955 in Israel, is a painter and sculptor who currently lives and works in New York.

SHEILA **PEPE**, born in 1959, is an American artist whose work employs conceptualism, surrealism, and craft to address feminist issues. She lives and works in Brooklyn.

RAYMOND **PETTIBON**, born in 1957, is an American artist who works with drawing, text, and artist's books. He lives and works in New York.

SOPHEAP **PICH**, born in 1971, is a Cambodian sculptor who works with bamboo and rattan. He currently lives and works in Phnom Penh.

ROBERT **POLIDORI**, born in 1951, is a French, Canadian, and American photographer who currently lives in Santa Monica, California.

RONA **PONDICK**, born in 1952, is an American sculptor who lives and works in New York.

LILIANA **PORTER**, born in 1941, is an Argentinian artist working in a wide variety of mediums, including photog-

raphy, printmaking, mixed-media pieces, installation, and video. She has lived and worked in New York since 1964.

WILFREDO **PRIETO**, born in 1978, is a Cuban conceptual artist. He currently lives and works in Havana.

RASHID **RANA**, born in 1968, is an artist working in photography, sculpture, and a variety of digital media. He lives and works in Lahore, Pakistan.

KRISHNA **REDDY**, born in 1925, is an Indian printmaker and sculptor. He currently lives and works in New York.

MATTHEW **RITCHIE**, born in 1964 in London, is an American artist who works in a variety of mediums, including painting, drawing, sculpture, and installation. He currently lives and works in New York.

DOROTHEA **ROCKBURNE**, born in 1932, is a Canadian abstract painter who draws inspiration primarily from her interest in nature as visualized through mathematics and astronomy. She currently lives and works in New York.

ALEXIS **ROCKMAN**, born in 1962, is an American painter who lives and works in New York.

ANNABETH **ROSEN**, born in 1957, is an American sculptor and ceramicist. She currently lives and works in Davis, California.

MARTHA **ROSLER** is an American conceptual artist who works in a wide range of mediums, including video, photo-text, installation, and performance. Brooklyn born, she now lives and works there.

TOM **SACHS**, born in 1966, is an American sculptor who lives and works in New York.

DAVID **SALLE**, born in 1952, is an American painter, printmaker, and essayist. He currently lives and works in Brooklyn.

CAROLEE **SCHNEEMANN** is an American multidisciplinary artist who works in a variety of mediums, including painting, photography, performance art, and installation. She currently lives and works in Springtown, New York.

DANA **SCHUTZ**, born in 1976, is an American painter who currently lives and works in Brooklyn.

ARLENE **SHECHET**, born in 1951, is an American sculptor who currently lives and works in New York City and Hudson Valley, New York.

JAMES **SIENA**, born in 1957, is an American artist who works in a wide range of mediums, including lithography, etching, woodcut, engraving, drawing, sculpture, and painting. He is based in New York.

KATRÍN **SIGURDARDÓTTIR**, born in 1967, is an Icelandic installation artist who is based in New York.

SHAHZIA **SIKANDER**, born in 1969, is a Pakistani artist who works in drawing, painting, animation, large-scale installation, performance, and video. She currently lives and works in New York.

JOAN **SNYDER**, born in 1940, is an American painter. She currently lives and works in Brooklyn and Woodstock, New York.

PAT **STEIR**, born in 1940, is an American painter and printmaker who lives and works in New York.

THOMAS **STRUTH**, born in 1954, is a German photographer. He currently lives and works in Berlin.

HIROSHI **SUGIMOTO**, born in 1948, is a Japanese photographer who currently lives in Tokyo and New York.

EVE **SUSSMAN**, born in 1961 in London, is an American artist who works in a variety of mediums, including film, video, installation, sculpture, and photography. She currently lives and works in Brooklyn.

SWOON, born Caledonia Dance Curry in 1977, is an American street artist who currently lives and works in Brooklyn.

SARAH **SZE**, born in 1969, is an American sculptor and installation artist who lives and works in New York.

PAUL **TAZEWELL**, born in Akron, Ohio, is an American costume designer for the theater, dance, and opera.

WAYNE **THIEBAUD**, born in 1920, is an American painter widely known for his colorful works depicting commonplace objects. He currently lives and works in Sacramento, California.

HANK WILLIS **THOMAS**, born in 1976, is an American photo-conceptual artist who lives and works in New York.

MICKALENE **THOMAS**, born in 1971, is an American painter, photographer, and filmmaker who currently lives and works in New York.

ARTIST BIOGRAPHIES

FRED **TOMASELLI**, born in 1956, is an American painter. He currently lives and works in Brooklyn.

JACQUES **VILLEGLÉ**, born in 1926, is a French mixed-media artist and *affichiste* (poster designer). He currently lives and works in Paris.

MARY **WEATHERFORD**, born in 1963, is an American painter who sometimes incorporates neon lighting tubes in her work. She currently lives and works in Los Angeles.

WILLIAM **WEGMAN**, born in 1943, is an American artist who works in a variety of mediums, including painting, photography, and video. He currently lives and works in New York.

KEHINDE **WILEY**, born in 1977, is an American portrait painter who is currently based in Brooklyn.

BETTY **WOODMAN**, born in 1930, is an American artist. The vessel and ceramics have been at the center of her practice for the past sixty years. She lives and works in New York and outside Florence, Italy.

XU BING, born in 1955, is a Chinese printmaker and installation artist who currently lives in Beijing and New York.

DUSTIN **YELLIN**, born in 1975, is an American artist living in Brooklyn who is best known for his sculptural paintings using glass. Yellin is the founder of Pioneer Works, a nonprofit institute for art and innovation in Red Hook, Brooklyn.

LISA **YUSKAVAGE**, born in 1962, is an American painter who currently lives and works in New York.

ZHANG XIAOGANG, born in 1958, is a Chinese painter. He currently lives and works in Beijing.

All works preceded by an asterisk are in the collection of The Metropolitan Museum of Art. Unless otherwise specified, photographs of works in the Museum's collection are by the Imaging Department at The Metropolitan Museum of Art. Dimensions are given in height × width × depth.

pp. 16–17:
Acconci Studio, *Mur Island*, Graz, Austria, 2004. Steel, glass, rubber, asphalt, water, light. 1,052 sq. m. © 2017 Vito Acconci / Artists Rights Society (ARS), New York
*Gerrit Rietveld, *Zig Zag Stoel*, ca. 1937–40. Elm. 28 ⅜ × 12 ½ × 15 ½ in. (72 × 31.8 × 39.4 cm), 14 lb. (6.4 kg). Purchase, J. Stewart Johnson Gift, 2006 (2007.11). © 2017 Artists Rights Society (ARS), New York / c/o Pictoright Amsterdam

pp. 18–19:
Ann Agee, *Vase*, 2009. Porcelain. 17 ½ × 15 ½ × 7 in. (44.5 × 39.4 × 17.8 cm). Philadelphia Museum of Art; Purchased with funds contributed by the Women's Committee and the Craft Show Committee of the Philadelphia Museum of Art, 2010 (2010-189-1). © Ann Agee. Photo credit: The Philadelphia Museum of Art / Art Resource, NY
Harlequin Family, ca. 1740–45, French, Villeroy. Soft-paste porcelain. 14 ⁵⁄₁₆ × 8 ³⁄₁₆ × 6 ⅜ in. (36.4 × 20.8 × 16.2 cm). The Jack and Belle Linsky Collection, 1982 (1982.60.255)

pp. 20–21:
Njideka Akunyili Crosby, *I Still Face You*, 2015. Acrylic, charcoal, colored pencils, collage, oil, and transfers on paper. 84 × 105 in. (213.36 × 266.7 cm). Los Angeles County Museum of Art; Purchased with funds provided by AHAN: Studio Forum, 2015 (Art Here and Now purchase). © Njideka Akunyili Crosby
*Georges Seurat, *Embroidery; The Artist's Mother*, 1882–83. Conté crayon on Michallet paper. 12 ⁵⁄₁₆ × 9 ⁷⁄₁₆ in. (31.2 × 24.1 cm). Purchase, Joseph Pulitzer Bequest, 1951; acquired from The Museum of Modern Art, Lillie P. Bliss Collection (55.21.1)

pp. 22–23:
Ghada Amer, *Heather's Dégradé*, 2006. Embroidery and gel medium on canvas. 78 × 62 × 1 ½ in. (198.1 × 157.5 × 3.8 cm). Brooklyn Museum; Frank L. Babbott Fund, Mary Smith Dorward Fund, William K. Jacobs, Jr. Fund, and Florence B. and Carl L. Selden Fund, 2013 (2013.50.1). © Ghada Amer
Garden Gathering, 1640–50, Islamic, Iran, probably Isfahan. Stonepaste, painted and polychrome glazed (cuerda seca technique). Panel with tabs: 41 × 74 × 2 ½ in. (104.1 × 188 × 6.4 cm), 400 lbs. (181.4 kg); each tile: 8 ⅞ × 8 ⅞ in. (22.5 × 22.5 cm). Rogers Fund, 1903 (03.9c)

pp. 24–25:
Kamrooz Aram, *A Monument for Living in Defeat*, 2016. Canvas: oil, wax, and pencil on canvas. 60 × 108 in. (152.4 × 274.32 cm). Tile platform: terrazzo and brass on panel. 54 × 48 × 2 in. (137.16 × 121.92 × 5.08 cm). Pedestals: solid walnut and brass. 48 × 8 × 8 in. (121.92 × 20.32 × 20.32 cm); 41 × 8 × 8 in. (104.14 × 20.32 × 20.32 cm). Sculptures: soapstone and alabaster. 7 × 6 ½ × 6 in. (17.78 × 16.51 × 15.24 cm); 8 × 4 × 6 in. (20.32 × 10.16 × 15.24 cm). © Kamrooz Aram
Bricks with a Palmette Motif, ca. 6th–4th century BC, Iran, Susa, Achaemenid. Ceramic, glaze. 3.35 × 5.51 × 7.48 in. (8.51 × 14 × 19 cm). Rogers Fund, 1948 (48.98.20a–c)
Bull's Head from Column Capital, ca. 5th century BC, Iran, Istakhr, near Persepolis, Achaemenid. Limestone. 18.5 in. (46.99 cm). Rogers Fund, 1947 (47.100.83)

pp. 26–27:
Cory Arcangel, *Super Mario Clouds*, 2002. Handmade hacked Super Mario Brothers cartridge and Nintendo NES video game system. Dimensions variable. Whitney Museum of American Art, New York; Purchase with funds from the Painting and Sculpture Committee (2005.10). Courtesy the artist and Team Gallery, New York. © Cory Arcangel
Harpsichord, late 17th century, Italian. Wood, various materials. Inner case dimensions: L. w/o moldings, 89 ¹¹⁄₁₆ in. (227.8 cm); L. w/ moldings, 91 ⁷⁄₁₆ in. (231.2 cm); W. w/o moldings, 31 ⅜ in. (79.7 cm); W. w/ moldings, 32 ¹⁄₁₆ in. (81.5 cm); D. 9 ¾ in. (24.8 cm); Octave span: c–b2, 19 ¹¹⁄₁₆ in. (49.9 cm). Gift of Susan Dwight Bliss, 1945 (45.41)

pp. 28–29:
*John Baldessari, *Soul (Rare View)*, 1987. Gelatin silver prints with applied oil tint. 48 ⅝ × 82 ⅜ in. (123.5 × 209.2 cm). Purchase, John B. Turner Fund and The Horace W. Goldsmith Foundation Gift, through Joyce and Robert Menschel, 1988 (1988.1001a, b). © John Baldessari
*Philip Guston, *Stationary Figure*, 1973. Oil on canvas. 77 ½ × 128 ½ in. (196.9 × 326.4 cm). Bequest of Musa Guston, 1992 (1992.321.2)

pp. 30–31:
Barry X Ball, *Sleeping Hermaphrodite*, 2008–10. Marble, stainless steel, resin. 68 ½ × 35 ¹³⁄₁₆ × 31 ⅝ in. (174 × 91 × 80 cm). Courtesy the artist. © Barry X Ball
Fragment of a Queen's Face, ca. 1353–1336 BC, Egypt, New Kingdom, Amarna Period, Dynasty 18, reign of Akhenaten. Yellow jasper. 5 ⅛ × 4 ¹⁵⁄₁₆ × 4 ¹⁵⁄₁₆ in. (13 × 12.5 × 12.5 cm). Purchase, Edward S. Harkness Gift, 1926 (26.7.1396)

pp. 32–33:
*Ali Banisadr, *Interrogation*, 2010. Oil on linen. 48 ⅛ × 60 × ¹⁷⁄₁₆ in. (122.2 × 152.4 × 37 cm). Purchase, 2011 NoRuz at The Met Benefit, 2012 (2012.38). © Ali Banisadr
*Hieronymus Bosch, *The Adoration of the Magi*, ca. 1475. Oil and gold on oak. John Stewart Kennedy Fund, 1913 (13.26)

pp. 34–35:
Dia Batal, *Mourning Hall*, 2012. Printed vinyl on 15th-century hand-painted Damascene tiles, audio recording. Courtesy the artist. © Dia Batal. Photo: Dia Batal
Tile Panel with Calligraphic Inscription, dated AH 1000 / AD 1591–92, Islamic, Syria. Stonepaste, polychrome painted under transparent glaze. 63 ¼ × 11 ½ × 1 ¾ in. (160.7 × 29.2 × 4.4 cm), 58 lbs. (26.3 kg). Bequest of Agnes Miles Carpenter, 1958 (58.90.1a–g)

pp. 36–37:
Zoe Beloff, *The Days of the Commune*, 2012. Video, color, sound. 154 min. 59 sec. © Zoe Beloff
*Édouard Manet, *Civil War (Guerre Civile)*, 1871–73, published 1874. Lithograph on chine collé, final state (II). Stone: 15 ⅝ × 20 in. (39.7 × 50.8 cm); sheet: 19 ⅛ × 24 ¾ in. (48.6 × 62.9 cm). Rogers Fund, 1922 (22.60.18)

pp. 38–39:
*Dawoud Bey, *The Blues Singer*, 1976, printed 1979. Gelatin silver print. 5 ¹⁵⁄₁₆ × 8 ¹⁵⁄₁₆ in. (15.1 × 22.7 cm). Twentieth-Century Photography Fund, 2013 (2013.112). © Dawoud Bey
*Roy DeCarava, *Mott Avenue*, 1951. Gelatin silver print. Image: 13 × 8 ⁹⁄₁₆ in. (33 × 21.8 cm). Purchase, Alfred Stieglitz Society Gifts, 2014 (2014.531)

pp. 40–41:
Nayland Blake, *Work Station #5*, 1989. Steel, glass, aluminum, leather, plastic, rubber, cleavers. 54 ½ × 24 ½ × 55 ½ in. (138.43 × 62.23 × 140.97 cm). San Francisco Museum of Modern Art; Gift of Dare and Themistocles Michos, in memory of John Caldwell. © Nayland Blake. Photo: Ben Blackwell
Power Object (Boli), 19th–first half of 20th century, Mali, Bamana peoples. Wood, sacrificial materials (patina). 14 ¼ × 7 ⁹⁄₁₆ × 20 ½ in. (36.2 × 19.2 × 52.1 cm). The Michael C. Rockefeller Memorial Collection, Bequest of Nelson A. Rockefeller, 1979 (1979.206.175)

pp. 42–43:
Barbara Bloom, *Greed*, 1988. Mixed media. 40 × 28 in. (101.6 × 71.1 cm). International Center of Photography; Gift of James and Deborah Kern, 2001 (8.2001). © Barbara Bloom
*Vilhelm Hammershøi, *Moonlight, Strandgade 30*, 1900–1906. Oil on canvas. 16 ⅛ × 20 ⅛ in. (41 × 51.1 cm). Purchase, European Paintings Funds, and Annette de la Renta Gift, 2012 (2012.203)

pp. 44–45:
Andrea Bowers, *Migration Is Beautiful II (May Day, Los Angeles 2013)*, 2015. Graphite on paper. 16 ⅞ × 24 ¼ in. (43 × 61.5 cm). Courtesy the artist and Andrew Kreps Gallery. © Andrea Bowers
*Howardena Pindell, *Oval Memory Series II: Castle Dragon*, 1980–81.

CAPTIONS AND CREDITS

Cut-and-pasted postcards, tempera, gouache, fluorescent paint, punched papers, nails, thread on foam board. 22 ¾ × 36 ¼ in. (57.8 × 92.1 cm). Purchase, Lillian L. Poses Gift, 1981 (1981.327). © Howardena Pindell

pp. 46–47:
Mark Bradford, *Crack Between the Floorboards*, 2014. Mixed-media collage on canvas. 132 ⅛ × 120 ¼ × 2 ⅛ in. (335.5 × 305.5 × 5.5 cm). Courtesy the artist and Hauser & Wirth. © Mark Bradford. Photo: Joshua White
*Clyfford Still, *Untitled*, 1950. Oil on canvas. 112 × 169 ¼ in. (284.5 × 429.9 cm). Gift of Mrs. Clyfford Still, 1986 (1986.441.6). © 2017 City & County of Denver. Courtesy Clyfford Still Museum / Artists Rights Society (ARS), New York

pp. 48–49:
*Cecily Brown, *Fair of Face, Full of Woe*, 2008. Oil on canvas. Each canvas: 17 × 13 ⅛ in. (43.2 × 33.3 cm). Gift of Calvin Tomkins and Dodie Kazanjian, 2009 (2009.533a–c). © Cecily Brown
Virgin and Child, 1345, South Netherlandish. Marble with traces of gilding. 45 ¾ × 16 × 8 ⅞ in. (116.2 × 40.6 × 22.5 cm). Fletcher Fund, 1924 (24.215)

pp. 50–51:
Luis Camnitzer, *Landscape as an Attitude*, 1979. Gelatin silver print. 9 ½ × 13 ⅛ in. (24.13 × 33.33 cm). Collection Walker Art Center, Minneapolis; T. B. Walker Acquisition Fund, 2011. © Luis Camnitzer
*Giovanni Battista Piranesi, Domenico Cunego, *Della Magnificenza e d'Architettura de' Romani* (On the Grandeur and the Architecture of the Romans by Gio. Battista Piranesi, Fellow of the Royal Society of Antiquaries of London), 1761, 1765. Etchings and engravings. Overall: 22 ¹/₁₆ × 16 ¾ × 2 ¾ in. (56 × 42.5 × 7 cm). Rogers Fund, Transferred from the Library, 1941 (41.71.1.7)

pp. 52–53:
Nick Cave, *Soundsuit*, 2008. Mixed media. 112 × 43 × 35 in. (284.5 × 109.2 × 88.9 cm). Brooklyn Museum; Mary Smith Dorward Fund (2009.44a–b). Courtesy the artist and Jack Shainman Gallery, New York. © Nick Cave. Photo: James Prinz Photography
*Woman's Ceremonial Underskirt, early to mid-20th century, Democratic Republic of the Congo, Kuba peoples, Bushoong group. Barkcloth, raffia fiber. 134 × 16 in. (340.4 × 40.6 cm). Purchase, William B. Goldstein Gift, Holly and David Ross Gift, and funds from various donors, 2006 (2006.124)

pp. 54–55:
Alejandro Cesarco, *Musings*, 2013. 16mm film transferred to video, black-and-white, sound. 15 min. 30 sec. Installation view, Galleria Raffaella Cortese, Milan. Courtesy the artist and Galleria Raffaella Cortese. © Alejandro Cesarco
*Alberto Giacometti, *Woman of Venice II*, 1956. Painted bronze. 47 ⅞ × 12 ⅝ × 5 ½ in. (121.6 × 32.1 × 14 cm). Jacques and Natasha Gelman Collection, 1998 (1999.363.25). Art © Alberto Giacometti Estate / Licensed by VAGA and ARS, New York, NY

pp. 56–57:
*Enrique Chagoya, *The Headache, A Print after George Cruikshank*, 2010. Etching with digitally printed color on gampi paper, chine collé. Printer's proof, 5 / 10. Plate: 8 × 10 in. (20.3 × 25.4 cm); sheet: 15 × 21 in. (38.1 × 53.3 cm). Stewart S. MacDermott Fund, 2010 (2010.285). © 2011 Enrique Chagoya
*Goya (Francisco de Goya y Lucientes), *The Sleep of Reason Produces Monsters (El sueño de la razon produce monstruos)*, plate 43 from *Los Caprichos*, 1799. Etching, aquatint, drypoint, and burin. Plate: 8 ⅜ × 5 ¹⁵/₁₆ in. (21.2 × 15.1 cm); sheet: 11 ⅝ × 8 ¼ in. (29.5 × 21 cm). Gift of M. Knoedler & Co., 1918 (18.64[43])

pp. 58–59:
Roz Chast, *Pigeon Little*, 2009. Ink on paper. Image: 5 × 4 ½ in. (12.7 × 11.4 cm); sheet: 11 × 8 in. (27.9 × 20.3 cm). Published in *New Yorker*, June 8, 2009. Courtesy the artist. © Roz Chast
*Fra Carnevale (Bartolomeo di Giovanni Corradini), *The Birth of the Virgin*, 1467. Tempera and oil on wood. 57 × 37 ⅞ in. (144.8 × 96.2 cm). Rogers and Gwynne Andrews Funds, 1935 (35.121)

pp. 60–61:
*Willie Cole, *Shine*, 2007. Shoes, steel wire, monofilament line, washers, and screws. 15 ¾ × 14 × 15 in. (40 × 35.6 × 38.1 cm). Hortense and William A. Mohr Sculpture Purchase Fund, 2008 (2008.259). © Willie Cole
*Headdress (Ci Wara): Female Antelope, 19th–early 20th century, Mali, Bamako region, Bamana peoples. Wood, metal bands. 28 × 12 ⅛ × 2 ⅛ in. (71.2 × 30.8 × 5.4 cm). The Michael C. Rockefeller Memorial Collection, Gift of Nelson A. Rockefeller, 1964 (1978.412.436)

pp. 62–63:
*George Condo, *Rush Hour*, 2010. Acrylic, graphite, charcoal, and pastel on canvas. 83 ⁵/₁₆ × 73 ⅛ × 3 ½ in. (211.6 × 185.7 × 8.9 cm). George A. Hearn Fund, 2011 (2011.306). © George Condo
*Claude Monet, *The Path through the Irises*, 1914–17. Oil on canvas. 78 ⅞ × 70 ⅞ in. (200.3 × 180 cm). The Walter H. and Leonore Annenberg Collection, Gift of Walter H. and Leonore Annenberg, 2001, Bequest of Walter H. Annenberg, 2002 (2001.202.6)

pp. 64–65:
*Petah Coyne, *Untitled #875 (Black Atlanta)*, 1997. Wax, steel, pigment, artificial birds, wire, ribbon, satin, cable, chain, cable nuts, shackle, swivel, thread, paper towel, plastic. 64 ½ × 41 × 39 in. (163.83 × 104.14 × 99.06 cm). Gift of Vera G. List, 2002 (2002.375a–n). Courtesy Galerie Lelong, New York. © Petah Coyne
*Outer Robe (Uchikake) with Mount Hōrai, second half of the 18th century–first half of the 19th century, Japanese, Edo period. Silk, metallic thread embroidery on silk satin damask with stencil-dyed details. Overall: 73 × 48 in. (185.4 × 121.9 cm). Gift of Dr. and Mrs. Jonas M. Goldstone, 1970 (1970.296.1)

pp. 66–67:
John Currin, *Thanksgiving*, 2003. Oil on canvas. 68 × 52 in. (172.9 × 132.3 cm). Tate; Lent by the American Fund for the Tate Gallery. Courtesy Marc Jacobs, 2004: L02546. © John Currin
*Ludovico Carracci, *The Lamentation*, ca. 1582. Oil on canvas. 37 ½ × 68 in. (95.3 × 172.7 cm). Purchase, Lila Acheson Wallace and The Annenberg Foundation Gifts; Harris Brisbane Dick, Rogers, and Gwynne Andrews Funds; Pat and John Rosenwald, Mr. and Mrs. Mark Fisch, and Jon and Barbara Landau Gifts; Gift of Mortimer D. Sackler, Theresa Sackler and Family; and Victor Wilbour Memorial, Marquand, The Alfred N. Punnett Endowment, and Charles B. Curtis Funds, 2000 (2000.68)

pp. 68–69:
*Moyra Davey, *Copperhead Grid*, 1990. 100 chromogenic prints. Each: 10 × 8 in. (25.4 × 20.3 cm). Purchase, Vital Projects Fund Inc. Gift, through Joyce and Robert Menschel, 2011 (2011.17a–vvvv). © Moyra Davey
*Rosary Terminal Bead with Lovers and Death's Head, ca. 1500–1525, made in northern France or South Netherlands. Ivory, emerald pendant, silver-gilt mount. Overall: 5 ⅜ × 1 ⁹/₁₆ × 1 ¹¹/₁₆ in. (13.6 × 4 × 4.3 cm); ivory only: 2 ¹³/₁₆ × 1 ⁹/₁₆ × 1 ¹¹/₁₆ in. (7.2 × 4 × 4.3 cm). Gift of J. Pierpont Morgan, 1917 (17.190.305)

pp. 70–71:
Edmund de Waal, detail from *Lichtzwang*, 2014. 281 porcelain vessels with gilding in a pair of wood, aluminum, glass vitrines. Each: 108 × 47 × 5 in. (274.5 × 120 × 13.5 cm). Courtesy the artist. © Edmund de Waal. Photo: Mike Bruce
*Ewer in the Shape of a Tibetan Monk's Cap, early 15th century, China, Ming dynasty. Porcelain with incised hidden or anhua decoration under transparent glaze (Jingdezhen ware). H. 7 ¾ in. (19.7 cm). Gift of Stanley Herzman, in memory of Adele Herzman, 1991 (1991.253.36)

pp. 72–73:
*Thomas Demand, *Vault*, 2012. Chromogenic print. 86 ⅝ × 109 in. (220 × 276.9 cm). Purchase, Louis V. Bell Fund; Alfred Stieglitz Society, The Fledgling Fund, through Diana Barrett and Robert Vila, Joseph M. and Barbara Cohen Foundation Inc. and Hideyuki Osawa Gifts, 2013 (2013.163). © 2017 Artists Rights Society (ARS), New York / VG Bild-Kunst, Bonn
*Studiolo from the Ducal Palace in Gubbio, designed by Francesco di Giorgio Martini, executed under the supervision of Francesco di Giorgio Martini in the workshop of Giuliano da Maiano and Benedetto da Maiano,

ca. 1478–82, Italian, Gubbio. Walnut, beech, rosewood, oak, and fruitwoods in walnut base. 15 ft. 10 ¹⁵⁄₁₆ in. × 16 ft. 11 ¹⁵⁄₁₆ in. × 12 ft. 7 ³⁄₁₆ in. (485 × 518 × 384 cm). Rogers Fund, 1939 (39.153)

pp. 74–75:
Teresita Fernández, *Fire*, 2005. Silk yarn, steel armature, epoxy. 96 × 144 in. (243.84 × 365.76 cm). The San Francisco Museum of Modern Art; Accessions Committee Fund purchase (Created in collaboration with the Fabric Workshop and Museum, Philadelphia) (2007.144.a–b). © Teresita Fernández. Photo: Don Ross
*Funerary Mask, 5th–1st century BC, Colombia, Calima Valley region, Calima (Ilama). Gold. 7 ¾ × 9 ⅝ in. (19.7 × 24.4 cm). Jan Mitchell and Sons Collection, Gift of Jan Mitchell, 1991 (1991.419.39)

pp. 76–77:
Spencer Finch, *Bright Star (Sirius)*, 2010. Fluorescent lamps, fixtures, filters, aluminum. 107 ⅞ in. High Museum of Art, Atlanta; Purchase through funds provided by patrons of the Second Annual Collectors Evening, 2011 (2011.5). © Spencer Finch
*William Michael Harnett, *The Artist's Letter Rack*, 1879. Oil on canvas. 30 × 25 in. (76.2 × 63.5 cm). Morris K. Jesup Fund, 1966 (66.13)

pp. 78–79:
Eric Fischl, *A Visit To / A Visit From / The Island*, 1983. Oil on canvas. 84 × 168 in. (213.4 × 426.7 cm). Whitney Museum of American Art, New York; Purchase, with funds from the Louis and Bessie Adler Foundation, Inc., Seymour M. Klein, President (83.17a–b). © Eric Fischl
*Max Beckmann, *Beginning*, 1949. Oil on canvas. Overall: 69 × 125 ½ in. (175.3 × 318.8 cm); left (a): 65 × 33 ½ in. (165.1 × 85.1 cm); center (b): 69 × 59 in. (175.3 × 149.9 cm); right (c): 65 × 33½ in. (165.1 × 85.1 cm). Bequest of Miss Adelaide Milton de Groot (1876–1967), 1967 (67.187.53a–c). © 2017 Artists Rights Society (ARS), New York / VG Bild-Kunst, Bonn

pp. 80–81:
*Roland Flexner, *Untitled*, 2007. Sumi ink on paper. 5 ½ × 7 in. (14 × 17.8 cm). Purchase, Stephen and Nan Swid Gift, 2010 (2010.434). © Roland Flexner
*Jacques de Gheyn II, *Vanitas Still Life*, 1603. Oil on wood. 32 ½ × 21 ¼ in. (82.6 × 54 cm). Charles B. Curtis, Marquand, Victor Wilbour Memorial, and The Alfred N. Punnett Endowment Funds, 1974 (1974.1)

pp. 82–83:
Walton Ford, *Visitation*, 2004. Color etching, aquatint, spit-bite, and drypoint on paper. 44 × 31 in. (111.7 × 78.8 cm). Smithsonian American Art Museum; Museum purchase through the Luisita L. and Franz H. Denghausen Endowment (2010.3). © Walton Ford. Photo credit: Smithsonian American Art Museum, Washington, DC / Art Resource, NY
*Jan van Eyck and Workshop Assistant, *The Crucifixion; The Last Judgment*, ca. 1440–41. Oil on canvas, transferred from wood. Each 22 ¼ × 7 ⅔ in. (56.5 × 19.7 cm). Fletcher Fund, 1933 (33.92a, b)

pp. 84–85:
Natalie Frank, *All Fur III (Grimm's Fairy Tales)*, 2011–14. Gouache and chalk pastel on paper. 22 × 30 in. (55.88 × 76.2 cm). Courtesy the artist. © Natalie Frank
*Käthe Kollwitz, *Young Couple (Junges Paar)*, 1904. Etching. Plate: 11 ⅝ × 12 ⁷⁄₁₆ in. (29.5 × 31.6 cm); sheet: 15 ⅝ × 21 ¼ in. (39.7 × 54 cm). Harris Brisbane Dick Fund, 1928 (28.68.5)
*Käthe Kollwitz, *Raped (Vergewaltigt)*, published by Emil Richter, Dresden, 1907, second edition published 1921. Etching and soft-ground etching with drypoint. Plate: 12 ¹⁄₁₆ × 20 ¹³⁄₁₆ in. (30.6 × 52.8 cm); sheet: 20 ³⁄₁₆ × 26 ⅝ in. (51.3 × 67.7 cm). Museum Accession, 1965 (65.603bis)

pp. 86–87:
LaToya Ruby Frazier, *Grandma Ruby and Me*, 2005. Gelatin silver print. 18 ⅜ × 23 ³⁄₁₆ in. (46.7 × 59.2 cm). The Museum of Modern Art; the Photography Council Fund (22.2015). © LaToya Ruby Frazier. Digital image © The Museum of Modern Art / Licensed by SCALA / Art Resource, NY
*Gordon Parks, *Red Jackson*, 1948. Gelatin silver print. 19 ⅛ × 15 ⁹⁄₁₆ in. (48.5 × 39.6 cm). Gift of Photography in the Fine Arts, 1959 (59.559.58). Photograph by Gordon Parks. Courtesy and © The Gordon Parks Foundation

pp. 88–89:
Suzan Frecon, *soforouge*, 2009. Oil on linen. Two panels; overall: 108 × 87 ⅜ × 1 ½ in. (274.3 × 221.9 × 3.8 cm); each panel: 54 × 87 ⅜ × 1 ½ in. (137.2 × 221.9 × 3.8 cm). Courtesy the artist and David Zwirner, New York / London. © Suzan Frecon
*Duccio di Buoninsegna, *Madonna and Child*, ca. 1290–1300. Tempera and gold on wood. Overall, with engaged frame: 11 × 8 ¼ in. (27.9 × 21 cm); painted surface: 9 ⅜ × 6 ½ in. (23.8 × 16.5 cm). Purchase, Rogers Fund, Walter and Leonore Annenberg and The Annenberg Foundation Gift, Lila Acheson Wallace Gift, Annette de la Renta Gift, Harris Brisbane Dick, Fletcher, Louis V. Bell, and Dodge Funds, Joseph Pulitzer Bequest, several members of The Chairman's Council Gifts, Elaine L. Rosenberg and Stephenson Family Foundation Gifts, 2003 Benefit Fund, and other gifts and funds from various donors, 2004 (2004.442)

pp. 90–91:
*Adam Fuss, *Ark*, 2004. Daguerreotype. Image: 14 × 11 in. (35.6 × 27.9 cm); frame: 21 ½ × 18 ½ in. (54.6 × 47 cm). Purchase, Alfred Stieglitz Society Gifts, 2006 (2006.171). © Adam Fuss
*Marble Grave Stele of a Little Girl, ca. 450–440 BC, Greek, Classical. Marble, Parian. H. 31 ¾ in. (80.6 cm), W. (top) 14 ⁹⁄₁₆ in. (37 cm), W. (base) 15 ½ × 4 in. (39.4 × 10.2 cm), 131 lb. (59.4 kg). Fletcher Fund, 1927 (27.45)

pp. 92–93:
Maureen Gallace, *Rainbow Road, Martha's Vineyard*, 2015. Oil on panel. 9 × 12 in. (22.9 × 30.5 cm). Courtesy 303 Gallery, New York. © Maureen Gallace
*Paul Cézanne, *Still Life with Apples and a Pot of Primroses*, ca. 1890. Oil on canvas. 28 ¾ × 36 ⅜ in. (73 × 92.4 cm). Bequest of Sam A. Lewisohn, 1951 (51.112.1)
*Paul Cézanne, *Still Life with a Ginger Jar and Eggplants*, 1893–94. Oil on canvas. 28 ½ × 36 in. (72.4 × 91.4 cm). Bequest of Stephen C. Clark, 1960 (61.101.4)

pp. 94–95:
Jeffrey Gibson, *People Like Us*, 2014. Found canvas punching bag, repurposed wool army blanket, glass beads, tin jingles, nylon fringe, artificial sinew, acrylic paint. 65 × 14 ½ × 14 ½ in. (165.1 × 36.8 × 36.8 cm). Courtesy the artist. © Jeffrey Gibson
*Tin Mweleun (commissioned by Tain Mal), Slit Gong (Atingting kon), mid- to late 1960s, Vanuatu, Ambrym Island. Wood, paint. 175 ¼ × 28 × 23 ½ in. (445.1 × 71.1 × 59.7 cm). Rogers Fund, 1975 (1975.93)

pp. 96–97:
Nan Goldin, *Ayla at my apartment*, Berlin, 2015. Chromogenic print. 30 × 37 in. (76.2 × 17.78 cm). Courtesy Nan Goldin and Matthew Marks Gallery. © Nan Goldin
*Julia Margaret Cameron, *Julia Jackson*, 1867. Albumen silver print from glass negative. 10 ¹³⁄₁₆ × 8 ⅛ in. (27.4 × 20.6 cm). Purchase, Joseph Pulitzer Bequest, 1996 (1996.99.2)
*Julia Margaret Cameron, *Pomona*, 1872. Albumen silver print from glass negative. Image: 14 ⁵⁄₁₆ × 10 ⅜ in. (36.4 × 26.3 cm); mount: 19 ⁹⁄₁₆ × 14 ¾ in. (49.7 × 37.4 cm). David Hunter McAlpin Fund, 1963 (63.545)

pp. 98–99:
*Wenda Gu, *The Mythos of Lost Dynasties—Form C: Pseudo-Seal Scripture in Calligraphic Copybook Format*, 1983–87. Hanging scroll, ink on paper. Image: 24 ¼ × 36 ⅞ in. (61.6 × 93.7 cm); overall with mounting: 53 ⅛ × 41 ⅝ in. (134.9 × 105.7 cm); overall with knobs: 53 ⅛ × 44 ¾ in. (134.9 × 113.7 cm). Gift of Doris Dohrenwend, in memory of her mother, Gertrude Funke Dohrenwend, 2013 (2013.628). © Gu Wenda
*Robert Motherwell, *Lyric Suite*, 1965. Ink on paper. 11 × 9 in. (27.9 × 22.9 cm). Anonymous Gift, 1966 (66.233.1). Art © Dedalus Foundation, Inc. / Licensed by VAGA, New York, NY

pp. 100–101:
Diana Al-Hadid, *Gradiva's Fourth Wall*, 2011. Steel, polymer gypsum, wood, fiberglass, paint. 183 ½ × 190 ¾ × 132 in. (466.1 × 484.5 × 335.3 cm). Sharjah Art Foundation, Sharjah, UAE. © Diana Al-Hadid
*Cubiculum (bedroom) from the Villa of P. Fannius Synistor at Boscoreale,

ca. 50–40 BC, Late Republic, Roman. Fresco. Room: 8 ft. 8 ½ in. × 10 ft. 11 ½ in. × 19 ft. 7 ⅛ in. (265.4 × 334 × 583.9 cm). Rogers Fund, 1903 (03.14.13a–g)

pp. 102–3:
*Ann Hamilton, *abc*, 1994/1999. Single-channel digital video, black-and-white, silent. 13 min. Gift of Peter Norton Family Foundation, 2001 (2001.270). © 1999 Ann Hamilton
*Marionette: Male Figure (Merekun), 19th–20th century, Mali, San region, Bamana or Bozo peoples. Wood, cloth, metal, pigment, iron rods. 28 ¼ × 11 ¼ × 3 ¾ in. (71.8 × 28.6 × 9.5 cm). The Michael C. Rockefeller Memorial Collection, Bequest of Nelson A. Rockefeller, 1979 (1979.206.52)

pp. 104–5:
*Jane Hammond, *Untitled (41,231,85,56,200,35)*, 1991. Oil on canvas. 76 × 75 in. (193 × 190.5 cm). Purchase, Sarah-Ann and Werner H. Kramarsky Gift and George A. Hearn Fund, 1991 (1991.295). © Jane Hammond
*Unknown, 243 amateur snapshots, 1900s–1970s. Gelatin silver prints, instant prints, and chromogenic prints. Various sizes. Gift of Peter J. Cohen, 2012 (2012.556.1.1–.243)

pp. 106–7:
*Jacob El Hanani, *Tehilim*, 1978–81. Ink on canvas. 50 × 50 in. (127 × 127 cm). Gift of Syril and Leonard Rubin, 1983 (1983.199). © Jacob El Hanani
*Master of the Barbo Missal (illuminator), *Mishneh Torah*, ca. 1457, North Italian. Tempera, gold leaf on parchment, leather binding. Binding: 9 ⁷⁄₁₆ × 8 ³⁄₁₆ × 3 ¼ in. (24 × 20.8 × 8.2 cm); leaf (of 346 leaves): 8 ¹⁵⁄₁₆ × 7 ¼ in. (22.7 × 18.4 cm). Jointly owned by The Israel Museum, Jerusalem, and The Metropolitan Museum of Art, New York, 2013. Purchased for the Israel Museum through the generosity of an anonymous donor; René and Susanne Braginsky, Zurich; Renée and Lester Crown, Chicago; Schusterman Foundation—Israel; and Judy and Michael Steinhardt, New York. Purchased for The Metropolitan Museum of Art with Director's Funds and Judy and Michael Steinhardt Gift (2013.495)

pp. 108–9:
*Zarina Hashmi, *Home Is a Foreign Place*, 1999. Portfolio of 36 woodcut chine collé with Urdu text printed on paper and mounted on paper. Image (b–nn): 8 × 6 in. (20.3 × 15.2 cm); sheet: (b–nn): 15 ⅞ × 13 in. (40.3 × 33 cm); box: (oo): 17 ⅜ × 14 ½ in. (44.1 × 36.8 cm); frontispiece: (a): 11 × 8 ½ in. (27.9 × 21.6 cm). Purchase, The George Economou Collection Gift, 2013 (2013.565a–nn). © Zarina Hashmi
*Dedicatory Inscription from a Mosque, Panel, dated AH 905 / AD 1500, Islamic, India, Bengal. Carved gabbro. 16 ⅛ × 45 ⁵⁄₁₆ × 2 ¾ in. (41 × 115.1 × 7 cm), 194 lbs. (88 kg). Purchase, Gift of Mrs. Nelson Doubleday and Bequest of Charles R. Gerth, by exchange, 1981 (1981.320)

pp. 110–11:
*Sheila Hicks, *Écailles*, 1976. Silk, wool, razor-clam shells. Unframed: 9 ¼ × 8 ¼ in. (23.5 × 21 cm); framed: 24 × 16 ⁷⁄₁₆ × 1 ½ in. (61 × 41.8 × 3.8 cm). Purchase, Melvin L. Bedrick Gift, 1989 (1989.29). © Sheila Hicks
*Attributed to Baselyos, *Prayer Book: Arganonä Maryam (The Organ of Mary)*, late 17th century, Ethiopia, Lasta region, Amhara peoples. Parchment, pigment ink, wood, leather, fiber. 6 ½ × 6 ⅛ in. (16.5 × 15.5 cm). Louis V. Bell Fund, 2006 (2006.99)

pp. 112–13:
Rashid Johnson, *The New Negro Escapist Social and Athletic Club (Marcus)*, 2010. Archival pigment print. 20 × 16 in. (50.8 × 40.6 cm). Collection Museum of Contemporary Art Chicago, Gift of Sara Albrecht (2011.48). © MCA Chicago and Rashid Johnson. Photo: Nathan Keay
*Robert Frank, *Trolley–New Orleans*, 1955. Gelatin silver print. 8 ⅝ × 13 ¹⁄₁₆ in. (21.9 × 33.2 cm). Gilman Collection, Purchase, Ann Tenenbaum and Thomas H. Lee Gift, 2005 (2005.100.454). © 2016 Robert Frank from *The Americans*

pp. 114–15:
Y. Z. Kami, *Man with Violet Eyes*, 2013–14. Oil on linen. 108 × 72 in. (207.3 × 182.9 cm). Courtesy the artist and Gagosian Gallery. © Y. Z. Kami

*Panel Painting of a Woman in a Blue Mantle, AD 54–68, Egypt, Roman Period, Nero. Encaustic on wood. 14 ¹⁵⁄₁₆ × 8 ¾ in. (38 × 22.3 cm). Director's Fund, 2013 (2013.438)

pp. 116–17:
Deborah Kass, *Double Red Yentl, Split (My Elvis)*, 1993. Screenprint and acrylic on canvas. 72 ¼ × 72 in. (183.5 × 182.9 cm). The Jewish Museum, New York; Purchase, Joan and Laurence Kleinman Gift (1993-120a–b). © 2017 Deborah Kass / Artists Rights Society (ARS), New York. Photo: John Parnell. Photo credit: The Jewish Museum, New York / Art Resource, NY
*Signed by Hieron as potter, attributed to Makron, Terracotta Kylix (drinking cup), ca. 480 BC, Greece, Classical, Attic. Terracotta; red-figure. H. 5 ⁷⁄₁₆ in. (13.8 cm), D. 13 ¹⁄₁₆ in. (33.2 cm). Rogers Fund, 1920 (20.246)

pp. 118–19:
Nina Katchadourian, *Lavatory Self-Portrait in the Flemish Style #4*, 2011. From the project *Seat Assignment*, 2010–ongoing. Chromogenic print. 14 ¼ × 10 in. (36.2 × 25.4 cm). San Francisco Museum of Modern Art; Gift of Nion McEvoy. © Nina Katchadourian
*Hans Memling, *Tommaso di Folco Portinari (1428–1501); Maria Portinari (Maria Maddalena Baroncelli, born 1456)*, ca. 1470. Oil on wood. Tommaso (.626) overall: 17 ⅜ × 13 ¼ in. (44.1 × 33.7 cm); painted surface: 16 ⅝ × 12 ½ in. (42.2 × 31.8 cm). Maria (.627) overall: 17 ⅜ × 13 ⅜ in. (44.1 × 34 cm); painted surface: 16 ⅝ × 12 ⅝ in. (42.2 × 32.1 cm). Bequest of Benjamin Altman, 1913 (14.40.626–27)

pp. 120–21:
*Alex Katz, *Face of a Poet*, 1972. Oil on canvas. 114 × 210 in. (289.6 × 533.4 cm). Gift of Paul Jacques Schupf, 1986 (1986.363). © Alex Katz
*Franz Kline, *Black, White, and Gray*, 1959. Oil on canvas. 105 × 78 in. (266.5 × 198 cm). George A. Hearn Fund, 1959 (59.165). © 2017 The Franz Kline Estate / Artists Rights Society (ARS), New York

pp. 122–23:
Jeff Koons, *Gazing Ball (Farnese Hercules)*, 2013. Plaster, glass. 128 ½ × 67 × 48 ⅝ in. (326.4 × 170.2 × 123.5 cm). The Broad (F-KOONS-2013.025). © Jeff Koons
*Marble Statue Group of the Three Graces, 2nd century AD, Roman, Imperial. Marble. 48 ⁷⁄₁₆ × 39 ⅜ in. (123 × 100 cm). Purchase, Philodoroi, Lila Acheson Wallace, Mary and Michael Jaharis, Annette and Oscar de la Renta, Leon Levy Foundation, The Robert A. and Renée E. Belfer Family Foundation, Mr. and Mrs. John A. Moran, Jeannette and Jonathan Rosen, Malcolm Hewitt Wiener Foundation and Nicholas S. Zoullas Gifts, 2010 (2010.260)
*Marble Statue of a Youthful Hercules, AD 69–96, Roman, early Imperial, Flavian. Marble. H. 97 ³⁄₁₆ in. (246.9 cm). Gift of Mrs. Frederick F. Thompson, 1903 (03.12.13)

pp. 124–25:
*An-My Lê, *Dong Thap, Southern Vietnam*, 1994. Gelatin silver print. 15 ⅞ × 22 ⅝ in. (40.3 × 57.4 cm). Purchase, The Horace W. Goldsmith Foundation Gift, through Joyce and Robert Menschel, 1998 (1998.251). © An-My Lê
*Eugène Atget, *Cuisine*, ca. 1910. Albumen silver print from glass negative. 8 ⁷⁄₁₆ × 6 ¾ in. (21.4 × 17.2 cm). Purchase, The Horace W. Goldsmith Foundation Gift, through Joyce and Robert Menschel, 1990 (1990.1026.2)

pp. 126–27:
*Il Lee, *Untitled 303*, 2003. Ballpoint pen on paper. 30 × 22 in. (76.2 × 55.9 cm). Purchase, Vilcek Foundation Gift, 2016 (2016.18). Courtesy the artist and Art Projects International, New York. © Il Lee
*Rembrandt (Rembrandt van Rijn), *Portrait of a Young Woman with a Fan*, 1633. Oil on canvas. 49 ½ × 39 ¾ in. (125.7 × 101 cm). Gift of Helen Swift Neilson, 1943 (43.125)

pp. 128–29:
Lee Mingwei, *Sonic Blossom*, 2013–15. Ongoing participatory performance installation with chair, music stand, costume, spontaneous song. Courtesy the artist. © Lee Mingwei. Photo: Anita Kan
*Velvet Textile for a Dragon Robe, 17th century, China, Qing dynasty. Silk velvet with weft patterning in silk, metallic thread, and feather thread.

55 in. × 8 ft. 6 in. (139.7 × 259.1 cm). Purchase, Friends of Asian Art Gifts, 1987 (1987.147)
*Woman's Ceremonial Robe (the Bat Medallion Robe), first half of the 18th century, China, Qing dynasty. Silk and metallic thread embroidery on silk satin. 54 × 75 in. (137.2 × 190.5 cm). Anonymous Gift, 1943 (43.119)

pp. 130–31:
Lee Ufan, *From Line*, 1974. Oil on canvas. 71 ½ × 89 ⅜ in. (181.6 × 227 cm). The Museum of Modern Art; Committee on Painting and Sculpture Funds (392.2010). © Lee Ufan. Digital image © The Museum of Modern Art / Licensed by SCALA / Art Resource, NY
*Moon Jar, second half of the 18th century, Korean, Joseon dynasty. Porcelain. H. 15 ¼ in. (38.7 cm); Diam. 13 in. (33 cm); Diam. of rim 5 ½ in. (14 cm); Diam. of foot 4 ⅞ in. (12.4 cm). The Harry G. C. Packard Collection of Asian Art, Gift of Harry G. C. Packard, and Purchase, Fletcher, Rogers, Harris Brisbane Dick, and Louis V. Bell Funds, Joseph Pulitzer Bequest, and The Annenberg Fund Inc. Gift, 1975 (1979.413.1)

pp. 132–33:
*Glenn Ligon, *Untitled: Four Etchings*, 1992. Portfolio of 4 etchings (pictured: 1st of 4 etchings in the series). 25 × 17 ¼ in. (63.5 × 43.8 cm). Gift of The Peter Norton Family Foundation, 1998 (1998.456.2a–d). © Glenn Ligon
*Reliquary Element: Head (*The Great Bieri*), 19th century, Gabon, Fang peoples, Betsi group. Wood, metal, palm oil. 18 ⁹⁄₁₆ × 9 ¾ × 6 ⅝ in. (46.5 × 24.8 × 16.8 cm). The Michael C. Rockefeller Memorial Collection, Bequest of Nelson A. Rockefeller, 1979 (1979.206.229)

pp. 134–35:
Lin Tianmiao, *Rotation-Revolution*, 2016. Polyurea, steel, acrylic, silk, mixed media. Dimensions variable. Courtesy the artist. © Lin Tianmiao
*Alex Katz, *Black and Brown Blouse*, 1976. Oil on canvas. 72 × 60 in. (182.9 × 152.4 cm). George A. Hearn Fund, 1978 (1978.9). © Alex Katz

pp. 136–37:
*Kalup Linzy, *Conversations wit de Churen V: As da Art World Might Turn*, 2006. Single-channel digital video, color, sound. 12 min. 10 sec. Funds from various donors, 2012 (2012.250). © 2006 Kalup Linzy
*Édouard Manet, *Mademoiselle V. . . in the Costume of an Espada*, 1862. Oil on canvas. 65 × 50 ¼ in. (165.1 × 127.6 cm). H. O. Havemeyer Collection, Bequest of Mrs. H. O. Havemeyer, 1929 (29.100.53)

pp. 138–39:
Robert Longo, *Untitled (Russian Bomb/Semipalatinsk)*, 2003. Charcoal on paper. 97 ½ × 71 in. (247.7 × 180.3 cm). The Museum of Modern Art; The Judith Rothschild Foundation Contemporary Drawings Collection Gift (2252.2005). © 2017 Robert Longo / Artists Rights Society (ARS), New York. Digital image © The Museum of Modern Art / Licensed by SCALA / Art Resource, NY
*Jackson Pollock, *Autumn Rhythm (Number 30)*, 1950. Enamel on canvas. 105 × 207 in. (266.7 × 525.8 cm). George A. Hearn Fund, 1957 (57.92). © 2016 Artists Rights Society (ARS), New York

pp. 140–41:
*Nicola López, *Scaffold City*, 2008. Printed and published by Pace Prints. Etching, linoleum cut, collage. 56 ⁹⁄₁₆ × 83 ⅝ in. (143.7 × 212.4 cm). John B. Turner Fund, 2013 (2013.617). © Nicola López
*Jacques Callot, *May Day Celebrations at Xeuilley*, 1624–25. Etching; first state of four (Lieure). 7 ½ × 13 ¹⁄₁₆ in. (19 × 33.2 cm). Harris Brisbane Dick Fund, 1925 (25.2.5)
*Eugène Delacroix, Study for *The Sultan of Morocco and His Entourage*, ca. 1832–33. Brush and brown ink on heavy laid paper. 7 ⅝ × 9 ¹⁵⁄₁₆ in. (19.4 × 25.2 cm). Gift from the Karen B. Cohen Collection of Eugène Delacroix, in honor of Henri Loyrette, 2013 (2013.1135.20)

pp. 142–43:
Nalini Malani, *Gamepieces*, 2003/2009. Four-channel video / shadow play (color, sound: 12 min.), synthetic polymer paint on 6 Lexan cylinders. Dimensions variable. The Museum of Modern Art; Gift of the Richard J. Massey Foundation for Arts and Sciences (199.2007). © 2015 Nalini Malani
Hanuman Bearing the Mountaintop with Medicinal Herbs, ca. 1800,

India, Rajasthan. Ink and opaque watercolor on cloth. 51 ¼ × 45 ¾ in. (130.2 × 116.2 cm). Gift of Edward M. Bratter, 1957 (57.70.6)

pp. 144–45:
*Kerry James Marshall, *Untitled (Studio)*, 2014. Acrylic on PVC panel. 83 ½ × 118 ⅞ in. (211.9 × 301.8 cm). Purchase, The Jacques and Natasha Gelman Foundation Gift, Acquisitions Fund and The Metropolitan Museum of Art Multicultural Audience Development Initiative Gift, 2015 (2015.366). © Kerry James Marshall
*Jean Auguste Dominique Ingres and Workshop, *Odalisque in Grisaille*, ca. 1824–34. Oil on canvas. 32 ¾ × 43 in. (83.2 × 109.2 cm). Catharine Lorillard Wolfe Collection, Wolfe Fund, 1938 (38.65)

pp. 146–47:
Josiah McElheny, *Blue Prism Painting V*, 2015. Hand-formed cut-and-polished blue glass, low-iron mirror, blue architectural sheet glass, oak, Sumi ink. 43 ⅜ × 43 ⅜ × 7 ½ in. (110.2 × 110.2 × 19.1 cm). Courtesy Andrea Rosen Gallery, New York. © Josiah McElheny. Photo: Ron Amstutz
*Horace Pippin, *Self-Portrait II*, 1944. Oil on canvas, adhered to cardboard. 8 ½ × 6 ½ in. (21.6 × 16.5 cm). Bequest of Jane Kendall Gingrich, 1982 (1982.55.7). © Estate of Horace Pippin

pp. 148–49:
*Laura McPhee and Virginia Beahan, *The Blue Lagoon, Svartsengi Geothermal Pumping Station, Iceland*, 1988. Chromogenic print. 29 ¼ × 37 in. (74.3 × 94 cm). Gift of Laura McPhee and Virginia Beahan, 2000 (2000.101). © Laura McPhee and Virginia Beahan
*Pieter Bruegel the Elder, *The Harvesters*, 1565. Oil on wood. Overall, including added strips at top, bottom, and right: 46 ⅞ × 63 ¾ in. (119 × 162 cm); original painted surface: 45 ⅞ × 62 ⅞ in. (116.5 × 159.5 cm). Rogers Fund, 1919 (19.164)

pp. 150–51:
*Josephine Meckseper, *Blow Up (Michelli)*, 2006. Body form (torso with undergarment), two plastic frames with two photos in each, leg form (calf high with sock), leg form (thigh high with stocking), round metal stand, toilet scrubber in holder, metal sculpture, two glass balls, double-sided ENDLESS DEALS sign, clip stand, double-sided color prints mounted on Sintra, double-sided C-print / gelatin silver print mounted on Sintra, unmounted gelatin silver print. 82 × 96 × 27 in. (208.3 × 243.8 × 68.6 cm). Purchase, Stephen and Nan Swid Gift and The Cynthia Hazen Polsky Fund, 2014 (2014.297a–w). © Josephine Meckseper
*George Tooker, *Government Bureau*, 1956. Egg tempera on wood. 19 ⅝ × 29 ⅝ in. (49.8 × 75. 2 cm). George A. Hearn Fund, 1956 (56.78). Courtesy DC Moore Gallery, New York. © Estate of George Tooker

pp. 152–53:
Julie Mehretu, *Conjured Parts (head), Aleppo*, 2016. Ink and acrylic on canvas. 72 × 84 in. (182. 9 × 213.4 cm). No. 18443. Courtesy Marian Goodman Gallery. © Julie Mehretu
*Velázquez (Diego Rodríguez de Silva y Velázquez), *Juan de Pareja (born about 1610, died 1670)*, 1650. Oil on canvas. 32 × 27 ½ in. (81.3 × 69.9 cm). Purchase, Fletcher and Rogers Funds, and Bequest of Miss Adelaide Milton de Groot (1876–1967), by exchange, supplemented by gifts from friends of the Museum, 1971 (1971.86)

pp. 154–55:
Alexander Melamid, *Deep Fried Andy Warhol (medium rare)*, 2013. Paper, plastic food container. 9 × 7 in. (22.9 × 17.8 cm). The National Portrait Gallery, Washington, DC. © Alexander Melamid
*Ernest Meissonier, *1807, Friedland*, ca. 1861–75. Oil on canvas. 53 ½ × 95 ½ in. (135.9 × 242.6 cm). Gift of Henry Hilton, 1887 (87.20.1)

pp. 156–57:
Mariko Mori, *Dream Temple*, 1997–99. Metal, glass, plastic, fiber optics, fabric, Vision Dome (3-D hemispherical display), audio. 16 ft. 4 ¾ in. × 32 ft. 9 ⅝ in. (500 × 1,000 cm). Courtesy Fondazione Prada, Milan. © Mariko Mori
*Botticelli (Alessandro di Mariano Filipepi), *The Annunciation*, ca. 1485. Tempera and gold on wood. 7 ½ × 12 ⅜ in. (19.1 × 31.4 cm). Robert Lehman Collection, 1975 (1975.1.74)

CAPTIONS AND CREDITS

pp. 158–59:
*Vik Muniz, *Valentine, The Fastest*, 1996. Gelatin silver print. 13 ⅜ × 10 ½ in. (33.9 × 26.7 cm). Purchase, Anonymous Gift, 1997 (1997.230.1). © Vik Muniz
*The Henry R. Luce Center for the Study of American Art at The Metropolitan Museum of Art, for Vik Muniz's *Artist Project* 2015 episode. © 2015 MMA, photographed by Eugenia Tinsley

pp. 160–61:
Wangechi Mutu, *One Hundred Lavish Months of Bushwhack*, 2004. Cut-and-pasted printed paper with watercolor, synthetic polymer paint, pressure-sensitive stickers on transparentized paper. 68 ½ × 42 in. (174 × 106.7 cm). The Museum of Modern Art; Fund for the Twenty-First Century (99.2005). © Wangechi Mutu. Digital image © The Museum of Modern Art / Licensed by SCALA / Art Resource, NY
*Egon Schiele, *Seated Woman in Chemise*, 1914. Graphite on paper. 18 × 12 ⅛ in. (45.7 × 30.8 cm). Bequest of Scofield Thayer, 1982 (1984.433.313)
*Egon Schiele, *Seated Woman in Corset and Boots*, 1918. Crayon on paper. 19 ¾ × 12 ⅞ in. (50.2 × 32.7 cm). Bequest of Scofield Thayer, 1982 (1984.433.300)

pp. 162–63:
*James Nares, *Street*, 2011. HD digital video, color, sound. 61 min. Purchase, Vital Projects Fund Inc. Gift, through Joyce and Robert Menschel, 2012 (2012.573). © James Nares
*Wang Xizhi, 東晉 王羲之 十七日帖 十三世紀拓本 (*On the Seventeenth Day*), 13th-century rubbing of a 4th-century text, China. Album of 30 leaves; ink on paper. Each leaf: 9 ⅝ × 5 in. (24.4 × 12.7 cm). Gift of Mr. and Mrs. Wan-go H. C. Weng, 1991 (1991.380)

pp. 164–65:
Catherine Opie, *Self-Portrait/Nursing*, 2004. Chromogenic print. 40 × 32 in. (101.6 × 78.7 cm). Solomon R. Guggenheim Museum, New York; Purchased with funds contributed by the International Director's Council and Executive Committee Members: Ruth Baum, Edythe Broad, Elaine Terner Cooper, Dimitris Daskalopoulos, Harry David, Gail May Engelberg, Shirley Fiterman, Nicki Harris, Dakis Joannou, Rachel Lehmann, Linda Macklowe, Peter Norton, Tonino Perna, Elizabeth Richebourg Rea, Mortimer D. A. Sackler, Simonetta Seragnoli, David Teiger, Ginny Williams, and Elliot K. Wolk; and Sustaining Members: Tiqui Atencio, Linda Fischbach, Beatrice Habermann, and Cargill and Donna MacMillan, 2005 (2005.14). Courtesy Regen Projects, Los Angeles and Lehmann Maupin, New York and Hong Kong. © Catherine Opie
*Bed Valances and Side Curtains, ca. 1700, French. Canvas, silk-and-wool embroidery in gros and petit point. Gift of Irwin Untermyer, 1953 (53.2.1–.8)
*Pair of Wine Jugs, ca. 1680, French, Nevers. Faience (tin-glazed earthenware). Purchase, The Charles E. Sampson Memorial Fund, Gift of Irwin Untermyer, by exchange, Rogers Fund, and Bequest of John L. Cadwalader, by exchange, 1985 (1985.181.1, .2)

pp. 166–67:
*Cornelia Parker, *Endless Sugar*, 2011. Silver-plate and tinned-copper wire. 5 in. (12.7 cm) above floor and approximately 10 ¼ in. deep × 162 ½ in. long (26.03 × 412.75 cm) when installed. Purchase, Hortense and William A. Mohr Sculpture Purchase Fund, 2013 (2013.991a–dd). © Cornelia Parker
*Robert Capa, *The Falling Soldier*, 1936, printed at later date. Gelatin silver print. 9 ¾ × 13 ⅜ in. (24.7 × 34 cm). Gilman Collection, Purchase, Alfred Stieglitz Society Gifts, 2005 (2005.100.166). Photograph by Robert Capa © Cornell Capa / Magnum

pp. 168–69:
Izhar Patkin, *The Black Paintings (Night)*, 1986. Ink and vinyl paint on neoprene, twenty-two panels. 14 × 22 × 28 ft. (426.7 × 670.6 × 853.3 cm). The Museum of Modern Art; Gift of Stephen and Marsha Berini (279.1987.a–v). © Izhar Patkin. Digital image © The Museum of Modern Art / Licensed by SCALA / Art Resource, NY
*Shiva as Lord of Dance (Nataraja), ca. 11th century, Indian, Tamil Nadu, Chola period (880–1279). Copper alloy. H. 26 ⅞ in. (68.3 cm), Diam. 22 ¼ in. (56.5 cm). Gift of R. H. Ellsworth Ltd., in honor of Susan Dillon, 1987. (1987.80.1)

pp. 170–71:
Sheila Pepe, *Red Hook at Bedford Terrace*, 2008. Shoelaces, cotton yarn, nautical towline. Dimensions variable. Smith College Museum of Art; Purchased with gifts from members of the Museum's Visiting Committee in honor of the retirement of Ann Johnson (SC 2008:31). © Sheila Pepe
*Kunz Lochner, Armor of Emperor Ferdinand I (1503–1564), dated 1549, German, Nuremberg. Steel, brass, leather. 67 in. (170.2 cm), 52 lb. 14 oz. (24 kg). Purchase, Rogers Fund and George D. Pratt Gift, 1933 (33.164a–x)

pp. 172–73:
*Raymond Pettibon, *No Title (They Were A)*, 1998. Ink and graphite on paper. 17 ¼ × 11 ¾ in. (43.8 × 29.8 cm). Gift of Gabriella De Ferrari, in memory of Delia Brignole De Ferrari, 2006 (2006.574.2a, b). © Raymond Pettibon
*Joseph Mallord William Turner, *Venice, from the Porch of Madonna della Salute*, ca. 1835. Oil on canvas. 36 × 48 ⅛ in. (91.4 × 122.2 cm). Bequest of Cornelius Vanderbilt, 1899. (99.31)

pp. 174–75:
*Sopheap Pich, *Buddha 2*, 2009. Rattan, wire, dye. 100 × 29 × 9 in. (254 × 73.7 × 22.9 cm). Purchase, Friends of Asian Art Gifts, 2012 (2012.349). © Sopheap Pich
*Vincent van Gogh, *Road in Etten*, 1881. Chalk, pencil, pastel, watercolor; underdrawing in pen and brown ink. 15 ½ × 22 ¾ in. (39.4 × 57.8 cm). Robert Lehman Collection, 1975 (1975.1.774)

pp. 176–77:
*Robert Polidori, *5417 Marigny Street, New Orleans, Louisiana*, March 2006. Chromogenic print. Image: 34 × 48 in. (86.4 × 121.9 cm); mount: 40 × 54 in. (101.6 × 137.2 cm); frame: 41 × 55 × 2 ¼ in. (104.1 × 139.7 × 5.7 cm). Gift of the artist, 2006 (2006.526.1). © Robert Polidori
*Jules Bastien-Lepage, *Joan of Arc*, 1879. Oil on canvas. 100 × 110 in. (254 × 279.4 cm). Gift of Erwin Davis, 1889 (89.21.1)

pp. 178–79:
Rona Pondick, *Monkeys*, 1998–2001. Stainless steel. 41 ¼ × 66 × 85 ½ in. (104.77 × 167.64 × 217.17 cm). Edition of 6. New Orleans Museum of Art; Gift of the Sydney and Walda Besthoff Foundation. © Rona Pondick
*Nose and Lips of Akhenaten, ca. 1353–1336 BC, Egypt, New Kingdom, Amarna period, Dynasty 18, reign of Akhenaten. From Middle Egypt, Amarna (Akhetaten), Great Temple of the Aten. Indurated limestone. 3 ³⁄₁₆ × 2 ½ × 2 ³⁄₁₆ in. (8.1 × 6.3 × 5.5 cm). Purchase, Edward S. Harkness Gift, 1926. (26.7.1395)

pp. 180–81:
Liliana Porter, *Dialogue (with Penguin)*, 1999. Cibachrome. 35 × 27 in. (88.9 × 68.58 cm). Courtesy the artist. © Liliana Porter
*Jacometto (Jacometto Veneziano), *Portrait of a Young Man*, 1480s. Oil on wood. 11 × 8 ¼ in. (27.9 × 21 cm). The Jules Bache Collection, 1949 (49.7.3)

pp. 182–83:
Wilfredo Prieto, *Yes/No*, 2002. Two motorized fans. Overall dimensions variable. The Solomon R. Guggenheim Museum, New York; Guggenheim UBS MAP Purchase Fund, 2014 (2014.48). © Wilfredo Prieto. Installation view: *Under the Same Sun: Art from Latin America Today*, The Solomon R. Guggenheim Museum, New York, June 13–October 1, 2014. Photo: Kristopher McKay. Photo credit: The Solomon R. Guggenheim Foundation / Art Resource, NY
*Auguste Rodin, Study of a Hand, probably modeled ca. 1895, French. Cast plaster. L. 13 ½ in. (34.3 cm). Gift of the artist, 1912 (12.12.8)

pp. 184–85:
Rashid Rana, *Desperately Seeking Paradise I*, 2007–8. Chromogenic print, Diasec, stainless steel. 39 ⅜ × 39 ⅜ × 39 ⅜ in. (300 × 300 × 300 cm). Edition of 3. Courtesy the artist and Lisson Gallery, London. © Rashid Rana. Photo: Vipul Sangoi
*Umberto Boccioni, *Unique Forms of Continuity in Space*, 1913, cast 1949. Bronze. 47 ¾ × 35 × 15 ¾ in. (121.3 × 88.9 × 40 cm). Bequest of Lydia Winston Malbin, 1989 (1990.38.3)

pp. 186–87:
*Krishna Reddy, *Maternity*, 1954. Mixed-color intaglio. 25 ½ × 19 ½ in. (64.8 × 49.5 cm). John B. Turner Fund, 2014 (2014.80). © Krishna Reddy
*Henry Moore, *Reclining Figure, No. 4*, 1954–55. Bronze. 15 ½ × 23 ½ × 12 ½ in. (39.4 × 59.7 × 31.8 cm). Gift of Mr. and Mrs. Leonard S. Field, 1995 (1995.600). Reproduced by permission of The Henry Moore Foundation © The Henry Moore Foundation. All Rights Reserved, DACS 2016 / www .henry-moore.org

pp. 188–89:
Matthew Ritchie, *The Hierarchy Problem*, 2003. Acrylic wall drawing, rubber and Tyvek carpet, photographic light box, oil and marker painting. Solomon R. Guggenheim Museum, New York; Purchased with funds contributed by the International Director's Council and Executive Committee Members: Ruth Baum, Edythe Broad, Elaine Terner Cooper, Dimitris Daskalopoulos, Harry David, Gail May Engelberg, Shirley Fiterman, Nicki Harris, Dakis Joannou, Rachel Lehmann, Linda Macklowe, Peter Norton, Tonino Perna, Elizabeth Richebourg Rea, Mortimer D. A. Sackler, Simonetta Seragnoli, David Teiger, Ginny Williams, and Elliot K. Wolk; and Sustaining Members: Tiqui Atencio, Linda Fischbach, Beatrice Habermann, Miryam Knutson, and Cargill and Donna MacMillan, 2004 (2004.75). Courtesy the artist and Andrea Rosen Gallery, New York. © Matthew Ritchie. Photo: Peter Oszvald
The Triumph of Fame over Death, ca. 1500–1530, South Netherlandish. Wool warp, wool and silk wefts. 144 × 128 in. (365.8 × 325.1 cm). Bequest of George D. Pratt, 1935 (41.167.2)

pp. 190–91:
*Dorothea Rockburne, *Study for Seraphim: Love*, 1982. Watercolor on vellum. 36 × 37 in. (91.4 × 94 cm). Purchase, Louis and Bessie Adler Foundation Inc. Gift, 1983 (1983.19). © 2017 Dorothea Rockburne / Artists Rights Society (ARS), New York
*Head of a Ruler, ca. 2300–2000 BC, early Bronze Age, Iran or Mesopotamia. Copper alloy. 13 ½ in. (34.3 cm). Rogers Fund, 1947 (47.100.80)

pp. 192–93:
Alexis Rockman, *Host and Vector*, 1996. Oil on wood panel. 84 ¹⁄₁₆ × 72 in. (213.5 × 182.9 cm). Whitney Museum of American Art, New York; Gift of the Nye Family (2002.1). © 2017 Alexis Rockman / Artists Rights Society (ARS), New York
*Martin Johnson Heade, *Hummingbird and Passionflowers*, ca. 1875–85. Oil on canvas. 20 × 12 in. (50.8 × 30.5 cm). Purchase, Gift of Albert Weatherby, 1946 (46.17)

pp. 194–95:
Annabeth Rosen, *VELO*, 2006–7. Fired ceramic. 19 × 17 × 13 in. (48.26 × 43.18 × 33.02 cm). Courtesy the artist and Gallery Paule Anglim. © Annabeth Rosen
*Figural Spill Vase, 1830–70, American, made in Bennington, Vermont, United States. Earthenware with flint enamel glaze. 8 ¾ × 11 in. (22.2 × 27.9 cm). Bequest of Helen Hay Whitney, 1944 (45.35.32)
*Lyman, Fenton & Co. (1849–52), Figural Spill Vase, 1849, American, made in Bennington, Vermont, United States. Earthenware with flint enamel glaze. 10 ¾ × 10 ¾ in. (27.3 × 27.3 cm). Rogers Fund, 1938 (38.125.1)

pp. 196–97:
*Martha Rosler, *Semiotics of the Kitchen*, 1975. Single-channel digital video, transferred from video tape, black-and-white, sound. 6 min. 9 sec. Purchase, Henry Nias Foundation Inc. Gift, 2010 (2010.245). Courtesy Electronic Arts Intermix (EAI), New York. © Martha Rosler
*Cuxa Cloister, ca. 1130–40, Catalan. Marble. The Cloisters Collection, 1925 (25.120.398–.954)

pp. 198–99:
Tom Sachs, *Unité*, 2001. Foamcore, thermal adhesive, Uniball Micro, resin, Bristol board, and Wite-Out. 7 ft. 2 in. × 17 ft. 3 in. × 3 ft. 2 in. (218.4 × 525.8 × 96.5 cm). Solomon R. Guggenheim Museum, New York Gift; Anonymous Donor, 2003 (2003.1). © Tom Sachs
*Architectural Elements from North Family Dwelling, New Lebanon, New York, ca. 1830–40, American, Shaker. Wood. Dimensions unavailable. Purchase, Emily Crane Chadbourne Bequest, 1972 (1972.187.1)

pp. 200–201:
David Salle, *Mingus in Mexico*, 1990. Oil and acrylic on canvas with photosensitized linen. 84 × 114 in. (213.4 × 289.6 cm). Saatchi Gallery. © David Salle
*Marsden Hartley, *Mt. Katahdin (Maine), Autumn #2*, 1939–40. Oil on canvas. 30 ¼ × 40 ¼ in. (76.8 × 102.2 cm); frame: 36 ⅛ × 46 ¼ × 1 ¾ in. (91.8 × 117.5 × 4.4 cm). Edith and Milton Lowenthal Collection, Bequest of Edith Abrahamson Lowenthal, 1991 (1992.24.3)
*Marsden Hartley, *Lobster Fishermen*, 1940–41. Oil on Masonite. 29 ¾ × 40 ⅞ in. (75.6 × 103.8 cm); frame: 39 ⅝ × 50 ⅝ × 2 ½ in. (100.6 × 128.6 × 6.4 cm). Arthur Hoppock Hearn Fund, 1942 (42.160)

pp. 202–3:
Carolee Schneemann, *Cycladic Imprints*, 1991–93. Slide projections, motorized violins, quadraphonic sound collage by Malcolm Goldstein. 15 min. loop. 240 × 432 in. (609.6 × 1,097.28 cm). Courtesy the artist. © Carolee Schneemann
*Attributed to the Bastis Master, *Marble Female Figure*, 2600–2400 BC. Marble. H. 24 ¾ in. (62.79 cm). Gift of Christos G. Bastis, 1968 (68.148)

pp. 204–5:
Dana Schutz, *Presentation*, 2005. Oil on canvas. 10 × 14 ft. (304.8 × 426.7 cm). The Museum of Modern Art; Fractional and promised gift of Michael and Judy Ovitz (245.2005). Courtesy the artist and Petzel, New York. © 2015 Dana Schutz
*Balthus (Balthasar Klossowski), *The Mountain*, 1937. Oil on canvas. 97 ⅝ × 143 ⅝ in. (248 × 365 cm). Purchase, Gifts of Mr. and Mrs. Nate B. Spingold and Nathan Cummings, Rogers Fund and The Alfred N. Punnett Endowment Fund, by exchange, and Harris Brisbane Dick Fund, 1982 (1982.530). © Balthus

pp. 206–7:
*Arlene Shechet, *Seeing Is Believing*, 2015. Glazed ceramic, painted steel. 60 ⅛ × 22 × 25 in. (152.7 × 55.9 × 63.5 cm). Purchase, The Modern Circle Gifts, 2016 (2016.229a, b). © Arlene Shechet. Photo: Chris Kendall
*Bronze Statuette of a Veiled and Masked Dancer, 3rd–2nd century BC, Greek, Hellenistic. Bronze. 8 ¹⁄₁₆ × 3 ½ × 4 ½ in. (20.5 × 8.9 × 11.4 cm), 4.1 lb. (1.9 kg). Bequest of Walter C. Baker, 1971 (1972.118.95)

pp. 208–9:
*James Siena, *Squa Tront*, 2005–10. Engraving. Plate: 19 ⅛ × 15 in. (48.6 × 38.1 cm); sheet: 27 × 22 ¾ in. (68.6 × 57.8 cm). John B. Turner Fund, 2011 (2011.509.1–.10). © James Siena
*Buddha of Medicine Bhaishajyaguru (Yaoshi fo), ca. 1319, China, Yuan dynasty. Water-based pigment over foundation of clay mixed with straw. Gift of Arthur M. Sackler, in honor of his parents, Isaac and Sophie Sackler, 1965 (65.29.2)

pp. 210–11:
*Katrín Sigurdardóttir, *Boiserie*, 2010. Painted MDF panels, mirrors, piano hinges. As installed: 288 × 70 × 196 in. (731.5 × 177.8 × 497.8 cm). Purchase, William S. Lieberman Bequest, 2011 (2011.186.1–.82). © Katrín Sigurdardóttir
*Boiserie from the Hôtel de Cabris, Grasse, France, ca. 1774, with later additions, French. Carved, painted, and gilded oak. Overall: 11 ft. 8 ½ in. × 22 ft. 10 ½ in. × 25 ft. 6 in. (3.56 × 6.96 × 7.77 m). Purchase, Mr. and Mrs. Charles Wrightsman Gift, 1972 (1972.276.1)

pp. 212–13:
*Shahzia Sikander, *Orbit*, 2012. Color-direct gravure. Plate: 27 × 21 ¼ in. (68.6 × 54 cm); sheet: 26 × 29 ½ in. (66 × 74.9 cm). Stewart S. MacDermott Fund, 2013 (2013.154). © Shahzia Sikander
Laila and Majnun in School, folio from a *Khamsa* (Quintet) of Nizami. Painting by Shaikh Zada, AH 931 / AD 1524–25, Islamic, present-day Afghanistan, Herat. Folio from an illustrated manuscript; ink, opaque watercolor, gold on paper. Painting: 7 ½ × 4 ½ in. (19.1 × 11.4 cm); page: 12 ⅝ × 8 ¾ in. (32.1 × 22.2 cm); mat: 19 ¼ × 14 ¼ in. (48.9 × 36.2 cm). Gift of Alexander Smith Cochran, 1913 (13.228.7.7)

pp. 214–15:
*Joan Snyder, *Heart On*, 1975. Oil, acrylic, paper, fabric, cheesecloth,

papier-mâché, mattress batting, thread on canvas. 72 × 96 in. (182.9 × 243.8 cm). Gift of Mr. and Mrs. Donald Rugoff, 1981 (1981.199). © Joan Snyder
*Florine Stettheimer, *The Cathedrals of Art*, 1942. Oil on canvas. 60 ¼ × 50 ¼ in. (153 × 127.6 cm). Gift of Ettie Stettheimer, 1953 (53.24.1)

pp. 216–17:
*Pat Steir, *Sixteen Waterfalls of Dreams, Memories, and Sentiment*, 1990. Oil on canvas. 78 ½ × 151 ⅛ in. (199.4 × 383.9 cm). Kathryn E. Hurd Fund, by exchange, 2009 (2009.473). © Pat Steir, New York, NY
*Power Figure (*Nkisi N'Kondi: Mangaaka*), 19th century, Republic of the Congo or Cabinda, Angola, Chiloango River region, Kongo peoples, Yombe group. Wood, iron, resin, ceramic, plant fiber, textile, pigment. 46 ½ × 19 ½ × 15 ½ in. (118 × 49.5 × 39.4 cm). Purchase, Lila Acheson Wallace, Drs. Daniel and Marian Malcolm, Laura G. and James J. Ross, Jeffrey B. Soref, The Robert T. Wall Family, Dr. and Mrs. Sidney G. Clyman, and Steven Kossak Gifts, 2008 (2008.30)

pp. 218–19:
*Thomas Struth, *The Restorers at San Lorenzo Maggiore, Naples*, 1988. Chromogenic print. Image: 46 ⅞ × 62 ⅞ in. (119.1 × 159.7 cm); frame: 48 × 63 in. (121.9 × 160 cm). Purchase, Vital Projects Fund Inc. Gift, through Joyce and Robert Menschel; Alfred Stieglitz Society Gifts; Jennifer Saul Gift; Gift of Dr. Mortimer D. Sackler, Theresa Sackler and Family; and Gary and Sarah Wolkowitz Gift, 2010 (2010.121). © Thomas Struth
*唐 彩繪漆金夾紵阿彌陀佛像 Buddha, Probably Amitabha (Amituofo), early 7th century, China, Tang dynasty (618–907). Hollow dry lacquer with traces of gilt and polychrome pigment and gilding. 38 × 27 × 22 ½ in. (96.5 × 68.6 × 57.1 cm). Rogers Fund, 1919 (19.186)
*北宋 彩繪木雕文殊菩薩像 (地黃木胎) Bodhisattva Manjushri (Wenshu), late 10th–early 12th century, China, Northern Song dynasty (960–1127). Wood (foxglove) with traces of pigment; single woodblock construction. 43 × 23 in. (109.2 × 58.4 cm). Gift of Abby Aldrich Rockefeller, 1942 (42.25.5)

pp. 220–21:
*Hiroshi Sugimoto, *Boden Sea, Uttwil*, 1993. Gelatin silver print. 16 ⅝ × 21 ⁵⁄₁₆ in. (42.3 × 54.2 cm). Purchase, The Horace W. Goldsmith Foundation Gift, through Joyce and Robert Menschel, 1994 (1994.144.8). © Hiroshi Sugimoto
*Attributed to Tosa Mitsunobu, 四季竹図屏風 (*Bamboo in the Four Seasons*), late 15th–early 16th century, Muromachi period (1392–1573), Japan. Pair of six-panel screens. Ink, color, gold leaf on paper. Image: 61 ¹³⁄₁₆ × 9 ft. 9 ¾ in. (157 × 360 cm). The Harry G. C. Packard Collection of Asian Art, Gift of Harry G. C. Packard, and Purchase, Fletcher, Rogers, Harris Brisbane Dick, and Louis V. Bell Funds, Joseph Pulitzer Bequest, and The Annenberg Fund Inc. Gift, 1975 (1975.268.44, .45)

pp. 222–23:
Eve Sussman / Rufus Corporation, still from *whiteonwhite:algorithmicnoir*, 2009–11. S16mm film, 8mm film, video; continuous loop. Courtesy the artist. © Eve Sussman and Rufus Corporation
*William Eggleston, *Huntsville, Alabama*, ca. 1970. Dye-transfer print. 18 ⁷⁄₁₆ × 12 ¾ in. (46.9 × 32.4 cm). Gift of Jeffrey Fraenkel and Frish Brandt, 1991 (1991.1271). © 2005 Eggleston Artistic Trust. Courtesy Cheim & Read, New York. Used with permissions. All rights reserved.
*William Eggleston, *Untitled (Memphis)*, ca. 1970, printed 2002. Dye-transfer print. Image: 14 ½ × 21 ¾ in. (36.8 × 55.3 cm); sheet: 19 × 22 ¼ in. (48.3 × 56.5 cm). Purchase, Louis V. Bell, Harris Brisbane Dick, Fletcher, and Rogers Funds and Joseph Pulitzer Bequest, and Charlotte A. and William E. Ford Gift, 2012 (2012.293). © Eggleston Artistic Trust
*William Eggleston, *Untitled (Memphis)*, 1971, printed 1999. Dye-transfer print. Image: 21 ¹³⁄₁₆ × 14 ½ in. (55.4 × 36.8 cm); sheet: 24 × 20 in. (61 × 50.8 cm). Purchase, Louis V. Bell, Harris Brisbane Dick, Fletcher, and Rogers Funds and Joseph Pulitzer Bequest, The Horace W. Goldsmith Foundation Fund, through Joyce and Robert Menschel, and Charlotte A. and William E. Ford Gift, 2012 (2012.285). © Eggleston Artistic Trust
*William Eggleston, *Untitled (Memphis)*, ca. 1972, printed 1986. Dye-transfer print. Image: 13 ⅜ × 20 ⁹⁄₁₆ in. (34 × 52.3 cm); sheet: 18 ⅝ × 24 ¾ in. (47.3 × 62.9 cm). Purchase, Louis V. Bell, Harris Brisbane Dick, Fletcher, and Rogers Funds and Joseph Pulitzer Bequest, and Louis V. Bell Fund, 2012 (2012.288). © Eggleston Artistic Trust

pp. 224–25:
Swoon, *Dawn and Gemma*, 2014. Wood, paper, paint. 52 × 23 ¾ × 1 in. (132.1 × 60.3 × 2.5 cm). Brooklyn Museum; Gift of the artist (2015.58) © Swoon. Photo: Tod Seelie
*Honoré Daumier, *The Third-Class Carriage*, ca. 1862–64. Oil on canvas. 25 ¾ × 35 ½ in. (65.4 × 90.2 cm). H. O. Havemeyer Collection, Bequest of Mrs. H. O. Havemeyer, 1929 (29.100.129)

pp. 226–27:
Sarah Sze, *360 (Portable Planetarium)*, 2010. Mixed media, wood, paper, string, jeans, rocks. 162 × 136 × 185 in. (411.5 × 345.4 × 470 cm). Courtesy National Gallery of Canada, Ontario. © Sarah Sze
*Mastaba Tomb of Perneb, ca. 2381–2323 BC, Old Kingdom, Dynasty 5, reigns of Isesi to Unis. From Egypt, Memphite Region, Saqqara, Tomb of Perneb, Egyptian Antiquities Service/Quibell excavations. Limestone, paint. H. 15 ft. 9 ¹³⁄₁₆ in. (482.2 cm). Gift of Edward S. Harkness, 1913 (13.183.3)

pp. 228–29:
Paul Tazewell, Costume Design for Eliza for the Broadway Production of *Hamilton*, 2014. Courtesy the artist. © Paul Tazewell
*Anthony van Dyck, *James Stuart (1612–1655), Duke of Richmond and Lennox*, ca. 1633–35. Oil on canvas. 85 × 50 ¼ in. (215.9 × 127.6 cm). Marquand Collection, Gift of Henry G. Marquand, 1889 (89.15.16)

pp. 230–31:
Wayne Thiebaud, *Pie Counter*, 1963. Oil on canvas. 29 ¹³⁄₁₆ × 35 ¹⁵⁄₁₆ in. (75.7 × 91.3 cm). Whitney Museum of American Art, New York; Purchase, with funds from the Larry Aldrich Foundation Fund (64.11). Art © Wayne Thiebaud / Licensed by VAGA, New York, NY
*Rosa Bonheur, *The Horse Fair*, 1852–55. Oil on canvas. 96 ¼ × 199 ½ in. (244.5 × 506.7 cm). Gift of Cornelius Vanderbilt, 1887 (87.25)

pp. 232–33:
Hank Willis Thomas, *Thenceforward and Forever Free*, 2012. Mixed media. 61 × 17 ½ × 4 ⅝ in. (154.9 × 44.5 × 11.7 cm). Courtesy the artist and Jack Shainman Gallery, New York. © Hank Willis Thomas
*Button, 1840s–50s. Daguerreotype. Image: diam. ⅝ in. (1.6 cm). Gilman Collection Purchase, Joyce F. Menschel Gift, 2005 (2005.100.78)

pp. 234–35:
Mickalene Thomas, *A Little Taste Outside of Love*, 2007. Acrylic, enamel, and rhinestones on wood panel. 108 × 144 in. (274.3 × 365.8 cm). Brooklyn Museum; Gift of Giulia Borghese and Designated Purchase Fund (2008.7a–c). © Mickalene Thomas
*Seydou Keïta, *Untitled*, 1953–57. Modern gelatin silver print. 15 ⅜ × 21 ¾ in. (39.1 × 55.2 cm). Anonymous Gift, 1997 (1997.267). Courtesy CAAC – The Pigozzi Collection. © Seydou Keïta / SKPEAC

pp. 236–37:
Fred Tomaselli, *Echo, Wow and Flutter*, 2000. Leaves, pills, photocollage, acrylic, resin on wood panel. 84 × 120 in. (213.36 × 304.8 cm). Courtesy James Cohan, New York. © Fred Tomaselli
Guru Dragpo, 18th century, Tibetan. Distemper on cotton. 24 × 17 ½ in. (61 × 44.5 cm). Purchase, Friends of Asian Art Gifts, 2015 (2015.269)

pp. 238–39:
Jacques Villeglé, *122 rue du temple*, 1968. Torn-and-pasted printed paper on canvas. 62 ⅝ × 82 ¾ in. (159.2 × 210.3 cm). The Museum of Modern Art; Gift of Joachim Aberbach (by exchange) (229.1988). © 2015 Jacques Villeglé / Artists Rights Society (ARS), New York / ADAGP, Paris
*Georges Braque, *Still Life with Banderillas*, 1911. Oil and charcoal with sand on canvas. 25 ¾ × 21 ⅝ in. (65.4 × 54.9 cm). Jacques and Natasha Gelman Collection, 1998 (1999.363.11). © 2017 Artists Rights Society (ARS), New York / ADAGP, Paris. Digital image © The Museum of Modern Art / Licensed by SCALA / Art Resource, NY
*Pablo Picasso, *Still Life with a Bottle of Rum*, 1911. Oil on canvas. 24 ⅛ × 19 ⅞ in. (61.3 × 50.5 cm). Jacques and Natasha Gelman Collection, 1998 (1999.363.63). © 2017 Estate of Pablo Picasso / Artists Rights Society (ARS), New York

pp. 240–41:
Mary Weatherford, *Coney Island II*, 2012. Synthetic polymer paint on linen with neon lights and transformer. 103 × 83 in. (261.6 × 210.8 cm). The Museum of Modern Art; Fund for the Twenty-First Century (61.2013.a–e). © Mary Weatherford. Digital image © The Museum of Modern Art / Licensed by SCALA / Art Resource, NY
*Goya (Francisco de Goya y Lucientes), *Manuel Osorio Manrique de Zuñiga (1784–1792)*, 1787–88. Oil on canvas. 50 × 40 in. (127 × 101.6 cm). The Jules Bache Collection, 1949. (49.7.41)

pp. 242–43:
William Wegman, *Lobby Abstract*, 2015. Oil, postcards on wood panel. 30 × 40 in. (76 × 101.5 cm). Courtesy Sperone Westwater, New York. © William Wegman
145 Postcards of Railroad Stations Collected by Walker Evans, 1900s–1930s. Photomechanical reproductions; gelatin silver prints. Each approx. 3 9/16 × 5 ½ in. (9 × 14 cm). Walker Evans Archive, 1994 (1994.264.1.1–.145)

pp. 244–45:
Kehinde Wiley, *The Two Sisters*, 2012. Oil on linen. 96 × 72 in. (243.84 × 182.88 cm). Private collection. Courtesy the artist and Sean Kelly Gallery, New York. © Kehinde Wiley
*John Singer Sargent, *The Wyndham Sisters: Lady Elcho, Mrs. Adeane, and Mrs. Tennant*, 1899. Oil on canvas. 115 × 84 ⅛ in. (292.1 × 213.7 cm). Catharine Lorillard Wolfe Collection, Wolfe Fund, 1927 (27.67)

pp. 246–47:
*Betty Woodman, *The Ming Sisters*, 2003. Glazed earthenware, epoxy resin, lacquer, paint. 32 × 81 × 8 in. (81.3 × 205.7 × 20.3 cm). Purchase, Gift of The A. L. Levine Family Foundation, by exchange, 2003 (2003.413a–c). © Betty Woodman
Terracotta Larnax (Chest-Shaped Coffin), mid-13th century BC, Minoan. Terracotta. Overall with lid: 40 × 18 × 42 ¼ in. (101.6 × 45.7 × 107.3 cm); H. of body: 30 ½ in. (77.5 cm); H. of lid: 9 ½ in. (24.1 cm). Anonymous Gift, in memory of Nicolas and Mireille Koutoulakis, 1996 (1996.521a, b)

pp. 248–49:
Xu Bing, *Book from the Sky (Tianshu)*, ca. 1987–91. Box set of four hand-printed books with thread binding, ink on paper plus wood box. Books (each): 18 1/16 × 11 ¾ in. (45.9 × 29.9 cm); box: 19 ¼ × 13 1/16 × 4 in. (48.9 × 33.2 × 10.2 cm). Princeton University Art Museum; Purchase of the East Asian Studies Program, Princeton University Art Museum, Fowler McCormick, Class of 1921, Fund; and the P. Y. and Kinmay W. Tang Center for East Asian Art (2002-281.1–.5). © 1991 Xu Bing. Photo. Bruce M. White. Photo credit: Princeton University Art Museum / Art Resource, New York
*Jean-François Millet, *Haystacks: Autumn*, ca. 1874. Oil on canvas. 33 ½ × 43 ⅜ in. (85.1 × 110.2 cm). Bequest of Lillian S. Timken, 1959 (60.71.12)

pp. 250–51:
Dustin Yellin, *The Triptych*, 2012. Glass, collage, acrylic. 212 ½ × 46 ½ × 27 in. (539.75 × 118.11 × 68.58 cm). Courtesy the artist. © Dustin Yellin. Photo: David Deng
*Cylinder Seal: Worshipper with an Animal Offering before a Seated Deity, ca. 1480–1450 BC, Elamite (Iran, Luristan, Surkh Dum). Apatite. 1 5/16 in. (2.49 cm). Rogers Fund, 1943 (43.102.39). (Pictured with modern impression and enlarged modern impression.)

pp. 252–53:
Lisa Yuskavage, *Wrist Corsage*, 1996. Oil on linen. 84 × 72 in. (182.9 × 213.3 cm). The Museum of Modern Art; Fractional and promised gift of David Teiger (332.2004). Courtesy the artist and David Zwirner, New York / London. © Lisa Yuskavage.
*Édouard Vuillard, *The Green Interior (Figure Seated by a Curtained Window)*, 1891. Oil on cardboard, mounted on cradled wood. 12 ¼ × 8 ¼ in. (31.1 × 21 cm). Robert Lehman Collection, 1975 (1975.1.222)

pp. 254–55:
Zhang Xiaogang, *Comrades No. 13, 1996*, 1996. Oil on canvas. 15 ¾ × 11 ⅞ in. (40 × 30.2 cm). Harvard Art Museums / Fogg Museum; Gift of

Reade and Elizabeth Griffith (2012.118). © Zhang Xiaogang. Image: Imaging Department. © President and Fellows of Harvard College
*El Greco (Domenikos Theotokopoulos), *The Vision of Saint John*, ca. 1609–14. Oil on canvas. 87 ½ × 76 in. (222.3 × 193 cm). Rogers Fund, 1956 (56.48)

Acknowledgments

The idea for this book was sparked by the success of the online series *The Artist Project*, which gave viewers the opportunity to hear the wonderful conversations we had with contemporary artists about works in The Met's collection. I am grateful to Thomas P. Campbell for his leadership as director of The Met during the process for both the online series and this innovative book. He inspired me and my colleagues at the museum to undertake these ambitious and exciting collection-wide projects and provided invaluable support.

 The Artist Project would not have happened without the contributions of Teresa Lai, who worked with me to conceive and develop the online series. We were assisted by the remarkable team that included Sarah Cowan, Stephanie Wuertz, Austin Fisher, Helena Guzik, Camille Knop, and the design and development team CHIPS. The photographers Jackie Neale and Kathryn Hurni shot the wonderful portraits of the artists in this book, and Jenn Sherman worked most directly with the artists both on the online series and in preparing this book for publication.

 I am also grateful to my colleagues throughout The Met for their support, including Sree Sreenivasan, formerly Chief Digital Officer, and Barbara Bridgers and her staff, in Imaging, for the photography of The Met works of art that appear on these pages. The entire Met curatorial staff contributed to the descriptions that accompany the works of art, and they helped connect the artists with the encyclopedic collection that spans five thousand years of art. In particular, the efforts of the contemporary art and photography curators—Ian Alteveer, Kelly Baum, Iria Candela, Nicholas Cullinan, Douglas Eklund, Jennifer Farrell, Mia Fineman, Beatrice Galilee, Marla Prather, Samantha Rippner, Jeff Rosenheim, and Sheena Wagstaff—deserve special recognition.

 Gwen Roginsky, Associate Publisher at The Met, proposed publishing a book based on *The Artist Project* and worked with Deborah Aaronson, Vice President, Group Publisher at Phaidon, to adapt this material into a coherent and accessible format that takes on new meaning on the printed page. Their efforts, superbly assisted by Rachel High, Publishing and Marketing Assistant at The Met, and Bridget McCarthy, Assistant Editor at Phaidon, have made this publication a reality.

 My thanks to Mark Polizzotti, The Met's Publisher, for his thoughtful edit of my introduction and support for this publication. Finally, I am grateful to the 120 artists who contributed to *The Artist Project* for their enthusiasm and willingness to share what they see when they look at art.

—Christopher Noey

The Artist Project is supported by
Bloomberg
Philanthropies

Published in association with
The Metropolitan Museum of Art
1000 Fifth Avenue
New York, NY 10028

Based on the online feature *The Artist Project*
artistproject.metmuseum.org

Phaidon Press Limited
Regent's Wharf
All Saints Street
London N1 9PA

Phaidon Press Inc.
65 Bleecker Street
New York, NY 10012

phaidon.com

First published 2017
© 2017 Phaidon Press Limited

All text and illustrations (unless otherwise noted)
© 2017 The Metropolitan Museum of Art

ISBN 978 0 7148 7354 1

A CIP catalog record for this book is available from the Library of Congress and the British Library.

Descriptions of the works in The Met's collection originally appeared in the Collection Online (metmuseum.org/art/collection), the Heilbrunn Timeline of Art History (metmuseum.org/toah/), MetPublications (metmuseum.org/art/metpublications), or on gallery labels. These texts have been reviewed and updated for this publication by Met curatorial staff, who in some cases provided new texts.

For Phaidon:
Project Editor: Bridget McCarthy
Production Controller: Nerissa Dominguez Vales
Design: Julia Hasting
Artworker: Aaron Garza

For The Met:
Project Development, Management, and Coordination:
Gwen Roginsky and Rachel High
Image Acquisitions and Artist Liaison: Jenn Sherman

Printed in China